Sustainable Urban Environm

Ellen van Bueren • Hein van Bohemen • Laure Itard
Henk Visscher

Editors

Sustainable Urban Environments

An Ecosystem Approach

 Springer

Editors
Ellen van Bueren
Faculty of Technology,
Policy and Management
Delft University of Technology
Jaffalaan 5, 2628 BX Delft
The Netherlands
e.m.vanbueren@tudelft.nl

Laure Itard
OTB Research Institute
for the Built Environment
Delft University of Technology
Jaffalaan 9, 2628 BX Delft
The Netherlands
l.c.m.itard@tudelft.nl

Hein van Bohemen
Former Lecturer Ecological
Engineering at Delft University
of Technology; now Eco
Engineering Consultancy
Holierhoek 36
2636 EK Schipluiden
The Netherlands
h.bohemen@kpnplanet.nl

Henk Visscher
OTB Research Institute for the
Built Environment
Delft University of Technology
Jaffalaan 9, 2628 BX Delft
The Netherlands
h.j.visscher@tudelft.nl

ISBN 978-94-007-1293-5 e-ISBN 978-94-007-1294-2
DOI 10.1007/978-94-007-1294-2
Springer Dordrecht Heidelberg London New York

Library of Congress Control Number: 2011935998

Cover illustration: Impression 'Hangende Tuinen', Erasmusveld Den Haag. Artist: A. van Timmeren, Atelier 2T, Haarlem.

Printed on acid-free paper

Springer is part of Springer Science+Business Media (www.springer.com)

Contents

Abbreviations

AMESH	Adaptive Methodology for Ecosystem Sustainability and Health
ASEAN	Association of Southeast Asian Nations
AU	African Union
BEE	Building Environmental Efficiency
BREEAM	Building Research Establishment (BRE) Environmental Assessment Method
C2C	Cradle-to-Cradle
CAFÉ	Corporate Average Fuel Economy
CBA	Cost–benefit analysis
CCPP	Combined cycle power plan
CCGT	Combine cycle gas turbine
C&D	Construction and demolition waste
CDM	Clean development mechanism
Ce	Cerium
CEO	Chief executive officer
CHP	Combined heat power
COP	Coefficient of performance
CPTED	Crime prevention through environmental design
CR	Corporate responsibility
CSD	Committee on spatial development
DALY	Disability adjusted life years
DC	Direct current
DFD	Design for deconstruction
DGBC	Dutch Green Building Council
DGNB	Deutsche Gesellschäft für Nachhältiges Bauen
EBI	Environmental Building Index
ECI	Environmental costs indicator
EGS	Enhanced geothermal systems
EIA	Environmental impact assessment

EM	Effective microorganisms
EMS	Environmental management systems
EPC	Energy Performance Certificate
EPD	Environmental product declarations
ESCO's	Energy service companies
ESDP	European Spatial Development Perspective
EU	European Union
FROG	Free range on grid
FSC	Forest Stewardship Council
GHG	Greenhouse gas
GDP	Gross domestic product
GRI	Global Reporting Initiative
GSI	Ground Space Index
HVAC	Heating, ventilating and air conditioning
IRENA	International Renewable Energy Agency
IRM	Integrated resource management
J	Joules
Ktoe	Kiloton oil equivalent
La	Lanthanum
LCA	Life cycle analysis/Life cycle assessment
LEED	Leadership in Energy and Environmental Design
MFA	Material flow analysis
MIB	Milieu-Index-Bedrijfsvoering
MJ	Megajoules
MKI	MilieuKostenIndicator
Nd	Neodymium
NO_x	Nitrogen oxides
NIMBY	Not in my back yard
OECD	Organisation for Economic Co-operation and Development
OEI	Operational Environmental Index
PRT	Personal rapid transit
SEA	Strategic environmental assessment
SHGC	Solar heat gain coefficient
SI	Sustainable implant
SMY	Standard meteorological year
Sm	Samarium
SME	Small and medium-sized enterprises
SO_2	Sulphur dioxide

TMY	Typical meteorological year
Toe	Ton oil-equivalent
TPES	Total primary energy supply
TRY	Test Reference Year

UAE	United Arab Emirates
UN	United Nations
UNEP	United Nations Environment Programme

Va	Voluntary agreement
VOCs	Organic compounds

Wh	Watt-hour

ZPE	Zero point energy

List of Figures

List of Tables

List of Boxes

Chapter 1
Introduction

Ellen van Bueren

Abstract Urban environments are bulk consumers of energy, water and materials and contribute to problems such as resource depletion, pollution and climate change. Considering urban environments as ecosystems helps us to understand the relationships between the many factors in the urban environment that together contribute to unsustainable development. It enables us to model the flows going in, through and out of cities or urban systems and to identify opportunities for making them more efficient, while being aware of influences from outside the systems that may influence the systems' performance. By providing a basic understanding of urban areas as systems this book will help (future) designers, builders, planners and managers of (parts of) our urban systems to analyse them and to identify appropriate solutions.

1.1 The Built Environment: Problem and Solution

The built environment is the place where the three pillars of sustainable development – people, planet and profit – meet. Buildings and cities are places where people live, love and work. This book starts with some notions and facts and figures about how the built environment influences the delicate balance of Earth's ecosystems from a people, planet and profit point of view.

As of 2007, half of the world's population lives in cities and urbanisation is expected to continue. In Europe and in North and South America, 75% of the population already live in cities, even though some cities are shrinking. In Asia and Africa, urbanisation is growing rapidly. In 2007, 35% of people lived in urban areas, and it is expected that by 2030 this percentage will have increased to 50% (WWI 2007)

E. van Bueren (✉)
Faculty of Technology, Policy and Management, Delft University of Technology,
Jaffalaan 5, 2628 BX Delft, The Netherlands
e-mail: e.m.vanbueren@tudelft.nl

E. van Bueren et al. (eds.), *Sustainable Urban Environments: An Ecosystem Approach*,
DOI 10.1007/978-94-007-1294-2_1, © Springer Science+Business Media B.V. 2012

and to 70% by 2050, resulting in megacities and hypercities of more than 20 million inhabitants (UN-HABITAT 2009). In developing countries, the drift to the city exceeds the capacity of these cities to accommodate the new citizens. The cities do not fulfil the promise of a better life that made people leave their rural villages. Of the three billion city dwellers in the world approximately one billion live in slums, and this figure is expected to double by 2030 (WWI 2007), despite efforts to reduce this number (UN-HABITAT 2008).

A significant part (40%) of the materials extracted from our planet are stored in buildings and infrastructures (Kibert et al. 2002). The construction industry produces nearly 40% of all human-generated waste (Sawin and Hughes 2007). Cities are built in catchment areas, or along rivers, and influence the hydrological cycle. The paved surfaces are impermeable to rainwater. Our use of water for industry and sanitation degrades the water quality. By impacting the hydrological cycle, cities also affect our climate. Cities are stone, dry heat islands that absorb warmth. The density of the urban structures leaves little room for natural ventilation in the streets and squares to cool down and diffuse the pollutants in the air. Cities are connected to other cities by roads, railway and airports. To support life in cities, food is grown and imported from all over the world along these transport lines. The energy needed to operate the buildings, infrastructures and transport modes mostly consists of non-renewable fossil sources and is transported over long distances. Road congestion makes cities inaccessible and causes air and noise pollution. More than 40% of the global energy consumed is used for operating buildings, including the use of electricity in buildings, buildings contribute to about one-third of emissions of global greenhouse gases (UNEP 2009).

But cities are also the centres of our economy. Exactly because they bring so many people together, they generate economic activity, such as shops, offices and services. The hustle and bustle attracts new citizens and activities that have to be accommodated. A considerable part of our capital is invested in the design, construction and management of our buildings, infrastructures, and urban structures. Buildings and infrastructure developments offer a relatively safe investment for institutional funds. About 5–15% of our Gross Domestic Product (GDP) is earned in building and construction; the construction sector employs about 5–10% of all employees (OECD 2003). On a micro-level, citizens pay a substantial part of their income in rent or mortgage.

These figures give an idea of how built environments, and especially cities, affect people, planet and profit. Traditionally, ecologists and environmentalists consider urbanisation as an infringement on our ecosystems – an infringement that should be controlled and its negative effects should be mitigated – whereas sociologists and economists tend to focus more on how urban growth can be accommodated and adapted to maximise opportunities. In this book, we aim to avoid thinking of cities in terms of good or bad. Cities are there, and most of them are growing. This is something that we should take as a starting point for our attempts to make them sustainable, a process in which we can use strategies of both mitigation and adaptation.

How significant the contribution of urban areas to sustainable development can be is illustrated by the following examples. To combat climate change, buildings

can be made energy efficient or even energy producing, such as the energy-producing dance floor in a dance club in Rotterdam. To reduce land use, cities can be built at high densities. In turn, high densities make public transport economically feasible, which reduces car dependency and increases travel opportunities for citizens. The depletion of natural resources can be slowed down by reusing buildings and constructions or the materials that they are made of. Human health can be improved by carefully selecting materials used in buildings and by improving ventilation of buildings. After all, we spent 90% of our time indoors, and indoor climate can be an important determinant of human health. In addition, shifts from car use to more sustainably powered modes of transport and measures that reduce congestion contribute to the air quality outdoors. Putting vegetation on roofs of buildings reduces the heating of these roofs and buildings during a day of sunshine and thus the need for air conditioning; while at night the evaporation of the vegetation helps to cool down the cities. In addition, green roofs slow down rainwater runoff and purify the air by binding particulate matter and carbon emissions. Also, they offer a living space for plants, birds and insects and make the city a nicer place.

These examples show that the urban environment holds various keys to a more sustainable planet. The green roof illustrates the many relationships that exist between problems and solutions. It is an example of how one solution can positively impact several problems, such as the urban heat island, water management, air quality, biodiversity, and liveability. The green roof also demonstrates how different spatial scales are connected. It is a solution that is implemented on the level of a building, but many green roofs together can impact temperature and humidity on a city level. In addition, the green roof shows that the urban environment affects multiple values, such as health, ecology, economy, liveability, and spatial quality.

1.2 Analysing the Urban Environment: An Ecosystem Approach

The introduction showed how urban environments, and cities in particular, can impact the environment positively or negatively. But where should we begin with changing unsustainable situations into sustainable ones? There is an indefinite number of variables present in the urban environment, ranging from buildings to land prices and species. These variables are somehow related, directly or indirectly. High land prices make real estate development profitable, which may further destroy the living area of species. There are numerous such causal chains, and each variable is part of multiple causal chains. As a result, cause-and-effect relationships are complex and intractable. In such a web of interconnected variables, it is difficult to know where to intervene or to predict how interventions will work out.

The ecosystem approach is a theoretical approach that helps us to frame the chaotic web of variables and relationships. The ecosystem approach has its origins in biology. It has helped biologists to understand the complexity of organisms and

the delicate relationship between populations and their environment. In this book, we will use this approach to explain the problems and opportunities for sustainability in urban environments. The essence of the approach is that it makes it possible to analyse part of a system – for example, the energy supply and energy use in a specific building – without losing sight of the wider system context in which it is situated and by which it is influenced – for example, the local climate, the energy price, user behaviour, and public and political attention for energy use, etc.

The ecosystem approach suggests that – analytically – we can distinguish subsystems that together constitute one big system. Because subsystems are smaller, i.e. they consist of fewer variables, it is easier to get to know them or to develop some understanding of the mechanisms at work within the subsystem while remaining aware of how the subsystem is influenced by the surrounding subsystems. In turn, subsystems can be split into smaller subsystems. Where to draw the line between (sub)systems is not straightforward. Often, clusters of interrelated variables can be identified which can be used for system demarcation. This can lead to the identification of an energy system, a water system, and a transport system, etc.

Defining systems' boundaries influences the problem diagnosis and potential solutions. For example, when you study sea level rise in nations which are situated just above – or even partly below – sea level, such as the Netherlands or some tropical island groups such as the Maldives, you may come to the conclusion that sea level rise is a problem that requires investing in higher levees. When you study sea level rise on a regional level, you may come to the conclusion that it could be wiser to invest in the relocation of human settlements. The value of ecosystem thinking is that it urges you to analyse a system within its context. The approach makes you aware of the – sometimes – constructed nature of system boundaries, and how these boundaries may influence your focus and judgement.

In the built environment, there are several ways to define system boundaries. Some common demarcations are introduced below.

1.2.1 Spatial Scales

A first way of defining system boundaries is based on how designers reduce complexity. They bring order to the built environment by distinguishing spatial scales. The building is usually the lowest scale distinguished, although buildings have smaller units and rooms and consist of building components and materials. Buildings are situated in neighbourhoods, neighbourhoods are situated in districts, districts in cities and towns, cities and towns in (metropolitan) areas or regions, regions in (multiple) nations, and nations in continents. At the building level, the architect largely determines the design, while at higher levels urban planners, transport infrastructure planners and landscape architects influence the design. There are many relationships between the spatial scales. Design choices at one scale influence the design choices at another scale. For example, the decision for a central heat delivery system in a newly built residential district conflicts with decentralised solutions

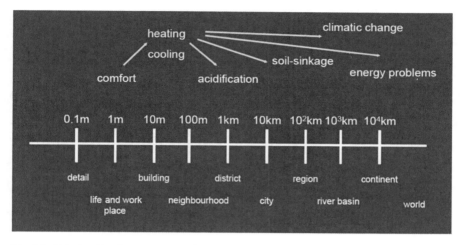

Fig. 1.1 Relationships between scales (Source: Kees Duijvestein 1997. Used with permission)

such as combined heat–power installations in individual homes. Usually, decisions at higher spatial scales constrain or condition the decisions at lower scales.

For close readers, this example of spatial scales already reveals a complexity by including spatial and administrative scales; sometimes they coincide, but in many cases there is a mismatch between spatial or physical scales and administrative ones. For example, river basins are preferably managed by one authority, to enhance policy coherency and efficiency, but rivers typically flow through multiple administrative jurisdictions.

Figure 1.1 shows how actions at a very local spatial scale, e.g. the decision to heat or cool a room to become comfortable, contributes to emissions to air and soil in the neighbourhood and district, and to exhaustion of energy sources and climate change on a global level.

1.2.2 Life Cycle Stages

A second often used demarcation in the design and decision-making about the built environment takes the life cycle of the built environment as a starting point. Buildings, constructions, built-up areas and infrastructures are initiated, designed, constructed, used, renovated and in some cases eventually demolished. These life cycle stages all have their own temporal and social dynamics, as is illustrated in Fig. 1.2. The time that each stage takes differs dramatically. Designs are prepared in weeks or months, while the use and maintenance stage of buildings and constructions can range from decades to centuries. In each stage, different stakeholders are involved, whose ideas and goals concerning the building, construction or area of their concern are likely to differ, and who have different means of power and

Fig. 1.2 Activities,
participants and time at
different life cycle stages
(Source: Kees Duijvestein
1997. Used with permission)

Participant	Activities	Time
Government	Initiative	Hours
Urban planners	Location selection	Days
Architects	Design	Weeks
Contractor	Construction	Months
Users	Use and upkeep	Years
Contractor	Renovation	Weeks
Users	(Re)use	Years
Contractors	Demolition	Days

influence at their disposal. Decisions taken by the designer have to be acted upon by actors in later stages, when the designer is no longer around to explain them.

From an ecosystems point of view, designers are challenged to take the entire life cycle into account, even when they are involved in only one stage. A method such as Life Cycle Analysis (LCA) helps to take the environmental performance of building materials from cradle to grave into account when designing buildings or larger scale developments. Cradle-to-Cradle (C2C) design goes a step further and challenges designers to only produce products – including buildings – that consist of components that can be decomposed and reused; the circle of life becomes a closed system in which there are no leakages in the forms of inefficiencies, spillages or waste. However, processes of decomposition and reuse also need energy.

1.2.3 Flows

A third way in which system boundaries can be defined is by looking at the flows that are used for the processes in the built environment. If you look at cities, or parts of them, from a system perspective focusing on input, throughput and output, you will see that cities are open systems. Processes in the built environment need input: they use water, energy and materials. Cities need water for functions such as drinking, sanitation and industry and for maintaining a liveable climate; they need energy for functions as transport, indoor climate control and working; and they need materials to construct and maintain the built environment. The throughput time of these resources differs dramatically. The resources come out of the system in a different or degraded form: the characteristics have changed and/or the quality is lower. Also, usage of the resources emits pollutants to air, water and soil. These can negatively impact the city itself, but may also impact systems at a higher level; at a regional or even global level (see Fig. 1.3).

From this flow perspective, making cities sustainable is about making efficient use of these resources and trying to maintain the quality of the resources during and after usage. For example, sewage water can be treated to be reused as drinking

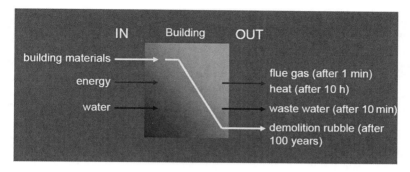

Fig. 1.3 Input, throughput and output of flows in the built environment (Source: Kees Duijvestein 1997. Used with permission)

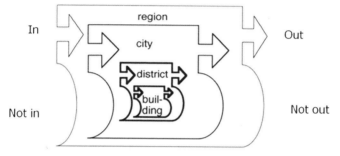

Fig. 1.4 The Ecodevice model (Source: Tjallingii 1996. Used with permission)

water, but industrial 'waste' heat is not powerful enough to be used as an energy source for industrial processes, though it can be used to heat the houses in a nearby residential area. Strategies to minimise the use of flows and to make more efficient use of flows are about good housekeeping and closing loops.

In addition to the input–throughput–output perspective, the Ecodevice Model (Fig. 1.4) is a model that shows the relationship between flows and areas. The figure invites us to formulate questions such as: what flows are coming in and out of an area? What is the quality of these flows? What is the speed of throughput? How to improve the efficiency of the flows in an area? For example, by reducing the incoming flows, by retaining the flows (longer) within an area, by improving or reusing the discharge flows, etc. How is the flow management of one area connected to the flows at other physical scales? The catchment and reuse of rainwater is an example of how the input of water can be reduced. Improvement of the retention capacity of urban surfaces by green roofs, permeable tiles and adding green structures is an example of how the retention capacity of urban areas can be improved. The figure thus perfectly illustrates how we can understand 'urban metabolism' in analogy to the human metabolism. It helps to model and analyse the metabolism by formulating system boundaries within which the metabolism can be studied, while being aware that the

system as defined is embedded in and connected to other systems. It is therefore no surprise that this Fig. 1.4 will also be used in other chapters in this book, when theoretical approaches and methods to analyse urban metabolism are discussed (Chaps. 2 and 11) or when a specific analysis of flows and areas is made (Chap. 4).

1.2.4 Conclusion

The above distinctions of subsystems in urban environments are based on spatial scale, life cycle and flows. There are many other demarcations possible, that – from a different point of view – may be equally valid. For example, water managers often debate the system boundaries of their jurisdiction. Administrative borders of water boards have often arisen historically in a period of decades or even centuries and do not always coincide with the physical borders of river basins or catchment areas. Analysing the built environment with an ecosystems approach helps to understand the different ways in which systems can be modelled, and it emphasises the need to look across the system boundaries as defined when trying to find ways to improve the system.

1.3 Analytical Focus Is on Ecological Processes

When analysing the urban environment as a system, the result is influenced by the system boundaries defined. Different system demarcations may lead to different problem diagnoses calling for different solutions. As a consequence, there is no single definition of 'sustainability'. The analytical point of view adopted and the subsystem boundaries defined influences the problems and opportunities for the sustainable development identified. That is why apparently 'simple' questions often cannot be answered with the same level of clarity. A frequently analysed example is the comparison between the environmental impact of a paper cup and a porcelain coffee mug. Every now and then, studies appear that claim that one or the other is to be preferred, depending on the assumptions, conditions and constraints taken into account when making the analysis.

With regards to urban environments, similar questions can be asked, such as: Should I construct my house of timber or concrete? Is it better to commute by car or by public transport? Should I have a garden and grow my own crops or should I live in a high rise apartment, using less space? The answer to all these questions is: it depends. It depends on how you define your subsystem boundaries and which values you want to enhance within these boundaries. In addition, it also depends on the system properties. Urban areas are situated in a specific climate, on land with specific geo-morphological conditions, and with specific opportunities and constraints, such as the availability of natural resources and of connections (roads, railways, a harbour, etc.). Also, densely populated areas call for different solutions compared with areas that are sparsely occupied.

How subsystems are demarcated depends on the people that define the boundaries, the values they prefer and the purpose for which the boundaries are defined. For example, civil engineers will most likely take the level of the construction as the boundary for their analysis, and will look at the materials needed to construct a house, a road or a bridge that will be solid and safe throughout its lifetime. Architects may focus on the design and construction stage of the life cycle of buildings, and will do so from a mixture of aesthetic and functional considerations. Facility managers, responsible for the exploitation, operation and maintenance of buildings and constructions, may be more focused on the use stage of the building, and may care especially about maintenance costs and the energy needed to operate the building throughout its lifetime. How people set boundaries is thus also influenced by the role they play in the built environment – which organisation or institute they represent – and on how they were trained. Each profession has its own set of methods and tools to diagnose, analyse and solve problems. For example, civil engineers typically divide problems into parts that can be solved, while designers as architects and urban planners tend to design more intuitively from a holistic point of view.

Also, the concept of sustainable development itself complicates the search for opportunities to improve urban environments. Sustainability contains multiple values: people, planet and profit represent, respectively, values such as democracy and social justice, nature and ecology and profit and prosperity, showing that, within these dimensions, there are also multiple values present which may be competing or conflicting. For example, attuning homes to the needs and wishes of current residents may turn out to diminish the opportunities for future residents to make a house their home, for example because alterations are physically impossible or too disruptive and expensive. Another example is large-scale wind parks that disrupt routes of migratory birds. Designing the urban environment is therefore also about setting priorities. In the design, some values are considered more important than others. The challenge for designers is to find out which values they want to support, and how they can support them. They can look for creative solutions that support multiple values and that reduce or resolve conflicting values.

As mentioned, the purpose of the analysis also plays a role in defining the system boundaries. When the purpose is to make buildings 'carbon neutral', it naturally follows that the building is the system analysed for its energy performance throughout its life cycle. When the purpose is to reduce car use for short distances, the geographical boundaries may cover an area of about 5 km, while the social-psychological system studied may include all those factors that influence travel behaviour, ranging from individual preferences to weather conditions and financial considerations. Also, the replacement of cars with combustion engines by electrically powered vehicles changes questions and answers as to how mobility issues should be approached. This might divert attention from locally discharged emissions to questions of congestion and safety.

Making the urban environment sustainable is thus a challenge that can be approached in different ways. Central to these approaches are the ecological processes that we want to improve – the flows of water, energy and materials and biodiversity – and the identifying of the appropriate spatial level or scale at which

to analyse these processes. This book presents an analytical framework that helps you – as (future) professionals – to appropriately demarcate the boundaries within which these processes can be analysed and addressed, while also pointing out how problems and solutions at one spatial scale are connected with problems and solutions on other scales; how some problems can better be solved at a regional level, while other problems can better be solved on a local level; how some problems should be addressed in connection to other problems, involving the knowledge and expertise of other disciplines and professions; how solutions to one problem will have positive or negative consequences for other problems, addressed by other stakeholders, at other places and at other times; and how some solutions – such as the green roof – address a range of problems that affect multiple subsystems at multiple spatial scales. In this book, we will remind you of these interconnections between subsystems, scales and time whenever appropriate, by pointing at relationships between the analysis or solution presented and problems and solutions at other spatial scales, within other flows or within other life cycle stages.

1.4 Setting the Boundaries in This Book

The focus of this book is on the urban environment, ranging from buildings and small settlements, villages and towns to cities and metropolitan areas. This book will explore the basics of how buildings and constructions and the servicing and connecting infrastructures, whether they are built in high or low numbers and densities, affect our ecosystems. The size and structure of the built environment become important variables when discussing the impact of the effects and the appropriateness of certain solutions, designs and technologies.

The book represents knowledge that applies to industrialised countries. Of course there are geographical, cultural and institutional differences between these countries, but this book does not intend to present tailor-made solutions for specific areas. Instead, it introduces a way of thinking (the ecosystems approach) and a way of working (methods and tools), as well as some fundamental understanding of the subsystems and ecological processes that matter with regards to the sustainability of urban environments. Reading this book should help (future) designers and other (future) professionals involved in the design and management of urban environments to recognise and make use of opportunities for contributing to sustainability.

There are three important choices underlying the structure and content of this book. First, it adopts an ecosystems approach to the sustainability challenge of the built environment. The built environment can be considered as an ecosystem that needs to balance the input, output, use and extraction of resources such as materials, water, and energy. To accommodate the use of these resources, man has created all kinds of infrastructures, for example for sewage, electricity and waste disposal. These resources are thus part of more specialised systems or subsystems that together constitute the urban environment. In this book, you are introduced to some important subsystems or flows, including the infrastructure to transport them, partly

or entirely man-made, that influence the sustainability performance of the built environment: urban ecology, water, energy, materials and transport.

This brings us to a second choice regarding the contents of this book. The book is based on a design perspective. To improve the sustainability of the built environment, changes have to be made in the subsystems of which the built environment is made up. When designing or redesigning the built environment, these subsystems should be taken into account. How these subsystems are used within the built environment affects the balance within these subsystems and of the larger system that they are part of: the built environment. A design perspective differs from a purely analytical perspective. The book intends not just to analyse problems but aims to solve them as well, or at least to present promising directions for problem solving. By providing the reader of this book with basic knowledge of problems and ways – methods, tools – to address these problems, the reader is able to recognise, analyse and resolve problems that come up in his or her professional life.

A third choice, then, is to take the environmental dimension of sustainability as a leading focus. The size of the challenge, in terms of use, degradation, pollution and exhaustion of resources is enormous, not least as illustrated by global warming and climate change. Environmental sustainability is considered as a condition for achieving goals with regards to economy and social justice. Also, this choice acknowledges that the instruments available to the audience of this book, advanced students and professionals with an interest in design of urban environments, are mostly of a physical nature. These instruments shape or reshape the built environment and the way resources are used, and, by doing so, they can also contribute to social and economic changes.

1.4.1 Outline of the Book

The structural choices explained above have resulted in the following contents of the book. Chapter 2 starts with an introduction to ecosystems thinking. The chapter presents the origins of ecosystems thinking, the main concepts used and how it has been applied to urban environments, including ways of modelling 'urban ecosystems'. Chapter 3 continues with urban ecology by explaining how urban environments condition the presence and diversity of flora and fauna.

Chapters 4–6, respectively, introduce the flows essential to urban environments: water, energy and materials, and the man-made technologies and infrastructures that accommodate these flows of natural resources. Chapters 7 and 8 present how these flows and subsystems influence human living conditions in urban environments. Chapter 7 discusses the effects of these flows on air quality and human health, indoors and outdoors, while Chap. 8 presents what liveability, the well-being, of citizens is all about and how it is affected by the urban environment.

Chapter 9 discusses the environmental effects of an entirely man-made system, that of urban transport. Also, it shows how transport needs are related to urban design. The connection between urban form and environmental impacts is further

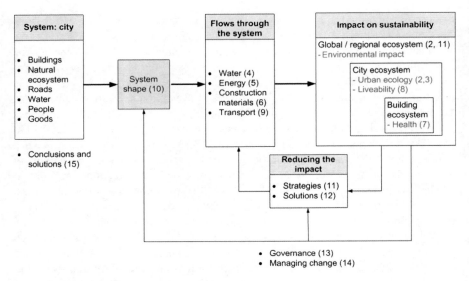

Fig. 1.5 Outline of the book

introduced in Chap. 10, with a special focus on the alleged advantages of compact cities. Chapter 11 introduces some specific and often used strategies and tools for integrated design. Chapter 12 shows what these strategies and tools may bring us by presenting and discussing some promising integrated designs.

Unfortunately, being able to make sustainable designs or design choices is no guarantee that these designs are realised. Chapter 13 discusses governance tools that can be used in support of sustainable urban environments, while Chap. 14 focuses on the management of the process of change towards sustainable urban environments by professional stakeholders – public and private – and citizens.

The concluding Chap. 15 reflects on the material presented in the book and an outlook for the future. The topics addressed in the various chapters, the achievements and remaining challenges are described. It concludes with some far-reaching examples of integrated urban design in which ecological processes are optimised and synergies between these processes maximised, which demonstrates how ecosystems thinking can lead to sustainable urban environments.

Figure 1.5 presents a schematic overview of the contents of the book, by distinguishing the system, the flows, and their impacts.

Questions

1. Why is it worthwhile to focus on cities and urban development when discussing sustainable development?
2. How can the ecosystems approach be of help when you want to support sustainable development?

3. When you consider the city as an ecosystem, what are relevant questions to ask when you want to make the system more sustainable?
4. What is the relationship between flows and areas and why is the relationship important for the design and management of urban areas?
5. Architects sometimes argue that the Egyptian pyramids are an excellent example of sustainable building. List arguments supporting and opposing this statement and refer to different subsystems, flows, and spatial and time scales. Which side do you take and why?

References

Duijvestein CAJ (1997) Ecologisch Bouwen. Delft University of Technology, Faculty of Architecture, Delft

Kibert CJ et al (2002) Construction ecology: nature as the basis for green buildings. Spon Press, London/New York

OECD (Organisation for Economic Development and Cooperation) (2003) Environmentally sustainable buildings: challenges and policies. OECD Publication Service, Paris

Sawin JL, Hughes K (2007) Energizing cities. In: The World Watch Institute, state of the world 2007: our urban future. The World Watch Institute, Washington, DC

Tjallingii S (1996) Ecological conditions. Strategies and structures in environmental planning. IBN-DLO, Wageningen

UNEP (United Nations Environment Programme) (2009) Buildings and climate change. Summary for decision-makers. UNEP DTIE, Paris. http://www.cakex.org/virtual-library/885. Accessed 26 Jan 2011

UN-HABITAT (United Nations Human Settlements Programme) (2008) State of the world's cities 2010/2011: bridging the urban divide. Earthscan, London. http://www.unhabitat.org/content.asp?cid=8051&catid=7&typeid=46&subMenuId=0. Accessed 24 Jan 2011

UN-HABITAT (United Nations Human Settlements Programme) (2009) Planning sustainable cities. Earthscan, London. http://www.unhabitat.org/downloads/docs/GRHS2009/GRHS.2009.pdf. Accessed 24 Jan 2011

WWI (The World Watch Institute) (2007) State of the World 2007, our urban future. The World Watch Institute, Washington, DC

Chapter 2
(Eco)System Thinking: Ecological Principles for Buildings, Roads and Industrial and Urban Areas

Hein van Bohemen

Abstract (Eco)system thinking can facilitate sustainable development of urban areas. In this chapter, some basic ideas, concepts and models are given as an introduction to the different aspects (energy, water, materials, air, urban transport and liveability) that will be described in depth in the chapters to follow. A short overview about the development of (eco)system theory is followed by descriptions of the main characteristics of ecosystems and of the functioning of ecosystems. Besides this knowledge, information is given about how we can understand urban areas as ecosystems. Some examples have been included to illustrate how we can improve the living urban environment from a single object to the total earth as a living system.

2.1 Introduction

In this chapter, it will be shown how (eco)system theory and practice can be applied in civil engineering in design, construction and management of buildings, roads, industrial areas and urban areas. It will be shown that, instead of concentrating on reducing negative impacts of human activities, as is still often the case in urban planning, this more integrated concept gives many possibilities for making improvements of environmental conditions for the sake of nature as well as humans.

After showing the general characteristics of (eco)system thinking, the development of (eco)system theory and examples of classifications of ecosystems, it will be illustrated on different levels of scale how the body of (eco)system knowledge can be of help in the planning and design of buildings, road and rail infrastructure, industrial areas and urban areas as a basis for the other chapters in this book.

H. van Bohemen (✉)
Former Lecturer Ecological Engineering at the Delft University of Technology;
now Eco Engineering Consultancy, Holierhoek 36, 2636 EK Schipluiden, The Netherlands
e-mail: h.bohemen@knpplanet.nl

E. van Bueren et al. (eds.), *Sustainable Urban Environments: An Ecosystem Approach*,
DOI 10.1007/978-94-007-1294-2_2, © Springer Science+Business Media B.V. 2012

In this chapter and in the book, characteristics of ecosystems and the relationship with human activities stay central, but in principle, mathematically and thermodynamically based systems ecology can be of help in describing interrelationships within and between ecosystems.

Applications of ecological engineering principles will be given to show how to integrate nature and man in an ecosystem context. They will illustrate how a (eco) system-wide approach instead of a sector-oriented way of mitigation and compensation of negative impacts of sprawl, mobility, housing, industry and agriculture can reduce the use of energy and natural resources and give possibilities for improving biodiversity.

2.1.1 Ecosystem Approaches

We will describe how different ecosystem approaches are possible (Marcotullio and Boyle 2003), like the urban ecology approach, the flows or urban metabolism approach and the biosocial approach.

- Urban ecology approach: the urban areas as habitat for plants and animals. This concerns the understanding of the city as an ecological system, often seen separately from human activities. But the approach can be very useful to integrate the natural environment with human use, especially in the fields of mitigation and compensation measures to be used in relation to water use, wastewater treatment, green buildings with green roofs and green façades and green roads (eco-road approach). Ecological infrastructure of parks and other types of green areas is an important concern within the urban ecology approach.
- The flows or urban metabolism approach: the urban areas as input and output systems of materials and energy. The flows and pathway approach can study the inputs and outputs of natural resources (water, materials, food), energy, waste and the information to reduce the ecological and environmental burden on near or distant surroundings. Important concepts that have been developed within this approach are carrying capacity and ecological footprint analysis, life cycle analysis and the "cradle to cradle" (C2C) methodologies.
- Biosocial approach: the urban areas as areas of human activities in an ecological perspective. This approach first started with knowledge from the fields of animal ecology and physiology to understand competition and cooperation, later adding natural components within this approach to develop a human ecosystem approach (natural, socio-economic and cultural resources) that is regulated by a social system.

2.1.2 Focal Objects of Ecosystems Approaches

It can be concluded that the city as an ecosystem, as mentioned in Chap. 1, can be looked upon, studied or designed with different emphases. But the central themes of

the ecosystem approach are dealing with patterns, processes and organisms that have been transferred into a "flows, areas and actor approach". This approach can form a practical framework for decision making about urban planning (Tjallingii 1996).

Problems to be dealt with are sprawl and suburbanization at the cost of good farmland and natural areas and the use of enormous amounts of energy that are damaging our ecological worlds as well as our society. Different people and organizations have drawn attention to the impact of human activities as well as showing solutions like small is beautiful (Schumacher), use of renewable energy, recycling, C2C, pedestrian and bicycling modes, better public transport with points of clustering of development, organic farming to redesign our urban areas, design with nature (McHaig), arcology (Paolo Soleri), eco-sanitation, creating rooftop gardens, urban community gardens, street orchards, and solar greenhouses towards ecocity and ecopolis strategies.

2.1.3 Outline

In 1968, a UNESCO conference took place in Paris as one of the first intergovernmental meetings about the rational use of the biosphere. In 1972, Meadows et al. (1972) presented for the Club of Rome, an international group of people worried about the environmental situation, the report *The Limits to Growth* showing the approaching end of several natural resources, although the relationships between the decrease of biodiversity (see Table 2.1) and human activities were not discussed. In 1972 and 1992, the United Nations organized conferences on the environment and development in Stockholm and Rio de Janeiro, respectively. In between, in 1987, G.H. Brundlandt published the report *Our Common Future*.

These all form the basis of this chapter, which should lead to a new integral approach of ecosystem thinking to create sustainable urban areas, which will be worked out in more detail in the following paragraphs.

Our motto for guidance should be "The city in nature instead of nature in the city." In Sect. 2.2, general characteristics of (eco) systems will be given whereas Sect. 2.3 deals with some basics about the development of system theory and ecosystem theory. In Sect. 2.4, more details are described about ecosystem structure and functioning. Section 2.5 deals with classification of ecosystems on different levels of scale. This information can be of importance in the field of conservation of nature and natural resources, but is also relevant in deciding where to build with least harm to nature and as a basis for the planning of ecological networks, ecological corridors and greenways and the integration of nature and culture for future sustainable urban and rural landscapes, as well as integration of conservation of ecological values and transportation/infrastructure planning.

In Sect. 2.6, examples are shown of urban ecology, the flows and biosocial approaches in an urban context. Section 2.7 deals with understanding urban areas as ecosystems, and Sect. 2.8 shows how ecological engineering can play a role in

Table 2.1 Definitions of biodiversity (Adapted from Peck 1998)

	Definitions of biodiversity
Wilcox (1982)	Biodiversity is the variety of life forms, the ecological role they perform and the genetic diversity they contain.
Keystone Center (1991)	Biodiversity is the variety of life and its processes.
1992 Global Biodiversity Strategy	Biodiversity is variability among living organisms from all sources, including terrestrial, marine and other aquatic ecosystems and the ecological complexes of which they are part; this includes diversity of:
	α- or genetic diversity (variation of genes within a species)
	β- or species diversity (variation of species within a region)
	γ- or ecosystem diversity refers to number of species on a location, the ecological functions of the species, the manner in which the composition of the species varies within a region, the associations of species on a location, and the processes within and between these ecosystems.
Ahern et al. (2006)	Biodiversity is the totality, over time, of genes, species, and ecosystems in an ecosystem or region, including the ecosystem structure and function that supports and sustains life.

In conclusion, biodiversity can be described in different ways, from simple to more complex. The descriptions are all concerned with species and processes. Also important is the level of scale (genetic, population, community, landscape, biome, world); temporal and sometimes evolutionary aspects are also included (Peck 1998).

improving urban systems. Section 2.9 describes the Earth as a living system. The chapter ends with a discussion of some of the ways to achieve ecocity development within a wisely used and conserved natural surrounding.

2.2 General Characteristics of (Eco)System Thinking

A system can be described as the manner in which something has been organized and the rules used to maintain it. Ecosystems can be seen as more or less finite wholes of abiotic and biotic components and the interactions between them. However, ecosystems are not superorganisms. An ecosystem indicates the integration level of water, soil, air, temperature, plants and animals and their interactions; humans are an integral part of ecosystems. The entire biosphere, as well as a single pond on a heath, can be seen as an ecosystem. So, ecosystem processes (transfer of energy and materials) can be studied at different levels of scale. Ecotope refers to the location, the space that an ecosystem occupies. The significance of ecosystems lies mainly in the fact that the components of the ecosystems form a network of relationships with each other and that there exists interdependence. System ecology was developed from the 1940s and 1950s (Boulding 1956). Environmental problems in part promoted the further extension of knowledge about the characteristics of ecosystems. But the acceptance of the "idea" that we are fully dependent of the ecosystems of the earth has also stimulated research into the components and interactions.

Fig. 2.1 Ecosystems as a black box (Lazo and Donze 2000. Used with permission)

Fig. 2.2 Ecosystems as a black box (Lazo and Donze 2000. Used with permission)

Besides analytical research about individual organisms or physical aspects, a more integrated or holistic approach including humans is essential to reach a reasonable level of sustainability.

The body of thought of (eco)system theory is not only relevant for protected areas, like nature reserves, ecological networks or management of land, water and (living) resources, but is also important for prevention, mitigation and compensation of negative effects of the construction and use of buildings, roads and industrial and urban areas as well as for the incorporation and increase of ecological values on, in and around buildings, roads and industrial and urban areas. The ecosystem concept helps us to see the town as an integrated, fully ecologically dependent and functioning system, so there is little need for a defense of nature strategy against cities, as is still often the case.

Simple systems consist of elements, relationships between elements, edges/boundaries, inputs and outputs. Dependent on the objective and the amount of information, systems can be represented in various manners based on available (limited or detailed) information. The following figures with short explanations will give some background about the level of detail when applying the ecosystem concept (see Figs. 2.1–2.7). Figure 2.4 gives the meanings of the symbols in Figs 2.5–2.7. The schemes give different analytical approaches, from black boxes to more fundamental approaches in which more insight about processes can be gained. Models can be descriptive or are designed to make predictions. The first models were developed about aquatic ecosystems. They were followed by models for making population dynamic predictions, and then computer support made possible the development of more complex (ecological) models to solve environmental management problems.

Figures 2.1 and 2.2 show systems in the form of a black box model. A wetland can be analyzed based on a system in the form of a black box model by monitoring input and output without taking into account its substances before and after passing through the black box. Monitoring input concentration, internal processes (Lazo and Donze 2000) and output concentration permits a deeper analysis since the efficiency of the system based on concentrations can be estimated. If water flow is also monitored, conclusions can be drawn that are much more exact (Lazo and Donze 2000).

Figure 2.3 represents a system that shows for nitrogen the input and output and the passage in a wetland. The transformation of many chemical forms of nitrogen

Fig. 2.3 Ecosystem representation showing input and output of nitrogen as well as internal eco-system processes concerning nitrogen (Lazo and Donze 2000. Used with permission)

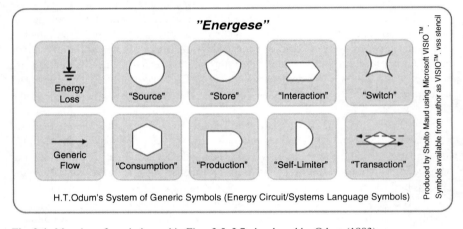

Fig. 2.4 Meaning of symbols used in Figs. 2.5–2.7; developed by Odum (1983)

inside a wetland cannot be observed nor measured but they determine the storage of the substance. The different chemical forms of nitrogen and total nitrogen can be measured in the input and output. The salts and organic nitrogen can be converted one into the other by biological processes, so the balance equation does not apply to the individual compounds but to total nitrogen only. However, a significant part of this element can escape to the atmosphere in the forms of ammonium, gaseous nitrogen and nitrogen oxide, while gaseous nitrogen can be fixed in organic compounds by microorganisms in the lagoon. These exchanges are not usually measured because this implies specific investigations that are expensive to carry out. Consequently, the balance equation for total nitrogen usually shows a rest term corresponding not only to measuring errors but also to these processes of loss and gain (Lazo and Donze 2000).

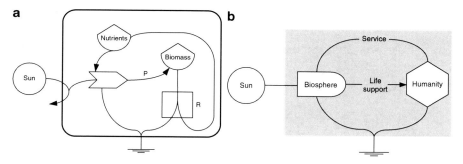

Fig. 2.5 (**a**) (*Left*) Generalized ecosystem model (Odum; in Kangas 2004) and (**b**) (*Right*) A life-support model (Odum 1989. Used with permission)

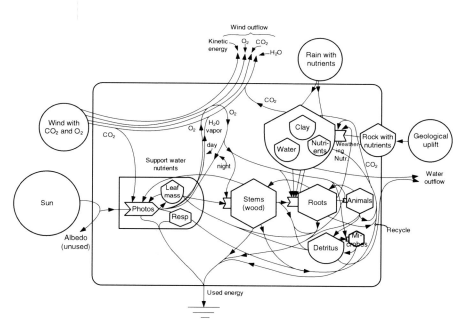

Fig. 2.6 Terrestrial system according to the systematic and symbols of Odum (Odum and Odum 1978. Used with permission)

Figure 2.5a gives a generalized ecosystem model showing the following functions: primary production (P) of biomass and community respiration (R). The sun delivers the energy which is dissipated into heat and nutrients are cycling. Figure 2.5b gives a life-support model reprinted from *Ecology and our endangered life-support systems* by Odum (1989). The original caption reads: "Humanity must service (i.e., preserve, maintain, and repair) the biosphere if we expect to continue to receive high-quality life-support goods and services".

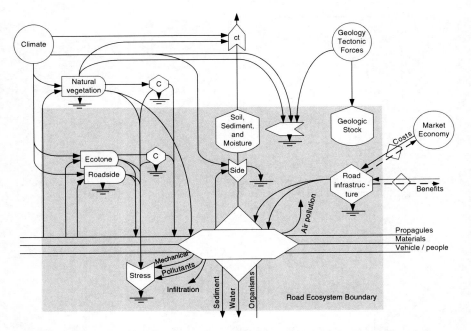

Fig. 2.7 Model of a road ecosystem (Lugo and Gucinski 2000. Used with permission)

Figure 2.6 gives an overview of a terrestrial system, using the system and symbols of H.T. Odum. The figure is taken from a handout for a short course which introduces concepts of systems, energy and kinetics with standard principles of biology (Odum and Odum 1978): "This diagram shows the increase in energy quality to the right, with the sun most dilute and geological uplift highest quality and most concentrated. In the chain of the photosynthesis, each higher quality state feeds back to the level before: sugars flow from leaves to stems, and stems hold up the leaves so they can use the sun. The gases flow with the wind. All consumers' wastes are recycled, the decomposers being very important."

Figure 2.7 gives a model of a road system using the energy symbols of Odum; the shaded area forms the road ecosystem (from Lugo and Gusinski 2000). Lugo and Gucinski (2000) describe the figure as "the six-way flow of materials, energy, and organisms along the road corridor; the interaction with human economy and human activity; and the external forces that converge on the road corridor." "The details of the model will obviously change with the type of road, its use, and the environment through which it traverses".

2.2.1 Ecodevice

The "ecodevice" is an ecosystem model that shows the interactions between areas and flows (Van Wirdum 1982; Van Leeuwen 1973, 1981). The ecodevice model

Fig. 2.8 The Ecodevice
model (Tjallingii 1996.
Used with permission)

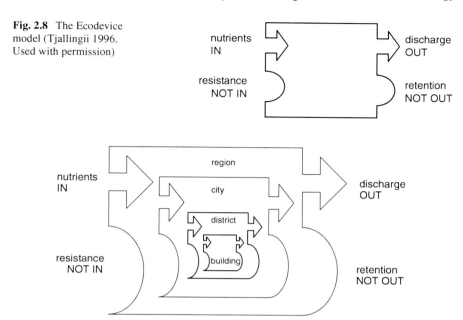

Fig. 2.9 Flow management at different scales (Tjallingii 1996. Used with permission)

takes the regulatory basic mechanisms as its starting point: input, output, resistance
(not in) and retention (not out) (Fig. 2.8). Tjallingii (1996) used the ecodevice
approach in an urban setting (Fig. 2.9) to visualize and discuss strategies for cycling
and retention of water on various levels of scale, like a building as a system with its
site and surroundings as its environment, like a district, city or region. This approach
is very helpful and can be used to clarify the discussions concerning the scale level
at which measures can be taken (see Chap. 1).

Figures 2.1–2.9 give different generalized examples of (eco)system representa-
tion. Essential aspects of systems are the relationships with the surroundings, the
internal relationships, energy and material flows (both in the form of input and out-
put, and in internal flows), and the fact that systems form parts of other systems. In
Chap. 4, these aspects will be worked out by Tjallingii for water in urban areas.

Urban areas as such have also been quantified in schematic form concerning
material flows, energy flows, energy balance and water balance. One example is
given about the water balance of Brussels (Duvigneaud and Denayer-De Smit 1977)
(Fig. 2.10). In 1973, Sukopp published a systematic representation of towns.
Figure 2.11 (Sukopp 1998) gives in addition to the mosaic-like biotope pattern an
example of a cross-section of concentric zones representative for many cities. In the
following sections and chapters more examples will be illustrated and described.

The examples of ecosystems given above present a short overview about how
organisms and their physical environment can be represented in different kinds of

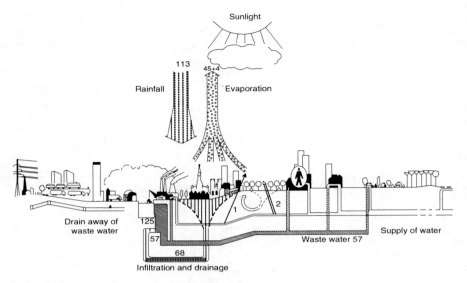

Fig. 2.10 Water balance of Brussels (Duvigneaud and Denayer-De Smet 1977)

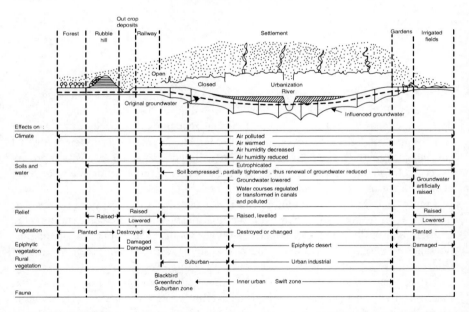

Fig. 2.11 Idealized cross-section of a large city with varying ecological features with intensive and extensive built up areas and inner and outer suburban zones (Sukopp 1998. Used with permission)

ecosystem models as well as on different levels of spatial scale from local to global and for making descriptions or predictions. Before studying research questions, the level of spatial scale should first be defined, as well as the temporal scale. It is also necessary that the level of detail of information should be established beforehand.

2.3 The Development of System Theory and Ecosystem Theory

System theory arose at the end of the 1950s and the beginning of the 1960s (Boulding 1956; Bertalanffy 1968). Lots of use was made of concepts and analogies from mechanics. The general theory of systems arose from the study and comparison of complex systems such as the universe, cellular functions and climates whereby general principles were seen to be characteristic for complex systems. In view of the dependency of man on the natural environment, an ecosystem approach can be an important tool for arriving at an integrated environmental and nature policy (Klijn 1997), and it gained an important boost through studies into and explanations of the regeneration ability of nature. Horizontal patterns, vertical structures, individual elements (the ecosystem components) and processes can be distinguished in ecosystems: atmosphere/climate, source material/rock, relief, flow of groundwater, surface water, soil, plants, vegetation and animals, as well as material and energy flows.

The (eco)system approach has been used more and more in (landscape) ecology since Tansley (1935), who "invented" and gave the concept of ecosystem more meaning. It draws special attention to the material (inter)change between organisms and the abiotic environment as well as between organisms. Some of the relationships have already been studied by Clements (1916) concerning community succession and, e.g., by Elton (1933) in the form of food chains and trophic structures. Tansley (1920) formulated a new approach: instead of Clements' organismic approach, he put forward a more fundamental and neutral concept of the structure and functioning of ecosystems including organisms and the whole environment (climate, soil). The relationships between plants, animals and decomposers, not only in the terrestrial field but also in aquatic environments, were studied in the early days of ecology and ecosystem theory. Initially, ecosystem studies mostly concerned terms such as stability (2.4.2.1), equilibrium (2.4.2.1) and homeostasis (2.4.2.3). Mainly theoretical ecologists and physical geographers carried out studies into the possibilities of a system approach. Chorley and Kennedy (1971) worked in the area of physical geography. Margaleff (1968) published much about the theoretical aspects of stability in relation to diversity. In 1970, the System Dynamics Group of the Massachusetts Institute of Technology in Boston started a study at the request of the Club of Rome to model (Forrester 1971) the relationship between the growth of the world's population, food production, industrialization, use of natural resources and pollution. In the early 1970s, the focus was mainly on ecology and describing "unifying concepts" (Van Dobben and Lowe-McConnell 1975). Odum (1983, 1971) carried out pioneering research in order to gain a broad base for system ecology. In the article *The Strategy of Ecosystem Development* Odum (1969) laid down general principles of development and functioning of ecosystems, which are still accepted, and described the differences between immature and mature systems (see Table 2.2).

Based on these ecosystems succession characteristics, Newman (1975) showed how urban areas can learn from the changes in form and structure over time of ecosystems. Newman (1975) gives, for energy and material, space, information and governance, the differences between young and mature ecosystems and the resulting city strategies.

Table 2.2 Characteristics of immature and mature ecosystems[a]

Ecosystem	Characteristics
Immature ecosystems	High production to biomass ratios
	Simple, linear, grazing food chains
	Low species diversity
	Small organisms
	Simple life cycles
	Open nutrient cycles
Mature ecosystems	Lower production to biomass ratios
	Production tends to be in flowers, fruits, tubers (rich in protein)
	High species diversity
	Large structural biomass of trees in forested systems
	Organisms larger than in immature ecosystems
	Long life cycles
	Closed nutrient cycles

[a]Under natural circumstances, ecosystem directional development of ecological succession takes place from pioneer stage to climax. This table generalizes the different characteristics of immature and mature ecosystems

The International Biological Program of the UNESCO, which was carried out from 1964 to 1974, has been instrumental to the development of the ecosystem approach in biological studies. It has stimulated modeling of structure and function due to the fact that detailed information about ecological entities was examined and an application of conservation knowledge was much needed. The studies of the International Biological Program concentrated more on patterns and processes within, rather than between, ecosystems. However, during the studies, ecologists found that ecological systems are often heterogeneous in space and time. Studies show that homogeneous units (landscape elements or patches) are influenced by other units through boundaries or transition zones between them (flow of material, energy, information and organisms). Besides sharp boundaries between different vegetation structures or vegetation compositions (for instance between woods and agricultural land) in many cases more gradual transitions occur (gradient situations). These gradients can form unique habitats for plant and animal species. Between ca. 1980 and 1996, collaborative research was undertaken about the role of land/inland water ecotones (= zone of transition between adjacent ecological systems), in part within the framework of UNESCO's Man and Biosphere Programme (1989–1996; Naiman et al. 1989). The questions to be studied among others were which role do ecotones play in maintaining local, regional and global diversity, what functions do terrestrial–aquatic ecotones have and is there any influence of terrestrial–aquatic ecotones on the stability of adjacent places. Van Leeuwen (1970) described ecological situations in border areas as effects of concentration (limes convergens or ecotone) and those based on dispersion (limes divergens or ecocline). In Chap. 3, De Jong will go into detail about different forms of edges or boundaries between diverse communities or ecosystems, like steep or gentle gradients, in the context of the ecological design of urban areas.

Another important factor stimulating the ecosystem approach in ecology has especially been caused by the development of landscape ecology, watershed approaches and interests in flows of materials and energy. The concept of ecosystems, boundaries and patch dynamics including metapopulation modeling has become an important field of study in landscape ecology.

More and more new information is becoming available about analyzing system properties, the functioning of ecosystems, ecosystem theory, ecological modelling and its application in environmental and ecological science. More detailed overviews can be found in, for example, Jørgensen et al. (2000, 2007, 2009) among other authors.

During the last decades, more attention has also been developed towards the recognition that humans, with their cultural diversity, are an integral component of ecosystems. Although widely accepted, this is still not found in many definitions of ecosystems, such as, for example, "Ecosystems means a dynamic complex of plants, animals and micro-organisms and their non-living interacting as a functional unit" (Article 2 of the Convention on Biological Diversity). Ecosystem parts consist of micro-organisms, aquatic and terrestrial plants and animals and they form a system with the abiotic environment in which humans form a part and cannot escape from it; human existence is dependent on the biological life-support systems of the earth. The relevance of an ecosystem approach has become more and more important due to the negative impacts on terrestrial and aquatic ecosystems on which we completely depend. These negative impacts are caused by land use changes, commercial freshwater and marine fisheries, nutrient enrichments, air and water pollution, plant and animal invasions, habitat destruction and fragmentation, influencing biogeochemical cycles, and the introduction of new chemicals (e.g., PCB, DDT, CFC) into the environment. Occasionally, critical transitions (Scheffer 2009) occur, which are gradual changes in (eco)systems becoming increasingly fragile to the point where even a minor perturbation can cause drastic changes towards another (stable) state.

More and more detailed insight into ecosystem processes and control systems will help us to restore the damage and make possible more sustainable use of ecosystem goods and ecosystem services. In this context, knowledge of the resilience of ecosystems and critical transitions are some of the aspects which are relevant "to stay alive" and which will be dealt with later.

Ecological engineering, "the design of sustainable ecosystems that integrate human society with its natural environment for the benefit of both" (Mitsch and Jørgensen 1989 and 2004), is able to help to integrate human use of ecosystem properties, ecosystem goods and ecosystem services for the benefit of man and nature and is based on ecological science; ecological engineering techniques can also reverse the disturbed landscapes towards ecologically sound conditions (Van Bohemen 2005). Some of the basic principles of ecological engineering are:

- Based on the self-design capacity of ecosystems (with some human help)
- Use of the sun as energy source (directly) as much as possible
- Rely on system approaches

Table 2.3 Examples of ecological engineering

Ecological engineering approaches	Examples of ecological engineering
Active restoration of ecosystems	Aeration of lakes
	Biomanipulation
	Restoration of banks (environment/nature-friendly river and canal banks)
	Restoration of wetlands
	Restoration of areas affected by opencast mining
	Application of defragmentation measures to roads
Sustainable use of ecosystem goods and ecosystem services	Traditional use of ecosystems
	Combined agriculture and forestry (agroforestry, multi-layered systems, permaculture)
	Integrated agri/fishculture
	Dynamic coastal management by sand supplementation on the foreshore.
Waste processing (imitation of natural cycles in ecosystem)	Composing of organic substances
	Urine separation in toilet systems for agricultural application
	"Living machines" as constructed ecosystems for purifying wastewater
	Wetlands for wastewater purification
	Use of vegetation for absorption of fine dust and other air pollutants
Creation of "constructed" ecosystems	Constructed wetlands as biotopes
	Green roofs as water buffers and habitats for plants and animals
	Creation and management of gardens, parks, wind belts and wildlife corridors such that they take on the function of green veins in the landscape (habitat and corridor functions for plants and animals in combination with human values).

- Support conservation of nature/biodiversity
- (Re)cycle macro- and micronutrients
- Protect human health
- Based on ecology

The following table (Table 2.3) gives some examples of ecological engineering arranged by the fields of application.

2.4 Important Concepts and Characteristics of Ecosystems

In order to be able to use the ecosystem concept within planning, design and realization of sustainable urban areas respecting the functioning of ecosystems as well as ecosystem services and ecosystem goods, some basics about components, structure and processes of ecosystems will be shown.

2.4.1 Ecosystem Structure and Processes

2.4.1.1 Compartments

In ecosystems, it is possible to distinguish between compartments which are also connected with each other by exchanging matter and energy:

- Abiotic compartments consisting of the atmosphere, water and soil with detritus, humus and nutrients.
- Biotic compartments consisting of plants, animals (herbivores and carnivores) and decomposers (fungi, bacteria, protozoa) are the three main compartments consisting of living organisms.

2.4.1.2 Processes

The following processes take place in ecosystems transferring matter and energy between the above-mentioned compartments:

- Photosynthesis: plants use solar energy for synthesizing sugars from CO_2 and H_2O.
- Nutrient absorption: organisms take up nutrients from the soil or from other living or dead organisms.
- Primary production: using energy and nutrients by producers (plants) forming organic substances, which can be used as food.
- Secondary production: storage of energy and material by consumers (animals).
- Storage of dead organic plant and dead animal biomass: storage of dead organic material.
- Disintegration of dead material: physical and biological decomposition of organic material by micro-organisms.
- Catabolism: reduction of organic material in more simple chemical substances.

An important aspect is that most nutrient flows show a cycling form of processes within and between ecosystems.

2.4.1.3 Hierarchy

In Fig. 2.9, a hierarchical nested pattern is shown. Within a particular system, components or subsystems, sub-subsystems and so on, can be present. Originally, the term "hierarchy" means vertical authority in human society. In system theory, "hierarchy" means that one system can contain smaller systems, and this concept can be helpful studying biological processes in ecosystems at different scales and learning more about (connected) complexities of ecosystems. In ecology, the "ecotope" is the smallest system that is homogeneous for specific chosen properties. It is important to formulate beforehand the scale of the system, as we can study the whole earth as a system or a forest patch.

2.4.1.4 Boundaries

Boundaries are important in describing a concrete object, like an organism. Organisms are apart from the environment by the surface of the skin, lungs, digestive tract and reproductive organs. They protect the organism and regulate the input and output (energy, matter and information).

If we work with the concept of ecosystem, it is also important to describe the boundaries which is sometimes more difficult than with concrete organisms. An ecosystem boundary (ecotone) can be a straight line or a gradient in which some environmental factor is gradually changing. In a lot of cases, a change of rate of flows has to be used to describe a boundary; also, a boundary of an ecosystem can be a dynamic entity as it can change over time.

2.4.1.5 Regulation and Control

Within systems, there is an essential requirement to account for self-regulation. Self-regulation can be defined as control of system's properties by its internal feedback mechanism (Pahl-Wostl 2000). Endogenous and exogenous interactions can change the state of a system. An example of endogenous influence is, for instance, nutrient (re)cycling or succession. An example of exogenous influences is, for instance, nutrient input or seasonal influence.

2.4.2 Disturbances and Resilience

To gain a more thorough understanding, a number of concepts are explained here in more detail. For this purpose, much use is made of a study commissioned by the Dutch Water Institute (RIZA) into the resilience after disturbance (Fig. 2.12) of fresh and salt waters (Knaapen et al. 1999).

Some of the given concepts may not immediately be seen as relevant for urban systems, but can be of use if we really apply the ecosystem approach fully in the design, building and maintenance of the complexities of urban areas.

2.4.2.1 Equilibrium

An equilibrium is a situation in which an object or system shows no change in essential characteristics, because the forces that affect it compensate each other. A distinction can be made between static and dynamic equilibriums. Equilibrium can be either stable or unstable (easy to disturb). There are also cyclic equilibriums.

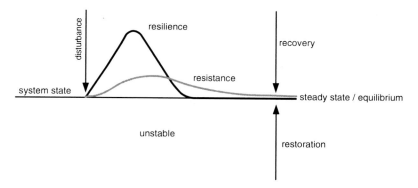

Fig. 2.12 Ecosystem responses to disturbance: resistance, resilience and instability (Adapted from Aber and Melillo 1991)

2.4.2.2 Disturbance

Disturbance means a temporary, jerked external change in circumstances for an (eco) system. These disturbances can be of natural or anthropogenic origin.

2.4.2.3 Resilience

Resilience is the ability of a system to be subjected to changes in input and status variables and then to return after some time to its original status (Fig. 2.12).

Knaapen et al. (1999) define resilience as follows. Resilience is the ability of systems or components thereof, to react in such a way to external or internal disturbances that – after a period of recovery – the essential characteristics (abiotic and biotic characteristics, as well as functional relationships) are retained. Later the description was amended. Resilience is the ability of systems or components thereof to react in such a way to changing circumstances or disturbances that the essential characteristics are recovered (Remmelzwaal and Vroon 2000). Resilience can relate to all aggregation levels ranging from that of the individual, through populations, up to and including the landscape, with respect to both the abiotic and biotic components. Resilience is a strategy for systems to retain their identity within dynamic environments.

Holling (1996) makes a distinction between "engineering resilience" and "ecological resilience". The former measures the deviation from the equilibrium and focuses on the speed of equilibrium recovery after disturbance; the latter relates to the scope of the disturbance of an ecosystem that can be absorbed without the structure and functions changing. When systems are managed from a single variable (e.g., timber production), loss of functional and structural diversity results in loss of ecological resilience. These two different approaches of stability are quite fundamental, developed within different schools and for different purposes.

Table 2.4 Some often used terms to describe ecosystems

Ecosystem terms	Description
Persistence	A persistent system exists for a long time. It is a form of remaining constant which means that the system is able to absorb a disturbance. The concept is also used for systems that do not become extinct. A metapopulation can be seen as a persistent system.
Homeostasis	Homeostasis is that characteristic of a system that reacts to an external disturbance through feedback, with the aim or result of retaining the function and operation of the system. However, the structure, composition and number of components in the system can change.
Negative and positive feedback	The term negative feedback refers to a force that counteracts a change that has an external cause. Positive feedback will accelerate changes.
Buffer capacity	Buffer capacity is the ability of a system to absorb disturbances thanks to the level of stock and/or mass. Examples: the chemical buffer capacity of soil against acidic substances and the climatic buffering of vegetation. Temporary storage of water, as long there is "space," is also considered to be buffer capacity.
Stress	Stress is a long-lasting load on a system or organism. This concerns environmental factors that have too high and/or too low values.
	Grime (1979) classified plant species by the manner in which they deal with the most important environmental factors. "Stress-tolerators" are plants that are capable of surviving when the supply of for instance nutrients is low. "Competitors" are species that compete under relatively favorable conditions. The "Ruderals" make use of situations where there is a temporary supply of opportunities without competition.
Adaptation	Adaptation of a system to changed circumstances by the system changing its structure, composition or operation, which leads to a new equilibrium.
Isolation	Isolation means the shutting off of part of the system or area from the remainder of the system or area.

2.4.2.4 Resistance

Resistance is the ability of objects or systems to resist, based on physical protection, external influences. The system does not give way, but remains unchanged and resists the external influence (see Fig. 2.12).

In Table 2.4, some more terms relevant for ecosystem description are given.

2.4.2.5 Self-organization and Self-design

Self-organization, according to Odum (1989), means "that after the first period of competitive colonization, the species prevailing are those that reinforce other species through nutrient cycles, aids to reproduction, control of spatial diversity, population regulation, and other means". Self-design, according to Mitsch and Jørgensen (2004), is defined as "the application of self-organization in the design of ecosystems".

From a system-dynamic point of view, Knaapen et al. (1999) distinguished the following systems:

- Stable systems – in the sense that the system variables are usually in equilibrium;
- Systems that have multiple points of equilibrium and for most of the time shift between these points, in other words they rotate through stable limit cycles (in fact run through a continuous series of points of equilibrium);
- Systems that are permanently out of equilibrium and are kept in existence by external influences; these systems are in fact inherently unstable.

Examples of resilient systems: this concerns systems that demonstrate signs of recovery following a natural or anthropogenic influence or disturbance. Examples are:

- A coastline that after a period of erosion returns to its original condition through natural accretion of sand;
- A forest that after being damaged by a storm or a fire regains its original structure and composition via natural recovery;
- An estuary that recovers after an oil spill;
- A lake that, after the poisoning and death of large numbers of organisms, returns to its original situation after a number of years.

It must be stated here that spatial variation is an important aspect in this. Spatial compartmentalization can lead to processes, which in a homogenous environment would run everywhere (almost) at the same time, being able to run in different phases from area to area (Knaapen et al. 1999). The result is that change processes can only have a local effect and moreover at different times. For instance, the local extinction of a prey by a predator can be compensated by immigration from other areas. The functioning of metapopulations (Verboom et al. 1991) is based on the same principle. In this context, gradients can play an important role. Because the environment keeps changing along the gradient, different species benefit over time and competitive exclusion is prevented. Spatial variability in the widest sense is a system characteristic that can contribute considerably to the persistence of systems that are not in equilibrium (Knaapen et al. 1999).

To learn more about natural resilient processes within different ecosystems some examples are given in Box 2.1 (Knaapen et al. 1999).

Box 2.1 Examples of Resilient Processes Within Different Ecosystems

A. The manner in which the sandy bed of a river reacts to a passing tidal ground swell: the bed changes from being rippled to having sand bars; it returns to being rippled after the tidal bore has passed. This is interpreted as being an adaptation to the necessity of having to have lowered resistance to allow the ground swell to pass.
B. Something similar also occurs in stream systems.
C. The meandering of streams and rivers is also a form of morphological resilience.
D. A river that continually finds another bed within a certain area.
E. The model for the description of the dynamics of populations in the form of the logistic growth. Here, the growth rate of the population is:

$$\frac{\mathrm{d}N}{\mathrm{d}t} = rN\left(1 - \frac{K}{N}\right)$$

N = population size
t = time
r = intrinsic growth rate
K = carrying capacity of the habitat

F. The functioning of populations in fragmented landscapes: metapopulations.
G. The extinction and colonization of species within a metapopulation are independent processes that keep each other – at the landscape level – in equilibrium. Such systems can be very persistent, as long as a number of conditions are met with respect to the possibilities for exchange, size of the subpopulations and birth/mortality ratios.
H. The island theory assumes a resilient model based on the processes of immigration and extinction of species on actual or habitat islands, whereby a dynamic equilibrium between these processes is formed.

2.4.3 Important Correlations

Much study has been carried out in the domain of predator–prey relationships. Many models have become available. During the development of system theory and theoretical ecology, the focus was on several assumed correlations between various concepts. This concerned in particular the hypothesis concerning the correlation between stability and diversity.

2.4.3.1 Stability and Diversity

The possible correlation between stability and diversity was extensively studied and discussed in the 1970s (see, among others, Van der Maarel 1993). The question was whether a stable ecosystem is the consequence of high diversity (in species). Arguments for this are the higher number of relationships between species (in particular between the various trophic levels), more feedback mechanisms and greater resistance to invasions of species alien to the system. May (1975) demonstrated that a higher diversity of ecological communities leads to lower stability. If systems are stable, they are not stable thanks to but in spite of their high diversity. Stability can lead to diversity under certain conditions. Constant environmental factors are favorable for equilibriums to occur in systems. But in general ecosystems are dynamic and constantly changing.

2.4.3.2 Resilience and Resistance

Resilience and resistance can complement each other. However, in most species populations and ecosystems, there is clear domination of either resilience or resistance. Research shows that some systems can display multiple points of equilibrium, this can also be called resilience. In the publication *Working with water; resilience as a strategy* (published in Dutch as Werken met water; veerkracht als strategie) (Remmelzwaal and Vroon 2000), four strategies are distinguished that organisms, populations or ecosystems use to maintain themselves when disturbances occur:

- Resilience: the ability to react to changing circumstances in such a way that the essential characteristics are recovered.
- Resistance: the suppressing of the natural dynamics.
- Buffer capacity/absorption: leveling off the dynamics; external influences are absorbed with no change to the essential system characteristics. It is, however, possible that in time there will be a reduction in buffer capacity.
- Isolation/protection: the isolation of (sub)systems from the remainder of the system.

Resilience seems to be an important principle in particular in dynamic environments. It is especially the processes that concern the growth of populations that are in essence resilient. The degree of resilience differs per species and depends in part on the surroundings. Resilience also plays an important role in many communities and ecosystems.

As far as the correlation between resilience and biodiversity is concerned, it can be stated that resilience accompanies a certain type of biodiversity, probably species and systems that are adapted to relatively high, but not extremely high, environmental dynamics. Dependent on the objective of the management of a certain system, it can be decided to strengthen the resilience, resistance, isolation or buffer capacity, with combinations of the approaches also being desirable in some cases. In Box 2.2, an example is given using resilience as a management strategy in the field of water management.

Box 2.2 Example of Using Resilience as a Management Strategy in the Field of Water Management

In the 4th Memorandum on Water Management (Ministerie van Verkeer en Waterstaat 1998), the concept of resilience was given a central position in water management in the Netherlands, and received priority in the desired order of strategies when solving problems in the area of water management.

1. Searching for resilience strategies.
2. Searching for an increase in buffer capacity.
3. Searching for resistance strategies.
4. Searching for isolation possibilities as a supplementary strategy in the event of undesired side effects of 1, 2 and 3.

With respect to employing a resilience strategy in water management, 11 guiding principles have been formulated (Remmelzwaal and Vroon 2000). Options when attempting to improve the resilience of water systems can be:

- Restoration of the natural dynamics
- Providing the water system with space
- Creating networks (restoration of connections)
- Differentiation of systems
- Restoration of gradients (natural, gradual transitions)

Furthermore, amending human behavior plays a role:

- Increasing water consciousness
- No shifting of the problems to other areas
- Priorities in the assignment of functions
- Opportunities in function requirements
- Design based on natural characteristics
- Making the load-bearing capacity normative

With respect to the mentioned "design based on natural characteristics" we should realize that aquatic ecosystems are complex adaptive systems that are characterized by historical dependency, nonlinear dynamics, threshold effects and limited predictability (Levin 1999). Natural disturbances (floods, droughts, nutrient leakage) and human-caused changes are influencing our water bodies. This means that the combination of natural changes and (increasing) human-caused changes can have extra impacts. Even a small event may have a devastating effect on the persistence of a system, especially when a critical threshold is crossed. This has been demonstrated in shallow lakes which can show clear as well as turbid situations with each different species and stabilizing mechanisms. Nutrient enrichment can change clear systems suddenly into turbid systems. Returning to a clear stage needs not only to stop nutrient inflow but also to reduce fish density for a short period (Scheffer 2009).

These regime shifts in ecosystems can be known about or can take place unconsciously. Water management should not only focus on variables of the moment (water levels, population numbers) but also on ecosystem properties like resilience, adaptive and renewal capacity and involves both the human component of the system and the biophysical components of the ecosystem (Galaz 2006). This means that we also should not only know about the social resilience as such but also about the resilience of intertwined social-ecological systems.

Resilience of social-ecological systems can have the following characteristics (Folke et al. 2002):

- The magnitude of shock that the system can absorb and remain in within a given state.
- The degree of self-organization of the system.
- The degree to which the system can build capacity for learning and adaptation.

Important is to recognize the difference between ecological and social resilience, as social resilience has the added capacity for humans to anticipate and plan for the future (Galaz 2006).

2.4.4 Principles of Ecosystems

During the last decades, various attempts have been published to develop a general ecosystem theory in order to have an integrated base for describing elements, patterns and processes within and between ecosystems, as well as possibilities to explain and predict impacts of environmental changes.

Jørgensen et al. (2007) give an overview of these attempts. They also present an overview of a new ecological approach in the form of a coherent ecosystem theory with system-based, thermodynamic properties. The seven basic principles they observe in ecosystems are listed and described:

1. Ecosystems have thermodynamic openness: they are open to energy, mass and information.
2. Ecosystems have ontic openness: due to complexity exact predictions are not possible.
3. Ecosystems have directed development: there is a tendency of increase feedback and autocatalysis.
4. Ecosystems have connectivity: networks connectivity has synergistic properties.
5. Ecosystems have hierarchic organization: we can only understand one level by studying the level above and below at the same time
6. Ecosystems have complex dynamics regarding growth and development: ecosystems gain biomass and structure, enlarge their networks and increase their information content.
7. Ecosystems have complex dynamics regarding disturbance and decay: we can explain and sometimes predict responses of ecosystems due to disturbances.

2.5 Classification of Ecosystems on Different Levels of Scale (from Global to Local Level)

For sound use of natural resources, solving environmental problems as well as design and realization of sustainable urban areas and road and rail infrastructure, it is wise to recognize and understand the ecological, climatological and land-use characteristics of the area where activities are taking place or will take place. As impacts of local activities will in many cases not only be relevant for the local eco-systems but can cross boundaries of ecosystems influencing nearby and distant eco-systems (even biosphere-wide), these should also be taken into account.

Classification of ecosystems (mostly based on climate, soil and plant communi-ties) and study of patterns of distribution of ecosystems are relevant in order to know which types of ecosystems can be found in an area, to know which are natural, semi-natural or highly influenced by man, and which in need of conservation or restoration and useful for ecosystem management. In order to find a balance between conservation and sustainable use of natural resources, knowledge about the origin, understanding of the relationships within ecosystems and the distribution of ecosys-tems are essential for wise planning. Also, the boundary between different ecosys-tems should be taken into account. The choice of the type of classification by researchers, planners and policymakers depends on the type of impact and the scale of the planned activities.

In this section, it will be shown how ecosystems can be classified on the basis of different characteristics and on different levels of scale. First, some general classifi-cations are given, then concerning a certain type of ecosystem (wetlands) and finally human-made functional structures (road infrastructure).

We first have to realize that the biosphere consists of interrelated ecosystems comprising vegetation and (mobile) animals adapted to a certain type of soil and climate. The geographical size of ecosystems can vary from oceans to ponds, and tropical rainforest to barren tops of tropical mountains.

Below, we will give examples of the classification and distribution of ecosystems from a world perspective towards more local and regional situations and with differ-ent emphasis concerning the criteria used. Using or developing classifications, it is important to decide beforehand which criteria have been used and which should be included.

For building and use of urban areas sustainably, it is not only relevant to look at the physical conditions (rock type, landform, climate, water supply) but to include soil, vegetation and animals, and to make optimal use of the urban areas as well as the surroundings. Knowledge of the distribution of plants and plant communities, in com-bination with information about interactions of plants and animals and the influence by activities of man, are very useful for designing urban (as well as rural) settlements.

On a world scale, a range of different systems of classification and distribution of the major biogeographical regions have been published. Different criteria have been used to describe and classify ecosystems mostly based on physiognomy, dominant plant species and floristic composition.

Table 2.5 An overview of the different zonal vegetation of the main continents (Bailey 1998)

Zone	Vegetation
Icecap	–
Tundra	Ice and stony deserts; tundras
Subarctic	Forest-tundras and open woodlands; taiga
Warm continental	Mixed deciduous–coniferous forests
Hot continental	Broadleaved forests
Subtropical	Broadleaved–coniferous evergreen forests; coniferous–broadleaved semi-evergreen forests
Marine	Mixed forests
Prairie	Forest-steppes and prairies; savannas
Mediterranean	Dry steppe; hard-leaved evergreen forests; open woodlands and shrub vegetation
Tropical/subtropical steppe	Open woodland and semideserts; steppes
Tropical/subtropical desert	Semideserts; deserts
Temperate steppe	Steppes; dry steppes
Temperate desert	Semideserts and deserts
Savanna	Open woodlands; shrub vegetation and savannas; semi-evergreen forest
Rainforest	Evergreen tropical rainforest (Selva)

Table 2.5 shows the zonal vegetation of the ecoregions of the world. Ecosystem regions or ecoregions are large areas of the surface of the earth over which the ecosystems have characteristics in common.

On a European scale, we can recognize the following regions, based on the distribution of plants and plant communities (Table 2.6).

In the above-mentioned approach of classification, the distribution of tree species has been an important criterion. But we should realize that many more different vegetation types can be recognized, such as coastal mud-flats, brackish waters, salt-marsh, sand-dunes and sea-cliff vegetation, rock crevice, scree and boulder-field vegetation, freshwater aquatic vegetation, bogs and fens, springs, grasslands, fringe vegetation, fjell-fields, snow-bed vegetation, and weed communities.

Even on the scale of a country such as the Netherlands, the classification into physical-geographical regions is relevant for planning activities in the field of land-use; regions are areas for which the physical-geographical properties are characteristic for the region as a whole. There appears to be considerable similarity with the classification of the Netherlands into "flora districts" (Fig. 2.13). The map shows how the differences of distribution of the flora can be used to show that plants are not randomly distributed (Van der Meijden 1996). In the last two decades, with regard to plant and vegetation distribution, more attention has been given to urban environments as ecosystems and not as ecologically uninteresting areas or urban "deserts." Extensive surveys of urban plants and vegetation types show a great diversity of semi-natural and man-made habitats with their own flora. In many cases it has been found that in urban landscapes more species per unit area can be found than in the same unit scale of the surrounding landscapes (see also Chap. 3).

Table 2.6 Vegetation types of Europe (Hartley et al. 2000)[a]

Vegetation type	Description
Alpine north	The Scandinavian mountains; these have been named Alpine north, because they show environmental conditions as the Alps on a higher latitude, but on lower mountains.
Boreal	The environmental zone covering the lowlands of Scandinavia, mainly characterized by conifer forests.
Nemoral	The zone covering the southern part of Scandinavia, the Baltic States and Belarus. It is the environmental zone characterized by mixtures of taiga forest and deciduous broadleaved forests.
Atlantic North	This is the area under the influence of the Atlantic ocean and the North Sea, humid with rather low temperatures in summer and winter, but not extremely cold.
Alpine south	The high mountains of central and southern Europe that show the environmental conditions of high mountains. Unlike the biogeographical zonation of Europe as presented by the EEA (http://www.eea.eu.int), here small Alpine patches are also found in mountain areas outside the Alps, Pyrenees and Carpathians.
Continental	This is the part of Europe with an environment of warm summers and rather cold winters and where beech is a dominant tree species.
Atlantic Central	This is the area with moderate climate where the average winter temperature does not go far below 0°C and the average summer temperatures are relatively low.
Pannonian	This is the most steppic part of Europe, with cold winters and dry hot summers. Most precipitation falls in spring. The characteristic plants include *Stipa* spp.
Lusitan	This is the southern Atlantic area from western France to Lisbon. Here, the summer temperatures are rather high and some dry months occur, while winters are mild and humid. It is the region of the southern European heath lands and the Pyrenean oak.
Anatolian	Represents the steppes of Turkey, a Mediterranean steppic environment. It is not included in the PAN database as there is so far no representation from Turkey.
Mediterranean Mountains	These mountains are influenced by both the Mediterranean zone they are situated in, while they still show an influence of mountain climate. This is the area where Mediterranean beech forests are found.
Mediterranean North	The Mediterranean northern represents the major part of the Mediterranean climate zone with holm oak, cork oak, many fruit plantations and olive groves.
Mediterranean South	This zone represents the extreme Mediterranean climate that is shared with northern Africa, short precipitation periods and long hot, dry summers.

[a]The Vegetation map of Europe can be found at: http://bioval.jrc.ec.europa.eu/products/glc2000/products/europe_poster.jpg Accessed March 2011

Looking at the scale of the Netherlands and based on the degree of naturalness and of the amount of human impact, Westhoff (1956) proposed the following classification of the Dutch landscapes:

- Natural landscapes (systems);
- Almost natural landscapes (systems);

Fig. 2.13 Flora districts of the Netherlands (Van der Meijden 1996. Used with permission)

D =	Drents district
E =	Estuariëndistrict
F =	Fluviatiel district
G =	Gelders district
	(Halfdistrieten E, L, N)
K =	Kempens district
L =	Laagveendistrict
N =	Noordelijk kleidistrict
	(Pleistocene districten D, G, K, S, V)
R =	Renodunaal district
S =	Subcentreuroop district
V =	Vlaams district
W =	Waddendistrict
Y =	Ijsselmeerpolders
Z =	Zuidlimburgs district

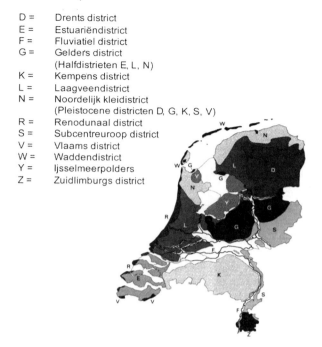

- Semi-natural landscapes (systems);
- Cultural landscapes (systems).

Urban landscapes (systems) can be added to this classification. The series displays the degree of human influence when seen over time. The approach used in northern and central Europe evaluates human-caused impacts by the distance between the present and a former state of undisturbed indigenous vegetation. Another approach developed and used in central Europe evaluated the present level of human impact on a site or landscape by comparing it with the end stage of succession. The so-called (nine) hemeroby grades summarize the level of human impact preventing the final stage of succession (Sukopp 2004).

Yeang (1999) proposed the following categories for the different types of ecosystems:

- Ecologically mature systems (forests, wetlands);
- Ecologically immature systems (affected by man, recovering);
- Ecologically simple systems (strongly influenced by man);
- Mixed natural–cultural systems (agro-forests, gardens, parks);
- Monoculture (forests consisting of one species for the production of wood);
- Zero culture (open-cast mining, some urban areas).

Haber (1990) gives a two-category classification:

- Bio-ecosystems: domination of natural components and biological processes.
 - Natural ecosystems: without direct human influence; self regulation.
 - Almost natural ecosystems: little direct human influence; self-regulation.
 - Anthropogenic (biological) ecosystems: consciously created by man; completely dependent on human management.
- Techno-ecosystems: human-determined technical systems. Intended for industrial, economic and/or cultural activities. Dependent on human control.

In the following, we will discuss the classification of wetlands (as an example of bio-ecosystems), and an example in the field of infrastructure/roads and nature (as an example of techno-ecosystems) will be given. It is important to realize when classifying that within a category locally different environmental situations may exist. In constructed wetlands and constructed road verges, rare plants and rare plant communities, including rare animal species, can develop. About 10% of the flora of the Netherlands is more or less restricted to roadside verges, as agricultural intensification brought about decline of floristic diversity in agriculturally dominated landscapes.

2.5.1 Wetland Ecosystems

Different classification systems have been developed for wetland ecosystems based on: flooding depth, dominant forms of vegetation, and salinity regimes or based on wetland functions. Mitsch and Gosselink (2007) divided wetlands in the US into:

- Coastal wetlands (salt marsh, tidal freshwater marsh, mangrove)
- Inland wetlands (freshwater marsh, peat land, freshwater swamp, and riparian systems)

Other wetland classifications concentrate on peatlands, coastal wetlands, and deepwater habitats.

The Ramsar classification system is world based and also includes underground karst systems and oases. Recently, classifications based on wetland functions have also been developed as well as wetlands classified for value to society.

2.5.2 Ecosystems, Infrastructure, and Traffic: Roads as Ecosystems

The quality and speed of traffic has developed as synergetic processes with little attention to ecosystems. If we want to keep the developments within ecological

boundaries, then the transport system must be able to develop more self-regulatory feedback in relation to the surroundings. An example of the last could be on-site measurement of air pollution and calculation of the allowable traffic intensity (based on air standards), which should be automatically maintained or automatic speed reduction when animals are approaching a road with the intention to cross.

A road can be seen as a "road-ecosystem". Haber (1990) defined roads as techno-systems because they "have structure, support a specialized biota, exchange matter and energy with other ecosystems, experience temporal change and are systems, built and maintained by people."

Roads are increasingly becoming a part of the landscape and it is impossible to imagine life without them. They occupy 'ecological space' and can be analyzed, described and managed as ecosystems. Roads and verges (roadside verge ecosystems) form part of the ecological infrastructure and influence landscape ecological patterns and processes. In this field of interest, various scales can be distinguished: landscape scale, road networks and road sections, including the associated verges. Forman (1995) makes a distinction between five functions of roads (including the verges):

- A *habitat patch* is the concrete place where plants and animals find all the necessary resources for survival and reproduction.
- A *corridor* or migration route can connect habitat patches.
- A *source* exists when the number of animals exceeds the number of deaths and some of the offspring leaves the site
- A *sink* has a negative birth to death ratio; the population can only exist if there is input of individuals from elsewhere.
- A *filter* exists when some seeds or animals can pass the road and others are not able to pass the road.
- A *barrier* or isolator cannot be passed by animals.

The most important characteristics of the relation of roads/traffic and their ecological effects are: the width of the road and the verge and the degree of connectivity. Roads and traffic (intensity or cars/day) influence the surroundings. There is influence on: (1) patterns and (2) processes. The scope of the various types of influence can differ; a road effect zone can be described for different manners of influence (Fig. 2.14).

Looking at the way we can conserve plants and animals in the direct vicinity of a road, there are two possible conservation strategies, described here in their extremes:

- Retaining strips of natural vegetation along roads. For example, in the grain-growing area of south-west Australia, there are conspicuous wide and small strips (30–40 m wide) of natural vegetation bordering the roads. They are managed as "road reserves."
- "Perforation" of roads to stimulate animal movement and ecological flow by small or large eco-ducts and eco-tunnels.

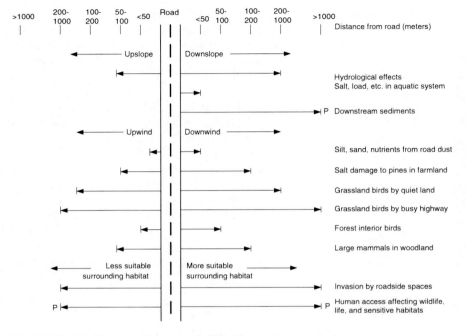

Fig. 2.14 Road effect zone (Forman et al. 2003. Used with permission)

Such mitigation measures, which aim to reduce the negative effects of roads and traffic on ecological values, serve, especially in combination with each other, the actual objective of nature conservation: the conservation of (extensive) nature areas with a high ecological value, as well as maintaining the natural processes within and outside the specific nature areas. As we argue, the ecological infrastructure of the landscape is of vital importance for the survival of plant and animal species. Mitigation measures on roads contribute to an environmentally friendly transportation system.

When applying ecological knowledge in the field of mitigation of impacts on ecosystems, it is essential to ask as many questions as possible in advance and to formulate a response from an ecological point of view, such as: Does the plan/ design causes a reduction or change to the shape of important, large or small, natural or semi-natural areas. Which animals will be hindered in their movement? What is the minimum size of a viable population of the species in question? Are corridors required? Must habitat patches be enlarged? What shape, quality, or surface area should these habitat patches have? Etc.

In addition, to study the relationship between habitat patches on, among other aspects, the basis of metapopulation models, the involvement of the effects on the composition of the matrix (see Box 2.3) is also important, not only in the form of resistance but in particular from a functional viewpoint (Hansson and Angelstam 1991).

Box 2.3 Habitat Patch–Corridor–Matrix Model

Landscapes are made up of a mosaic of various landscape elements with various soil, hydrological and ecological characteristics. Plants, animals, water, material (nutrients) and energy within this mosaic have a continuous motion and flow characterized by special distribution. Landscape mosaics are made up of three landscape ecological elements: habitat patches, corridors and a matrix (Forman 1995). The matrix forms the area in which the patches and corridors are situated.

Hansson and Angelstam (1991) give various examples of the influence of organisms in the matrix with respect to the organisms in the habitat patches:

- Predation by species that live in the matrix: small predators that achieve greater predation in the edge zone of forests than in the center of the forest.
- The eating of seeds by mice from the matrix in small areas of forests, and by doing so the mice can influence the speed of regeneration and the structure of a community.
- Small flower-full pastures in a matrix in areas of intensive agriculture show a shortage of pollinators.
- Plant species that are rich in nectar can by influence of pollinators strongly influence the distribution of the seeds of remaining species.

When considering (eco)systems, the aim is to gain insight into the possible positive and negative feedback mechanisms. Furthermore, changes, caused by natural processes and/or by processes determined by the interaction between man and nature, play a role.

Ecological engineering provides opportunities to use nature and to control natural processes, whereby the function and value can remain in relationship to each other and whereby there is sufficient space remaining for the entire range of ecosystems from those that are not influenced (undisturbed), which will have little influence or are strongly influenced or even disturbed (see examples Sect. 2.8.1 and 2.8.2).

2.6 Examples of Urban Ecosystem Approaches

First, an overview will be given about urban ecology, flows and biosocial approaches, and in Sect. 2.7.1, 2.7.2 and 2.7.3, examples will be given from different fields of interests and areas (industrial areas, urban agriculture, transportation, wastewater treatment, and energy, as well as green roofs and green façades) as illustrations of an ecosystem approach on different levels of scale.

2.6.1 Urban Ecology, Flows and Biosocial Approaches in Urban Settings

Although William Cobbert wrote as early as 1830 about London as a town, and as an organism spreading its tentacles across the English countryside (Douglas 1981), during the last decennia more and more interest has arisen about the city as a natural entity. For example, Marcotullio and Boyle (2003) described the development of the eco-city approach in three categories:

- Urban ecology
- Flows approach
- Biosocial approaches

2.6.2 Urban Ecology

In the urban ecology field of interest, urban ecologists look at cities as natural eco-systems studying patterns and processes like distribution of plants and animals, effects of stress and disturbances, and structure and functioning of urban ecological systems, and also in relation to other systems outside the cities. For sustainable urban areas, green infrastructure networks are essential for biodiversity (creation of habitats and corridors for plants and animals). Important parts of green infrastructure should all be included together: urban parks, country parks, regional parks, green spaces near housing, green roofs, green façades, community gardens, city farms, cemeteries, natural and semi-natural urban green spaces, and green corridors. Also, trees in streets and public spaces are important. Green infrastructure is also important for human existence as it reduces heat island effects, controls air and water pollution, can reduce noise, and manage floods and should be fully integrated in urban planning and design. Chapter 3 will give more details of urban ecology, especially about the scale-paradox of diversity.

2.6.3 Flows Approach

In the flows approach cities are seen as entities with quantifiable inputs and out-puts of resources, materials, and energy, as well as information. Within the UNESCO/MAB projects and a range of other international and national projects (see, for instance, Binder et al. 2009), a range of studies have been realized about increasing efficiency of flows, self-sufficiency, minimizing impact on near and distant hinterlands, use of plants as indicators of chemical changes, urban food production, urban forestry, managing urban space for children, vegetation and urban climate.

In the field of the use of materials in an urban context (from buildings to infrastructures), the relevance can be shown of (re)cycling (including re-use) thinking in the field of production and consumption to reduce input and output. When looking at the city as an urban ecosystem, it has to be related to other ecosystems nearby as well as distant, which means considering the urban ecosystem at different scales within and outside the town area. When considering sustainability issues in this respect, we need to combine social, ecological and economic issues.

From an environmental and ecologically sustainable approach, there is a need to look at the carrying capacity for water systems, for airsheds and other natural and semi-natural ecosystems in order to be able to facilitate further use of ecosystem goods and ecosystem services as well as to find the best places for housing and infrastructure projects and to set standards for water, air, soil and green space.

From a sustainable viewpoint, urban areas should be regarded as ecosystems on different levels of scale (see Fig. 2.9). Important aspects are the input of resources, the use of resources as well as the waste, and the after use phase. Most cities show linear processes, they are fully dependent for supply and disposal on their nearby or worldwide hinterland. Nowadays, the input is larger than the output which means larger stocks of material due to increasing population and rising income, leading to more emissions and more waste. An important question is how the waste can become a resource. But it will be more practical to start with the design process in order to make re-use of construction elements possible as well as to incorporate easier ways for recycling in the phase of demolishment. From an analytical point of view, it is worthwhile to make use of the input–output ratio for comparison.

In his *The Gaia Atlas of Cities*, Girardet (1992) shows us the usefulness of the circular metabolism instead of the linear metabolism approach. By using a circular approach, production and consumption processes can improve the eco-efficiency (see Fig. 2.15).

Within the urban metabolism school, concepts like ecological footprint and carrying capacity have been developed by Rees and Wackernagel (1996) providing a measure for environmental impact of cities (Macotullio and Boyle 2003). The footprint analysis has been developed to get more public awareness about the "load" imposed by a given human population on nature. It is a useful method for comparison between two people or two or more countries, and to show the dependence on nature. But it should be realized that the method is not measuring all environmental impacts, the footprint number is only part of the story.[1]

In Table 2.7, the average ecological footprint and CO_2 emission of a UK resident is given (Anonymus 2008).

Ecological footprint analysis (Wackernagel and Rees 1996) can give us insight into the consumption of resources in relation to availability. In 2008, the footprints

[1] For a world ranking list about the ecological footprint per state, information can be found on the website of the Earth Council: www.ecouncil.ar.cr.

Linear metabolism cities consume and pollute at a high rate

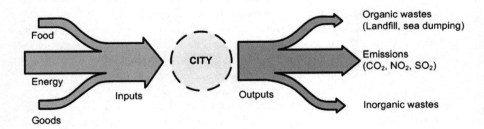

Circular metabolism cities minimize new inputs and maximize recycling

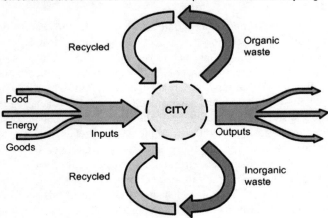

Fig. 2.15 Linear and circular metabolism (Girardet 1990. Used with permission)

Table 2.7 Average ecological footprint and CO_2 emissions of a UK resident (in %) (Stockholm Environment Institute, in Anonymus 2008)

	Ecological footprint (%)	CO_2 emissions (%)
Housing	8	8
Home energy	18	23
Transport	15	23
Food	23	8
Consumer goods	14	13
Private services	9	10
Government	7	8
Capital assets	6	7
Total	100 (= 5.45 Gha/cap)[a]	100

[a]If everyone in the world used the same amount of resources, we would each have 1.8 global hectares available (in the gha, the biologically productive land have been used as well as 10% for other species)

of urban areas are much larger than agricultural landscapes. When looking at London, the ecological footprint is 120 times the area of the city and Tokyo needs 1.2 times of all Japan to sustain the current consumption levels. We have now reached a phase in which the total footprint of all cities is larger than our earth, which means we are exploiting the natural resources. The question is how this information can be useful for reaching a sustainable city, as it requires a change in attitude by people. The footprint analysis shows the impact of cities on the environment but provides few solutions as such for policy makers. In 2008, the BioRegional Development Group and the Government Advisory Commission for Architecture and the Built Environment in the UK published *What makes an eco-town?* in which an overview is given on how living within ecological limits can be reached and attention is drawn to how and how much reduction should and can be achieved by residents as well as by governments and businesses (Anonymus 2008).

2.6.4 Biosocial Approach

Within the biosocial approach, sociologists study the role of competition and cooperation as mechanisms of change and progress (Marcotullio and Boyle 2003). In the 1970s, William Burch Jr. started a biosocial approach to human ecosystems examining the energy, materials, nutrients, population, genetic and non-genetic information, labor, capital, organization, beliefs and myths and the knowledge that affects the distribution of critical resources within a human ecosystem. They developed the Human Ecosystem Framework, which includes: natural resources, socio-economic resources, and cultural resources in relation to the social system (social institutions, social cycles and social order).

The Human Ecosystem Framework integrates social-cultural and biophysical systems, uses different scales, can give insight into resilience, resistance, persistence and variability in patterns and processes and give more insight for social scientists, human scientists and ecologists about the understanding of ecosystems and how to manage them.

Besides the structure of human ecosystems (Machlis et al. 1997; Machlis 2003), another group of scientists developed the so-called "diamond schematic" (Fig. 2.16) and an Adaptive Methodology for Ecosystem Sustainability and Health (AMESH) (Kay and Schneider 1994; Kay et al. 1999).[2]

Scenarios, visions and managing emerge from the integration of ecosystem understanding. According to Kay et al. (1999) "The diagram illustrates the necessity to integrate the biophysical sciences and the social sciences to generate an ecosystem description of the biophysical and socio-economic-political situation. This is used to formulate feasible and desirable futures, one of which is chosen to

[2] See also www.jameskay.ca.

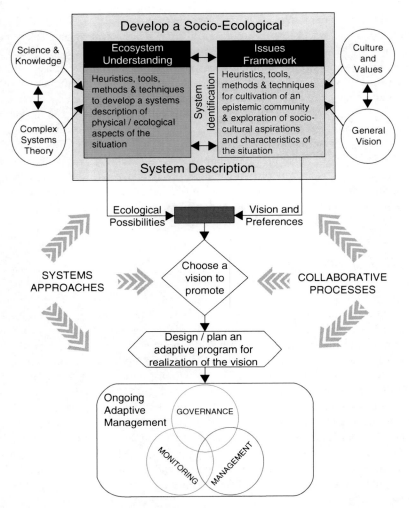

Fig. 2.16 A "diamond" heuristic of the ecosystem approach (Kay et al. 1999. Used with permission)

promote. It is then necessary to design a collaborative learning process for the ongoing adaptive process of governance, management and monitoring for sustainability."

The "diamond" in the diamond schematic is the nexus in which ecological understanding and socio-cultural preferences meet and interface with policy makers and managers (Waltner-Toews and Kay 2005), and in which "…..the challenge facing the practice of environmental management is to learn how to work with self-organizing processes in a way which allows us to meet our species needs, while still

preserving the integrity of ecosystems, that is to say the integrity of self-organizing processes ..." (Kay and Schneider 1994). In the context of uncertainty and complexity, policies can be seen as hypotheses and management activities as tests of these hypotheses. On this basis, an Adaptive Methodology for Ecosystem Sustainability and Health (AMESH) has been developed involving governance, management and monitoring. Ecological systems provide the biophysical context and the flow of exergy,[3] materials and information that are required by the self-organizing processes of the societal system. Societal systems can and do alter the structure in ecological systems. Besides researchers studying these complexities, full account should be given to all the stakeholders involved, not only policymakers or business people, but especially the local people. So not only "participation by consultation" but an approach of "interactive participation," which will also foster resilience and adaptive capacity of eco-social systems, is needed (see also Chap. 14). The AMESH approach has been used and tested in rural situations in Kenya, Canada and Nepal, but the way of approaching the relationship between ecosystems and society can also be of relevance in urban situations.

In the Environmental Education Communication for a Sustainable World; *Handbook for international practitioners*, Hough and Day (2000) formulate a set of principles that are derived from general systems theory for a case study of the improvement of nature and environmental education processes in El Salvador. The assumption is that almost all environmental problems are human-behavioral problems (Hough and Day 2000). A thorough systems analysis of the local situation prior to the proposal of measures can make the options for solving the problems more visible.

Ten principles for systems analysis according to Hough and Day (2000) are presented in Table 2.8. Not all social scientists will agree with this kind of approach, which has the danger of ecologizing things. However, the main message is that systems thinking can play a role in getting things clearer.

When social aspects are studied in the context of ecosystems, these systems become much more complex than technical systems; man is often looking and working with the elements of the system and not with the links between the different elements of the system. This makes social systems difficult to handle. Constanza (1987) spoke about social traps, as "any situation in which the short-term local reinforcement guiding individual behaviour is inconsistent with the long-run, global interest of the individual and society." This should be realized when studying social systems. In Chaps. 12–14, more insight will be given into the relationships of ecosystems, cultural values, governance, management and monitoring of effects in an urban context.

[3] For an explanation of exergy: see Chap. 5.

Table 2.8 Ten principles for systems analysis according to Hough and Day (2000)

Ten principles	The principles applied to a case
1. A concrete living system is made up of objects that as a population constitute the mass of the system. A living system consists of objects such as atoms, molecules, cells, organisms, people, groups, organizations and communities	The El Salvador study was intended to gain insight into the behavior and attitude of people towards environmental education instead of data on use, migration, etc. The data about the population's knowledge, attitudes and practice regarding the environment were collected through interviews.
2. A system is a part of a hierarchy of systems, made up of subsystems and supra-systems. Systems are "nested" systems: atoms are subsystems of molecules, which in turn are subsystems of cells. The same applies to local authorities, provinces and national governments.	In the El Salvador study, strategic subsystems of the population were chosen: teachers, students and journalists, who could influence all of the other subgroups at various levels in the entire system.
3. Every system has objects that are in coupled motion: predator/prey, dancing partners, etc.	In El Salvador, public–private partnerships are mainly involved: a newspaper that publishes a special page for children on nature and the environment every week or month.
4. Living systems receive inputs from outside. Thus, they are open as opposed to closed systems. Living systems depend on external energy sources (the sun).	El Salvador imported material and methods for the project that had already been developed outside El Salvador and that suited the culture and the ecology of the country.
5. Each subsystem is defined by its capacities for matter-energy/information input, short-term storage, metabolism, long-term storage and output. Every subsystem has a special function within the entire system. Seen from the environmental aspect, this concerns the role that each of the players involved plays and which subsystems are resilient, weak or subject to risk.	In El Salvador, all the activities (printed material, training strategy for journalists, etc.) were tested before they were used on a wide scale. Pre-testing examines the capacity of the system for information input, short-term storage and metabolism.
6. The structure of a system is defined by the subsystem it can activate, by the supra-systems that may activate it, and by the linkages through which the activations take place. Subsystems are activated in response to changes in other subsystems. A system structure is the entirety of all of the relationships with the subsystems. Every change in information, energy or component has an effect on various subsystems.	In El Salvador, people needed to be informed about what the public and the private sectors do and what they should be doing to protect the environment. By offering extra training to journalists, the relative relationships between a number of subsystems could change.
7. A system may use energy inputs to add more objects, to change the linkages or relationships among its subsystems, or to produce an output. A system can use its energy in all these three ways, dependent on the stage of development/growth of the system.	An example of how the energy input changed the relationships between subsystems in El Salvador concerns a workshop for 5,000 teachers. When used in class, interactive teaching methods were one of the subjects that changed the relationship between teachers and students.

(continued)

Table 2.8 (continued)

Ten principles	The principles applied to a case
8. Growth creates form. If a system grows, its form changes. If growth happens in the form of an increase in population, the system gets larger. If growth results from changes in the linkages between coupled objects in a system, the system itself does not need to grow, but new subsystems can arise with new characteristics. An example is the development of the Internet. The expectation was that a few large mainframes would be overloaded. Another form of growth occurred, being decentralized servers.	In El Salvador, a new organization came into being after the journalists had been trained. This organization organized a national award for the best article, and a public movement developed. This means that growth came from changes in the relationships among subsystems. As the public became better informed by the increased press coverage, a popular movement developed.
9. If a system's energy exports exceed its energy imports, the system is entropic. If a system cannot supplement its shortage of energy from stored energy, vital tasks will be affected and this can lead to the loss of objects.	In El Salvador, the private and public sectors were consciously involved to be able, based on their commitment, to continue with the activities that had been initiated when international financial input and other donations stopped.
10. Structure limits growth. In centrally managed systems, the dispersal of products depends on the capacity of a single central object. In decentralized systems, dispersal can occur in very many ways. Every structure has its own limitations and needs for sustainability.	In El Salvador, the effectiveness of nature and environmental education was increased by involving many subsystems (media, teachers, students).

2.7 Understanding Urban Areas as Ecosystems

In Sect. 2.6.1, 2.6.2, 2.6.3 and 2.6.4, examples of different urban ecosystem approaches were described. In this section, examples of different concrete (aspects of) urban areas as ecosystems are given to show what we can learn from ecosystems for solving human-caused problems. For a good understanding of the meaning of different types of cities, Table 2.9 (changed from Downton 2009) summarizes some aspects concerning the conventional city, sustainable city, ecocity and the ecopolis.

2.7.1 Industrial Ecology and Industrial Areas as Ecosystems

Industrial ecology means that linear processes can be changed in cyclic, energy efficient processes by comparing ecosystem processes. In nature. most waste is used by organisms, although exceptions exist like the forming of moors by accumulation

Table 2.9 Comparison of different city types (Changed from Downton 2009)

Characteristic	Conventional city	Sustainable city	Ecocity or green city	Ecopolis
Relation to the biosphere	In conflict; usually exploitative and polluting.	Mostly harmless.	In balance with nature.	Consciously integrated into the biosphere processes to optimize their functioning for human purposes.
Protection of bio zones	None.	Conservation of wetlands.	River and creek restoration.	Ecosystem restoration.
Maintenance of food production	None.	Limited food production.	Urban agriculture.	Remodeling urban agriculture.
Ecosystem connectivity: creating habitat	None, except in negative terms, e.g., polluting.	Some connectivity with natural networks.	Functional connectivity with essential elements of the natural environment.	Conscious connectivity with all elements of the environment.
Transport	Ad hoc. Decided by linear extrapolation from previous conditions.	Transit oriented.	Access partly by proximity, planning based on corridors and pedestrian and cycling networks.	Access fully by proximity, planning based on corridors and pedestrian and cycling networks.

of dying plants like mosses. But when looking at the food webs in ecosystems most products produced by an organism are used by other organisms. The idea or concept of industrial ecology is imitating the relationships within ecosystems.

Lowe (2001) has defined industrial ecology as an approach to managing human activity on a sustainable basis by seeking essential integration of human systems with natural systems, minimizing energy and material use as well as minimizing the ecological impacts of human activity.

The relationship between industries and ecosystems when the water, energy and resources flows are described can also be seen in the form of industrial watersheds, which can be defined by its water (rain-, process- and wastewater) in interaction with the watersheds. Three dimensions of the industrial watershed are:

- Surface area with the ground- and surface water and the skin of all the buildings, pavements, soils and landscape structures.
- Morphology of the industrial area and the surroundings (total surface area of the watersheds).
- Metabolic processes as the interaction between the industrial water use and the natural surroundings.

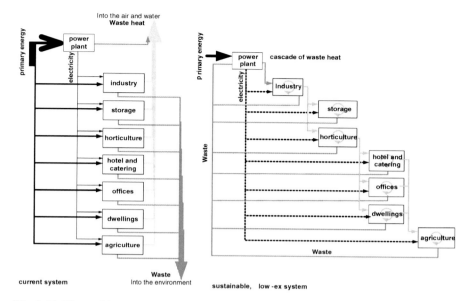

Fig. 2.17 The traditional energy system versus a more sustainable one that uses waste heat optimally (Van den Dobbelsteen et al. 2009. Used with permission)

There are many design possibilities: site design, eco-park infrastructure, individual facilities and shared support services.

An industrial park should be part of the natural systems in which they are built, minimizing environmental impacts and reducing costs: wetlands for cleaning run-off water from parking areas and reducing maintenance costs, realizing green roofs and green walls, using native plants for the green areas around the buildings and other facilities, allowing spontaneous development of native plants and animals, and increasing the ecological value of the site in connection with the ecological areas further away.

In the field of energy, it means using solar and wind energy and looking for possibilities that heated water or steam can be used by other factories in an energy-cascading manner (Fig. 2.17). Also, looking at water flow, re-use of water in one company is one option, while another is to look for cascading options between different companies. When looking at material flow, waste or by-products from one company can become a resource for another.

McDonough and Braungart (2002) show that an industrial system that "takes, makes and wastes" can become a creator of goods and services that generate ecological, social and economic values through ecologically intelligent design. The cradle to cradle (C2C) approach likes to promote growth by adapting our technical approach and, according to the authors, we can decrease our ecological footprint. But we should realize that recycling will cost energy, and more and more transportation of goods will take place. A more integrated approach including behavioral

responses, and cultural, ecological, and economical aspects should be fully included in decision-making processes in this field.

Examples of waste products that have become a resource:

- In steel factories, blast furnace slag is a waste product but it has been shown that it can replace cement in concrete making.
- The fly ash, a waste product of electric power plants, can also be used in cement making.
- Sulfur can be removed from gas to make sulfuric acid.
- Gypsum from cleaning processes of coal-fired power stations or similar industrial processes can be used when it is not contaminated for plasterboards or building blocks.
- Waste heat from factories can be used for heating houses. Waste heat from the industries on the Maasvlakte in The Netherlands is used for getting the right temperature of water in which shrimps are bred, and the waste heat is also transported to the greenhouse complexes in the Westland area.
- Also, glasshouses themselves can produce energy to be used for buildings.

In order to be able to bring together all the different single approaches to realize an integral eco-industrial park, there should be detailed information available about material and energy flow, input and output data about raw materials, and products and by-products (including what is normally called waste). In the end, a zero waste level should be realized. More and more eco-industrial parks have been created.[4]

2.7.2 Ecologically Responsible Agriculture

Examples of how to integrate aspects of food growing, energy use and energy savings, and use of wastewater in combination with living are:

- Bioshelters, developed by John Todd and others (Todd 2005), mimic ecosystems to integrate food growing, energy independence, waste treatment and living quarters.
- A systems approach in the field of agriculture (Fig. 2.18).
- Glasshouses in which tropical plants are nourished by wastewater and heated by waste heat (examples from Switzerland).
- Glasshouses in combination with buildings for living (example from the Netherlands (Fig. 2.19)).
- High-rise buildings or vertical farms ("sky farming") for the production of food in the city (urban farming, urban agriculture).

[4] For reviews and overviews of location of eco-industrial parks, articles and handbooks see the *Journal of Industrial Ecology* and the *Journal of Ecological Engineering* and various eco-industrial websites.

Flow resources in the integrated biosystem of
Montford Boys' Town in Suva, Fiji

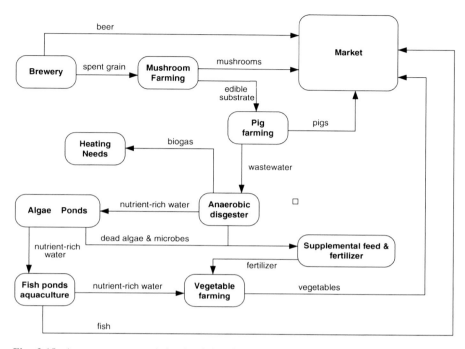

Fig. 2.18 A systems approach in the field of agriculture (Robert Klee, Yale University, in Chertow 2000. Used with permission)

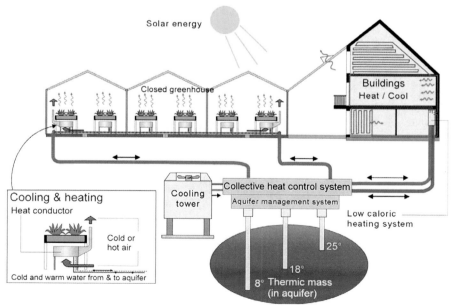

Fig. 2.19 Glasshouses combined with buildings (Wortmann 2005. Used with permission)

Fig. 2.20 The transportation system and built-up environment are sustained by the natural environment (Knoflacher and Himanen 1991. Used with permission)

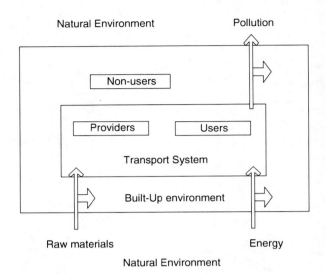

2.7.3 An Ecosystem Approach to Transport

Knoflacher and Himanen (1991) compared, using an ecosystem approach (Fig. 2.20), the development of transport systems (pedestrian, bicycle, train, motorcycle, car, truck, bus, special vehicles) with five principles of ecosystems (variety, recycling, efficiency of energy-use and resources, self-regulation and regionalization).

In the course of time, streets and roads developed from multi-functionality (center of human activities) to mono-functionality (transport). The diversity in transport modes increased, but due to high speeds, more conflicts (accidents, air pollution, e.g., NO_2, fine dust) and a simplifying of the road environment (many different paths to fully standardized motorways) occurred. And a decreasing efficiency of all modes instead of an increasing efficiency of energy-use takes place which is in contradiction to what you should expect in well-developed systems, although the transportation efficiency of goods may be increased. In nature, self-regulation is an important factor for survival as it stabilizes ecosystems after disturbance (feedback), but in transport it looks as if destabilizing processes are still going on, although some feedback mechanisms have been introduced (catalytic converter, mitigation and compensation measures as well as price-mechanisms).

In the sphere of production and consumption, we now find the same products all over the world with little care for the environment and the people. The main conclusion is to find a discrepancy between the rules by which life is solving problems and the technical and economic solutions in the transport system (Knoflacher and Himanen 1991).

In order to reach sustainability, a strong feed-back (transition) by effective policy instruments viewed from a full system vision is needed. It should consist of all the

transport modes, including a full integration with pedestrians and cyclists, public transportation systems (train, light rail, metro, buses) and organized in system-based urban planning with higher densities, clustered developments and reduced sprawl. See Chap. 9 for more details about this kind of approach.

To reduce transportation costs and emissions, an option for food production is to produce more within and nearby large urban settlements.

2.8 Improving Urban Systems: Ecological Engineering

Ecological engineering is the design of sustainable ecosystems that integrate human society with its natural environment for the benefit of both. The planning, design, construction and management of ecosystems, but also civil engineering projects, should be carried out such that there is value for humans and the environment. The field of interest and opportunities lies especially in the field of using ecosystems as interfaces between technology and the environment.

Ecological engineering was first used by Howard Odum in 1962 who described the term as those cases where the energy supplied by man is small relative to the natural sources, but sufficient to produce large effects in the resulting patterns and processes. Mitsch and Jørgensen (1989) stimulated the use of ecological engineering based on system thinking, self-organization, sustainability and integration of human society with its natural environment.

Before too long, we will have to change our fossil fuel-based system. One of the most promising for the future is solar-based energy systems, if the nuclear options (fission and fusion) are not acceptable. Besides new systems, we also need a more low-carbon economy to reduce the amount of CO_2 output. The eco-efficiency needs a step further; that means a paradigm change to be able to have more innovations in the field of eco-design of products and processes to dematerialize and to reduce emissions.

In the following section, some concrete eco-design solutions for our environmental problems are given based on ecological engineering.

2.8.1 Ecological Alternatives of Wastewater Treatment

More and more stress on potable water and other natural resources due to population growth, especially in urban areas, requires a more ecologically sound way of wastewater management. During the last decades, a lot of knowledge and experience has become available from local to more centralized systems.[5]

New developments show possibilities of gray water use, urine and feces separation, instead of first mixing it, where urine can be applied in agriculture. Under different names like eco-sanitation, sustainable ecological sanitation or

[5] See for example: www.ecosan.org and www.iees.ch, both accessed March 2011.

eco-system-based sanitation gives way to a more eco-sufficient methods of handling our wastewater.

"A more holistic approach towards sustainable sanitation if offered by the concepts referred to as ecological sanitation. The key objective of this approach is not to promote a certain technology, but rather a new philosophy of dealing with what has been regarded as wastewater in the past. The systems of this approach are based on the systematic implementation of a material-flow-oriented recycling process as a holistic alternative to conventional solutions. Ideally, ecological sanitation systems enable the complete recovery of all nutrients from feces, urine and grey water to the benefit of agriculture, and the minimization of water pollution, while at the same time ensuring that water is used economically and is reused to the greatest possible extent, particularly for irrigation purposes".[6]

A more integrated approach is needed to combine storm water collection, source separation, black water and gray water recycling for potable and non-potable use, and advanced conservation of water based on an ecosystem or watershed approach (Del Porto 2006). Nowadays, we combine wastes, including excreta, toxics and heavy metals, and then at the end of the pipe we use advanced ultra-filtration processes in large centralized wastewater treatment plants. The question is whether a more integrated approach can be organized (including the way we get clean water from watersheds – collect, store and use local (storm)water – as well as recycling, conservation of water and on-site wastewater treatment). It means using waste as a resource and based on a material-flow-oriented recycling process that recover all nutrients from feces, urine and gray water. Ecological engineering principles and techniques can be helpful to change waste into a resource, to get rid of pollution and produce valuable ecosystem goods and ecosystem services to increase the quality of life of humans and other organisms as much as possible.

In some countries, sustainable sanitation systems have been introduced that means source separation of gray water, urine and feces and reuse mainly in agriculture, but a drinking water standard is also possible to reach, but most people are still hesitant about it. An important condition is that all organic flows must cycle and ecological sanitation is a way that uses low energy and produces valuable biomass or biogas. Modern agricultural systems have a linear nutrient flow regime from fossil resources to deposits in recipients, and for long-term sustainability all nutrients in toilet water should be reused in agriculture which will also reduce the pressure on the quality of drinking water demands.

Constructed wetlands and reed beds or helophyte filter purification systems for cleaning of wastewater are based on natural systems. These facilities can become part of the landscape, can have ecological values, and have relatively low maintenance costs and low operating costs.

The living machines developed by John Todd are integrated wastewater treatment systems based on ecosystem thinking. Figure 2.21 gives a comparison of two different

[6] From web page Deutsche Gesellschaft fur Technische Zusammenarbeit, as of January 2011 part of GIZ: http://www.giz.de/en/home.html. See also: http://www.unep.org/GC/GC23/documents/Germany.pdf Accessed March 2011.

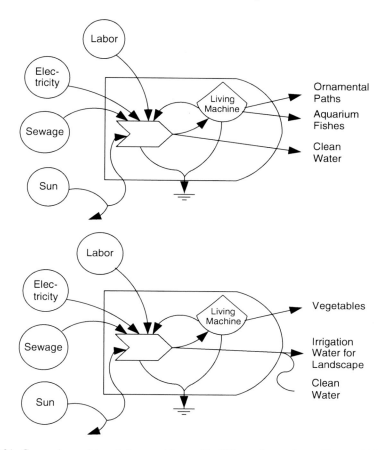

Fig. 2.21 Comparison of two living machines with different by-products (Kangas 2004. Used with permission)

living machine systems showing different by-products. Figure 2.22 shows the interior of part of the living machines or eco-machines in use for an apartment building complex in Nova Scotia.

In principle, the line should be to reduce, reuse and utilize (recycled) wastewater to save clean water supplies and to prevent water pollution as well as reducing wastewater treatment costs.

By using ecological engineering techniques, it is possible to have more local solutions for wastewater treatment instead of the modern large centralized urban systems collecting wastewater from many different sources, mixing it and using end-of-pipe methods of solving the waste problem instead of using more efficient local beginnings for the pipe solutions. There is an urgent need for integrated strategies for source separation, black water and gray water recycling for potable and non-potable use (Del Porto 2006). There are many possibilities: local rainwater harvest and local use, minimizing household water use (water-saving equipment), local treatment and reuse of black and gray water.

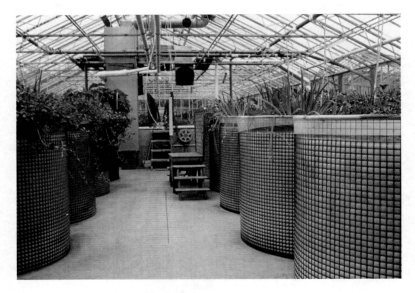

Fig. 2.22 The interior of part of a living machine system: Tanks with rafted plants on the water surface (Photo: H. van Bohemen. Used with permission)

2.8.2 Green Roofs and Green Façades in an Urban Setting

Greening of buildings in the form of vegetated roofs and vegetated façades is seen from different viewpoints to be becoming more and more attractive. Green roofs (Figs. 2.23 and 2.24) are not only good for diversity of plant and animal species within urban areas but vegetated roofs will decrease and slow down the amount of rainwater and will reduce local floods. The green roof protects the roof underneath from ultra-violet light and frost, reduces costs of air-conditioning during hot weather and reduces the heat island effect in urban areas, and can take up fine dust and CO_2 and emit O_2. There is a great variety of types of green roofs and green façades from extensive to more intensive. The most widely-used plants for green roofs are different species of *Sedum*. They can resist periods of droughts, and as succulents they can actively store water in their tissues. For a number of reasons, creating a wild-flower meadow should be stimulated as it will improve the biological diversity, much more than *Sedum* vegetation alone, if the construction will hold the thicker soil layer needed, which is of course heavier.

Vertical greening of façades of buildings can also be attractive from an ecological point of view as well as for filtering particulate matter (Fig. 2.25). Vertical greening of façades has more potential to impact the area per building then for example a green roof (i.e., greening of a building façade can encompass more than four times

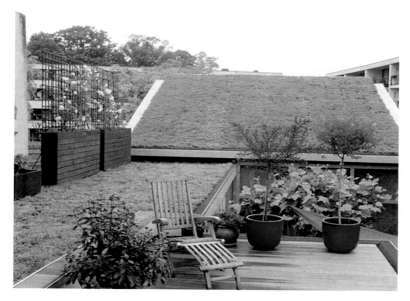

Fig. 2.23 Example of a green roof (Photo: Mrs. T. v.d. Weijer. Used with permission)

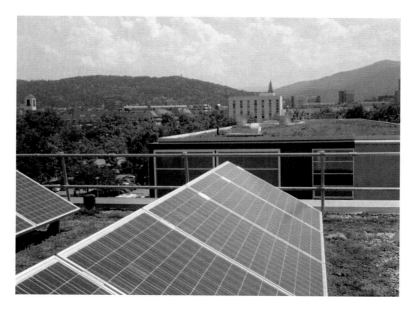

Fig. 2.24 Example of a green roof with solar cell panels (Photo: H. van Bohemen. Used with permission)

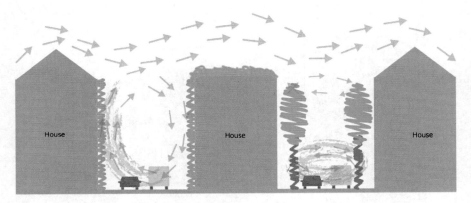

Fig. 2.25 Street canyons with green façades and green roofs and with trees, in relation to the movement of dust particles (Marc Ottelé, Delft University of Technology. Used with permission)

the area of the roof). A variety of different systems are also available for greening of vertical walls. Even skyscrapers can be designed as green towers with more or less continuous vertical greening using stepped-planters to enable more ecological interactions (Yeang 1999).

This example of streets with and without trees also shows that looking on different scales and alternatives for problem solving is very relevant. Instead of cutting trees in narrow streets, it is wise to look first on a higher level of scale: looking at the traffic system will give other solutions, like promoting more quiet traffic zones. But if you have to cut trees, you should first consider replacing them with more adapted species with for instance a slender instead of a wide crown. If that is not possible and you have to cut the trees, you could compensate the trees with greening of the façades of the buildings (Ottelé 2011).

2.8.3 Accumulation of Carbon in Urban Areas

Accumulation of carbon in soil organic matter, in trees, in peatland and uptake in oceans is well known, but the accumulation of carbon in urban areas is also relevant in this context of CO_2 reduction.

Carbon is accumulated in the biomass of humans, trees and other plants, animals, buildings, furniture, and books, as well as in landfills (Bramryd 1982). Besides the forming of CH_4, the carbon accumulation in landfills could be of relevance as an alternative to incineration which produces CO_2. In many urban areas, separate collection of organic material and other waste takes place and the use of the resulting compost will stimulate the accumulation of more stable or long-lived humus in the soil. Organic carbon accumulation can also be stimulated by using straw bales in construction works, such as houses, instead of burning the straw (Corum 2005). If there is no direct use, organic waste could be deposited in the form of artificial ecosystems where accumulation of the organic material can take place.

2.9 The Earth as a Living System

The Gaia hypothesis developed in the early 1970s by J. Lovelock and L. Margulis, which is now a theory accepted by many scientists, shows that our planet is one (open) system ("a living entity") in which the abiotic and biotic parts are interconnected, interdependent, self-organizing living systems, subsystems and sub-subsystems. The word Gaia comes from the Greek god of the earth. Lovelock (1972, 2007) suggested that life on earth provides a homeostatic feedback system leading to stabilization of temperature and chemical conditions.

Margulis (1998) proposed a more nuanced formulation that the atmosphere, hydrosphere, lithosphere and biosphere are regulated in homeostasis at certain "po ints", but that the "points" can change in time. It is important to note that in general among ecologists the biosphere is considered as an ecosystem and that the interactions within and between the biosphere, the geosphere, the atmosphere and oceans are important fields of study, also seen from the viewpoint of the large changes caused by humans in our global environment, which can have negative impacts on the well being of humans. Especially the human-caused large-scale, accelerating changes of the atmosphere, the oceans, the coastal zones, the water cycle, and the biogeochemical cycles give concern for the meaning of the development of sustainable urban areas.

Besides the supporters of the Gaia hypotheses, other scientists rejected the idea of the "good mother" as several great extinctions on earth have taken place in the past based on the idea that life itself has been the cause (Ward 2009). We know that, without changing policy, the current level of 380 ppm CO_2 will increase, and when 1,000 ppm (in between 95 and 300 years from now) is reached, melting ice will lead to mass extinctions (at least melting ice will result in sea level rise which will cause submergence between perhaps 2150 and 2200, seriously impacting coastal cities). On a larger timescale (500 million to a billion years from now), CO_2 will reduce, plants will die and O_2 will decrease.

Which of the hypotheses are correct is still under question and much research is needed. But with the existing knowledge we should make our urban areas, and the world as a whole, as habitable as possible and take technological- as well as ecological-based measures in combination with each other (low carbon-producing energy production and reduction of CO_2 emissions by transportation and the building industry) to save our and other species from extinction.

2.10 Discussion

In this chapter, different forms and aspects of ecosystem thinking have been illustrated, from a direct ecological viewpoint as well as bio-socially. It shows that in some fields of interest the ecosystem view is fully accepted and implemented (as in the field of conservation of nature and hydrology in urban areas). In other fields of

study, more and more integral approaches to combine ecology, economy and social aspects are developing. The ecosystem thinking approach can be used to describe urban systems in all their complexity, and can be used to identify opportunities for improving the sustainability of urban life.

Summarizing the fundamentals of an ecosystem approach, we can state that it is integrated, it includes all ecosystem goods and ecosystem services, it has a long-term view, it includes (local) people, should be a base for nature restoration of what has been lost and will reduce the urbanization impact on ecosystems. For example, for biodiversity and sustainable urban area planning, it is a prerequisite that developers should have a biodiversity action plan as well as a green infrastructure plan showing how the housing or industrial development proposals are going to integrate the different aspects.

Slowly, a bio-social approach is forming, but full integration of bio-social thinking based on an ecosystem approach in the form of real eco-city development is still in its initial phases, although all kinds of separate initiatives are being taken. In the planning of sustainable urban areas, the developer should decrease the ecological footprint and decrease CO_2 emissions, not only at the building scale but also at other relevant scales incorporating local and regional food production, production of goods, private and public transportation and supporting a life-style choice that makes it easy to reduce the ecological footprint and the CO_2 emissions.

2.10.1 Antropocentric Versus Ecocentric

In this chapter, we looked upon the value of ecosystem thinking in general and in a context of urban areas and civil engineering activities. It is written from a human perspective. We should be aware of the difference between an anthropocentric and ecocentric approach. As humans, we like to make use of our environment for our own survival. We should realize that, besides the ecosystem goods and ecosystem services, we should keep intact the intrinsic ecological values in the form of ecological processes and patterns for their own sake as well as for long-term use by humans.

2.10.2 Sense of Place

For real success of sustainability measures one should respect the "sense of place," the relationship between ecosystem properties, landscape historical characteristics, and the history and cultural values of people living in a specific area.

Questions

1. Give a short description of the (eco)system approach?
2. Mention and describe some different (eco)system models?

3. What are the main characteristics of ecosystems?
4. Give a short presentation about the relevance of the notion of resilience?
5. Which three eco-city concepts exist, and give for each of them a short description?

References

Aber JD, Melillo JM (1991) Terrestrial ecosystems. Saunders College Publishing, Philadelphia
Anonymus (2008) What makes an eco-town? A report from BioRegional and CABE (Commission for Architecture and the Built Environment) inspired by the eco-towns challenge panel. www. bioregional.com and www.cabe.org.uk
Bailey RG (1998) Ecoregions: the ecosystem geography of the Oceans and continents. Springer, New York
Binder CR, Van der Voet E, Rosselot KS (2009) Editorial special issue journal of industrial ecology: Applications of material flow analysis. J Ind Ecol 13(5):643–649
Boulding KE (1956) General systems theory. Man Science 2(3):197–208
Bramryd T (1982) Fluxes and accumulation of organic carbon in urban ecosystems on a global scale. In: Bornkamm R, Lee JA, Seaward MRD (eds) Urban ecology. Blackwell Scientific Publications, Oxford
Chertow MR (2000) Industrial symbiosis: literature and taxonomy. Annu Rev Energy Environ 25:313–337
Chorley RJ, Kennedy BA (1971) Physical geography: a systems approach. Prentice-Hall Int, London
Clements FE (1916) Plant succession. Carnegie Institution, Washington Pub. 242, 512 pp
Constanza R (1987) Social traps and environmental policy. Bioscience 37:407–412
Corum N (2005) Building a straw bale house: the red feather construction handbook. Princeton Architectural press, New York
Del Porto D (2006) Urban and industrial watersheds and ecological sanitation: two sustainable strategies for on-site urban water management. In: Rogers P, Llamas R, Martinez-Cortina L, Rogers P, Llamas R, Martinez-Cortina L (eds.) Water crisis: myth or reality. Taylor & Francis/ Balkema plc, London
Douglas I (1981) The city as an ecosystem. Prog Phys Geogr 5:315–367
Downton PF (2009) Ecopolis: Architecture and cities for a changing climate, Springer
Duvigneaud P, Denayer-De Smet S (1977) De ecosystemen van de stad Brussel. Gemeente Brussel
Elton CH (1933) The ecology of animals. Methuen, London
Folke C, Carpenter SR, Elmqvist T, Gunderson L, Holling CS, Walker B (2002) Resilience and sustainable development: building adaptive capacity in a world of transformations. Ambio 31:437–440
Forman RTT (1995) Land mosaics: the ecology of landscapes and regions. Cambridge University Press, Cambridge
Forman RTT et al (2003) Road ecology: science and solutions. Island Press, Washington, DC
Forrester JW (1971) World dynamics. Wright Alln Press, Cambridge
Galaz V (2006) Does the EC Water Framework Directive build resilience? Harnessing social-ecological complexity in European water management. Policy Paper, Swedish Water House
Girardet H (1992) The Gaia atlas of cities. Gaia Books, London
Girardet H (1999) Creating a Sustainable Cities. Schumacher Briefing no. 2, Green Books for the Schumacher Society, Devon
Grime JP (1979) Plant strategies and vegetation processes. Wiley, Chichester
Haber W (1990) Using landscape ecology in planning and management. In: Zonneveld IS, Forman RTT (eds) Changing landscapes: an ecological perspective. Springer, New York, pp 217–232
Hansson L, Angelstam P (1991) Landscape ecology as a theoretical basis for nature conservation. Landsc Ecol 5:191–201

Hartley A, Pekel JF, Ledwith M, Champeaux JL, de Badts E, Bartalev SA (2000) Vegetation map of Europe. Euroforest project EC

Holling CS (1996) Surprise for science, resilience for ecosystems, and incentives for people. Ecol Appl 6(3):733–735

Hough RR, Day BA (2000) Environmental education and communication for a sustainable world. In: Day BA, Monroe MC (eds.) Handbook for international practitioners. New Society Publ., Gabriola Island

Jørgensen SE, Müller F, Jørgensen SE, Müller F (2000) Handbook of ecosystem theories and management. Lewis Publishers, Boca Raton

Jørgensen SE, Fath BD, Bastianono S, Marques JC, Mueller F, Nielsen SN, Patten BC, Tiezzi E, Ulanowicz RE (2007) A new ecology: systems perspective. Elsevier, Amsterdam

Jørgensen SE, Chon T-S, Recknagel F (2009) Handbook of ecological modelling and informatics. WIT Press, Southampton

Kangas PC (2004) Ecological engineering: principles and practice. Lewis Publishers, Boca Raton

Kay JJ, Schneider ED (1994) Embracing complexity, the challenge of the ecosystem-approach. Alternatives 20(3):32–38

Kay J, Regier H, Boyle M, Francis G (1999) An ecosystem approach for sustainability: addressing the challenge of complexity. Futures 31(7):721–742

Keystone Center (1991) Final consensus report of the Keystone Policy Dialogue on Biological Diversity on Federal Lands, Washington, DC

Klijn F (1997) A hierarchical approach to ecosystems and its implications for ecological land classification. Dissertation Leiden University, Leiden

Knaapen JP, Klijn J, van Eupen M (1999) Veerkracht van zoete en brakke wateren: een benadering vanuit ecologie en ruimte. DLO-Staring Centrum, Wageningen

Knoflacher H, Himanen V (1991)Transport policy between economy and ecology. VTT Research Notes 1221, Finland

Lazo N, Donze M (2000) Sources of variation in the performance of lagoons and wetlands for sewage treatment. A data analysis based on the results of the Leon Experimental Station, Nicaragua. Communications no. 86 of the Water Management and Sanitary Engineering Division, TU Delft

Levin SA (1999) Towards a science of ecological management. Ecol Soc 3(2):6

Lovelock J (1972) Gaia as seen through atmosphere. Atmos Environ 6(8):579–580

Lovelock J (2007) The revenge of Gaia. Basic Books, New York

Lowe E (2001) Eco-industrial park handbook for Asian developing countries. A report to Asian Development Bank, Environment Department, Oakland: Indigo Department

Lugo AE, Gucinski H (2000) Functions, effects and management of forest roads. For Ecol Manage 133:249–262

Machlis GE (2003) The structure of human ecosystems. Paper presented at East Carolina University, Executive-in-Residence Program, Greenville, 2–3 April

Machlis GE, Force JE, Burch WR (1997) The human ecosystem part 1: the human ecosystem as an organization concept in ecosystem management. Soc Nat Resour 10:347–367

Marcotullio PJ, Boyle GR (eds.) (2003) Defining an ecosystem approach to urban management and policy development. Report UNU/IAS, Tokyo

Margaleff R (1968) Perspectives in ecological theory. University of Chicago Press, Chicago

Margulis L (1998) Symbiotic planet: a new look at evolution. Basic Books, New York

May RM (1975) Island biogeography and the design of wildlife preserves. Nature 254:177–178

McDonough W, Braungart M (2002) Cradle-to-Cradle: Remaking the way we make things. North Point Press, New York

Meadows DH, Meadows DL, Randers J, Behrens WW (1972) The limits to growth. A report for the Club of Rome project on the predicament of mankind. Universe, New York

Ministerie van Verkeer en Waterstaat (1998) 4ᵉ Nota Waterhuishouding. Ministerie van Verkeer en Waterstaat, Den Haag

Mitsch WJ, Gosselink JG (2007) Wetlands. Wiley, New York

Mitsch WJ, Jørgensen SE (1989) Ecological engineering: An introduction to ecotechnology. Wiley, New York

Mitsch WJ, Jørgensen SE (2004) Ecological engineering and ecosystem restoration. Wiley, Hoboken

Naiman RJ, Décamps H, Fournier F (1989) The role of land/inland water ecotones in landscape management and restoration; a proposal for collaborative research. Unesco, Paris

Newman P (1975) An ecological model for city structure and development. Ehistics 239:258–265

Odum EP (1969) The strategy of ecosystem development. Science 164:262–270

Odum EP (1971) Fundamentals of ecology. Saunders, Philadelphia

Odum HT (1983) Systems ecology. Wiley, New York

Odum EP (1989) Ecology and our endangered life-support systems. Sinauer Ass. Inc, Sunderland

Odum HT, Odum EC (1978) Energy systems module for teaching biology. Handout for short course in energy systems in Athens. Wiley, New York

Ottelé M (2011) The green building envelope. Vertical greening. Thesis TU Delft

Pahl-Wostl CL (2000) Ecosystems as dynamic networks. In: Jørgensen SE, Mueller F (eds.) Handbook of ecosystem theories and management. Lewis Publishers, Boca Raton, pp 317–344

Peck S (1998) Planning for biodiversity: issues and examples. Island Press, Washington, DC

Rees W, Wackernagel M (1996) Urban ecology footprints. Why cities cannot be sustainable – and why they are key to sustainability. Environ Impact Assess Rev 16:223–248

Remmelzwaal A, Vroon J (2000) Werken met water, veerkracht als strategie. RIZA rapport 2000.021, Lelystad

Scheffer M (2009) Critical transitions in nature and society. Princeton University Press, Princeton/Oxford

Sukopp H (1998) Urban ecology – scientific and practical aspects. In: Breuste J, Feldmann H, Uhlman O (eds.) Urban ecology. Springer, Berlin

Sukopp H (2004) Human-caused impact on preserved vegetation. Landsc Urban Plann 68(4):347–355

Tansley AG (1920) The classification of vegetation and the concept of development. J Ecol 8:118–149

Tansley AG (1935) The use and abuse of vegetational concepts and terms. Ecology 16:284–307

Tjallingii S (1996). Ecological conditions. Strategies and structures in environmental planning. Dissertation IBN-DLO, Wageningen

Todd NJ (2005) A safe and sustainable world. The promise of ecological design. Island Press, Washington, DC

Van Bohemen H (2005) Ecological engineering: bridging between ecology and civil engineering. Aeneas Technical Publicers, Boxtel

Van den Dobbelsteen A, van Dorst M, van Timmeren A et al (2009) Introduction. In: van den Dobbelsteen A, van Dorst M, van Timmeren A (eds.) Smart building in a changing climate. Techne Press, Amsterdam

Van der Maarel E (1993) Some remarks on disturbance and its relation to diversity and stability. J Veg Sci 4:733–736

Van der Meijden R (1996) Heukels' Flora van Nederland. Wolters-Noordhoff, Groningen

Van Dobben WH, Lowe-McConnel RH (1975) Unifying concepts in ecology. Pudoc, Wageningen

Van Leeuwen CG (1970) Raum-zeitliche Beziehungen in der Vegetation. In: Tuexen R (ed.) Gesellschaftsmorphologiue. Junk/Den Haag. P, pp 63–69

Van Leeuwen CG (1973) Oecologie en natuurtechniek. Nat Landsc 27:57–67

Van Leeuwen CG (1981) Ecologie en natuurtechniek 1–5. Tijdschrift KNHM 92:61–67,99-106,155-165,255-262,297-306, KNHM, Arnhem

Van Wirdum G (1982) Design for a land-ecological survey of nature protection. In: Perspectives in landscape ecology. Pudoc, Wageningen, pp 245–251

Verboom J, Schotman A, Opdam P, Metz JAJ (1991) European nuthatch metapopulations in a fragmented agricultural landscape. Oikos 61:149–156

von Bertalanffy L (1968) General systems theory: foundation, development, applications. George Braziller Inc, New York

Wackelnagel M, Rees WE (1996) Our ecological foot-print: reducing human impact on the earth. New Society Publishers, Gabriola Island

Waltner-Toews D, Kay J (2005) The evolution of an ecosystem approach: the diamond schematic and an adaptive methodology for ecosystem sustainability and health. Ecol Soc 10(1):38

Ward P (2009) The medea hypothesis. Is life on earth ultimately self-destructive? Princeton University Press, Princeton

Westhoff V (1956) De verarming van de flora en vegetatie. In: Vijftig jaar natuurbescherming in Nederland. Natuurmonumenten, Amsterdam

Wilcox BA (1982) In situ conservation of genetic resources. In: Proceedings World Congress National Parks. Washington Smithsonia Institution Press, Bali, pp 639–647

Wortmann EJSA (2005) De Zonneterp: een grootschalig zonproject. InnovatieNetwerk Groene Ruimte en Agracluster, Utrecht

Yeang K (1999) The green skyscraper: the basis for designing sustainable intensive buildings. Prestel, Munich

Chapter 3
Urban Ecology, Scale and Identity

Taeke M. De Jong

Abstract This chapter takes identity (difference from the rest and continuity in itself) as a common ground for human and ecological urban development. Compared with the previous chapter, the attention shifts from the systems to their boundaries. Any difference becomes visible at the boundaries and culminates in spatially sudden or gradually changing ecological conditions. Therefore, this chapter removes the negative sound of 'boundary' as a separation, showing the landscape boundary as a very source of biodiversity. And the urban landscape is boundary-rich. However, to be successful, the concept of identity requires further scale-articulation. So, this chapter also stresses the scale-paradox of diversity: conclusions drawn from one level of scale could already turn into their opposite at a factor 3 scale difference. That forces design, science and policy to distinguish more legend units, variables and agendas than they are used to. It reduces the ease of scientific and governmental generalisation, but it results in an optimistic view on urban life and living. This chapter takes the Netherlands – a small and densely populated country in north-western Europe – as a reference, because of its boundary-richness and its availability of data about a millennium of civil engineering and urbanisation. Its nature of a river delta offers interesting points of departure to study other deltas in the world. Everywhere, deltas are increasingly populated and urbanised, often comparable to different stages of Dutch history.

3.1 Introduction

3.1.1 Dutch Reference as a Starting Point

In this chapter, the Netherlands is a reference because of its (often artificial) boundary-richness and its availability of data. From mediaeval times onwards, the Netherlands has been a largely artificial and urbanised low peat and clay area

T.M. De Jong (✉)
Delft University of Technology, Delft, The Netherlands
e-mail: T.M.deJong@tudelft.nl

E. van Bueren et al. (eds.), *Sustainable Urban Environments: An Ecosystem Approach*,
DOI 10.1007/978-94-007-1294-2_3, © Springer Science+Business Media B.V. 2012

gradually changing into the eastern sandy higher parts more similar to the rest of
Europe. It caused an interesting natural and scientific diversity. The part of it
below sea level is artificial thanks to a millennium of increasingly smart civil
engineering, resulting in a biodiversity one would not expect from human impact.
So, the Dutch urban ecology allows some optimism in a mainly depressing image
of human impact on global biodiversity. The biodiversity and its development of
any Dutch km^2 is well documented. Maps and data are available about govern-
mental, managerial, cultural, economic, technical and spatial developments for a
long period of time at many levels of scale. That permits comparison with other
increasingly populated delta areas in the world at different stages of development.
It shows the potentials of an extended boundary between land and sea and of
boundaries in general.

3.1.1.1 Human Dominance

An urban area is dominated by the human species. So, its ecology, 'the science
of distribution and abundance of species' (Andrewartha 1961, Begon et al.
2006), should start with the dispersion and density of people and their arte-
facts. These artefacts (buildings, roads, canals, 'selectors' always combining
different kinds of separation or connection) accommodate not only people
but also a surprising amount of other species adapting to the variety of shel-
tering or supplying conditions. Some species accept or even welcome human
presence like step vegetation (for example, greater plantain), mosquitos or
sparrows.

3.1.1.2 Intensity of Use

Taking time into account, on average, 1 m^2 in the Netherlands is used by humans
only 4 h of the 8,760 h in a year. The intensity of the human use of urban space is
also remarkably low. Based on figures about time use and land use in the
Netherlands 20 years ago, I estimated intensity to be highest in shops (135 h/
m^2 per year), followed by offices, social-cultural facilities, schools and homes
(homes, together with their gardens, count 48 h/m^2 per year). If you divide the
time spent in public paved space by its surface in the Netherlands, on average it
comes down to meeting a human on the road during a minute four times an hour.
Most people live in suburban areas and most people are at home, in particular the
youngest and the elderly. We are not aware of that quiet emptiness of public space,
mainly caused by the large surface of quiet suburban areas, because we visit pri-
marily busy places during busy periods. Some places like industrial estates, yards
or roadside verges are even not accessible for the public. So, these places and the
other hours of the year may be available for other species depending on the condi-
tions the human species leaves them by design.

::: Floron biobase until1999
::: Observations local KNNV until 2001
 . 10 wild plant species

Fig. 3.1 Number of plant species per km² found in the new town Zoetermeer

3.1.1.3 The Urban Treasury

The awareness of urban nature is considerably stimulated by local associations for nature study, present in nearly every Dutch municipality, often divided into specialised working groups studying birds, butterflies, plants and so on. Some of them count species per km² every year (see Fig. 3.1, Jong and Vos 2000).

They report the gains and losses of their city with remarkable results. Figure 3.1 shows a map with the number of wild plant species in public spaces counted in any km² of the town of Zoetermeer (near The Hague) until 2001. Many of them are rare in the Netherlands and the central square kilometres count more species than do many Dutch natural reserves, and many more than the surrounding countryside does (e.g. 350 species/km²). This kind of observation gradually reverses the idea of the city as the wrongdoer. A concentration of humans is an ecological advantage, even if it locally results in high rise buildings and completely paved surfaces.

3.2 Ecologies

3.2.1 Different Paradigms

Jong (2002, not related to the author) describes in her thesis the strikingly separated Dutch development of different paradigms in ecology during the twentieth century. The clearest controversy appears between the 'holistic-vitalistic' synecology (studying communities, the biotic relations of different species together, the basis of current Dutch nature preservation policy) and the 'dynamic' systems ecology (counting inputs and outputs at a clearly defined system boundary, mainly stressing abiotic conditions as elaborated in the previous chapter). Synecology has a continental origin (Braun-Blanquet 1964), whereas systems ecology is more related to an Anglo-Saxon approach (Odum 1971).

 That controversy also represents a beautiful example of spatial differentiation causing scientific diversity of paradigms in a small country. Synecology primarily developed at the Catholic University of Nijmegen (Westhoff in the 1960s and 1970s) extending to the Wageningen University of Agriculture (mainly studying one species and its requirements at a time: 'autecology') in the higher east of The Netherlands. 'System dynamic' ecology originated from the University of Leiden (Baas Becking in the 1930s) in the lower, very artificial wet west area, a product of civil engineering during many centuries.

3.2.2 Six Kinds of Ecology

This chapter chooses a position in between synecology and system dynamics ecology. There, a typical Dutch 'cybernetic ecology' can be located (emphasising spatial and temporal variation at boundaries). Its emphasis on boundaries fits best in the vocabulary of urban designers and urban ecology. But, in practice, you can meet still other paradigms. Table 3.1 shows them in a sequence of a decreasing human-centred approach. In that sequence, environmental science (emphasising human society and health) appears at the top and 'chaos ecology' (stressing unpredictability from minor initial physical events) at the bottom. Any of these ecologies uses its own concepts to distinguish abiotic components from biotic ones.

 In a perspective of urban ecology, it is important to understand the differences to avoid the debates that paralysed thinking about nature conservation in the Netherlands for years. This book chooses system dynamics as a starting point. However, nature conservation in The Netherlands is primarily founded on synecological principles indicating target species and target communities. This chapter shifts from both sides into cybernetic ecology. It stresses conditional thinking rather than causal thinking (see below) as a principle of steering biodiversity.

Table 3.1 Six ecologies and their key concepts

	Concepts used for	
	Abiotics	Biotics
Environmental science	Environment	Human society
Autecology	Habitat	Population
Synecology	Biotope	Life community
Cybernetic ecology	Abiotic variation	Biotic variation
System dynamics ecology	Ecotope	Ecological group
Chaos ecology	Opportunities	Individual strategies for survival

3.2.3 Causal and Conditional Thinking

A house (in Greek: oikos) does not cause a household. It makes many households possible. It is not a machine with a predictable product, a result of operational engineering. Environmental design does not cause activity, it conditions free choice for future generations. And diversity is a first condition for choice. The (landscape) architect or urban designer has to shape new (unpredictable) possibilities. Empirical science clarifies existing truth or probability by unveiling returning apparently causal relationships, repetition within the confusing diversity of nature. That is another mode of thinking. Within that frame, a designer is a liar, drawing non-existing or at least not probable objects (otherwise designs were mere predictions). However, they may be possible. But how to explore possibility beyond scientific probability? Freedom of choice for future generations cannot be planned with the well-known targets of preceding generations alone. It should be conditioned by diversity, new possibilities from which the future course of history can select.

3.2.4 Diversity, a Risk Cover for Life

And that is what ecology needs as well. Diversity has proven to be a risk cover for life. In its evolution, life survived any catastrophe because there was always a species or specimen able to adapt to the new circumstances. So, decreasing biodiversity increases risk. Apart from the operational (necessarily causal) approach, ecology needs conditional thinking: 'Could you imagine A without B and not the reverse? Then you have to start with A'. You should not build a house starting at its ridge. You should start with its foundations as a first condition for the possibility of a house and the possibility of a household.

3.2.5 Vegetation as a First Condition

I cannot imagine animals without vegetation. The reverse I can. So, this chapter focuses primarily on the urban vegetation as the foundation of the food pyramid.

The vegetation selects insects and other animals, feeding birds and predators in an often unpredictable way. After all, that is what we appreciate in nature: the absence of human everyday time schedules and planning, unpredictable surprise embedded in timeless recognition.

3.2.6 Nature Outdating Targets

However, until now, the Dutch conservation strategy is planning nature by conserving target species and target communities (the biotic relationships of different species together rather than their abiotic conditions). These communities are listed in policy papers, and local conservationists are held responsible for their presence. But conservation of what we know so well, what we expect, is now overtaken by global warming. Cities do already have a warmer climate and they seem to be the precursors and seed banks of our unpredictable future nature.

3.2.7 Conditions for Possible Nature by Diversity

The longer I studied ecology because of my assignment in a department of urbanism, the more I became convinced we still know very little about nature. No ecologist has predicted the emergence of one of the important Dutch natural reserves, the Oostvaardersplassen, an area in a polder reclaimed from the sea after the Second World War, planned as an industrial estate. Unexpectedly, it became an important refuge for European birds in the large freshwater 'IJsselmeer' area after separation from the sea by a dike ('Afsluitdijk') in the 1930s. However, environmental measures between 1970 and 1990 reduced the amount of phosphates in the IJsselmeer area, reducing the food supply for several bird species of European importance. That still has to be explained to experts at other levels of scale, protecting rareness at that level. If we cannot predict ecological developments, then diversity is the best strategy. Diversity has always been the risk cover of evolution. So, we should shape possibilities by conditions for any kind of diversity, different at different levels of scale.

3.3 Urban Ecology Including the Human Species and Its Artefacts

3.3.1 A Dutch Reference

The most comprehensive Dutch textbook on urban ecology until now (Zoest and Melchers 2006) is called *Leven in de stad* (Life in the city). This standard work discusses and combines an overwhelming number of 500 international references.

Fig. 3.2 Number of species and landscape heterogeneity in West Flanders

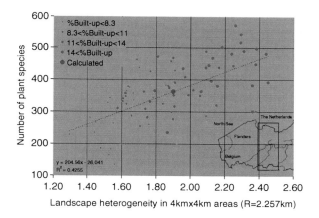

As far as I know, for the first time it fully includes human life and health, paying extensive attention to the urban history and the policy of green areas within cities. An English summary (Zoest 2007) covering a small part of that impressive work in the Dutch language has been published in a book entitled *Landscape ecology in the Dutch context; nature, town and infrastructure* (Jong et al. 2007). A German peer reading the many contributions of authors in the section 'town' missed important German references. So, due to language barriers, this view on urban ecology may still be limited mainly to sources in the English language.

3.3.2 Landscape Heterogeneity

One of the many studies cited by Zoest (Honnay et al. 2002) triggered me in particular, and I elaborated the accompanying graph (represented as Fig. 3.2 into Fig. 3.3) relating the number of plant species to the number of land uses per surface unit (landscape heterogeneity).

Along a rural–urban line in the Phoenix metropolitan area (Jenerette and Wu 2001; Luck and Wu 2002) something similar was studied, but Honnay related the heterogeneity directly to the number of plant species. However, landscape heterogeneity is very dependent on the scale and the chosen categorisation of land use. But Honnay's graph tells more than a very global relationship in Fig. 3.2 ($R^2 = 4.2$).

It distinguishes the data in four classes of %built-up area, well known in urban design as GSI (Ground Space Index). So, I took the average heterogeneity (whatever that may mean) at the middle of each class relating it to the clear category of %built-up area see Fig. 3.3). Four known points in a graph may be a poor evidence to prove that a built-up area offers positive diversity conditions to vegetation comparable with green areas with little built-up area, but it fits well in the observations of Fig. 3.1. So, it is worth the effort to further investigate that relationship. It may offer another view on urban fragmentation.

Fig. 3.3 Landscape
heterogeneity and %built-up,
adapted from Fig. 3.2

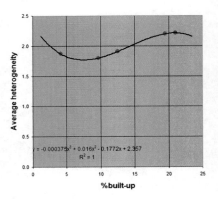

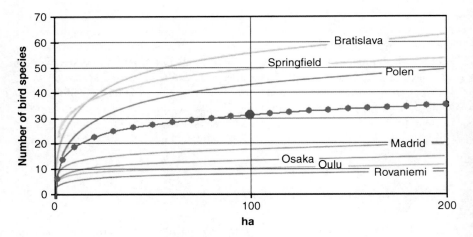

Fig. 3.4 Island theory predicting the number of birds in urban parks by size

3.3.3 Urban Fragmentation

Urban fragmentation of the land into smaller patches is usually associated with poor
ecological conditions based on island theory (MacArthur and Wilson 1967). That
theory states that larger islands count more species according to a logarithmic rela-
tion such as $y(x) = a0 + a1 \cdot \ln(x)$ where x is the surface and y the number of species.
In Fig. 3.4, based on Fernandez-Juricic and Jokimaki (2001), an example is given of
an increasing number of bird species in urban parks all over Europe increasing by
their surface according to that relationship.

3.3.4 Urban Diversity

However, the parameters $a0$ and $a1$ are very different at different locations, for example resulting in a prediction for the same 100-ha park of more than 50 birds in Bratislava and less than 10 in Rovaniemi (see Fig. 3.4). These very determining and variable parameters are dependent on many local factors difficult to generalise, such as the diversity and variation in time of water supply, soil characteristics, exposure to sunlight, management and so on.

In contrast to larger animals, plants and many insects do not need large feeding areas, so they are less hindered by roads surrounding urban or rural 'islands' (see, for example, Zapparoli 1997). Their diversity primarily depends on the local diversity of physical conditions. It may be probable that this kind of physical diversity will increase by surface, but that is not self-evident. If physical conditions are the same everywhere, a larger surface will not increase the number of plant species. Even very locally, urban areas offer different living conditions and that physical diversity can be influenced by design and maintenance.

3.3.5 The Ecological Value of Boundaries

So, perhaps a more practical approach stresses the positive effect of these kinds of diversity, in particular at boundaries separating homogeneous areas (see Jong (2007): 'Connecting is easy, separating is difficult'). Homogeneous areas are easier to categorise ecologically and in terms of policy than their boundaries, where many environmental characteristics change at a limited surface from one system into another. And at these very boundaries you will often find rare species. There they can 'choose' the conditions precisely fitting their rare requirements. An urban environment is 'boundary rich' offering many different conditions in which to settle, in particular for plants.

3.3.6 Ecological Tolerance

The principle explained above is clarified in Fig. 3.5. The curve of ecological tolerance relates the chance of survival of a plant species to any environmental variable, for instance the presence of water. In that special case, survival runs between drying out and drowning. Imagine the bottom picture as a slope from high and dry to low and wet. Species A will survive best in its optimum. Therefore, we see flourishing specimens on the optimum line of moisture (A). Higher or lower there are marginally growing specimens of the same species (a). However, the marginal specimens are important for the survival of the species as a whole.

Fig. 3.5 Ecological tolerance
in theory and reality

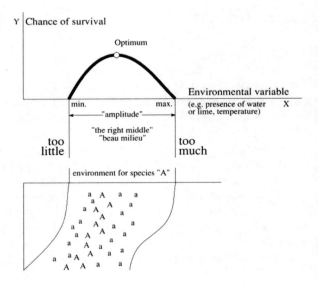

Suppose, for instance, long-lasting showers: the lower, too wet standing marginal specimens die, the flourishing specimens become marginal, but the high and dry standing specimens start to flourish! Long-lasting dry weather results in the same in a reversed sense. Levelling the surface and water-supply for agricultural purposes in favour of one useful species means loss of other species and an increased risk for the remaining.

3.4 Scale and Size: Technically, Scientifically, Administratively

3.4.1 Temporal Levels of Scale

The change of urban landscapes at different time scales (see Table 3.2) cannot be understood without a selective study of human dynamics as the primary driving force behind it at different levels of temporal scale.

3.4.2 Spatial Levels of Scale: Frame and Grain

Apart from these time scales, this section focuses in particular on spatial scales to find a sound structure of the discipline. The scale of a drawing can be named simply by a nominal radius R from the range {…1, 3, 10, 30 m …} globally encompassing the drawing as a whole (frame) in reality, and the smallest drawn detail (grain), named by a nominal radius r from the same range. The distance between frame and

Table 3.2 Urban dynamics on different time scales

Within last:	Changes in urban areas
Millennium	Mediaeval, industrial, modern towns
Century	Economic development
Decade	Groundworks, building activities
Year	Seasons
Month	Migrations, flowering periods, trade
Week	Alternating work and weekend
Day	Intensity of use, transport
Hour	Sunlight and precipitation
Minute	Human activity

Table 3.3 Operational variation per level of scale

Operational variety conditions for vegetation	In a radius of approximately
Elevation, soil	30 km
Soil, water management	10 km
Seepage, drainage, water level, urban opening up	3 km
Urban lay-out	1 km
Allotment (dispersion of greenery)	300 m
Pavement, treading, pet manuring, minerals	100 m
Difference in height, mowing, disturbance	30 m
Solar exposition, elevation	10 m

The radius should be interpreted elastically between adjacent radiuses.
The last four levels of scale hide from the usual view of observations per km^2.

grain determines the resolution of the drawing. If that distance is small, designers speak about a sketch, and if it is large, about a blueprint. However, any verbal argument has to be as precise about scale to avoid drawing conclusions at another level of scale than the argument is valid. Any level of scale (combination of frame and grain) presupposes a specific legend, a specific vocabulary of the drawing and consequently technically, scientifically, and from a viewpoint of government and management, a different approach with scale sensitive categories and variables.

3.4.3 The Technical Relevance of Scale

The level of scale is technically relevant. For example, if you aim for diversity in vegetation on different levels of scale, at every level of scale there are different technical means at your disposal (see Table 3.3). However, what causes diversity at one level may cause homogeneity at another level of scale (scale paradox; see Fig. 3.6). Here, the rule you cannot extend conclusions from one level of scale into another without concern is demonstrated most strictly.

Studying 'states of dispersion' of species and artefacts at different levels of scale in the same time systematically (see Jong and Paasman 1998), you can compare designs (proposed form, dispersion of matter) mutually, such as variants $R = 100$ km

Fig. 3.6 Scale paradox

scope

'difference'

'equality'

for the Dutch Randstad (Jong and Achterberg 1996) or judge local spatial visions $R = 10$ km ecologically based on rareness expressed in kilometers and replaceability in years (method of Joosten and Noorden 1992, applied in Jong 2001; Fig. 3.7).

3.4.4 The Scientific Relevance of Scale

The level of scale is scientifically relevant to avoid drawing conclusions at another level of scale than for which the argument is valid. For example, the frame and grain of biotic and abiotic categories are different at different levels of scale. All kinds of ecology (microbiology, biology, autecology, chaos ecology, systems ecology, syn-ecology, landscape ecology, environmental science) are useful if arranged to the scale of their most appropriate application.

So, microbiology applies on levels of scale and size measurable in micrometers. Chaos ecology stressing individual opportunities and survival strategies or biology stressing cooperation and competition of specialised functions (organisms or organs) apply on levels measurable in millimetres, and so on. Table 3.4 shows my prelimi-nary distinction of levels of scale and ecologies supposed to be most appropriate on each level of scale. However, that does not mean these ecologies always have to limit themselves to their primary level of scale as presented.

But, at the level of the earth (let us say 10,000 km 'nominal' radius), we certainly have to consider other categories, variables and legend units than at the level of a grain of sand (let us say 1 mm nominal radius). The ecological categories or legend units for the earth as a whole are called 'biomes'. They are mainly based on classes of different year averages of temperature and precipitation. Within biomes, at a continental level, we may recognise areas of vegetation, mainly based on altitude

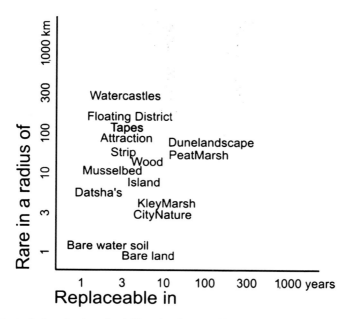

Fig. 3.7 Ecological evaluation of neighbourhoods named by designers ($r = 300$ m) according to the method of Joosten and Noorden (1992)

Table 3.4 Ecologies arranged to their primary supposed range of scale (based Jong 2002)

Nominal	Abiotic	Biotic	Ecology
Kilometres radius			
10,000	Earth	Biomes	Environmental
1,000	Continent	Areas of vegetation	ecology
100	Geomorphological unit	Plant-geographical or flora-districts	Landscape ecology
10	Landscape	Formations	
Metres			
1,000	Hydrological unit, biotope	Communities	Synecology
100	Soil complex, ecotope	Ecological groups	System dynamic
10	Soil unit and transition	Symbiosis	Cybernetic
Millimetres			
1,000	Soil structure and ~ profile	Individual survival strategies	Chaos ecology
100	Coarse gravel	Specialisation	Autecology
10	Gravel	Integration	Biology
1	Coarse sand 0.21–2	Differentiation	
Micrometres (µ)			
100	Fine sand 50–210	Multi-celled organisms	Microbiology
10	Silt 2–50	Single-celled organisms	
1	Clay parts < 2	Bacteria	
0,1	Molecule	Virus	

and soil moisture. Within these areas of vegetation – at a national level – we may distinguish plant-geographical districts or flora-districts and within these – at a regional level – landscape formations and so on. Different categorisations result in different kinds of ecology, and different, often controversial, paradigms. However, looking at Fig. 3.6, many of these controversies are not necessary if we are more precise about the range of scale where our conclusions are valid (scale-articulation). And between the earth and a grain of sand there are ten decimals!

3.4.5 The Governmental and Managerial Relevance of Scale

The level of scale is administratively relevant. From a viewpoint of local government, according to Table 3.3, a municipality could focus its policy on a specific scale of rareness and replaceability (identity). For example, focusing on global ($R = 10,000$ km), European ($R = 3,000$ km, tables of flora- and fauna legislation), national ($R = 300$ km, Dutch 'Red List' species), provincial ($R = 100$ km), regional ($R = 30$ km) or local ($R = 10$ km) rareness are different policies. Large cities could focus on global identity, small ones on a regional identity. To value their nature, they have to add replaceability as a criterion. Early-successional vegetation needs less time to recover than mature vegetation such as forests. So, 'replaceability' could be expressed in years like 'rareness' is expressed in kilometers. These temporal and spatial measures could be applied to human artefacts as well. How much time does it take to build a mature airport and in which radius is there an airport with the same competence? So, these measures may help in balancing natural and cultural interests.

3.4.6 Changing Paradigms in Policy

Ecology has played an important role in Dutch spatial planning since the 1960s. After the introduction in spatial planning of systems ecology (Baas Becking 1934, in Leiden; Odum 1971, in the U.S.) stressing sequences of succession, an emphasis on their boundaries emerged and on species-rich gradients between systems (*cybernetic ecology*; Van Leeuwen 1964, in Delft), still particularly popular amongst designers. These paradigms were based on characteristics of an abiotic context and the species-rich transitions at their boundaries.

 Then, the national task of nature conservation was transmitted into the Ministry of Agriculture stressing synecology (Braun Blanquet 1964; Westhoff and Van den Held 1969). That paradigm emphasised synergy of species in plant communities and accompanying fauna. After all, on equal subsoils, different accidental successions, caused by different incidental histories, could be observed. So, some 100 typically Dutch communities were identified for protection (Bal et al. 2001). Connection of fragmented communities in favour of animal populations requiring a larger surface became an issue ('ecological infrastructure'). Current Dutch nature conservation policy still has a synecological character. According to Table 3.4, it is

Table 3.5 The levels of scale in Dutch synecological nature conservation policy (based on Bal et al. 1995)

	Policy 1	Policy 2	Policy 3	Policy 4
Name	Almost naturally	Supervised naturally	Half-naturally	Multifunctional
Radius	3 km	1 km	300 m	100 m
Strategy				
Surface	Landscape thousands of ha	Landscape >500 ha	Ecotope/mosaic to approx. 100 ha	Ecotope mostly a few ha
Directing variables	None	Process-focused on landscape level	Process- and pattern-focused up to ecotope level	Process- and especially pattern-focused up to ecotope level

most appropriate to areas of approximately 1 km radius, but it claims to offer tools of nature conservation at 3 km, 300 m and 100 m as well (see Table 3.5). Now, the public appeal of caressing animal species and the European emphasis on protecting each rare species separately shifts scientific attention into autecology, the ecology of populations per species, naturally belonging to the attention of the University of Agriculture in Wageningen.

So, as we indicated earlier, there seems to be a 'ecology of paradigms' as well. The first paradigms based on an abiotic context were mainly studied at universities in the lower western part of the country (Leiden extending into Delft), the last in the higher eastern part (Nijmegen extending into Wageningen). However, scale articulation could divide their tasks instead of opposing them. That brings me into the question of identity, introducing the interests of human species.

3.5 Identity: Difference from the Rest, Continuity in Itself

3.5.1 Connecting Ecological and Human Interests

To connect ecological interests with human interests, I am increasingly interested by the concept of identity (Jong 2007). That concept plays a remarkable and probably increasing role in the political, cultural, and economic debate and in design at different levels of scale. However, its meaning is not always properly defined. So, I choose: 'difference from the rest and continuity in itself'. That definition has the same temporal and spatial roots of 'descent and origin' or 'name and address' as the police officer summarises them if asking for your 'identity'.

3.5.2 Again at Every Level of Scale Anew

Even the concept of identity is scale-dependent. What is typical for Europe, for a nation within Europe, a region within a nation, a town, a neighbourhood? The parts

of a neighbourhood need to have something in common, and those characteristics have to be different from 'the rest'. That is the impact of the scale paradox: internal homogeneity can be combined with external heterogeneity. However, the reverse is possible as well: internal heterogeneity combined with external homogeneity: the paradox of the 'homogeneous mixture' (Fig. 3.6), an impact of globalisation. So, the scale paradox also shows directions of view. Identity covers the first direction, mixture the second. From thermodynamics, we learn the second is most probable in physics. From architecture, we learn the view from inside outwards is very different from the view from outside inwards. A ball is concave in the first view, but convex in the second.

3.5.3 Different Variables to Determine Identity at Different Levels of Scale

The identity of a town should not be hampered by an extravagant diversity of its neighbourhoods. These have to be different to get their own identity, but they should also have something in common to make the town recognisable as a town. That paradox is solved by choosing different variables to determine identities at different levels of scale (for example Table 3.3). To start at the foundations, ecology can offer designers, planners, politicians many legends, categories and agendas at any level of scale. Globally, the differences of temperature and precipitation are given, determining 'biomes'. They only have to be protected and utilised for governmental, cultural, economic, technical, ecological and spatial differentiation or specialisation. And not in a deterministic causal sense, but in a conditional one, increasing the freedom of choice for future generations. Continentally, there are different areas of vegetation, nationally there are different geomorphological units, regionally there are different landscape formations, and so on (see Table 3.4), to finally reach unexchangeable genius loci at any location. If we continue that inference by design effort, any place on earth can be different from any other place. That uniqueness will force us to travel less into ever more distant destinations that our holidays require to escape boredom.

3.5.4 Beauty

Beauty or image quality is a dynamic balance between recognition and surprise. That is shown in Fig. 3.8 replacing the abscissa of the ecological tolerance in Fig. 3.5 by variety and the ordinate by image quality. Variety combines the concepts of difference and change, determining identity.

Too much difference or change results in an impression of chaos, overloading our senses and sense. Too little variety results in an impression of monotony

Fig. 3.8 Quality as a working of variety

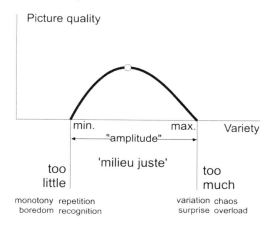

and boredom. The neural system we inherited from evolution may have kept some of its unconscious ecological wisdom not to overdo in one or the other direction, but to keep the middle (milieu) to experience beauty. How to make use of that capacity, eroded by the urge of equalising production since the Neolithic revolution? That revolution is less than 1% away from the time we started to evolve as humans.

3.5.5 What Is the Difference?

The identity of an area is recognisable by its difference with the rest and continuity in itself. Identity seems to be important for government or management, for culture, economy, technology and ecology. For example, the investor will ask 'Why invest just here?' To make every place unique, getting its own role within the urban, regional or global composition, the next questions should be answered:

* What is the difference with other regions? (30 km radius)
* What is the difference with other conurbations? (10 km)
* What is the difference with other townships? (3 km)
* What is the difference with other districts? (1 km)
* What is the difference with other neighbourhoods? (300 m)
* What is the difference with other ensembles? (100 m)

If an area succeeds in finding appropriate different variables on every level of scale to rule its human impact by civil engineering and architecture, biodiversity will follow, be it often in an unexpected way.

3.6 Conclusion

Human activity can be a useful condition of physical diversity if it does not result
in uniformity or chaos. In the Netherlands, urban areas sometimes appeared to
count more species than their agricultural and sometimes even natural surround-
ings. Based on managerial, cultural, economic, technical, demographic and spatial
diversity, differences in local identity emerge. That identity should in the main
slightly change walking through the area to keep recognition and orientation. Small
contrasts every 300 m, larger ones every 1,000 m introduce welcome surprise, but
too much contrast will cause the impression of chaos. If that sensory balance for
people is reached by design at any level of scale, any place on earth will be differ-
ent from every other place. And, that is the best opportunity for biodiversity humans
can offer the planet.

Questions

1. How could 'identity' be defined to be useful in design questions?
2. Which kinds of ecological paradigms can you distinguish?
3. What is 'island theory'? Summarise some points of critique.
4. What is 'ecological tolerance' and which conclusions can you draw in terms
 of risk?
5. Why is the spatial level of scale relevant scientifically, technically and in terms
 of policy?

References

Andrewartha HG (1961) Introduction to the study of animal populations. University of Chicago
 Press, Chicago
Baas Becking LGM (1934) Geobiologie of inleiding tot de milieukunde W.P. van Stockum&Zoon
 N.V., Den Haag
Bal D, Beije HM, Hoogeveen YR, Jansen SRJ, Reest PJvd (1995) Handboek natuurdoeltypen in
 Nederland. IKC Natuurbeheer, Wageningen
Bal D, Beije HM, Fellinger M, Haveman R, Opstal AJFMv, Zadelhoff FJv (2001) Handboek
 natuurdoeltypen. Ministerie van Landbouw, Natuurbeheer en Visserij, Wageningen
Begon M, Harper JL, Townsend CR (2006) Ecology; from individuals to ecosystems. Blackwell
 Science, Oxford
Braun-Blanquet J (1964) Pflanzensoziologie. Springer, Wien
Fernandez-Juricic E, Jokimaki J (2001) A habitat island approach to conserving birds in urban
 landscapes: case studies from southern and northern Europe. Biodivers Conserv 10:2023–2043
Honnay O et al (2002) Satellite based land use and landscape complexity indices as predictors for
 regional plant species diversity. Landscape Urban Plann 969:1–10
Jenerette GD, Wu J (2001) Analysis and simulation of land-use change in the central Arizona - Phoenix
 region, USA. Landscape Ecol 16(7):611–626

Jong TMd (2001) Ecologische toetsing van drie visies op Almere Pampus. Stichting MESO, Zoetermeer

Jong TMd (2007) Connecting is easy, separating is difficult. In: Jong TMd, Dekker JNM

Jong TMd (2002) Scheidslijnen in het denken over Natuurbeheer in Nederland. Een genealogie van vier ecologische theorieen. DUP Science, Delft

Jong TMd, Achterberg J (1996) Het Metropolitane Debat. 25 Varianten voor 1mln inwoners. Stichting MESO, Zoetermeer

Jong TMd, Paasman M (1998) Het Metropolitane Debat. Een vocabulaire voor besluitvorming over de kaart van Nederland. Stichting Milieu en stedelijke ontwikkeling (MESO), Zoetermeer

Jong TMd, Vos J (eds.) (2000) Kwartaalbericht KNNV Zoetermeer 21–30. KNNV Zoetermeer, Zoetermeer

Jong TMd, Dekker JNM, Posthoorn R (eds.) (2007) Landscape ecology in the Dutch context: nature, town and infrastructure. KNNV-uitgeverij, Zeist

Joosten JHJ, Noorden BPM (1992) De Groote Peel: leren waarderen. Een oefening in het waarderen van natuurelementen ten behoeve van het natuurbehoud. Natuurhistorisch maandblad 81:203 e.v–222

Leeuwen CG van (1964) The open- and closed theory as a possible contribution to cybernetics Rijksinstituut voor Natuurbeheer, Leersum

Luck M, Wu J (2002) A gradient analysis of urban landscape pattern: a case study from the phoenix metropolitan region, Arizona, USA. Landscape Ecol 17(4):327–339

McArthur RH, Wilson EO (1967) The theory of island biogeography. Princeton University Press, Princeton

Odum EP (1971) Fundamentals of ecology. W.B. Saunders Co., Philadelphia/London/Toronto

Westhoff V, den Held AJ (1969) Plantengemeenschappen in Nederland. Thieme, Zutphen

Zapparoli M (1997) Urban development and insect biodiversity of the Rome area. Italy Landscape Urban Plann 38:77–86

Zoest JV (2007) Driving forces in urban ecology. In: Jong TMd, Dekker JNM, Posthoorn R (eds.) Landscape ecology in the Dutch context: nature, town and infrastructure. KNNV-uitgeverij, Zeist

Zoest JV, Melchers M (2006) Leven in de stad; betekenis en toepassing van natuur in de stedelijke omgeving KNNV, Utrecht

Chapter 4
Water Flows and Urban Planning

Sybrand Tjallingii

Abstract This chapter discusses planning strategies for the role of water in making urban development more sustainable. The first part analyses the most relevant flows in urban areas: rainwater, groundwater, river water, drinking water and wastewater. This leads to a focus on 'closing the circle' and 'cascading' as key *guiding principles*. Through the experience of practical projects, these principles generate a toolkit of *guiding models*, conceptual schemes of the structure of operational water systems at different levels of the urban landscape. Here, the first question is how urban design can contribute to sustainable water management. The second question is how water can contribute to sustainable qualities of urban areas. Planning for the interaction between *flows* and *areas* also requires strategies for the *actors* in planning processes. Guiding principles and guiding models are conceived as elements of a common language for the communication between interest groups and different groups of specialists.

4.1 Introduction

Without water there is no life. This chapter discusses urban life and how cities create special conditions for water flows. The central question is how we can make urban water systems more sustainable. This implies that the approach will address the role of water in urban ecosystems and will discuss the issues from a planning, design and management perspective. The first cities were built in river valleys and other places where water was easily available. As cities grow and as urban water use grows, the water demands of many cities tend to approach the limits of the carrying capacity of

S. Tjallingii (✉)
Delft University of Technology – Emeritus, Delft, The Netherlands
e-mail: s.tjallingii@gmail.com

E. van Bueren et al. (eds.), *Sustainable Urban Environments: An Ecosystem Approach*,
DOI 10.1007/978-94-007-1294-2_4, © Springer Science+Business Media B.V. 2012

their regional water resource base and, as a result, questions about sustainable water use are becoming urgent. The questions relate to the role of water in regional eco-systems and the interactions between town and country. But also inside cities, water use and water management raise special questions to be solved. Urban activities may suffer from water scarcity and pollution, but they also create scarcity and pollution. The city may suffer from floods, but the abundant paved surfaces also create peak-flow and flood problems. Climate change does not create completely new issues, but it may considerably increase their scale and urgency. The sea level rise and the higher peaks and deeper troughs in rainwater and river flows create a sense of urgency and put water issues high on political agendas. For urban planners, this implies there is a greater need to develop robust solutions and to integrate water in plans to make cities more attractive and more liveable places. Because water can contribute so much to the visual quality of cities, there is also a great opportunity to combine urban development with healthy and environmentally sound water prac-tice. In this way, water can play a significant role in making cities more sustainable. The city should be good for water, but water can also be good for the city.

The starting point is to understand water flows as water cycles. This is both about water cycles in urban systems and about the role of cities in the greater hydrological cycle. Understanding the cycle will be the basis for a discussion of promising options for sustainable combinations of urban development and water management.

The second section analyses the question of how water flows run through urban systems and how technicians and planners can steer these flows. Water is not only a precious resource of which there can be too little to serve as drinking water or to irrigate the crops that feed urban populations. Often there is too much: rainstorms, erosion and floods may threat the safety of life in cities. A third category of issues is water pollution that may be a main threat to the health of urban residents. Too little, too much and too polluted are not only the threats to be dealt with separately; the complexity of urban and regional water cycles also creates opportunities for integrated water resource management.

Opportunities are also vital to the third section that discusses the area-bound spatial issues. The central question is where water creates opportunities for visible and sustainable combinations with economic and social life in the built environ-ment. Obviously, urban waterfronts and river valleys are focal areas. But the interac-tion between the water cycle and urban development creates opportunities at all levels of spatial planning and design. The discussion leads to guiding models, prom-ising combinations that may guide the planning process from the level of individual houses up to the regional watershed.

The last section briefly discusses the role of actors. Who are the users, who is responsible, who pays, who decides? These questions lead to a discussion of differ-ent strategies for urban water management. Traditionally, the dominant approach is command and control, with a central role for standards and targets. In recent years, a negotiation approach has emerged that emphasises interactive processes between actors. A third approach, which adopted here, focuses on learning and uses guiding models to guide planning processes that include both targets and interaction. Making an urban water system more sustainable requires a process of change that

will be different in every individual situation. Success stories cannot be copied, but we may learn from them and use their lessons to generate guiding models that lead us towards new sustainable urban water stories.

4.2 Flow Issues: Cycles and Cascades

4.2.1 The Urban Water Cycle

'All rivers run into the sea, yet the sea is not full'. There is a curiosity about the waters of the world in this line from the Bible book of Ecclesiastes, presumably an account of the wisdom of King Solomon, and written in the sixth century BC. What happens to the waters? 'Unto the place whither the rivers go, thither they go again'. Apparently, there was already a vague notion of the existence of a water cycle. In the ancient Greek mythology of that age, there was the story of the mysterious island of Atlantis, far away in the ocean. There, the waters were thought to descend, down to the interior of the earth from where they could re-emerge as the sources of the rivers, for example, as the mysterious sources of the Nile that nobody had ever seen. Half a millennium later, the truth about the water cycle dawned on those who were still puzzling. The story goes that the Roman architect Vitruvius sat in his bath and was irritated about the cold drops that fell on his back from the stone ceiling. Suddenly he realised that the hot vapour in the air condensed to water drops on the cold ceiling. The water cycle closes not through the earth but through the air. This is the basis of our scientific understanding of the water cycle, that is currently defined as 'the succession of stages through which water passes from the atmosphere to the earth and returns to the atmosphere: evaporation from the land or sea or inland water, condensation to form clouds, precipitation, accumulation in the soil or in bodies of water, and re-evaporation' (UNESCO 2006).

The oceans evaporate about 10% more water than the rain they receive and this is why the sea is never full and becomes salty. Thus, the regional water cycle (Fig. 4.1) is only a subsystem, linked through inputs and outputs to the full world water cycle. Urban water systems are only a small chain in the regional cycle. Sustainable development is sometimes summarised as 'closing the circle'. In urban water systems, closing the circle is only possible for some issues, such as recycling wastewater to drinking water. For other issues, such as drainage, flood control and erosion prevention, a sustainable approach has to keep an eye on the watershed system and should seek to adapt urban practice to the potential of the watershed context. For the city, this implies exploring the practical options of the guiding principles 'keep water clean and keep it longer', and 'do not shift water problems to downstream neighbours'. Practical options often involve storage and cascading solutions. For most water issues, however, sustainable practice needs to use both strategies: closing circles and cascading flows.

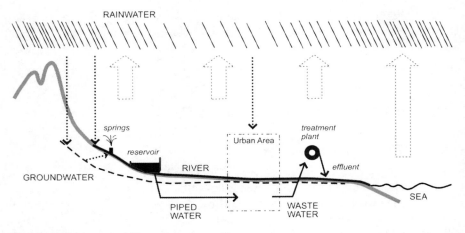

Fig. 4.1 Urban areas and the water cycle

Fig. 4.2 Urban areas and the water balance

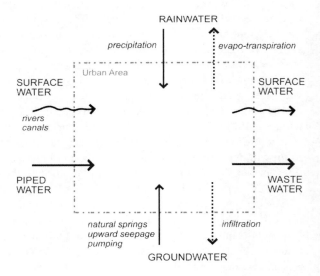

 Figure 4.1 illustrates the origin of the different water flows that run through the city. Figure 4.2 focuses on the urban system itself and indicates the ingoing and outgoing flows. Understanding the specific water balance of the planning situation starts with a detailed analysis of the quantity and quality of these flows. In general terms, they will be discussed in the following paragraphs.

4.2.2 Rainwater: From Down the Drain to First Retain

Rainwater falls on the city and, from roof to river valley, runs through the city. But, as Fig. 4.1 illustrates, rainwater also indirectly reaches the urban environment. Mountains push up the air masses to greater heights where water vapour turns to water drops. In this way, mountain areas generate precipitation that reaches the city as river water or via groundwater, springs and rivers. Thus, even in arid areas, urban life can develop if settlements are not too far from the mountains or are close to rivers or groundwater aquifers. The city is a special environment for rainwater. Typically, in the temperate zone, of the 100% precipitation that falls on a green landscape, approximately 40% evaporates and 50% infiltrates in the soil. Run-off is only 10%. In an almost completely sealed urban landscape, however, up to 85% of the rainfall will become run-off. Evaporation and infiltration are very low. Of course, there are great differences between cities. The overall climate and the proximity to mountains and rivers create a great variety of situations. Moreover, urban density and the design of open spaces create differences that make a difference.

How do cities react to the rain? Rainfall is the primary source of water on earth. Yet, in cities, the role of the rain as a source of water is underestimated. In urban areas with their high percentage of paved surfaces, rainstorms are seen instead as a source of problems. The first priority is preventing floods by realising effective drainage systems. In the humid tropics, where annual rainfall can be up to 10 m (10,000 mm), it is easy to understand that this is the most urgent issue. Yet in arid regions, with an annual rainfall of no more than 0.125 m (125 mm), the rare rainstorms can also be short and heavy and sudden floods can be devastating. However, increasingly cities have started adopting more sustainable technology and design principles such as rainwater harvesting. At the building level, rainwater cisterns storing rainwater from roofs to be used as drinking water are an old tradition in many parts of the world. New projects include mosquito prevention measures and other health precautions. There are, however, many other ways of using rainwater inside buildings, such as cleaning and washing, toilet flushing and watering plants. All these reduce the use of precious drinking water for the same purposes. A promising perspective is using rainwater for cooling buildings by evaporation (Schmidt 2006). At the level of gardens and parks, rainwater from roofs and streets is led to infiltration ditches (*swales*) or to retention ponds. In this way, rainwater can fulfil the water demand of green spaces to a larger extent and contribute to cooling of the urban heat island. In general terms, a more sustainable approach does not neglect the flood protection but shifts the priority principle from 'down the drain' to 'first retain'. Storage is the key issue.

4.2.3 Groundwater: From Pumping to Careful Use and Recharge

Groundwater occurs in different forms: *phreatic* or shallow groundwater is the water body near the surface that is usually in direct contact with surface waters and shows

seasonal fluctuations. In dry periods, the shallow groundwater table falls below the level of adjacent surface waters that slowly replenish the groundwater. In wet periods, the opposite process takes place. This implies that infiltrating rainwater can make the groundwater rise, and this can be an important way of seasonal storage of rainwater in urban areas. The water bodies of deeper layers are called aquifers. Hydro-geological surveys can reveal the nature and capacity of aquifers and their depth between impermeable layers of clays or loams. Replenishment is very slow and often takes decades or more. Water quality in most aquifers is usually good and this makes them an excellent source for drinking water production. Depletion of aquifers is a risk that may go unnoticed because it is invisible. Layers of the earth carry water, but water also carries the earth. Pumping up groundwater from deeper aquifers for drinking water reduces the carrying force of water and as a result land may subside. Groundwater pumping in Mexico City has caused a subsidence of 10 m in parts of the city. The flood problems of Venice also result from pumping groundwater from aquifers deep under the city. But rapid drainage of the soils on the surface of the earth can also cause subsidence. Dewatering and drainage cause subsidence in the wet peat soils that surface in the west Netherlands, leading in turn to excessive groundwater levels, the response to which is to lower the polder water level. A consequence is further subsidence, and a downward spiral. In the past 1,000 years, some parts of this region have subsided 5 m. In cities, the houses are founded on poles resting on deeper and stable sand layers. But streets and green spaces do not have foundations. As a result, public authorities and private landowners in these cities are obliged to pay large sums for raising gardens, parks and streets.

A more sustainable approach of groundwater management is emerging. For the deeper groundwater, the strategy is careful stock management. In some cases, it will be more sustainable to take surface water as a resource for drinking water. For the near surface groundwater with its sinking tables under the paved surfaces of the cities, the sustainable strategy gives priority to groundwater recharge. One option is to replace paved surfaces by hard but permeable pavement. If feasible, infiltration swales in green spaces and roadsides may contribute to groundwater recharge. Building construction may reduce the vulnerability for higher groundwater tables. Floating buildings and roads are among the options. Together, these measures are sometimes called *groundwater-neutral building*. In general terms, a more sustainable approach shifts the priority from pumping-up to careful use and from pumping away problems to groundwater recharge.

4.2.4 River Waters: From Taming the Stream to Space for the River

Rivers are dynamic. In dry periods, they may only use a narrow riverbed, but after the spring snow melt or after heavy rains the full floodplain is used. Natural storage in forest soils, in lakes and swamps, in meandering, and in the soils of river floodplains, slows down the peak flows and creates water bodies that help plants animals

and humans to survive dry periods. River dynamics are also characterised by sedimentation dynamics. If water flows rapidly, gravel and sand particles will stay behind. As the flow slows down, loams and clays are the sediments that create a landscape of natural levees and basins when the valley widens or becomes a delta. The river itself heightens its banks and deposits fertile clays.

Urban use of the river environment is manifold. Mining of gravel sand and clay for brick works produces essential building materials for cities. The ideal place for the early settlements was the high bank of the river, high enough to be safe for most of the floods and close to drinking water. Upstream rivers provided the hydropower for the mills of early industry and downstream towns took advantage of navigable rivers for transport. The ecological impacts are closely related to the efforts to tame river dynamics. Building weirs and locks, cutting meanders and constructing channels turned wild rivers into more reliable navigation routes. Draining or filling swamps and old river arms created more fertile land for market gardens and improved health by removing breeding places for mosquitoes. As cities developed, however, the channelling of streams and reduced storage caused more risks for heavier floods downstream. Water pollution also moved downstream and increasingly created problems. A special case of taming river dynamics is the construction of large dams and reservoirs. Usually, the dam projects are far from the cities. Water supply is taken for granted by the urbanites that do not see any of the related problems. From a water quantity point of view, big reservoirs and dams have the advantage of big storage, although there is also a huge evaporation, especially in arid regions. The problem with big dams is the risk of mistakes in the view of big profits. Their strength lays in combined benefits of the dam's hydropower with irrigation projects and drinking water production. Their weakness is that big dam projects tend to ignore the so-called side effects and there can be many of them: mass migration of poor farmers from the fertile grounds of the flooded valley to unfertile hills; sediment trapping in the new reservoir and as a result silting up of the lake; and water quality problems in dams caused by inundated landscapes and contaminated soils as well as by wastewater discharge and runoff from agricultural areas. This will increase health risks of water-borne diseases such as schistosomiasis (bilharzia). On the other side, discontinued fertile floods downstream may lead to a lack of nutrients for the food chain that is the basis of fishing in the coastal waters where the river runs into the sea. The story of dam construction in the Narmada river valley in India is just one recent example of such experiences (Roy 2002). In the wider floodplains and deltas of the world, it is not attractive to build dams, but here the cumulative effect of all the upstream activities act together. Deforestation, urbanisation with increased paved surfaces, meander shortcuts and channels all contribute to higher risks for higher floods. In most cases, the reaction was to build higher dikes or levees to protect the urban areas. Yet higher dikes also create higher peaks as they force the river into narrow channels. Cities are often bottlenecks with their quays and bridges. Between the dikes, the river sedimentation continues, steadily heightening the riverbed. On the other side of the dike, increased drainage may lead to land subsidence. So the situation becomes more risky with the dikes separating higher river levels and lower lying urbanised areas. This is what happens, for example,

in the Rhine delta in The Netherlands and in the Mississippi delta in New Orleans (Benton-Short and Short 2008: 115).

Learning lessons from these experiences, more sustainable approaches have been developed over the last decades. The big dam stories are an argument for smaller projects within or closer to the urban areas. Such projects will be more visible and may have fewer risks and more time to investigate social, economic and ecological impacts. In the arid zone, for example in African countries, sand dams hold back the rare but powerful flows in wadi rivers, thus using river water for the augmentation of groundwater. A sustainable approach shifts the priority from single big taming-the-river projects to more subtle interaction and space for river dynamics. Devastating floods in many river valleys in all parts of the world have taught the lesson to keep floodplains free of buildings. In cities, this is a difficult message. The city of Curitiba, Brazil has developed a special resettlement program for people who have built their squatter huts in the floodplains. Many historic city centres and also recent urban developments cannot be removed. Here, the strategy is to create new bypasses or spillways for the river to pass bottlenecks. A more sustainable strategy for river management shifts the priority from higher dikes to space for the river.

In some cases, higher dikes or storm surge barriers are indispensable, but in a sustainable approach, resistance to floods is always part of a more comprehensive strategy to work with the forces of nature. This comprehensive strategy is character-ised by resilience. In cities of the deltas, such as New Orleans, Dhaka, Bangladesh, and the Randstad Holland, this implies working with the forces of the sea, the tidal movement, the currents, the winds, and the hurricanes or typhoons. Resilience aims at providing protection by giving space to the sea and to the delta rivers, steering the streams as part of a dynamic approach that includes mounds, building on piles and some dikes, as necessary and appropriate.

4.2.5 Drinking Water: From Shortage and Wastage to Sufficient and Efficient

From the three water flows discussed so far, groundwater is the preferred source of drinking water in most cities. Groundwater is less polluted than river water and pumping up groundwater is often easier than collecting rainwater. Thus, it is easy to understand why it is efficient for drinking water producers to opt for groundwater. In the case of a Third World village where the residents take their drinking water from wells, digging more wells can be a simple and healthy solution. Both in devel-oped and in developing cities, groundwater use for drinking water can be an effi-cient solution. But is it also sustainable? Rapid growth of urban populations leads to increased industrial and domestic water use. Limited aquifer resources and their slow replenishment are leading to sinking groundwater tables in many parts of the world. Groundwater pumping stations are sometimes vulnerable if the source is pol-luted by public or private waste-dumping sites. Being dependant on one single source creates a vulnerable and therefore unsustainable system, thus cities are

looking for more options. Reservoirs that collect rainwater from an upstream catchment area have their own advantages and disadvantages, as discussed in the previous section. Another option is the use of downstream river water. In the western part of the Dutch delta, for example, the deeper groundwater is too salty and drinking water companies take river water as a source. In this case, depletion is not an issue. River water is abundant. But the problematic quality of this source asks for more purification efforts to produce the required quality. In the past decades, the city of Rotterdam embarked upon a long process of talks with upstream cities in Belgium, Germany, France and Switzerland to convince them of the need to reduce their pollution loads discharged to the rivers that are the basis of drinking water for millions of people living downstream. This was not easy and it took a long time, but the positive result significantly contributes to sustainable water resource management. Taking downstream river water as a source for drinking water, therefore, may generate an extra incentive to keep river water clean. It may act as a feedback mechanism for urban and industrial activities to take their responsibility in making water management more sustainable. Thus, the water cycle of use and reuse can be closed.

On the water supply and distribution side, an integrated approach is also essential. This may be illustrated by the case of a West African city that, as with many urban centres in developing countries, attracts huge numbers of people from the surrounding countryside (Schuetze et al. 2008: 27). Most of the immigrants have settled in squatter areas around the old colonial centre. In these squatter districts, a neighbourhood-upgrading programme is going on, that includes several projects: improving huts and houses, improving drainage, improving access to healthy drinking water, and improving sanitation. An assessment of the projects concluded that the new piped water taps ran dry several times per day. As a result, many people returned to the old wells. These were often more contaminated than before because the new pit-latrines contaminated the groundwater close to the wells. Groundwater was also polluted by solid waste thrown into the pits dug for the production of adobe, the sun-baked clay blocks for new houses. Moreover, the new corrugated iron roofs and the new network of street gutters now efficiently remove most of the clean rainwater that used to recharge the groundwater feeding the wells. What we see is a programme of individual projects, each with their own efficiency, well organised in their own domain, but not integrated and therefore vulnerable. One weak link, a predictable frequently failing power supply to the drinking water pumps, makes the whole programme vulnerable.

Central treatment to produce drinking water quality and a complete piped water network of public mains seems to offer complete control over a system that provides full access to healthy drinking water for everybody. The fact that the most developed cities have such systems, however, does not necessarily imply that this is the most water-efficient system in every stage of urbanisation. Piped water networks are also vulnerable. Reliable pumping is one condition. Leakage is another persistent problem. Leakage rates of up to 50% and more are not exceptional. Proper maintenance and quality control are crucial conditions. In some cases, decentralised water supply systems are more efficient and more sustainable. On the other extreme of the centralised–decentralised spectrum of options is roof-top rainwater use. In southern

Australia, 42% of the households use tank rainwater as their main source of drinking water. It is a water-efficient system that is relatively cheap. However, here as well, proper maintenance and quality control are essential (Heyworth et al. 1998).

For a long time, there has been a lively debate going on about centralised versus decentralised systems for water use and wastewater reuse. One item is hardly debatable: reducing water consumption has to start with the users. In the last 10 years, water-saving taps, water-saving showerheads and water-saving toilets have found their way into mainstream practice in many countries. Other water-saving technologies, such as waterless, dry toilets, are at the stage of pilot projects. Saving water is not only a technical issue, however. The lifestyles of the cities in humid temperate climates are often exported to developing countries even in the arid zones: lush English gardens with lawns in desert environments. This may lead to a culture of squandering water in situations of scarcity. Generally, governments cannot prescribe individual citizens how to use water in their private garden. But there are other options. One is metering and pricing water based on the real volumes used. Another option for the local government is giving a good example in public parks and green spaces by demonstrating the use of native vegetation, adapted to dry conditions and rainwater harvesting. The use of water in the daily life of affluent societies sets an example for development. In a sustainable development context, the example of efficiency by the affluent enables sufficiency for the poor. But this is the cultural link. The physical links between sustainable water use and potential water production have to be explored and maintained in every individual catchment basin.

4.2.6 Wastewater and Pollution: From Problems to Prevention

The city of Rome was famous for its first wastewater sewer, the Cloaca Maxima, and for its aqueducts that brought clean water to the city. After that, however, it took almost 2,000 years for the industrialised cities of the world to achieve sanitary sewer and piped water networks and, in doing so, to realise a breakthrough in the health conditions of their citizens. Today, over 25% of the developing world's urban population still lacks adequate sanitation. The United Nations Environmental Programme estimates that improved sanitation alone could reduce related deaths by up to 60% and diarrhoeal episodes by up to 40% (UNEP 2007). Sewers are just one of the options for improved sanitation, but for most cities the sewer system is the central issue. In the course of the nineteenth and twentieth centuries, most sewers originated from stormwater sewers that were improved to also be used as sanitary sewers. In the early days, they just transported stormwater and wastewater to the river or to another receiving waterbody that often became seriously polluted. Later, sewage treatment plants were built, but most old cities still have the mixed sewer system. For the treatment plants, this implies they have to cope with huge quantities of rainwater that does not require advanced treatment at all. As a result, sewage treatment plants are oversized and expensive. Moreover, the irregular arrival of large quantities of cleaner

rainwater disturbs the purification process. Other problems occur in the city. The storage and discharge capacity of the mixed sewers is inadequate in heavy storms, leading to sewer overflow, causing diluted wastewater mixed with sewer sludge to end up in the surface waters of the city. This is an important source of pollution in urban waters of many European and North American cities. Until recently, the main solution to these problems was to collect the overflow water temporarily in storage and settling basins. There has been a turnaround in thinking on this subject too, with the emphasis shifting to preventing problems by disconnecting the paved area, so that stormwater no longer runs into the sewers. One option for disconnecting is constructing a new network of stormwater drains, but this is expensive. More important even, this approach disregards further use of stormwater inside buildings, as non-potable or service water, or for watering urban green spaces and making them more diverse and attractive. The more sustainable approach is to lead stormwater to cisterns inside buildings or through open gutters to infiltration ditches or to ponds or canals. This open gutter approach makes water visible and makes it a true design issue to make rainwater part of the urban landscape. This includes the design of wetlands, along the banks of watercourses or as constructed wetlands in other forms, to restore run-off water quality. In Western Europe, with an annual precipitation of 800 mm, disconnecting rainwater from combined sewers will approximately halve the volume of water that goes to the central treatment plants. In that case, the separated rainfall equals the average domestic water demand per year.

Although sewer networks and central municipal treatment plants have the advantage of central control of the operation and of the performance of the purification process, there are also a number of serious disadvantages. One of them is the huge investment required for the sewer network and the treatment plants that make it very difficult for poor cities to set up a central system. Secondly, from a recycle and reuse point of view, the central treatment makes it almost impossible to reuse wastewater at the domestic level. Thus, the central system misses great opportunities to be more water efficient. Home-based decentralised system options, therefore, deserve more attention. They can offer an attractive alternative for urban areas that do not yet have a central sewer system. Even in cities that already have a centralised system, the decentralised technologies may create conditions for gradually improving water efficiency at the household level. At this level, it is both sensible and feasible to separate different qualities of wastewater: grey water from kitchens, bathing and washing, black water and urine. A number of on-site technologies are available and a great number of pilot projects have demonstrated their practical value. Schuetze et al. (2008) provide an overview and describe pilot projects. These technologies do not only recycle water but also organic matter as compost or fertiliser. Anaerobic digestion produces methane gas.

The water cycle and the flows of organic matter and nutrients are intimately linked. In the developed world, water pollution from cities has been greatly reduced by the separate treatment of industrial waste and by municipal treatment plants. Many developing cities are making progress in the same direction (UNESCO 2006). As a result, in many urban areas, cities are no longer the most important polluting factor and in many cases cities even have to be protected against pollution that

Fig. 4.3 Two guiding
principles: cascading and
closing the circle

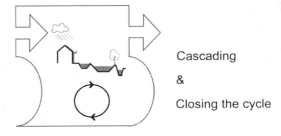

Cascading

&

Closing the cycle

comes from the countryside. In modern agriculture, and also in vegetable gardens and some parks of cities, more nutrients such as phosphates and nitrogen are applied than the plants can take up. In surface waters this high nutrient content may lead to abundant algal growth, an algal bloom. This will reduce diversity in aquatic ecosystems and in some cases it can even lead to fish kill. Apart from preventive measures, strategies are being developed to use constructed wetlands for the uptake of excess nutrients from surface waters. In many regions, cities have opportunities to combine water storage and wetland treatment with parks and recreation areas. Potentially, some cities can even become sources of clean water.

4.2.7 The Ecodevice Model

The discussion of the five *water flows* leads to two general strategies for a sustainable management of urban water flows: closing the circle and cascading, as presented in Fig. 4.3. This scheme, the so-called *ecodevice* model, first presented by Van Leeuwen and Van Wirdum (Tjallingii 1996: 184), represents an ecosystem in which the life-support conditions are regulated by input and output flow control. But an ecosystem can potentially also regulate the essential flows by retention, represented by the convex side, or by resistance, shown by the concave side. Cities are systems that traditionally regulate flows by input and output: too little asks for more supply and too much asks for discharge. This solves the problem inside the system but often at the cost of the neighbours upstream or downstream. However, cities are ecosystems. They can also store a surplus of water, for example, and use this storage to prevent shortage. In this perspective, closing the circle is a way of storing water and nutrients inside an ecosystem. In a sustainable approach, closing the circle is a priority for drinking water and wastewater. For the role of urban environments in the rainwater, ground water and river water flows, the first priority is cascading: keeping water longer and keeping it clean. Cascading and closing the cycle are the guiding principles of a sustainable approach to urban water. The next question is: where? Where should sustainable urban development start?

4.3 Urban Spaces and the Water Cycle

4.3.1 Flows and Areas

The *ecodevice* model of Fig. 4.3 illustrates the interaction of flows and areas. Typically an urban area can be represented as a series of ecosystems at different levels as illustrated in Fig. 4.4. In the debate between decentralists and centralists, between small is beautiful and big is beautiful, the priority of the first is to close circles at the building level: the autonomous home. Centralists prefer big dams, big power plants and treatment plants, preferably at the regional or higher level.

Keeping away from dogmatism in this debate, there is a good reason to start bottom-up: to use the full potential of the local situation and the local population, and to start processes aimed at more sustainable urban environments with local initiatives that are already there. It is dangerous to let only narrowly defined efficiency determine the plan. Planning proposals, at the building level and at higher levels, should be both effective and environmentally sound. This approach asks for a toolkit of guiding models at different levels, conceptual models embodying the learning process that has generated best practices and promising combinations in urban planning. In urban water planning, the cascading and closing the circle are the guiding principles. They show the way in a sustainable direction and have generated guiding models, the more concrete tools for making concrete plans. To give some examples, this section will discuss a number of guiding models that have been generated by such a learning process in The Netherlands and some other countries (Fig. 4.5) (see also Chaps. 1, 2 and 11). The toolkit is open, in other parts of the world and in other urban planning situations other tools may be necessary.

4.3.2 Guiding Models

At the building level, the guiding model example is made for the situation of a single-family house in a row (terraced housing) with a small garden. The starting point is

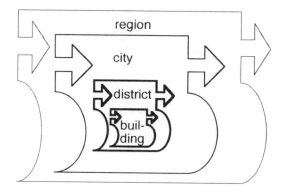

Fig. 4.4 Ecosystems, from buildings to region

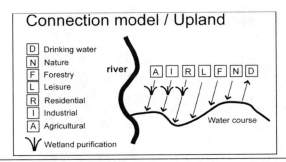

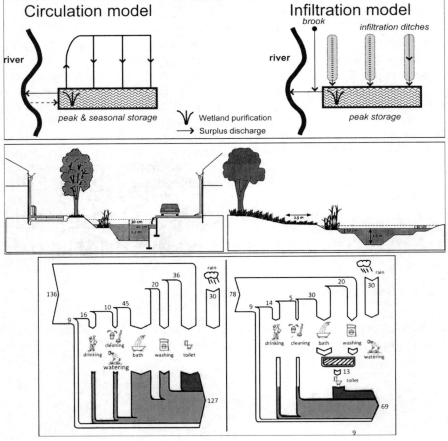

Fig. 4.5 A toolkit of *guiding models* for urban water planning: some examples. From bottom-up: Single house level (*left* existing; *right* new; *numbers* refer to water use per person per day in litres); street/park level; urban district level; catchment level

an average family with no special environmental commitment and a daily water consumption of 135 l per person per day. The combined application of water saving taps, showerheads and toilets and the reuse of grey water from bathing and washing for toilet flushing results in a reduction from 135 to 78 l. Rainwater is used for watering the garden. The outcome is only illustrative. The model guides the design process of technical construction and installation.

At the street level, the two models demonstrate promising combinations for the situation of an ordinary street and a green space with surface water. The fluctuating level of surface water creates conditions for rainwater storage and the bank design accommodates the fluctuation. Open gutters or pipes, if necessary, carry run-off rainwater to the purifying vegetation that lines the banks. The shallow zones create safety for children and good conditions for decorative plants such as reed and irises. Fish can breed in this zone, which contributes to healthy surface water and biodiversity. A maintenance path for a small crane also serves as a path for pedestrians and cyclists.

At the district level, the situation is a new or existing residential or commercial area. The infiltration model is useful in situations of permeable soils. Sometimes, infiltration ditches or swales can improve permeability. The groundwater table should not be too high so that groundwater recharge is possible. Networks of swales that only temporarily carry water can be designed as a green structure in the district. The circulation model is tailored to situations with limited infiltration and focuses on surface water retention. From the retention lake water is pumped up and circulates through the canals of the built-up area back to the lake.

Water quality is improved by keeping water moving, to allow for oxygen uptake, and by the wetland that is part of the lake. In the design of the system, water table fluctuations create sufficient retention capacity for the urban area to pass dry periods without an inlet of water from other areas. This prevents an input of polluting water. In existing urban districts with a combined sewer system, the circulation model create conditions for disconnecting rainwater from the sewer system. Thus, another source of surface water pollution can be removed. Retention lakes do not require extra space. They are part of the city's park system or of recreation areas in the urban fringe. They can also create attractive views for new housing developments whose profits can also contribute to the realisation of water retention.

At the regional level, the connection model is conceived to guide land use planning in a situation of urbanised or urbanising landscapes. The focus is on the catchment area and the basic principle is cascading water quantity and quality. Upstream land use should not create problems or shift them to downstream activities. Preferably, therefore, the less polluting and less peak generating activities should be positioned upstream. If this is not possible, water management, purification and retention should be organised by water works. Or, as in the case of Rotterdam, discussed in the section about drinking water flows, vulnerable activities downstream should act as a feedback mechanism to make upstream activities more sustainable.

These guiding models are examples. They are not ready-made plans, but models that can guide the planning and design process. Different ecological situations, including climate, mountains and soils and different socio-economic and political contexts, may ask for different guiding models.

4.3.3 Water in the Urban Landscape

The central question for the guiding models is 'how can urban areas contribute to a more sustainable use of the water cycle?' The opposite question is also worth considering: 'how can water contribute to sustainable qualities of urban areas?' This brings us to a brief remark about the role of water in the identity and beauty of urban areas and in their multifunctional use.

The historic and future identity of many cities is closely linked to green river valleys and to urban waterfronts. From Beijing to Boston and in many European cities (Werquin et al. 2005), the green promenade along the river is a characteristic feature of the city, popular for walking, sporting and as an attractive view for residential development. In cities with dry summers, cool airflows from surrounding forested hills follow the green valleys and penetrate deep into the heart of the city. They contribute to health and biodiversity.

River valleys bear the traces of history, from water mills and navigation to historic parks. They are a link between the past and the future and between town and countryside. The challenge for planners and designers is to integrate ecological aspects of water flows in plans for the social and economic development of cities. Guiding models are conceived as tools for this purpose.

In an integrated urban planning perspective, traffic networks often play an important role as carrying conditions for dynamic development. The motors of the urban economy, industry and commerce and increasingly also agriculture are highly dependent on transportation infrastructure. In the same way, water networks or green–blue networks support the qualities of the quiet side: nature and biodiversity, sports and recreation. The ecological development of the city depends on the greenways and blue networks. Residential quality in cities typically depends on the two sides, the quiet and the dynamic, the slow lane and the fast lane. The Two Networks strategy (Tjallingii 2005) is an approach to urban planning that takes the water and traffic networks as carrying structures as a durable framework allowing for a flexible but sustainable infill. For water planning, it is essential that it is not something extra at the end of the planning process but one of the backbones of urban development.

4.4 Water Planning and Innovation: The Role of Actors

4.4.1 Change, Strategic and Operational Plans

Section 4.2 of this chapter discussed five 'water flows', environmental problems related to traditional practices and the need for a more sustainable approach. The shift from traditional to sustainable requires a different emphasis in some cases, but a real shift in paradigms in others: from down the drain to first retain (rainwater); from pumping to careful use and recharge (groundwater); from taming the stream to

space for the river(s); from shortage and wastage to sufficient and efficient (drinking water) and from urban problems to opportunities (waste water and pollution). Who is responsible for the realisation of these processes of change? Who can start? Who pays? Who are the actors and how can they co-operate to set steps in a sustainable direction?

This is a real life story. In an urban fringe of a European city, various people and organisations are responsible for or committed to the quality of a small river valley. One of the actors is the regional Environmental Authority that defines the river as Class B, a category of limited water quality, and sets moderate targets for improvement. The Authority's quality standards are policy instruments to direct their budgets towards measurable improvement of environmental quality in many river valleys. In this particular case, the chemical and biological water quality parameters, measured twice per year, demonstrate no acute health risk. In the Authority's view, the quality of this river is not a real problem and they prefer to spend their money on other valleys with more serious problems and better prospects for improvement. At the same time, a local residents' group of a village downstream takes great efforts to have car wrecks removed and muddy footpaths improved in their part of the valley. To them, the problems of the valley are urgent and they can see their action can have visible results. For further improvement, however, they need the help of others. A third actor is the local Water Board, responsible for sewerage and surface water management. Their quality objective is to reduce the number of combined sewer overflows by 50% in 5 years. After heavy rainstorms, the sewers are unable to carry all the water and discharge diluted sewage into the river. This is one of the main causes of organic pollution and the Water Board has decided to build special concrete basins to temporarily store the overflow water and let it flow back into the sewers. Although the new storage basins will significantly reduce pollution from the sewers to the river, this solution is largely invisible and very expensive. Other sources of pollution, like fertilisers and pesticides from agriculture and heavy metals from the old mines in the area, remain untouched.

A process of change requires communication between the actors and this asks for a common language. In practice, this is not easy. Different agencies have their own definition of efficiency and what is obvious for one group remains invisible for others. Setting targets or standards alone is not enough. Jumping too early to fixed targets or efficiency standards may even create confusion and frustration. A process of change requires a *strategic plan* that results from an interactive process. It is important to have a committed group of initiators or a change agent who can bring actors together and generate a vision on the basis of shared understanding and a common language: a joint learning process. This is the basis for financial and organisational strategies that all become part of the strategic plan. The crucial question is whether different parts of the plan *fit* together and fit to the local landscape and local actors. If there is sufficient agreement and public support, the strategic plan can then lead to *operational plans* with a fixed time and budget planning, and here *efficiency* will become a more important criterion.

4.4.2 Innovation and New Technologies

Apart from the technical aspects and cost and space considerations, the introduction of new technologies necessarily implies the need for special care, both in construction and in the stage of use and maintenance. The implementation of new technology at the domestic level requires guidance and assistance even if it is relatively simple. This means that there is a need for an organisation to take up responsibility for the quality of the technical performance through customer advice and assistance, through training of professional technicians and, if necessary, through financial support or loans to stimulate the innovative process. The basis of change is an interactive process of learning by doing. Universities and research institutes should be involved in practical studies to bridge the gap between academia and practice. As in any innovative development, the introduction of new water use and reuse technologies, for example, requires a committed change agent who assumes the responsibility for making progress and who can organise a sharing of the risks related to construction and maintenance. Without risks, there is no innovation. The crucial question is who will play the role of change agent? In new development schemes or in redevelopment projects, it could be the developer or the housing corporation or a municipal agency, but it seems wise, depending on the situation, to set up a public–private organisation with the active participation of the users themselves.

Pilot projects may play an important role. They can demonstrate the working of new technology but also show the skills and tools that are required for realisation and maintenance. Moreover, the pilots give a real indication of the total costs and the impacts for all actors concerned. But it is still a big jump from successful pilots to mainstream practice. One of the essential conditions for bridging this gap is capacity building for all aspects of training and guidance.

An analysis of urban water plans in the Netherlands (Van de Ven et al. 2006) showed three contrasting approaches. The traditional and still dominant approach is command and control, with a central role for target images. In recent years, a negotiation approach has emerged that emphasises interactive processes between actors. A third approach focuses on learning, and uses guiding models to guide the planning process. Making an urban water system more sustainable requires a process of change that will be different in every individual situation. Success stories cannot be copied, but we may learn from them and use their inspiration for new sustainable urban water stories.

4.4.3 Bottom-Up or Top-Down

Rainfall is democratic. Using rainwater can start on every roof. The dilemma of Third World cities is whether strategies for sustainable water use should start: with the empowerment of individual residents to store and use rainwater in a healthy way, or by building central high-tech solutions for larger districts or whole cities. Bottom-up versus top-down, or decentralised versus centralised. Bottom-up is cheap

and it creates support of the users. But it takes time and is often difficult to organise quality control. The second strategy is expensive, but sometimes possible with foreign aid. Management and maintenance, however, will be difficult to finance and to organise. Leakage is a big problem. Moreover, centralised systems are often not accessible for the poor, for the squatters. It seems necessary to explore the combinations of bottom-up and top-down. Healthy water management requires both, and in both cases capacity building is essential. The guiding models for water planning in developed cities demonstrate the need for parallel activities at different levels. For certain issues, the central government is the agent that should take responsibility.

Floodplain planning is a good example. Floodplains are commons. The whole community, rich and poor, will benefit from the value of floodplains for flood prevention and water storage and for the blue–green networks in cities. Yet, in many Third World cities, floodplains attract squatters who set up their improvised houses because there is space and the risk of floods in unknown to them. The example from Curitiba, Brazil, demonstrates a possible solution. Planned city development concentrates along traffic axes where a special tax is imposed on builders and businesses that want to build. This creates a special fund for social housing projects close to but not in the floodplains. In this way, the squatters are offered a cheap alternative and the floodplains are cleared from slums and turned to commons again.

4.5 Conclusions

In a planning perspective, an ecosystem approach to urban water flows leads to the following steps that summarise the conclusions of this chapter.

1. *The water cycle.* In a given case, water use, flooding and pollution problems and water opportunities for urban development should be analysed in the context of the regional system. This includes the climate, the mountains and hills, the main river system, the rains and the drains. The basin is the basis. Five water flows are central to the analysis: rainwater, groundwater, river water, drinking water and wastewater. In some cases, of course, the role of the sea or big lakes may be essential. A cross-section, as in Fig. 4.1, combined with a water map of the region, can visualise the system.
2. *The water balance.* The situation of a given planning area should be described in a water balance, quantifying the inflows and outflows of the system. This will clarify the mutual dependencies between the systems of the planning area and its neighbours and between the whole area and sub-areas. This will create an understanding of the perspectives for sustainable management and the needs for cooperation and adjustment. Figure 4.2 shows a way to visualise the balance.
3. *Guiding principles.* Against the background of the water cycle and water balance, we can now take a fresh look at the water issues in the planning situation, the needs and the options for change. The general guiding principles for changes towards a more sustainable situation are cascading and closing the circle. Keep

water clean and keep it longer. The guiding principles can now be specified for the local situation and supplemented by other principles that are relevant in the local context. Figure 4.3 illustrates this

4. *Guiding models*. To make these principles work in urban planning, a bridge should be built between the flow strategies of the principles and the organisation of spaces and the management and maintenance options. Here, promising combinations resulting from a learning by doing process can produce a toolkit of guiding models. These conceptual models should be elaborated for different levels, from building to region, as illustrated in Figs. 4.4 and 4.5.

5. *Water in the urban landscape*. It is important to think about urban water in two ways. The city should be good for water and water should be good for the city. This may create a basis for co-operation and compromises between conflicting interest groups in the planning situation. In order to create space for a sustainable role of water in urban landscapes, the Two Networks Strategy may be a useful tool. This guiding model for spatial organisation of urban landscapes creates a durable framework with water networks supporting green activities – the quiet side – and traffic networks supporting industrial commercial and agricultural activities dependent on transport – the busy side. The two networks framework creates a carrying structure allowing for a flexible infill. In this way, planning can cope with the uncertainties of future development.

6. *Change*. Planning for more sustainable flows and areas in an urban environment requires strategies to work with a variety of actors. Investors and officials, local residents and politicians and a whole range of specialists of different organisations have to participate in the planning process. The language of guiding principles and guiding models may be useful in creating a common language between sectors, disciplines and interest groups in linking proposals for change to the sustainable use of local resources. This language is essential for sharing an understanding of the options for change and innovation and making choices for goals and means leading to strategic plans that can be followed by realistic operational plans. Both bottom-up and top-down activities and policies have their role to play in sustainable urban water management.

Questions

1. The resources for water use in urban environments can be described as five basic water flows. Which are these flows?
2. Planning for sustainable urban development asks for guiding principles. Which are the two most important principles for sustainable water management? And which basic flows do these principles address?
3. What are guiding models and why are they important in planning for sustainable urban development?
4. Blue–green networks in urban environments can play a double role. On the one hand, through them, the city can contribute to sustainable water management.

On the other hand, through them, water can contribute to the quality of life in urban environments. Give three examples of each role.

5. Urban water can be approached bottom-up, starting with the role of individual households, or top-down, starting with the role of central agencies. Give two potential strengths and two weaknesses of each approach in the context of urban water management in a developing country. What is essential for both?

References

Benton-Short L, Short JR (2008) Cities and nature. Routledge, London/New York

Heyworth J, Maynard E, Cunliffe D (1998) Who drinks what? Potable water use in South Australia. Water 25(1):9–13

Roy A (2002) The algebra of infinite justice. Flamingo. Harper Collins, London

Schmidt M (2006) The contribution of rainwater harvesting against global warming. IWA Publishing, London. http://www.evapotranspiration.net

Schuetze T, Tjallingii SP, Correljé A, Ryu M (2008) Every drop counts. UNEP DTIE IETC, Osaka/Shiga

Tjallingii SP (1996) Ecological conditions, strategies and structures in environmental planning. Diss, TU Delft

Tjallingii SP (2005) Carrying structures: urban development guided by water and traffic networks. In: Hulsbergen ED, Klaasen LT, Kriens L (eds.) Shifting sense, looking back to the future in spatial planning. Techne Press, Amsterdam, pp 355–368

UNEP (2007) GEO 4 Environment for development; GEO-4 fact sheet 6. available at: www.unep. org/geo/geo4/)

UNESCO (2006) Water, a shared responsibility. The UN world water development report 2. www. unesco.org/water/wwap

Van de Ven FHM, Tjallingii SP, Baan PJA, van Eijk PJ, Rijsberman M (2006) Improving urban water management planning. In: Hayashi et al. (ed.) Proceedings of the international symposium on lowland technology, Saga, Sept 2006, pp 573–578

Werquin AC et al (2005) Green structure and urban planning. Final report COST Action C11. ESF COST, Brussels. http://cost.cordis.lu

Further Reading

Centre for Science and Environment (2008) Urban model projects. New Delhi. available at: http://www.rainwaterharvesting.org

Curitiba. www.curitiba.pr.gov.br.br.

Douglas I (1983) The urban environment. Edward Arnold, London

Hough M (1995) Cities and natural process. Routledge, London/New York

Hooijmeyer F, van der Toorn VW (eds.) (2007) More water. Taylor & Francis, London

Tjallingii SP (1995) Ecopolis, strategies for ecologically sound urban development. Backhuys, Leiden

UN Habitat (2003) Water and sanitation in the world's cities: local action for global goals. Earthscan, London

UN Habitat (2006) The state of the world's cities report 2006/7 – The millennium development goals and urban sustainability: 30 Years of shaping the habitat agenda. Earthscan, London

UN Habitat and Rand Water (2003) Water demand management cookbook. Nairobi/Johannesburg. available at: http://www.unhabitat.org/pmss/getPage.asp?page=bookView&book=1781

Chapter 5
Energy in the Built Environment

Laure Itard

Abstract This chapter provides basic knowledge of energy flows in the built environment in general and more specifically in buildings. With the system approach offered and the basic data supplied, the reader should be able to understand and evaluate the quality of existing or new energy concepts and energy regulations. The accent lies on the energy use of buildings because buildings are the largest energy consumers in the built environment. This chapter may form a starting point to study in more detail either energy policies and regulations or the energy used in buildings from an engineering and design approach. After an introduction on the global energy consumption and energy issues, the energy chain in the built environment is analyzed from the demand side to the supply side. For the whole chain and for each of the components of the chain, solutions towards sustainability are introduced.

5.1 Introduction

5.1.1 Energy in Ecosystem Theory

Energy and material flows play an essential role in ecosystems because the whole life of and in these systems depends on them. Material transfer itself is driven by energy transfer. Energy flows are determinants for the growth of nutrients and organisms and for the levels of activity and health of organisms. Therefore, understanding the energy transfer mechanisms in an ecosystem is essential to understand the ecosystem.

L. Itard (✉)
OTB Research Institute for the Built Environment, Delft University of Technology, Jaffalaan 9, 2628 BX Delft, The Netherlands

The Hague University of Applied Science, The Hague, The Netherlands
e-mail: L.C.M.Itard@tudelft.nl

E. van Bueren et al. (eds.), *Sustainable Urban Environments: An Ecosystem Approach*,
DOI 10.1007/978-94-007-1294-2_5, © Springer Science+Business Media B.V. 2012

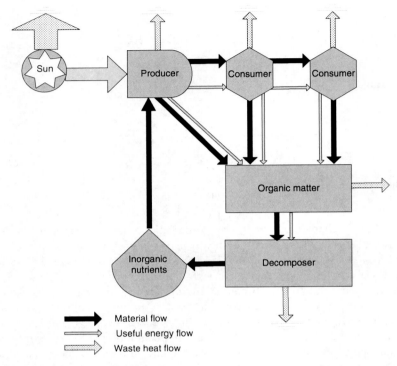

Fig. 5.1 The global ecosystem

Figure 5.1 represents the material and energy flows in a simple ecosystem. Basically the ultimate source of energy in any ecosystem is the sun (although there are some known exceptions) and derivates like wind, tide, rain and geological work. In energy conversion processes – the food chain is such a process leading to the growth of so-called producers and consumers – part of the incoming energy is converted to "useful" products (e.g., work powering the heart or internal energy allowing growth) through chemical reactions or photosynthesis. The remaining part of the energy input is released as low-temperature heat. Producers convert sun and inorganic nutrients into organic components (generally defined as components consisting of at least C and H elements) using photosynthesis. Consumers cannot be fed by such a process but are fed by producers or other lower level consumers. Finally, producers and consumers die, producing organic matter that is fed to decomposers, like bacteria and fungi, who break down organic components into inorganic nutrients stored in soil and water (minerals) or air (e.g., CO_2). During this process, low-level waste heat is released as well.

The global ecosystem, including human activities, is plotted in Fig. 5.2, where the interactions between "natural" and human parts are shown in a simplified way.

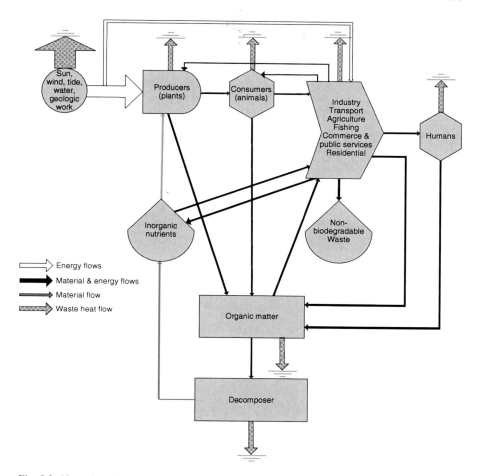

Fig. 5.2 Natural and human ecosystem

Energy flows are not only a main factor of the natural food chain, they are also a main factor of economic flows that include industry, transport, agriculture, fishing, transport, commerce and public and residential services.

5.1.2 Energy Use by Humans

We now focus on the industrial and economic parts of the ecosystem described by the interaction symbol in Fig. 5.2. Figure 5.3 shows the worldwide yearly primary energy supply from renewable resources (sun, wind, tide, etc.), inorganic nutrients (uranium for nuclear energy) and organic matters (coal, oil and gas) to the

116 L. Itard

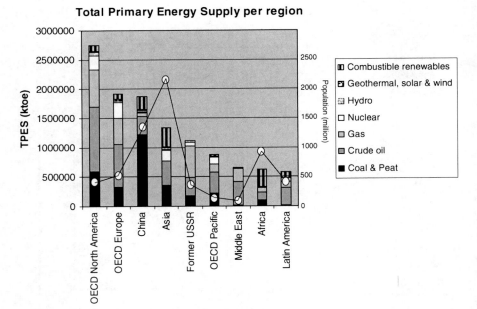

Fig. 5.3 Worldwide primary energy supply in 2006 from renewable resources (sun, wind, tide, etc.), inorganic nutrients and organic matters (*coal*, *oil* and *gas*) (from the energy balances from IEA, www.iea.org). Also shown is the relationship (or absence thereof) between the number of inhabitants and the use of resources

Box 5.1 Amount of Solar Radiation

Note that the total solar radiation falling on earth *within 1 h* is more (by a factor of about 1.3 in 2004) than the world, total primary energy *in 1 year* (the sum of the TPES of all regions).

industrial/economic system. This total primary energy supply (TPES) is expressed in kiloton oil equivalents (ktoe), which is a measure of the energy contained in the resource (1 ktoe = 41,868 GJ; see also Table 5.9 in Sect. 5.3.7.1). The largest part of the resources consumed (87% at world scale) comes from the "tank organic matters" and only 13% from renewable resources. According to the data of the international energy agency, the proved fossil fuel reserves are such that, with the actual rate of use, there would be enough coal for another 211 years, gas for 69 years and oil for only 43 years. However, the estimated total reserves are 5–20 times higher than the proven reserves.

These resources are used in the industrial/economic system as described in Fig. 5.4. The differences in Ktoe between Figs. 5.3 and 5.4 are caused by

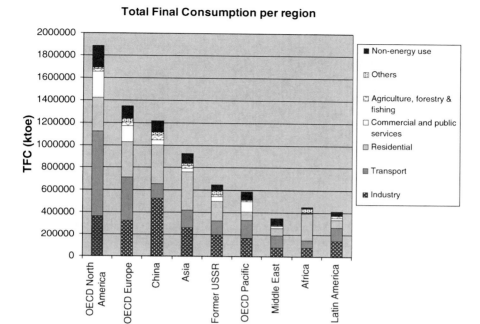

Fig. 5.4 Total final consumption per sector per region (based on energy balances from IEA, www.IEA.org)

the non-ideal transformation of raw resources into products (e.g., in petroleum refineries or liquefaction plants) and electricity. The efficiency of these processes varies between 54% and 73% with a global average of 68%. It is remarkable that the share of the transport sector varies a lot depending on the region: from 11% in China to 40% in North America, with a world average of 28%. The residential, commercial and public services sectors together, which are the sectors considered in this chapter, account for 32% of the global energy use, with percentages varying between 22% and 56%. At the level of OECD countries, that is a share of 30% for the residential and commercial sector and 34% for transport. As such, the built environment is responsible for a large part of the European/global depletion of national resources and pollutant emissions (see also Chap. 11). The energy used in industry, although it may be considered as part of the energy needed in the built environment, is not directly addressed in this chapter, although it represents 27% of the total energy consumption. It is not possible to draw general conclusions about the demand side in industrial processes because of their great variety. However, in Sects. 5.2 and 5.5, we will study how waste heat from industrial processes may be used as a heat source for the built environment.

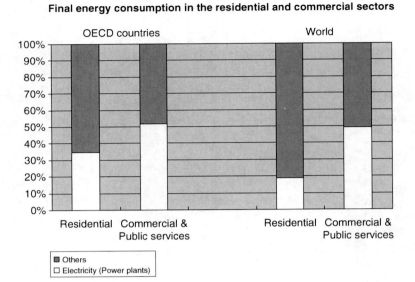

Fig. 5.5 Share of electricity in the final energy consumption in the residential and commercial and public services sectors

5.1.2.1 Energy Use in Urban Areas

Energy use in urban areas consists for the main part of energy used in the residential sector and in the sectors "commercial and public services". The public services sector includes subsectors like hospitals and schools, but also street and traffic lighting and sewage pumping. From EU-15 statistics, street lighting and sewage has a total share of no more than 8% in the total sector "commercial and public services". Of course, energy used in transport, industries and agriculture is also related to urban areas because the input of these sectors is necessary to maintain urban areas. These sectors may also be physically connected to urban areas: part of transport takes place within urban areas, and industrial zones may be adjacent to or sometimes included in urban areas. However, the energy issues of these sectors are quite different from those related to the residential, commercial and public services sectors and are not handled in this book, except for the transport aspects (see Chap. 9).

Figure 5.5 gives the total final energy consumption for OECD countries and the world for the residential, commercial and public services sectors by electricity (from central power plants) and by the category "others," which entails electricity production at building level (photovoltaic) and heat. In the residential sector, the electricity consumption is 35% of the total energy use in OECD countries but only 19% at world level. In the commercial and public services, it is much higher, around 50%.

The main part of the electricity used in the residential sector is used to power appliances (e.g., lighting, refrigerators, air-conditioning, computers). Heating applications

Fig. 5.6 Final energy
consumption in the residential
sector and in the commercial
and public services sector
for 19 OECD countries

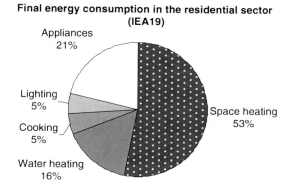

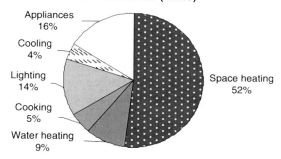

(space and water), cover a very high share of the final total energy consumption:
with almost 60%. Of course, this is an average, and there will be particularly large
differences in the shares between cold and warm countries (Fig. 5.6).

5.1.3 Is Energy Consumption an Environmental Problem?

Energy savings in the built environment are placed high on the political and scientific
agenda worldwide. Costs savings, security of supply and the environment are the main
reasons to save energy. Next to these considerations it must be noticed that energy
in itself is not an environmental problem but the cause of several environmental
impacts (see definitions in Chap. 11). By using fossil fuels, we contribute to the
depletion of abiotic resources, and by using wood or biomass at rates that exceeds
their rate of growth, we contribute to the depletion of biotic resources. By emitting
combustion products into the atmosphere, the production of energy contributes to
the depletion of ozone layer, global warming, acidification, eutrophication, photo-
chemical oxidation (smog), ecotoxicity (soil and water) and humane toxicity.

5.2 The Energy Chain: From Demand to Supply

To be able to reduce the total primary energy supply (TPES) to urban areas, a basic understanding of the energy chain from the demand side to the supply side is needed. The aim of this chapter is to provide the reader with this basic understanding. In the next section the buildup of the energy chain in residential and commercial and public services sectors is explained with the aim of identifying ways to reduce the related environmental problems like resource depletion and emissions during the production of electricity or heat (e.g., CO_2). The focus is on energy use in buildings as this is by far the largest part of the energy consumption in the residential and commercial and public services sectors (see Sect. 5.1).

5.2.1 The Energy Chain in Buildings and the Built Environment

A general energy chain consists of four main components (see Fig. 5.7): Natural resources (1) like coal, gas, sun or wind are converted into energy (e.g., heat, work or electricity) in an energy conversion process (2). This energy is then transported and/or temporarily stored in an energy distribution network (3) to the demand side (energy demand from the sectors described in Sect. 5.1) (4). The energy conversion process of non-renewable sources (fossil fuels) is mainly based on combustion.

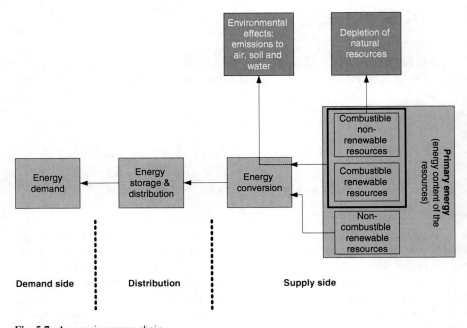

Fig. 5.7 A generic energy chain

During this energy conversion step, emissions to the environment occur due to the combustion reaction. These emissions may be CO_2, released to the atmosphere and contributing to global warming, or to ozone layer depletion, acidification, ecotoxicity, human toxicity, etc. (see also Chap. 11). These emissions depend on the fuel used and on the energy conversion process used, which is not necessarily combustion. For instance, by using a fuel cell with hydrogen as fuel, the only emission is water, which is harmless. When using a photovoltaic cell or wind energy, no emissions occur during the conversion process. As the depletion of natural resources is a major area of environmental concern, a distinction is made between non-renewable and renewable resources. Non-renewable resources consist of fossil fuels or of resources like biomass when they are used at a rate that exceeds their production rate. Renewable energy sources can be classified as combustible (e.g., biomass, biogas, animal waste, municipal or industrial waste) and non-combustible sources (e.g., solar, wind, hydro, geothermal, tide and wave). The combustion of combustible renewable sources will produce emissions to the environment. In contrast, non-combustible renewable sources will produce energy without any emissions during the conversion process.

When specifying this energy chain for buildings, the framework of Fig. 5.7 must be adapted to facilitate analysis. A decisive step in the design of a built environment using energy carefully is the energy conversion step because it largely determines the investment costs. Energy conversion systems in the built environment are found at the local (building) level and at the central (district, city or regional) level. When a local system is used, like a gas boiler, the building owner or occupant will usually pay for the initial investment and for the primary resources used (e.g., gas). When this local system is a photovoltaic cell, a non-combustible renewable resource is used for which the owner does not need to pay anything (except for the initial investment) and that does not produce any environmental effect, except for its production and discard (waste phase). De-centralized energy production avoids long distribution systems, but may be less reliable in terms of security of supply, efficiency, mainte- nance and costs. The investment in a de-centralized system will usually be made by the building owner, whereas investment in a central system like a power plant will be made by an energy company, a municipality or a government. Of course, more pos- sibilities exist and there is a trend at the moment to look for innovative investment and use exploitation organizations like Energy Service Companies (ESCOs).

The framework used in this chapter is presented in Fig. 5.8. The four steps des- cribed in Fig. 5.7 (demand, distribution, conversion and primary energy) are still visible, but are now organized around the processes in the built environment. The principal components are now the energy demand, the energy supply and the pri- mary energy use. The "primary energy use" is equivalent to the Total Primary Energy Supply (TPES) of Fig. 5.3. The "local energy supply" is equivalent to the Total Final Consumption (Figs. 5.4–5.6). In this chapter, we will further use the terms as described in Fig. 5.8. The different parts of this framework are explained step by step in the following sections. The energy demand is the subject of Sect. 5.3, Sect. 5.4 deals with energy storage and distribution, and the primary energy supply is dealt with in Sect. 5.5.

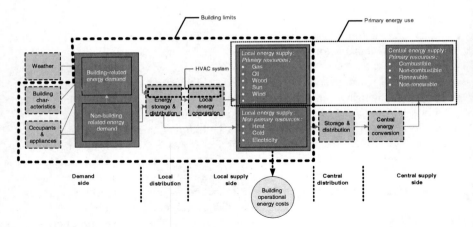

Fig. 5.8 Energy chain in buildings

5.2.2 The Energy Chain and the Three Steps Strategy

The relationship between the energy chain and the Three Steps Strategy, further described in Chap. 11, is straightforward. The first step of the strategy is about reducing the energy demand. The second step refers to the primary energy use (use renewable energy as much as possible) and the last step is about using an energy conversion process that is as efficient as possible when non-renewable resources are used.

The Three Steps Strategy therefore introduces a prioritization of measures. One could argue that, from the moment only sustainable energy is used, there is no need to reduce the energy demand. This is only correct to the extent that energy needed to produce the energy conversion systems (e.g., the power plant itself or photovoltaic cells) is not taken into account. The larger the energy demand, the larger the energy conversion systems should be, therefore the more natural resource will be used to manufacture them and the higher their costs. In the present state of affairs, it seems as important to go towards sustainable energy conversion as to reduce the energy demand. The trend in the built environment is to pay most attention to the first step (reduction of the energy demand), mainly because it seems easier to achieve than a change in energy conversion systems from fossil fuels to renewable resources. There have been very successful attempts to reduce the energy demand of buildings drastically (e.g., the passive building approach). It is likely that, in the future, the developments will be towards a combination of passive and active building approach, the building being well insulated and able to make maximal use of solar radiation, providing shading when necessary, using solar panels that can follow the sun and therefore producing enough electricity, heat and cold for its own use, and perhaps for other buildings.

5.3 Demand Side: Thermal Energy Demand

5.3.1 Introduction

Considering the fact that 92% of the energy consumed in the built environment is consumed within buildings, and that more than 50% of it is used for heating purposes, looking in more detail at the energy consumption of buildings seems to be necessary to understand how to reduce it or to make it sustainable. The energy demand is usually separated into building-related energy and user-related energy.

The *user-related energy demand* of a building is the energy demand that cannot be directly influenced by the design of the building. It mainly consists of the energy demand of electrical appliances like computers, televisions (also called brown goods), refrigerators and washing machines, etc. (also called white goods). Reducing the energy demand of these appliances is a task for the industries concerned, but not for building engineers. Note, however, that this user-related energy demand does influence the building-related energy demand: a large part of the electricity needed by appliances will be released into the building as heat, acting as an internal heat source.

The *building-related energy demand* is the energy that should be brought into a building to ensure that all comfort and health parameters like temperature, humidity and lighting intensity can be kept at the desired level (see Chap. 7.3.1). It is determined by the comfort preferences of the occupants, and by the design characteristics of the building, like surface area of walls and roofs, insulation degree and size of windows. It is also determined by occupancy characteristics like the number of persons present and the quantity of heat released by electrical appliances used in the building.

To determine how much energy a building needs to be maintained at a certain temperature, it is necessary to make an inventory of all energy flows through and into the building. If the sum of these energy flows is negative, the building receives too little heat and needs an additional incoming energy flow to maintain its temperature at the right level (heating). If the sum of these energy flows is positive, the building receives too much heat and this heat must be carried out by cooling. The process of making the inventory of all energy flows is called the energy balance and is based on the first principle of thermodynamics that states that the quantity of energy entering a system kept at a constant temperature (and composition) is equal to the quantity of energy leaving the system. When too much energy is supplied to the system, its temperature increases, when too much energy flows out of the system, its temperature decreases.

The thermal energy balance is essential to determining the energy-saving potentials of a building.

In the following sections, the system considered is the building delimited by the outer surface of the walls, roofs and ground floor. For the sake of simplification, we consider the building as one zone of homogeneous temperature and humidity. Conduction, convection and radiation heat transfer are combined into four main

Fig. 5.9 Environmental conditions influencing the energy balance of a building

heat flows: transmission, infiltration and ventilation, solar gains, and finally internal heat gains. Based on this, a simplified heat balance will be constructed and analyzed.

Heat can be transferred from one body to another by three mechanisms: conduction, convection and radiation. In a building, these three mechanisms are combined into the four main heat flows described above and that will be studied in Sect. 5.3.3. Heat transfer is very much dependent on temperature. This means that the chosen indoor temperature and the outdoor temperature are main determinants of the total heat demand of buildings. Wind pressure determines part of the convection losses and solar radiation a large part of the radiation heat transfer. The energy performance of a building is for a large part dependent on the outdoor conditions, which are determined by the local climate around the building.

5.3.2 The Building and Its Environment: Local Climate

The energy balance closely relates to outdoor conditions like temperature, humidity, wind speed and solar radiation. These outdoor conditions behave in a strongly dynamic way: the weather's parameters are never constant. Roughly stated, the outdoor air temperature in the inhabited world varies between −50°C and +50°C depending on the location, the season and the hour of the day, while the comfort temperature lies around 18–25°C, see also Chap. 7. The ground temperature is more constant because of the tempering properties of the ground, and will influence the heat losses through the ground floor (Fig. 5.9).

The relative humidity may vary from almost zero to 100% (whereas the comfort humidity lies in the range 30–70%). The wind speed varies from 2 m/s when there

Fig. 5.10 Solar radiation on a building

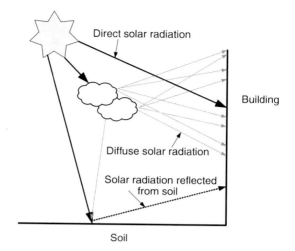

is "no" wind to more than 100 m/s in a heavy storm. But except in warm weather, draughts are not wanted inside a building.

The solar radiation reaching a building may vary drastically from one moment to the other. Beside the seasonal variations and the day–night rhythm, there are variations depending on the clouds and atmospheric pollution. During the last 40 years, many models have been developed to predict weather data. For solar radiation, models for overcast and clear sky have been developed. Nowadays, simulation models mostly use historic series for weather data, produced by weather stations all over the world. In these historic data, hourly data (and also data per 10 min or less) on temperature, humidity, wind speed and solar radiation is stored. Some of these data, like in the so-called TRY (Test Reference Year), TMY (Typical Meteorological Year) or SMY (Standard Meteorological Year), are statistically worked out in order to be used for the specific aim of making accurate energy or heat/cooling load calculations. In this case, the data of many years are aggregated into one artificial climate year (see, for instance, Clarke 2001; ASHRAE 1997 or NREL 1995; Meteonorm 2009; Energy-plus 2011).

5.3.2.1 Local Conditions

Next to this, the weather conditions of interest for the building may be influenced by local circumstances like the presence of shading by trees, other buildings or a mountain, the presence of wind protection like trees, or conversely the presence of wind couloirs. The local air temperature can also vary strongly, depending on the ground coverage. In stony environments, like cities, the temperature may be up to 5°C higher than in green environments due to less absorption by plants in the soil. This is called the heat island effect. The reflective properties of the surroundings (see Fig. 5.10)

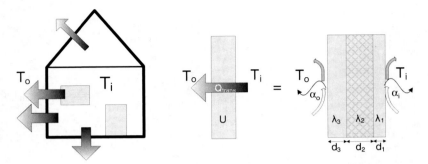

Fig. 5.11 Transmission losses through walls, roof, floor and windows (*left*) and their relationship with conduction, convection and radiation (*right*) in the case where $T_o < T_i$. If $T_o > T_i$, the heat flows in opposite direction

are expressed by the reflective coefficient albedo. The higher the albedo, the more solar radiation will be reflected towards the building. For instance, snow has an albedo of approximately 0.9, stony ground 0.5, grassland 0.3, woods 0.2, and asphalt 0.12, while the albedo of water may vary between 0.1 and 0.6. The part of the radiation that is not reflected is either absorbed by the ground, producing an increase in the soil temperature (heat island effect, see Sect. 5.3.2), or used for photosynthesis when the ground is covered by plants.

This means that the energy balance in a building is related to its location. There is no such thing as an ideal building (in terms of minimal energy use) which is universally valid. It all depends on place. Because the weather has an overall cycle of 1 year (if we do not take into account climate change), it is common to calculate the energy use of a building for a period of 1 year. This also offers the advantage of avoiding making calculations only for the winter or only for the summer, by which the building design may be sub-optimized for one season. To do this, it is necessary to use software simulation tools. A list of existing tools may be found on http://apps1. eere.energy.gov/buildings/tools_directory/ and on www.ibpsa.org. Many simplified methods have also been developed in order to make quick estimations. In the next sections, we will give a basic understanding of these simplified methods.

5.3.3 Energy Flow by Transmission

Because of the temperature difference between indoor air and outdoor air, heat will flow through the construction (walls, glazing, roof and ground; see Fig. 5.11).

The transmission heat losses through a wall of surface area A are calculated using the following equation:

$$P_{trans,s} = UA(T_o - T_i) \ [W] \tag{5.1}$$

Table 5.1 Typical R_c values of constructions (the U values are calculated with α_i=7.5 W/m²K and α_o=25 W/m²K)

	R_c (m²K/W)	U (W/m²K)
Single glazing	0.005	5.6
Double glazing	0.16	3
High efficiency glazing	0.38	1.8
Non insulated brick cavity wall	0.35	1.9
Cavity wall with 100 mm insulation	2.68	0.35
Passive house wall	>8	<0.12

$$\text{with} \quad U = \frac{1}{\dfrac{1}{\alpha_i} + R_c + \dfrac{1}{\alpha_o}} \quad \left[Wm^{-2}K^{-1} \right] \tag{5.2}$$

Where T_o is the outdoor temperature, T_i the indoor temperature and U is the overall heat transfer coefficient (also called transmittance) in W/m²K, A the surface area of the wall in m² and R_c is the thermal resistance of the wall ($R_c = d/\lambda$, where d is the width of the wall and λ its thermal conductivity in Wm^{-1}K^{-1}). α_i and α_o are the combined heat transfer coefficients for convection and radiation. One can assume for α_i (indoor side) a value of 7.5 W/m²K, because the air speed inside the building is very low. For α_o (outdoor side), the values will depend strongly on the wind speed. However one can assume a yearly average value of 25–30 W/m²K (see, for more details, Ashrae Fundamentals 2009 and Clarke 2001).

In the case of composed walls as in Fig. 5.11 (so-called walls in series), the thermal resistance can be calculated by Eq. 5.3:

$$R_c = R_{c1} + R_{c2} + R_{c3} = \frac{d_1}{\lambda_1} + \frac{d_2}{\lambda_2} + \frac{d_3}{\lambda_3} \quad \left[m^2 K W^{-1} \right] \tag{5.3}$$

Materials are classified as insulation materials if they have a thermal conductivity below 0.16 Wm^{-1}K^{-1}. Insulation materials like rock wool and glass wool have a thermal conductivity of approximately 0.04 Wm^{-1}K^{-1} and extruded or expanded polystyrene of about 0.03. The thermal conductivity of wood varies between 0.1 and 0.3, brick between 0.5 and 1.4 and concrete between 0.4 and 1.7 Wm^{-1}K^{-1}. In many countries, the R_c values of constructions are subject to minimal requirements. Table 5.1 gives typical R_c values of constructions.

To calculate the total energy flow by transmission, the transmission through walls, roofs, windows and ground should be calculated and summed. For the ground, the transmission is not to the air but to the ground temperature. For the windows, the U value of the total window construction should be used (therefore, the U value of the system (glass + window frame) and not only the U value of glass). These equivalent U values are currently published by producers of windows.

5.3.3.1 Thermal Bridges

In addition to transmission losses through surface areas, there are also transmission losses occurring at the junction of walls, or at the junctions of wall and ceiling, wall

and floor or wall and window frame, window frame and glazing. Especially when the insulation material is poorly placed, thermal leakage will occur, as may be the case at the junction of a balcony with a wall or with load-bearing columns going from outdoors to indoors. These losses are called thermal bridges and cause not only additional heat losses but also damage to the construction and to interiors because of condensation on the thermal bridge during cold weather. Heat losses through thermal bridges can be calculated using formula (4). See also ISO (2007).

$$P_{bridge} = \psi L (T_o - T_i) \ [WK^{-1}] \tag{5.4}$$

Where L is the length of the thermal bridge (m) and ψ the linear thermal transmittance of the thermal bridge W/(mK). The values of ψ may range from approximately 0.02 to 1. Some countries set minimal requirements for cold bridges, for instance, in Denmark, ψ values for the junction window frame-wall are not allowed to be higher than 0.06 and ψ values for the junction floor–external wall must be lower than 0.2 W/(mK) (see http://www.asiepi.eu/wp-4-thermal-bridges/information-papers.html). In older buildings, thermal bridges are a negligible part of the transmission losses. In more recent buildings, the proportion of heat loss due to thermal bridging is typically 10–15%. This can rise to 30% in better insulated low-energy buildings when insulation and construction details are not properly realized.

The total transmission losses are calculated using Eq. 5.5:

$$P_{trans} = P_{trans,s} + P_{bridge} \tag{5.5}$$

Where $P_{trans,s}$ is calculated using Eq. 5.1 and P_{bridge} Eq. 5.4.

5.3.4 Energy Flow Through Ventilation en Infiltration

Air from outside (so-called fresh air) flows into and out of the building through openings (e.g., windows or grilles) or systems (e.g., mechanical ventilation) conceived for this aim, and also through cracks in the construction, essentially at the junction of components like wall and window frame or roof and walls. In the first case, we speak about ventilation, and in the second case, about infiltration/exfiltration (will be referred below under the generic name 'infiltration'). Because infiltration is uncontrolled and depends on the final quality of the construction, infiltration is more complicated to model in detail and will be approached through practical rules of thumb.

To ensure an acceptable indoor air quality, fresh air is needed. Fresh air brings the oxygen needed for respiration, dilutes odors and indoor air pollutants like CO_2 or formaldehydes, and takes away humidity, especially the water vapor exhaled by human respiration and diffused by the human body by sweating (see also Chap. 7). Furthermore, additional ventilation air flows may be needed to pressurize escape paths in order to avoid smoke flowing into the escape paths in case of fire. The quantity of air needed per person depends on his metabolism and therefore on the activity

level of the person. Generally an air flow rate of 25–50 m³h⁻¹ per person is needed. That is a lot, especially in buildings with high occupancy rates like schools. This explains the very large air ducts one can observe in this type of buildings. In dwellings that have a much lower occupancy rate, the infiltration of air through cracks with some additional short airing by opening windows may be enough to ensure enough fresh air, especially in older houses, that are mostly not air-tight. In contrast, new dwellings are mostly highly air-tight, meaning that infiltration air flows are much too low to ensure the needed air quality, and therefore additional ventilation is needed.

5.3.4.1 Dry Air/Humid Air

The outdoor and indoor air does not consist of pure air, but is a mixture of air and water vapor called humid air. The energy content of humid air consists of both the energy content of dry air and the energy content of water vapor. For estimations of the heat losses through ventilation and infiltration, the water vapor may, however, be neglected because under atmospheric conditions the water contents of air will never exceed 3% of the total mass of air (humidity ratio), even if the air is completely saturated with water vapor, which is referred as 100% relative humidity and feels terribly humid. But note that when humidification or de-humidification is applied, this will cause a large additional energy demand, which is not treated in this book (for more information, see ASHRAE fundamentals).

5.3.4.2 Infiltration Losses

The thermal losses by infiltration and exfiltration are estimated using Eq. 5.6 where T_i is the indoor air temperature and T_o the outdoor air temperature

$$P_{inf} = \dot{m}_{inf} C_p (T_o - T_i) \ [W] \tag{5.6}$$

where \dot{m} is the mass flow rate of air (kg s⁻¹) and C_p the heating capacity of dry air in Jkg⁻¹K⁻¹. The heating capacity at ambient temperature (from −50°C to 60°C) is 1,000 Jkg⁻¹K⁻¹, which represents the quantity of heat one kilogram of air can absorb by changing its temperature by 1 K (or 1°C).

It is usual in HVAC literature to express air flow rates in cubic meter per hour (m³h⁻¹). For the conversion of volume flow rates to mass flow rates use Eq. 5.7,

$$\dot{m} = \frac{\rho \dot{V}}{3,600} \ \left[kgs^{-1} \right] \tag{5.7}$$

where ṁ is the mass flow rate of air (kgs⁻¹), ρ the density of air in (kgm⁻³) and \dot{V} the volume flow rate of air in (m³h⁻¹). The density of air varies with temperature but may be assumed to be 1.2 kgm⁻³ at ambient temperature.

The mass flow rate of infiltration air is not easy to determine accurately as it depends on the size of cracks in the construction and on pressure differences

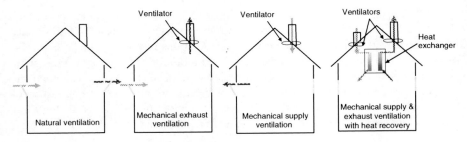

Fig. 5.12 The main types of ventilation systems

(and therefore on wind) between indoors and outdoors. Generally, estimates are based on volume flows per square meter envelope surface area, or on volume flows per square meter floor area or on air change per hour (ACH). Air change per hour Y is expressed in h^{-1} and is defined as follows:

$$Y = V_{inf} / V_{building} \ [h^{-1}] \tag{5.8}$$

where $V_{building}$ is the interior volume of the building in m^3 and V_{inf} is the infiltration volume flow rate in $m^3 h^{-1}$.

Typical air changes per hour varies from 0.1–0.2 for air-tight large new buildings (floor area >10,000 m^2), to 0.2–0.3 for smaller buildings and 0.5–1 or more for old buildings. In Ashrae standard 62.2 (2010), more data may be found. In many countries, building regulations set maximal values to infiltration air flow rates. For instance, in the Netherlands, the infiltration air flow rate should not exceed 0.2 m^3 per 500 m^3 of the building's volume.

5.3.4.3 Ventilation Losses

There are basically three types of ventilation systems (Fig. 5.12).

- Natural ventilation though grilles and windows. In this case, no ventilator is used.
- Mechanical supply ventilation or mechanical exhaust ventilation. In these cases, one ventilator is used either at the supply side or at the exhaust side.
- Mechanical supply and exhaust ventilation with heat recovery, also called balanced ventilation. In this case, two ventilators are used.

All systems may be controlled by a CO_2 sensor to ensure a reasonable air quality.

In the case of mechanical supply and exhaust ventilation, two ventilators are used, one for the supply and one for the exhaust. Because two ducts systems are used, it is very straightforward to apply heat recovery between both air flows in the air handling unit. That is the reason why mechanical supply and exhaust ventilation systems are generally equipped with heat recovery (although heat recovery may be lacking in older systems). In the cold season, the outdoor supply air is freely (without addition of energy) heated by the relatively warm exhaust air, which has a temperature

approximately equal to the indoor air temperature (~20°C). In the warm season, the outdoor supply air is freely cooled by the relatively cool exhaust air, which has a temperature approximately equal to the indoor air temperature (~24°C). The heat exchanger is generally located at a central place near to the roof, but there are also systems in development where the heat exchanger and ventilators are placed in the outdoor wall of each room near to the window or in combination with the window (see, for instance, Kristinsson 2004).

The heat losses through a mechanical supply and exhaust ventilation system with heat recovery are dependant of the efficiency of the heat recovery, which on average may vary in the range $\eta = 0.6$–0.9.

The thermal losses by ventilation are estimated for all systems using Eq. 5.9

$$P_{vent} = (1 - \eta)\dot{m}_{vent}C_p(T_o - T_i) \; [W] \tag{5.9}$$

where T_i is the indoor air temperature and T_o the outdoor air temperature, and η is the efficiency of the heat recovery. If not heat recovery is applied, $\eta = 0$

Next to these thermal losses influencing the buildings' energy balance, the electrical energy needed by the ventilators must be accounted for. The electric power needed by one ventilator can be calculated using Eq. 5.10, the so-called ventilator law.

$$P_{elec,vent} = \frac{\dot{V} \cdot \Delta p}{\eta} \; [W] \tag{5.10}$$

Where \dot{V} is the volume flow rate of ventilation air in m³ s⁻¹, Δp is the total pressure drop through valves, ducts and ventilator in Pa and η is the efficiency of the system (ventilator + motor), the value of which is mostly in the range 0.5–0.75.

The pressure drop Δp depends strongly on the design of the ventilator, air handling unit and the length of the air ducts and their design. For a quick estimate, assume a pressure drop of 200 (small buildings) to 800 Pa (large buildings).

5.3.5 *Energy Flow Through Solar Radiation*

Solar radiation penetrates into the building through windows. It is also absorbed by the outer surface of walls and roofs. For the sake of simplicity, we will assume that the solar radiation absorbed on the outer wall can be neglected. This is only true in well-insulated buildings where the wall is not able to transmit the accumulated solar heat to its indoor surface. In all other cases, this assumption will introduce an error. We also consider that no heat is accumulated into the window itself, which means that we neglect the fact that the windows act as radiant panels.

The solar radiation that is transmitted through the windows is NOT absorbed by the indoor air but by the surrounding walls and floors by multiple reflections on the different surfaces. In most software packages, detailed calculations are possible. Solar radiation is absorbed by walls and floors and produces an increase in wall (or floor) temperature. When the surface temperature of the wall exceeds the room air

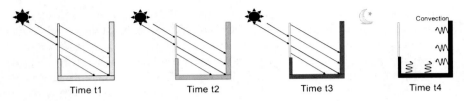

Fig. 5.13 The process of absorption of solar radiation into the construction. As time passes, the temperature of the walls increases, and finally, when it exceeds the room air temperature, heat is released by convection to the room air. This process may take more than half a day in heavy thermal constructions (like concrete) or no more than 3 h in light walls (like gypsum board)

temperature, part of the heat absorbed flows back to the room through conduction and convection (Fig. 5.13). This is evidently not an instantaneous process. In buildings with a heavy thermal mass, the temperature of the wall at moment t may depend of the former wall temperatures up to approximately the moment $t-24$, where t is in hours. In a light building, these dynamic effects have much less importance. The quantity of heat accumulated in the building is determined by the effective thermal mass of the building and by the heating capacity of the material used. For instance, wood cannot accumulate as much heat as concrete. A floor that is covered with a large amount of furniture and carpet absorbs less than an empty floor. A heavy concrete ceiling/floor absorbs almost no heat when a false ceiling or a system floor is used because the thermal mass cannot be reached by the solar radiation. It is therefore not an easy task to deal with solar absorption in buildings.

Generally, the thermal mass of a building does not affect the heating demand to a large extent (except when the mass is very high, like in non-insulated half-underground buildings), but does significantly affect the cooling demand. The higher the thermal mass of a building, the lower its cooling demand, because the incoming solar radiation by day is stored in the walls and floors and released at night to the room. This, for instance, reduces by a large amount the cooling need in offices. The thermal mass of a building can be artificially increased by using concrete activated floors (e.g., Lehman et al. 2007) or phase change materials (e.g., Dorp 2004). In dwellings, it may cause a too high night temperature, but this can be solved by ventilating more with cool outdoor night air. Concrete activated floors are floor slabs in the middle of which water circulates in pipes. The water circulates at a temperature of approximately 20°C and absorbs the incoming solar radiation. Phase change materials are materials like paraffin that smells at a temperature of about 24°C, absorbing heat from the room. At night, when the temperature cools down under 24°C, the paraffin crystallizes again, releasing its latent heat to the room. High cooling loads during daytime are therefore avoided.

5.3.5.1 Heat Gains Through Solar Radiation

In addition to the thermal mass, the heat gains through solar radiation depend essentially on the orientation, size and properties of the windows.

Table 5.2 Estimates of g_{glass} values for windows

Single glazing	Double glazing, uncoated	Double glazing, reflective	Double glazing, low-e	Triple glazing
~0.8	~0.7	~0.17	~0.3–0.6	~0.4–0.6

Table 5.3 Rough estimates of g_{shade} values for shading devices

No shade	External shade	Drapery/roller shade	Louvre half open	Louvre closed
1	~0.2	0.6–0.9	0.7	0.4

The percentage of the total solar radiation transmitted as heat through glass is generally referred as g value (or also as the solar factor, or solar heat gain coefficient "SHGC"). Additionally the g value of external or internal sunshades should be taken into account as well. Although the g value of a glass pane differs for diffuse radiation and direct radiation, and in the latest case depends on the angle of incidence of the solar beam, rough calculations can be made using the values for a normal incidence angle (sunbeam perpendicular to the window).

For very rough estimates, the effect of the building's mass is neglected, meaning that the time effects of heat absorbed in walls and ceiling and released later are neglected. A simple equation for the calculation of the solar heat gains is given by Eq. 5.11. More elaborate calculation methods can be found in Clarke (2001), NREL (2011) and in Ashrae Fundamentals (2009).

$$P_{sol} = \sum_i g_{glass}^i \cdot A_{window}^i \cdot g_{shade}^i \cdot P_{sol,w}^i \quad [W] \qquad (5.11)$$

Where, for each wall of orientation i, g_{glass} is the solar factor of the window (glass + frame), g_{shade} the solar factor of the sun shade (sometimes referred as IAC in the literature), A_{window} the surface area of the window in m^2 and $P_{sol,w}^i$ the total incident solar radiation in W per square meter window area (diffuse and direct). Be aware that these static calculations are not very precise, especially for the calculation of the cooling load, since the mass effects of the building are not taken into account. The solar heat gains for a building with a high thermal mass will be lower (up to more than 50%) than calculated with Eq. 5.13. For a more precise estimation, dynamic calculation methods taking into account the time lags of solar absorption heat in the wall are necessary. Tables 5.2 and 5.3 give estimates for the coefficients g_{glass} and g_{shade}.

5.3.5.2 Natural Lighting

Solar radiation does not only affect the heat balance of a building, it also affects the energy used for lighting. However, it does not affect the total lighting power to be installed in a building as lighting is also necessary at night. Whether artificial lighting is switched on depends on the incoming natural light flux and the illuminance needed for a certain task. In a corridor, an illuminance of about 100 lux is

needed, for reading and writing activities about 400 lux is needed, whereas in an operations room more than 3,000 lux is needed. The outdoor illuminance is much higher, up to 100,000 lux.

Large windows oriented towards the sun are not necessarily efficient in reducing the needs for artificial lighting because of the occurrence of glare. As a result of the visual discomfort from glare, the sunshades may be put down permanently, reducing natural lighting (and also solar gains). The design of windows and sunshades must take account of the orientation of the windows that will determine the amount of direct and diffuse incoming radiation. From the viewpoint of natural lighting, diffuse radiation must be preferred to direct radiation (glare). Trees and/or plants growing on the façade can help to reduce glare. Large windows on the north side (in the northern hemisphere) may therefore be preferable, especially for buildings with large internal heat gains. Generally, tall windows increase the penetration of daylight further into the room, as does the use of reflective ceilings, while wide windows increase the spread of daylight across the room. Generally, in deep buildings, it is difficult to bring enough daylight. This may be solved by designing atria in the center of the building or by using light pipes. More information about calculation procedures for daylight assessment may be found in, e.g., the Green Building Bible, vol. 2 (Nicholls and Hall 2008) or Clarke (2001).

5.3.6 Energy Flow due to Internal Heat Gains

Energy is also produced inside buildings by electrical appliances (brown and white goods) like refrigerators, washing machines, computers and printers, by lighting and by people themselves. This energy flow is referred to as internal heat gains.

5.3.6.1 People

The human body produces heat that must be dissipated to the surroundings to maintain the normal body temperature. Heat is dissipated through respiration, convection from skin to air, and sweating. The quantity of heat released depends on the level of activity, the type of clothes worn (insulation and permeability) and the temperature and humidity of the surrounding air. For further reading, see Ashrae Handbook (2009) or Indoor Climate Fundamentals (Van Paassen 2004).

For the calculation of the energy demand of buildings, the internal heat gains $P_{int,people}$ are calculated using the typical metabolic heat generation data of Table 5.4.

$$P_{int,people} = n_{people} \times P_M \quad [W] \tag{5.12}$$

where n_{people} is the number of persons present in the building and P_M the heat gain per person.

Table 5.4 Typical heat gains (P_M) caused by people in W/person

Resting/seating	Office work (writing/typing)	Filing standing	Cooking/walking	Dancing
100	117	144	180	360

Table 5.5 Luminous efficacy range of light bulbs in lumen/W

Incandescent	Halogen	Compact fluorescent	LED	Induction	Fluorescent tubes (argon)	Fluorescent lamps (sodium)
~10–13	~13–18	35–60	45–60	60–90	55–95	100–130

Table 5.6 Maximum allowable lighting power per square meter floor area, P_{light} (W/m^2)

Residential	Office	Retail	School	Theatre
10	12	18	14	28

5.3.6.2 Lighting

The total electrical lighting power to be installed in a building (see Sect. 5.3.5) does not depend on incoming daylight, but the instantaneous used electrical power will do. Next to this, the electrical lighting power depends on the type of lamps used and on the function of the building.

Table 5.5 gives the luminous efficacy range of several types of lamps in lumen per watt (1 lm = 1 lux/m²). As an example taken from Table 5.5, fluorescent sodium lamps need ten times less electrical power than incandescent lamps to achieve the same lighting flux. Incandescent lamps, also called tungsten filament lamps, are the common lamps found in homes. Halogen lamps are a special form of tungsten filament lamps. Compact fluorescent light bulbs are the so-called energy-efficient lamps found in homes as well. Light-emitting diode lamps (LED) are a promising development with potential efficacy of 160 lumen/W and life spans up to 30,000 h. However, this high efficacy has not yet been achieved in practice. Furthermore, in the current state of the art, LED lamps are not always suitable for workspace lighting. Induction lamps are electrode-less lamps with a very long life span (up to 100,000 h). They are very suitable for locations hard to access. Fluorescent tubes, also called tubular lights, are often found in office buildings and schools. These are gas discharge lamps filled with argon or sodium (the latest are also called SON or SOX lamps).

Table 5.6 gives the maximum allowable electrical lighting power [P_{light}; (W/m^2)] per square meter floor area for several building functions, according to Ashrae standard 90.1 (2007); see also LPD (2004). This lighting power can be easily achieved by using current state-of-the-art luminaires. Table 5.6 can be used for a first estimate of the total electrical lighting power P_{light}.

Note that it is possible to reduce this power by locating the lighting in the right place. In an office building, less power than indicated in Table 5.6 may be needed when desk lighting is used instead of standard lighting in the ceiling. The installed power may then be reduced from 12 to about 8 W/m². Note also that the instantaneous power needed may be much less than given in Table 5.6 if use is made of day lighting. At a certain time of the day, there are three possibilities:

- No lighting at all is needed when there is enough incoming natural light or no people are present, $P_{light} = 0$.
- Full power is needed. This is the case at night or during the day in buildings where lighting cannot be dimmed and/or cannot be controlled by zones, P_{light} is taken from Table 5.6.
- Intermediate power: in this case, the lighting is controlled in such a way that the lighting is on exclusively in the zones where it is necessary and/or at the necessary power. This may be achieved by the use of occupancy detection and an appropriate zoning of the lighting control: lighting may be switched off near the windows and be on deeper into the building. Additionally, when the lighting equipment is equipped with a dimmer, only a fraction of the full power described in Table 5.6 is needed: the artificial lighting is then just a complement to the natural lighting when it is insufficient. If twice less light flux is needed, approximately twice less electrical power is needed. By applying this kind of system, up to 50% electrical power may be saved.

Only a very small part of the power fed to illumination equipment is converted to light. The largest part comes directly as free heat in the room through convection and radiation. The light itself is absorbed by the walls and furniture in the room and is finally also converted to heat and released to the room. Therefore, the entire installed electrical power may be assumed to be released as heat. One exception to this is when the luminaries are connected to a ventilation duct and the exhaust ventilation air is expelled via the lighting fixture. In this case, a large part of the convection heat from the light bulbs is taken away and does not add to the internal heat gains. This system is useful for buildings with a high internal heat load and a high cooling demand. The internal heat load by lighting is then reduced by a factor of 0.2–0.6 depending on the air flow rates and the insulation of the air ducts.

The internal heat gains at a certain moment of the day due to artificial lighting may be calculated according to Eq. 5.13.

$$P_{int, lighting} = \zeta_{light, vent} \times \beta_{floor} \times A_{floor} \times P_{light} \quad [W] \tag{5.13}$$

Where A_{floor} is the building's total floor area in m², P_{light} is the lighting's electrical power at the moment considered in W/m² (see Table 5.6), and ζ_{light} is the fraction of the installed power that is released to the room. If the luminaries are not ventilated, $\zeta_{light} = 1$, if they are ventilated, $\zeta_{light} = 0.2$–0.6 (for rough calculation take 0.5). β_{floor} is the percentage of building's floor area where the light is on at the time considered. For simple estimations, consider $\beta_{floor} = 1$.

Table 5.7 Power of appliances in (W)

Desktop + screen	Laptop	Printer	Fridge/freezer	Television	Washing machine
80–150	20–50	75–130	~500	~70	~500

Table 5.8 Estimates of the total electrical power of appliances $P_{appliances}$ (W/m²)

Residential	Office	School	Server room
5	15	5	>500

5.3.6.3 Other Electrical Appliances

For electrical appliances in buildings like computers, televisions, printers, servers, refrigerators, freezers, washing machines, coffee machines, etc., the same considerations can be applied as for lighting: almost the total electrical power used will finally be released as heat in the building. Table 5.7 gives values for the electrical power of a number of appliances.

Table 5.8 gives values of $P_{appliances}$ the total power of all appliances (excluding lighting) per m² floor area for various types of buildings. These values can be used for quick estimates.

The instantaneous internal heat gains at a certain moment of the day due to appliances is calculated according to Eq. 5.14.

$$P_{int,appliances} = A_{floor} \times P_{appliances} \quad [W] \tag{5.14}$$

Total internal heat gains
The total internal heat gains are calculated using Eq. 5.15

$$P_{int} = P_{int,people} + P_{int,lighting} + P_{int,appliances} \quad [W] \tag{5.15}$$

5.3.7 *Thermal Energy Balance for Space Heating and Cooling*

5.3.7.1 A Few Preliminary Words on the Difference Between Power and Energy

The quantities (transmission, infiltration, ventilation, solar gains and internal heat gains) defined in the former sections were expressed in watts (W), which is the unit of power. Energy is expressed in joules (J). One W is equivalent to 1 J/s. The relation between energy and power is therefore straightforward:

$$\text{Energy[J]} = \text{Power[W]} \times \text{time (s)}$$

In other words, the quantity of energy produced by a process with power P during time t is the product of $P \times t$. When the time is expressed in hours instead of seconds,

Table 5.9 Conversion table for energy units (note that $1\ W = 1\ J\ s^{-1}$)

From	To MJ, multiply by:
MJ	1
kWh	3.6
ktoe	$41{,}868 \times 10^3$
Mcal	$41{,}868 \times 10^{-4}$
MBtu	1,055.1

Table 5.10 Unit prefixes

From	To unit, multiply by:
K (kilo)	10^3
M (mega)	10^6
G (giga)	10^9
T (tera)	10^{12}
P (peta)	10^{15}

the energy is expressed in Wh instead of J. Table 5.9 gives the conversion factors between different units for energy, the SI unit being J. Additionally, Table 5.10 gives some usual unit prefixes used to quantify energy consumption.

The energy demanded during 1 h and expressed in Wh is therefore identical to the (average) power during this 1 h. Therefore, the energy flows during 1 h are defined as follows:

$$Q_{trans} = P_{trans} \quad [Wh], \text{ see Eq. 5.5}$$
$$Q_{inf} = P_{inf} \quad [Wh], \text{ see Eq. 5.6}$$
$$Q_{vent} = P_{vent} \quad [Wh], \text{ see Eq. 5.9}$$
$$Q_{sol} = P_{sol} \quad [Wh], \text{ see Eq. 5.11}$$
$$Q_{int} = P_{int} \quad [Wh], \text{ see Eq. 5.15}$$

Note that the powers are average powers during 1 h. This means that the temperatures used in Eqs. 5.1, 5.4, 5.6 and 5.9 should be mean temperatures during 1 h. The air flow rates used in Eqs. 5.6 and 5.9 must also be averaged for 1 h, as well as the solar radiation used in Eq. 5.11 and all internal heat data used in Eq. 5.15.

5.3.7.2 Hourly Thermal Energy Balance

We saw in Sect. 5.3.1 that to determine how much energy a building needs to be maintained at a certain temperature, the inventory of all energy flows through and into the building is needed. If the sum of these energy flows is negative, the building receives too little heat and needs additional incoming energy flow to maintain its temperature at the right level (heating). If the sum of these energy flows is positive, the building receives too much heat and this heat must be carried out by cooling. Using the equations determined in the former sections, this means that:

$$Q_{balans} = Q_{trans} + Q_{inf} + Q_{vent} + Q_{sol} + Q_{int} \quad [Wh] \tag{5.16}$$

Where Q_{trans} is determined by Eq. 5.5, Q_{inf} by Eq. 5.6, Q_{vent} by Eq. 5.9, Q_{sol} by Eq. 5.11 en Q_{int} by Eq. 5.15.

If $Q_{balans} > 0$, heat must be carried out by cooling : $Q_{cooling} = Q_{balans}$

If $Q_{balans} = 0$, there is no heating or cooling demand in the building.

If $Q_{balans} < 0$, heat must be supplied to the building : $Q_{heating} = |Q_{balans}|$

$Q_{cooling}$ is referred as the cooling demand of the building during the considered hour and $Q_{heating}$ as the heating demand.

5.3.7.3 Yearly Thermal Energy Balance

To calculate a realistic energy demand, the required indoor temperature should be chosen adequately. This so-called design temperature may be prescribed in the building codes of countries. Generally, one can assume an indoor temperature (T_i) of 20°C in the cold season and an indoor temperature of 24°C in the warm season. However, be aware of regional preferences and legislation.

Calculations Using Hourly Weather Data

When working with hourly weather data (temperature and solar radiation), making a yearly energy balance is straightforward. Equation 5.16 can be repeated for all 8,760 h of 1 year, using, for instance, a spreadsheet program like Excel.

Yearly Heating and Cooling Demand

Figure 5.14 gives an example of results obtained for the hourly cooling and heating demands. The sum of all positive hourly values gives the total yearly energy demand for cooling in Wh. The absolute value of the sum of all negative hourly values gives the total yearly energy demand for heating in Wh. Note that this sum is equal to the area under the curves.

Heating and Cooling Load/Capacities

When designing heating and cooling equipment for a specific building, the sizing of the equipment is essential. The size of the heating and cooling equipment is referred as heating or cooling load, or as heating or cooling capacity or as peak load (all terms are equivalent). This is the maximum power needed during the year for cooling or heating, expressed in W. The heating load $P_{heating}$ is therefore the maximum

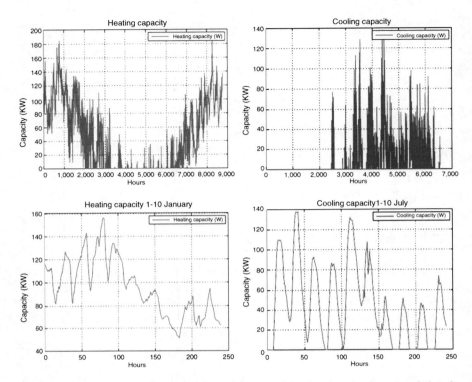

Fig. 5.14 The hourly heating and cooling capacities (*above* for the complete year, *below* for 10 days) that are also the hourly energy demand for heating. The area under the upper curve equals the sum of all hourly values and is equal to the yearly energy demand. The maximum value represents the capacity (or peak load), in this case ~185 kW for heating and 140 kW for cooling

hourly value of $Q_{heating}$ found in the range 1–8,760. The cooling load $P_{cooling}$ is the maximum hourly value of $Q_{cooling}$ found in the range 1–8,760 (be aware that, as seen in Sect. 5.3.7.1, because the calculations are hourly, the values of the powers $P_{cooling}$ and $P_{heating}$ (in W) are identical to the values of $Q_{cooling}$ and $Q_{heating}$ (in Wh)).

Note that these static load and energy demand calculations are not very accurate because the time lag introduced by heat accumulation in the building is not taken into account. This may introduce important overestimations of the cooling load in particular. Note also that, in detailed dynamic models, the energy balance is made not only on room air but separately on walls, windows and room air in the different zones of the buildings (see also Clarke 2001).

Simplified Calculations

When hourly weather data are not available, simplified calculations are possible using the degree day method or the load factor method. For detailed explanations on these methods, see ASHRAE 2009.

Table 5.11 Estimation of typical full load hours for heating and cooling in the Netherlands (Source: TNO)

	Residential	Offices	Schools
$h_{heating}$	~1,500	~1,200	~1,000
$h_{cooling}$	~100	~1,000	~1,000

Load Factor Method

The load factor method uses a simplified heating and cooling capacity calculation in combination with load duration curves. The heating capacity $P_{heating}$ is calculated based on a simplification of Eq. 5.16, where solar and internal heat gains Q_{sol} and Q_{int} are neglected to cover the case where the building must be maintained at temperature when both gains are not present (for instance at night). The chosen outdoor temperature must reflect the coldest temperature in the region. The cooling capacity $P_{cooling}$ is calculated according to Eq. 5.16, based on the highest occurring outdoor temperature (if this temperature is higher than the indoor design temperature), and the highest occurring solar gains and internal heat gains. The yearly energy demand is then calculated using Eqs. 5.17 and 5.18:

$$Q_{heating} = P_{heating} \times h_{heating} \quad [Wh] \tag{5.17}$$

$$Q_{cooling} = P_{cooling} \times h_{cooling} \quad [Wh] \tag{5.18}$$

Where $h_{heating}$ is the number of full load hours for heating and $h_{cooling}$ is the number of full load hours for cooling. The number of full load hours is the number of hours that the maximum heating (or cooling) capacity would have been needed to achieve the same yearly energy demand as in reality. Practically, the number of full load hours is statistically calculated from a large number of buildings from which the annual energy demand and the installed capacities are known. This method may be used for a very rough estimation, but is very inaccurate as the number of full load hours does not relate to a specific building but is an average. Table 5.11 gives some typical full load hours for the Netherlands (moderate sea climate).

Degree Day Method

Heating degree days (HDD) are the sum of the temperature differences between the outdoor temperature and a reference temperature chosen to be representative for the outdoor temperature under which heating is needed. If the outdoor temperature is above this reference temperature, there is no heating need. The reference temperature used depends strongly from the location of the building. In the U.S., reference temperatures of 18 or 15.5°C are used.

$$HDD = \sum_1^{365} \max(T_{ref} - T_o, 0) \tag{5.19}$$

where T_o is the average outdoor day temperature (over 24 h) and T_{ref} the chosen reference temperature.

Cooling degree days (CDD) are defined in the same way:

$$CDD = \sum_{1}^{365} \max(T_o - T_{ref}, 0) \tag{5.20}$$

The yearly energy demand is then calculated using Eqs. 5.21 and 5.22:

$$Q_{heating} = P_{heating} \times HDD \times 24 / (T_i - T_o) \ [Wh] \tag{5.21}$$

$$Q_{cooling} = P_{cooling} \times CDD \times 24 / (T_i - T_o) \ [Wh] \tag{5.22}$$

Where $P_{heating}$, $P_{cooling}$, T_o and T_i are calculated according to the rules described for the load factor method (For $Q_{heating}$, T_o is the coldest outdoor temperature- the one used to calculate $P_{heating}$. For $Q_{cooling}$, T_o is the hottest outdoor temperature- the one used to calculate $P_{cooling}$. T_i is the indoor temperature used to calculate $P_{heating}$ and $P_{cooling}$ respectively).

When using this method, it is very important to use the right degree days (right reference temperature and right location). In buildings with large internal heat gains or large solar heat gains, the results for the yearly heating and cooling demand may be very inaccurate as these demands depend for only a small part on the outdoor temperature.

5.3.7.4 Minimizing the Energy Demand for Space Heating and Cooling

We saw in the previous section that the thermal energy demand for space heating and cooling depends on the transmission losses, the infiltration and ventilation losses, the solar heat gains and the internal heat gains. It also may be that solutions to decrease the heating demand may increase the cooling demand and vice-versa. That is why the simulation of a specific building with its specific characteristics is needed to avoid suboptimization. Important relationships between design characteristics are highlighted below.

Indoor Temperature

Considerable energy savings may be achieved by using an indoor design temperature T_i that is not constant all over the year. Because people have a large adaptation capacity, an indoor temperature lower in winter than in summer is acceptable, and even recommended, e.g. 20°C in winter and 24°C in summer. The energy savings in comparison with a building that would be maintained to 22°C throughout the year will be considerable. Lowering the design temperature to 19°C in winter may also be effective, but may be thought to be too low especially by the elderly. Accepting a higher indoor temperature in summer is a very efficient way to reduce the cooling demand, but can only be done with certain types of ventilation. In a completely air conditioned building (mechanical supply and exhaust ventilation) with no possibilities to open windows, a temperature of 24°C should not be exceeded. If natural ventilation is possible and the windows can be opened, occupants will accept an indoor temperature of 28°C.

Insulation

In older (non-renovated) buildings, the heating demand is for a large part determined by the transmission losses. These losses can be strongly reduced by insulation. In so-called passive dwellings, R_c values above 8 W/m^2 K are used and combined with a very high air-tightness. In this way, the heating demand is reduced to almost zero (see http://www.passiefhuisplatform.be). In countries with hot summer temperatures, insulation will also help by reducing the cooling demand. However, in moderate climates, in buildings with a high internal heat load that also have a cooling demand when the outdoor temperature is low, insulation may prevent the heat being released "freely" outdoors. Calculations of the yearly heating and cooling energy demand should show which U value is optimum for a specific building and a specific climate.

From the point of view of reducing the transmission heat losses, large windows should be avoided because their U value is much higher than the U value of walls. However, large windows increase the solar heat gains. Therefore, depending on the U value of the window, on the orientation of the façade and on the outdoor climate, there is an optimum size of the window that reduces the heating energy demand and the cooling energy demand.

Ventilation and Infiltration

Reducing the uncontrolled infiltration losses is efficient to reduce the heating energy demand (and the cooling energy demand in hot countries). However, in moderate climates, in buildings with a high internal heat load that also have cooling demand when the outdoor temperature is low, a high infiltration rate would help in free cooling the building. In air-tight buildings, a mechanical air supply or exhaust is needed to ensure enough fresh air, especially when the occupancy rates are high. However, as seen in Sect. 5.3.4, Eq. 5.10 (see also Sect. 5.4), additional electrical energy is needed to power the ventilators, which may counteract the energy saved by reducing the infiltration losses. The same happens when mechanical ventilation is used instead of natural ventilation.

Applying night ventilation is a very efficient way to reduce the energy demand for cooling during long warm periods. By ventilating the building with cold fresh air at night, the indoor air temperature of the building and the wall temperatures will be reduced considerably, in such a way that the next day will start with a cool temperature which will increase during the day, but will be strongly reduced again during the next night. However, to achieve large energy savings, the building must be designed in such a way that natural night ventilation is possible, otherwise large ventilators must be used (mostly an air change rate of 5 is needed), increasing the use of electrical energy (see Eq. 5.10 and Sect. 5.4). The same considerations can be applied to free cooling with which cold outdoor air is used to cool buildings having a cooling demand when the outdoor temperature is lower than the indoor temperature. The cooling effect can be enhanced by using solar chimneys that will increase the air volume flow rates on a natural way, without the use of a ventilator, only using the temperature stack effect and pressure effects (see, for more information, Natvent 1998).

Solar Gain

An increase in solar gains by placing large and well-insulated windows facing
the south side (on the northern hemisphere) or in a west–east orientation, will
decrease the heating energy demand, but will increase the cooling demand. This
may be desirable in the heating season, but not in the cooling season. The use of
outdoor sunshades is therefore very important to keep out the sun when it is too hot.
In buildings with a high internal heat load, it may also be worth placing only small
windows on the south face and placing large ones on the north. Large windows on
the north face allow for the penetration of diffuse natural light. On the south,
the direct radiation produces glare that should be avoided to ensure a good visual
comfort. Furthermore, when the level of natural lighting is high, the sunshades
will be put down and artificial lighting will be put on, which may be avoided by
designing smaller windows on the south.

Note also that greening the facades, roofs and the close environment of the
building can reduce considerably the solar heat gains and therefore the cooling
demand.

Internal Heat Gains

In buildings with a high heating demand, it may seem preferable to have large inter-
nal heat gains in order to reduce this heating demand. However, large internal heat
gains produced by lighting and electrical appliances also produce a high electrical
energy demand, which should be avoided (see Sects. 5.4 and 5.5).

5.3.8 Other Thermal Energy Demand: Warm Tap Water and Cooking

Next to the thermal energy demand for heating spaces, heating energy is needed for
the production of warm tap water and for cooking. The energy demand for cooking
is generally low (under 5% of the total energy use, see Fig. 5.6), except for specific
building functions like restaurants and is not treated here.

Energy use for water heating is not negligible (see Fig 5.6) and especially in
well-insulated new buildings it represents more than 25% of the total energy use.
The heating energy demand for warm tap water depends on the quantity of water
used at kitchen taps, wash basins, showers and baths (for more information, see
ASHRAE 2007).

The yearly heating energy demand for hot tap water is calculated using Eq. 5.23

$$Q_{hottapwater} = 365 \times \rho V C_p (T_{hot} - T_{cold}) / 3,600 \ [Wh] \qquad (5.23)$$

Where ρ is the density of water (1,000 kgm^{-3}), V the daily average volume of
water in m^3, C_p the specific heat of water (4,187 Jkg^{-1}K^{-1}), T_{cold} the temperature of
the cold water and T_{hot} the warm water temperature.

Table 5.12 Average daily hot water demand (in liters) in the US

Residential	Offices	Schools
130–160 L/dwelling	3.8 L/person	2–7 L/student

Table 5.12 gives indicative values of the average daily water use for different types of buildings. Be aware that large deviations from this table may occur depending on country, climate and culture.

To calculate the peak load for hot tap water (heating capacity of the hot tap water equipment), the maximum volume flow rate per minute must be known. In residential buildings, it will be approximately 0.01 liter per second per person and the peak load in W can then be calculated using Eq. 5.24:

$$P_{\text{hottapwater}} = \rho V_{\text{max}} C_p (T_{\text{hot}} - T_{\text{cold}}) \ [W] \tag{5.24}$$

Where V_{max} is the maximum flow rate in m³/s.

To reduce the heating energy demand (Eq. 5.23) there are two possibilities: to reduce the volume of water used and to use lower temperatures for the hot tap water.

To reduce the volume of used warm tap water, water-saving taps and shower heads can be used, which may save up to 60% water. For warm tap water applications, a temperature of approximately 45°C is needed. However, at this temperature, there is a large risk of growth of the legionella bacteria, which causes legionnaire's disease. To avoid this, the temperature of warm tap water systems is usually maintained at 60°C. A way to reduce the energy demand is to heat the warm tap water most of the time up to 45°C and periodically above 60°C, to kill the bacteria. Other ways of killing the legionella bacteria are by using chemicals, e.g., with chlorodioxide or hydrogen peroxide.

5.4 Demand Side: Electrical Energy Demand of Buildings

As seen in Sect. 5.3, energy is needed to power the electrical appliances present in buildings. The electrical energy demand is determined by the electricity needs of ventilators for ventilation, lighting and other electrical appliances.

The yearly electricity demand is calculated using Eq. 5.25:

$$Q_{\text{electrical}} = \sum (P_{\text{elec,vent}} \times h_{\text{vent}}) + P_{\text{light}} \times A_{\text{floor}} \times h_{\text{lighting}}$$
$$+ \sum P_{\text{appliances}} \times A_{\text{floor}} \times h_{\text{appliances}} \ [Wh] \tag{5.25}$$

Where $P_{\text{elec,vent}}$ is determined for each ventilator by Eq. 5.10, P_{light} by Table 5.6 and $P_{\text{appliances}}$ by Table 5.8. The factors h represent the number of full load hours of the ventilators, lighting and appliances respectively. A_{floor} is the total floor surface area.

Note that, if vertical transport is needed (lifts), this should be added to the electrical energy demand. In high rise buildings, lifts may be responsible for up to 5% of the total energy demand.[1]

[1] http://www.e4project.eu/. Accessed March 2011.

Box 5.2 Electrical Energy Demand in Buildings

The electrical energy demand of buildings may be very high and has increased a great deal in the past years. Although household and office appliances are using less and less energy, the total electricity demand is still increasing because of the large amount of appliances being used. In low energy buildings, the electricity demand may be more than half of the total energy demand (see Figs. 5.15 and 5.16).

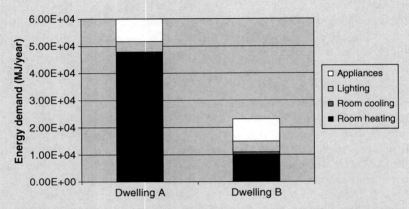

Fig. 5.15 Calculated average annual energy demand (MJ/year) for a pre-1940 poorly insulated (A) and a modern well-insulated (B) Dutch dwelling (A_{floor} = 80 m²). The electricity demand consists of the houses' appliances and lighting

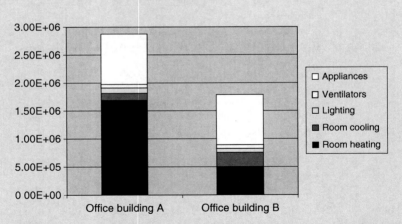

Fig. 5.16 Calculated average annual energy demand (MJ/year) for a pre-1940 poorly insulated (A) and a modern well-insulated (B) Dutch office building (A_{floor} = 3,000 m²). The electricity demand consists of the buildings' appliances, ventilators and lighting

In Sect. 5.5, we will see that electricity is energy of a much higher quality than the heat or cold needed in buildings. It is therefore important to find ways to limit the electrical energy demand of buildings. Note also that the electrical energy demand is not a "real" demand: electricity is a way to provide lighting or to power appliances. A reduction of the electrical energy demand of buildings can be achieved by using efficient lighting, by making as much as possible use of natural lighting, by using natural ventilation instead of mechanical ventilation and by using energy efficient appliances. This in turn will help to reduce the cooling energy demand, but will increase the heating energy demand because of the reduced internal heat gains.

Note also that the actual electricity consumption of a building may be much higher than calculated by Eq. 5.25 because (parts) of the heating demand and cooling demand may be met by heat and cold generation systems driven by electricity. However, this electricity does not belong to the specific electricity "demand" of the building (see also Sect. 5.6).

5.5 Energy Distribution: Between Supply and Demand

To meet the thermal and electrical energy demand, distribution equipment like piping, ventilators, pumps, radiators and electrical wiring are needed from the energy conversion systems to the building of parts of the building that should receive this energy. The energy conversion itself (see Sect. 5.6) may be placed inside or outside the building (e.g., a power plant).

The energy losses in the distribution equipment also affect the quantity of energy that must be supplied to the building in terms of electricity, gas (or any other fuel supplied to the house) or heat (in case of district heating). Note that the energy distribution and energy supply within the building is mostly referred in the literature as heating, ventilating and air-conditioning equipment (HVAC).

5.5.1 Thermal Energy Distribution

The aim of the thermal energy distribution system is to transport heat (or cold) from the conversion system (supply) to the building and to the rooms. The two basic choices that must be made concern the choice of the energy-carrying medium and the choice of the temperature level of the energy distribution system.

5.5.1.1 Energy Distribution: Water or Air?

Two main energy carriers are used in buildings: air and water, with preferences varying by traditions, countries and types of buildings. Transport of heat by air has been used widely, especially in non-residential buildings like office buildings. In this case, the quantity of heat/cold is brought into the rooms through the ventilation

air that is first heated or cooled in an air handling unit. The maximum temperature (for heating) and the minimum temperature (for cooling) of the air are limited by comfort considerations. Generally, the air flow rate needed for ventilation (to bring enough fresh air) is not sufficient to heat or cool the building. When air is used as the energy carrier, much larger ventilation air flow rates must be used than described in Sect. 5.3.4. This means much larger air ducts in the building and higher ventilator energy. The main advantage of air systems is that they are relatively cheap. No radiators are needed in the rooms, which is attractive from the viewpoint of space use and safety; for instance, nobody's hands can be burnt by a too hot radiator. This may be an important consideration in the design of nurseries or hospitals. However, these systems are not always very comfortable and are not as energy efficient as water systems.

Water systems, as used in radiators, floor heating or district heating, can carry much more energy per unit volume (specific heat of air is 1.2 $kJm^{-3}K^{-1}$, while the specific heat of water is 4,200 $kJm^{-3}K^{-1}$) and much smaller distribution pipes are needed than with air.

In large non-residential buildings, a mix of energy distribution by air and water is used.

5.5.1.2 Low Temperature or High Temperature Heating Distribution Systems?

In a high temperature distribution system, water at 90°C is used in radiators. Low temperature radiators used heat in the range 55–70°C. In floor or wall heating, water with a temperature in the range 30–45°C is used. Generally, low temperature systems are larger than high temperature systems because the heat transfer coefficient is lower at lower temperatures and because the average temperature difference between the heating system and the indoor temperature is lower. As the quantity of heat transferred is proportional to the temperature difference and the heat exchange area, low temperature systems require a larger area than high temperature systems. That is why conventional radiators are smaller than low temperature radiators. The surface area of a low temperature radiator is in turn much smaller than the heat exchange area in a floor heating system.

The choice for a low temperature or a high temperature system does not influence the energy demand – we have seen the factors of influence in Sects. 5.3 and 5.4.[2]

The choice for a low temperature or a high temperature system does, however, influence the efficiency of the energy conversion systems (see Sect. 5.6). Generally, the efficiency of energy conversion is higher when the distribution temperature is lower. This is especially the case in boilers (see Sect. 5.6.7.1 for the working principle): if the distribution temperature is low enough, the water vapor contained in the flue gas (exhaust gas) can be condensed and the latent heat of condensation can then be recovered, resulting in a higher efficiency.

[2]However, a low temperature heating system can influence the heating demand because the high radiation temperature of walls and floors may allow for a lower indoor air design temperature (see Chap. 7.3.1).

The efficiency of heat pumps (see Sect. 5.6.8) also relates to the heating temperature; the lower this temperature, the higher the efficiency. Heat pumps cannot be used with high temperature distribution systems, because their efficiency would be dramatically low.

The principal advantage of using low temperature heating is that it makes the use of more efficient energy conversion systems possible, like heat pumps or solar heat. Note that, conversely, high temperature cooling results in higher efficiency of a cooling machine than low temperature cooling.

5.5.1.3 Energy Losses During Distribution

Energy losses in distribution systems arise from heat losses and from pressure losses.

The energy needed by pumps and ventilators used to circulate the energy-carrying medium is proportional to the pressure losses in the distribution system, to the volume flow rate and additionally to the efficiency of the ventilator/pump. The longer the distribution pipes and the more bends they have, the higher are the pressure losses. Minimizing pipe length and the number of bends will lead to energy savings.

Heat losses are proportional to the temperature difference between the energy carrying medium and the temperature of the environment, and to the length of the pipe. Especially in large distribution systems outside the building, as in district heating, the energy losses may be very high. Pipes should therefore be insulated and temperatures as low as possible should be used. Energy losses in large distribution systems may be up to 25%.

5.5.1.4 Energy Storage

Because energy demand and energy supply are not always simultaneous, especially when renewable energy sources are used (e.g., solar boiler; see Sect. 5.6.7.2), thermal storage is needed. Heat or cold can be stored in water tanks or phase change materials. It can also be stored in the ground as in seasonal energy storage in aquifers (see Sect. 5.6.9). Storage is necessary to obtain stabile systems, but causes additional heat losses.

5.5.2 Electrical Energy Distribution

Electricity is transported from a central power plant to the consumer. This is done by a high voltage distribution system (200 kV) that transports the electricity on long distances. Close to industrial or built environments, a lower voltage distribution system is used (10–110 kV). Finally, electricity is transported to households using low voltage distribution (110–230 V). The energy losses in the power lines are less in the high voltage part (~1%) than in the low voltage part (~5%). Energy losses in transformers may be considerable, especially if the system is not well designed. The total energy losses may vary from 4% up to 15%.

The low energy losses in the high voltage part makes that it is possible to transport electricity on very long distances.

5.5.2.1 DC/AC

Conventional power plants produce AC current (alternative current) which is distributed through the electricity grid. Most household and office appliances work with DC current (direct current) and are equipped with inverters that convert AC into DC. During this conversion process energy losses up to 7–8% occur. Photovoltaic cells produce DC current, but because all appliances are equipped with a converter, the DC current produced by the PV cell must first be converted to AC current, before being re-converted to DC current, doubling the energy losses. It would be much better to directly use the DC current in the appliances.

5.5.2.2 Smart Grids

Future electricity grids are expected to increase in complexity by combining different electricity production processes: electricity from power plants, but also from wind or solar energy produced by the consumer itself, must be fed to the grid and the supply must be matched to the demand: what source should be used when? These smart grids are expected to increase the possibilities for renewable energy, as the storage problems usually encountered with renewables when used in stand-alone mode are solved by using another energy resource in the grid, instead of by storage. Electricity produced by wind is used when there is wind. If there is no wind, other sources like a central power plant are used.

5.5.3 Match Between Demand and Supply: Exergy Approach

The first principle of thermodynamics is that of energy conservation. It states that the sum of all energy input into a system is equal to the sum of the increase in internal energy within the system and the energy rejected by the system. Taken literally, this means that saving energy is not possible, as energy is never destroyed. In every real process, however, something is destroyed, and that is the quality of the energy, also called exergy. This is the subject of the second principle of thermodynamics. Energy produced at higher temperatures is of higher quality, meaning that more work (power) can be produced with this energy. For instance with a battery of energy content of 1 kWh, a computer or a light bulb or a motor can be driven. With 1 kWh steam at 600°C, electricity can be produced in a turbine (see Sect. 5.6). With 1 kWh of water at 100°C, cooking is possible. With 1 kWh of water at 40°C, you can only wash the dishes.

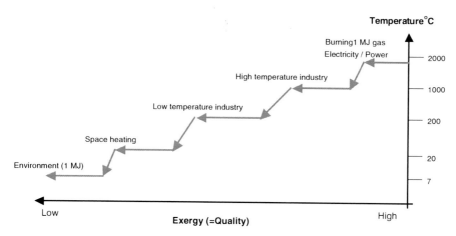

Fig. 5.17 Exergy, or energy cascading

Figure 5.17 provides an illustration of a situation in which the temperatures of several types of energy produced by the combustion of gas are plotted against the quality of the energy. In this example, the combustion of gas delivers 1 MJ of electricity (see also Sect. 5.6). Electricity is of maximum quality, as it can be fully converted into power. During this conversion, heat at lower temperatures will be rejected. On the other hand, heat at the temperature of the outside air (7°C in Fig. 5.1) is in equilibrium with its surroundings, and can therefore no longer be converted into electricity or power. This is why burning gas in a boiler in order to heat a building is very inefficient; the potential of the gas is not fully used. Gas is burned at approximately 1,800°C, whereas heat in a building is needed at about 30°C. With the same quantity of gas, it would have been possible to produce electricity and power. The residual high temperature heat could have been used in the process industry. Residual heat from this process could have been used by a low-temperature industry (e.g., the pulp industry), and this heat would have eventually reached a temperature suitable for heating a building (about 30°C). A consequence of the direct use of gas to produce heat for a building is that the electricity of power that has not been generated must be generated by other means, and this increases the primary use of fuels and the related emissions. Exergy is therefore a good measure for the sustainability of a system. More information on this subject can be found in the Lowex guidebook (IEA 2004).

Practically, this means that a very powerful way to save primary energy is to apply the exergy cascading principle by systematically re-using waste heat when present at a useful temperature. At all levels of a system (energy conversion system, building, neighborhood, city, region), it is worth making an inventory of waste heat flows (or cold flows) and where they could be reused (see also Sects. 5.6.3.3 and 5.6.3.4, and the example provided in Chap. 2, Fig. 2.17).

5.6 Supply Side: Energy Conversion Systems and Primary Energy Use

5.6.1 Introduction

Energy conversion systems are systems that convert natural resources into usable energy like heat, cold or electricity. As seen in Sect. 5.2, energy conversion systems in the built environment may be located locally (in the building itself), centrally at a block level (e.g., a central boiler in a block of buildings) or centrally at a district or city level.

The term energy supply covers both energy conversion systems and supply of natural resources to feed these energy conversion systems. The total energy content of the natural sources used in central and de-central energy conversion systems is called the primary energy consumption. It represents the heat that can be produced by the complete combustion of the fuel. This quantity of heat obtained from one unit of fuel is called the lower heating value (or net calorific value) of the fuel and is expressed in joules (J), watt-hour (Wh) or ton oil-equivalent (Toe) (see Table 5.9). Table 5.13 gives the lower heating values of the main fossil fuels. This value varies according to the quality and provenance of the fuel. The fuel used and the conversion process both determine the emissions (e.g., CO_2) in the atmosphere, see Fig. 5.7.

5.6.1.1 Local Energy Supply

Local energy conversion entails equipment at building level like boilers, heat pumps or compression cooling machines, local photovoltaic cells, solar boilers or small wind turbines. In general, the combustible resources needed to power the local conversion systems (e.g., gas, oil or wood), together with resources centrally converted (electricity, heat or cold), determine the energy bill of the occupant. In some situations, the occupant may feed the energy he generates himself (like electricity from photovoltaic cells or heat from a small cogeneration plant) to the central distribution system and get a financial reward for it.

5.6.1.2 Central Energy Supply

Heat, cold and electricity may also be supplied to buildings from a central energy conversion system like a power plant producing electricity and heat (district heating). This electricity and heat must be generated from natural resources as well and distributed.

Table 5.13 Net calorific value per fuel type

	Net calorific value
Hard coal	24–31 MJ/kg
Crude oil	42–44 MJ/kg
Natural gas	31–38 MJ/m^3

Table 5.14 Classification of energy generation systems

Heating	Cooling	Electricity
Boiler		Power plants
Solar boiler	(Adiabatic cooling)	
Heat pump	Cooling machine	Photovoltaic
Heat storage in ground	Cold storage in ground	Wind
Geothermy		Geothermy
Waste heat		Hydro/tidal

Cells having identical patterns refer to cogeneration possibilities

There are many different systems to convert fuels into heat, cold or electricity. Some systems are based on cogeneration, meaning that one system produces at the same time electricity and heat or heat and cold. The efficiency of the conversion process η determines the primary energy used for a given energy demand. When cogeneration is not applied, the primary energy use E is given by Eqs. 5.26–5.28:

$$E_{heating} = Q_{heating} / \eta_{heating} \tag{5.26}$$

$$E_{cooling} = Q_{cooling} / \eta_{cooling} \tag{5.27}$$

$$E_{electrical} = Q_{electrical} / \eta_{electrical} \tag{5.28}$$

Where $Q_{heating}$ and $Q_{cooling}$ are the heating and cooling energy demand as calculated in Sect. 5.3.7.3 ($Q_{heating}$ may also include $Q_{hottapwater}$ described in Eq. 5.23). $Q_{electrical}$ is the electricity demand described by Eq. 5.25.

The total primary energy use is then:

$$E = E_{heating} + E_{cooling} + E_{electrical} \tag{5.29}$$

When cogeneration is applied, the calculations are not straightforward and will be described in Sect. 5.6.4.

Table 5.14 gives a classification of the most important energy generation systems for heating, cooling and electricity. Free night cooling will not be treated here because it is in fact a (very efficient) way to influence the energy demand of the building, see Sect. 5.3.7.4. The same considerations are applied to concrete activated floors and the use of phase change materials in ceilings (see Sect. 5.3.5) for cooling.

5.6.2 Power Plants

Electricity may be produced by an electromagnetic generator powered by fossil fuel or biomass burning, nuclear power, hydropower, wind or solar energy (hydropower, wind, solar and biomass are treated separately in Sect. 5.6.3). It may also be produced by chemical reactions like hydrolysis in a fuel cell or by use of the photo-electric effect like in photovoltaic cells. Other ways of producing electricity

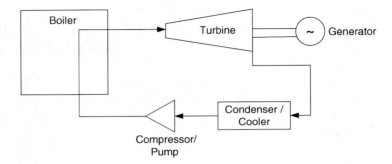

Fig. 5.18 A simple steam cycle

(e.g., triboelectric effect, thermoelectric effect as in thermocouples and piezoelectric effect are not discussed here, as their impact on large-scale electricity production is very limited). A typical power station has a capacity of 6–3,600 MW, but smaller units in the range 50 kW–6 MW can also be found.

5.6.2.1 Electromagnetic Generation of Electricity with Fossil Fuels

This is the conventional way of producing electricity in a power plant. The electricity is produced by an electromagnetic generator. Such a generator follows basically the law of Faraday (1831) that states that if a conductor (for instance a copper wire) placed in a magnetic field is moving, this produces a displacement of the electrical loads, i.e., an electrical current is created in the conductor.

A turbine is used to rotate the wire in the magnetic field. The turbine itself is activated by a moving fluid that acts on the blades so that they rotate and impart their energy to the rotor. The fluid may be gas, steam, a combination of both or renewable sources like wind or hydropower (see Sect. 5.6.3.1).

Gas Turbine or Steam Turbine

In a gas turbine, gas is burned and the flue gas resulting from the combustion (e.g., CO_2, CO, N_2) is expanded with high velocity into the turbine where it makes the blades of the turbine rotate. In a steam turbine (see Fig. 5.18), the gas is burnt in a boiler, heating water to steam. This superheated steam is used to rotate the turbine. The steam is then collected after the turbine in such a way that a closed cycle is realized. The efficiency of the electricity generation is directly related to the needed energy input (at the boiler) for this closed cycle (thermodynamic efficiency of the

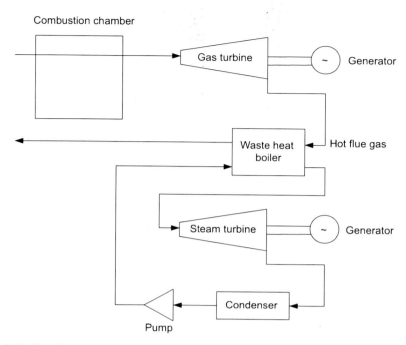

Fig. 5.19 Combined heat and gas cycle

cycle). The efficiency of the electricity generation $\eta_{electrical}$ in a gas or steam turbine power plant is approximately 30–40%, meaning that to produce 0.30–0.40 J electricity, resources containing 1 J net calorific value are needed. The differences between the primary energy and the electricity produced comes from the quantity of energy needed to power the air compressor and also consists of the heat losses into the open air: the flue gas leaving the turbine after expansion still has a high temperature (~400–600°C). In a conventional gas turbine power plant, this flue gas is just released to the open air. However, this flue gas may be used for high temperature industrial heating processes (e.g., refineries; see also Sect. 5.5.3).

Combined Steam and Gas Turbine

It may also be used to heat water and produce steam in a steam boiler. If this steam is expanded into an additional turbine, an additional generator may be driven, producing free additional electricity. This is the so-called steam and gas cycle, sometimes referred as Combined Cycle Power Plan (CCPP) or Combined Cycle Gas Turbine (CCGT), see Fig. 5.19. The efficiency of electricity generation $\eta_{electrical}$ in such a combined cycle may be up to 60%.

Fig. 5.20 Working
principle of a fuel cell

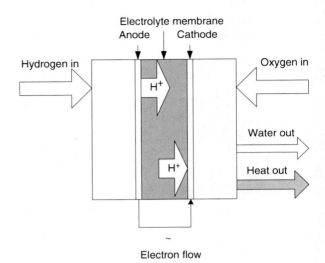

Gas turbine cycles and combined cycles may use natural gas as fuel, oil or coal, or a mixture. In energy statistics (e.g., IEA), the average fuel mix used in power plants is referred as electricity mix. Synthesis gas may be used as well as biofuels. The advantage of biofuels is that they are renewable. However, they produce emissions during combustion (see Sect. 5.6.3.2).

Nuclear Plants

In a nuclear power plant, the heat coming from the controlled fission of uranium or plutonium atoms is used to heat water and produce steam that is fed to the turbines. The electrical efficiency $\eta_{electrical}$ of a nuclear plant is about 0.33. The CO_2 emissions from a nuclear plant are practically zero, but nuclear waste is highly toxic.

5.6.2.2 Electromagnetic Generation of Electricity with Renewables

See Sect. 5.6.3.2.

5.6.2.3 Chemical Generation of Electricity by Fuel Cells

A fuel cell (see Fig. 5.20) works according to the same principle as a battery, except that the fuel is brought continuously to the cell. A redox reaction takes place. Oxidation occurs at the anode (produces electrons) and reduction at the cathode. An electrolyte (a substance conducting electricity) is placed between the cathode and the anode producing a current that can be collected by brushes at the anode and the cathode (for more information, see EG&G Technical Services (2005) (*Fuel cell*

handbook)). Most fuel cells use hydrogen as fuel. Hydrogen reacts with oxygen from air producing electricity and water and heat as by-products.

The sustainability of fuel cells is highly dependent on the way hydrogen is produced. Hydrogen can be produced chemically from a wide range of fossil (steam reformation) and renewable fuels (biomass gasification and reformation), from electrolysis or from a photosynthesis process using algae. When fossil and biomass fuels are used, CO_2 emissions are produced. When electrolysis is used, electricity is needed for the process; therefore, the sustainability of the electricity used determines the sustainability of the fuel cell. Promising developments are expected in the production of hydrogen by algae. The efficiency of the electricity production $\eta_{electrical}$, defined as the ratio between the electricity produced and the energy content of hydrogen, is generally in the range 0.35–0.65 depending on the type of electrolyte and fuel used.

5.6.3 Renewable Sources for Electricity Production

5.6.3.1 Wind and Hydropower

Instead of using gas or steam to drive a turbine, wind or water falling on the turbine blades can be used. Hydropower plants are generally placed outside urban areas. Unlike hydropower, wind energy produces intermittent power. This means that wind energy cannot be used to provide the base load, unless electricity storage is applied in flywheels, batteries, capacitors or CAES technology (Compressed Air Energy Storage in which the air for the combustion chamber is pre-compressed with off-peak electricity). This is now a large area of research, because of its importance for the success of wind energy, and to a lesser extent bio-fuels that mostly have a seasonal cycle.

As well as large off-shore and inland electricity parks with large capacities, it is also possible to install wind turbines close to urban areas. It is also possible to put small ones on the roof or to integrate them in buildings. Typically, a large wind turbine has a capacity between 0.5 and 5 MW. The full load hours vary from 1,500 in low wind areas up to more than 3,000 in coastal areas[3] and to 4,000 offshore. Small roof turbines have a capacity of about 2.5 kW. In some countries, there is legislation regulating the minimum acceptable distance between the turbine and the built area and acceptable noise levels. The annual energy production (Wh) is calculated by multiplying the capacity (W) by the number of full load hours. For further readings see Poul Erik Morthorst (2009).

In a hydropower plant (see Fig. 5.21), water is collected (e.g., through a barrage in a river) in a reservoir located high (10–100 m). When the water flows down the river bed, the potential energy of the water is used to rotate the turbine. Alternative forms of hydropower are tidal barrages and wave power.

[3]See Morthorst, Wind energy – the facts, Volume 2, Costs and facts, http://www.ewea.org/fileadmin/ewea_documents/documents/publications/WETF/Facts_Volume_2.pdf Accessed March 2011.

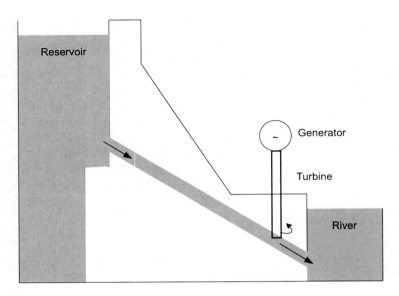

Fig. 5.21 Hydropower

In tidal barrages, water is collected when the tide rises and the turbine is activated by the escaping water when the tide falls. It is therefore a non-continuous system. In wave power, the turbine is driven by an air flow produced by the waves entering the generator. Alternatively, tide and wave may be used directly to drive the turbine.

Because there is no combustion and the resources are infinite, there are also no environmental effects, except the effects involved in constructing the infrastructure and local ecosystem effects with hydropower. The efficiency $\eta_{electrical}$ of electromagnetic generation with wind or power is considered to be infinite, meaning that the primary energy use is zero. Note that this is not true from a pure thermodynamic point of view: primary energy from the environment is used with a certain efficiency (determining the size of the wind turbine or the hydropower plant), but because this primary energy is infinitely and freely available we consider $\eta_{electrical} = \infty$.

5.6.3.2 Biomass and Domestic Waste

Electromagnetic power generation can also be powered by biomass. Biomass can be primary biomass (the plants themselves, e.g., wood) or secondary biomass (waste from plants or animals, e.g., farming waste, and by-products from crop processing, e.g., wood pellets). Similarly to fossil fuel power plants, the biomass is burnt in a boiler and the resulting flue gas or steam is used to drive a turbine. Another possibility is to use the biomass to produce biofuels (gasification, bio-refineries and anaerobic digestion) that can be used as fuels (like biodiesel, methane from sewage treatment plants or landfill gas from fermentation, see examples in Chap. 12) for a power

plant. The use of biomass is considered to be CO_2-neutral because CO_2 is released during combustion in the same quantity that was absorbed by the biomass during its growth. This is, however, a considerable simplification as growing and harvesting crops, transporting and processing them will also cause non-negligible CO_2 (and other) emissions. Another concern about using primary biomass is that it may turn away croplands from their primary function: food supply which may cause problems when there is a shortage of food. Domestic waste consists of a mix of processed biomass products like paper and plastics. Instead of simply burning it in an incineration plant, the produced gasses may also be used to power a turbine. As described in Fig. 5.3, biomass has an important share in worldwide electricity production and is the most used renewable resource, mostly in co-firing applications in coal power plants. The efficiency of electricity generation is typically lower than in conventional power plants: 0.3–0.4 for dry biomass and 0.25 for municipal solid waste. However, this efficiency does not take into account the fact that the fuel used is renewable. Therefore, the actual $\eta_{electrical}$ may be considered higher (but certainly not infinite because of the energy used involved in transport and processing). For more information, see, for instance, IEA (2007).

5.6.3.3 Solar Thermal Power Plants

In solar thermal plants, the solar radiation is concentrated by mirrors or lenses and collected by a heat transfer fluid circulating through the absorbing surface. Because the radiation is concentrated, high temperatures can be achieved, with which steam can be produced to power a turbine. These solar thermal plants work only in regions with a high share of direct solar radiation (diffuse radiation cannot be concentrated). Typical capacities of such solar thermal plants are in the range 25–400 MW.

5.6.3.4 Photovoltaic Cells

The production of electricity by photovoltaic (PV) cells works according to a completely different principle. There is no turbine powering a generator. Electricity is generated directly in the form of DC current by using two different layers of semi-conductors forming an electric field positive on one side and negative on the other. When solar radiation impacts the semi-conductor, electrons are brought into movement producing an electric current (DC, direct current), captured by a conductor.

The semi-conductor layers are mostly of monocrystalline, polycrystalline or amorphous silicon. Polycrystalline cells are the most commonly used and have an efficiency of 11–14%. Monocrystalline cells are a bit more expensive and also a bit more efficient (12–15%). Amorphous cells are much cheaper but have a low efficiency (5–7%). They are expected to gain a large part of the residential market because of their low prices. These efficiencies reflect the ratio of electricity produced by the quantity of solar energy used. Because solar energy is an infinite and freely available source, we consider $\eta_{electrical} = \infty$. Of course, energy is needed to produce PV cells. In the current state of the art, the service life of PV cells is estimated to be

30 years and the energy needed to produce a cell represents approximately 1–3 years of electricity production by the cell itself, meaning that it is definitely worth using them (see also Sect. 5.6.12).

The peak capacity of a PV cell is in the range 60–150 W/m^2, depending on the type of cell used. The number of full load hours varies strongly with the climate, from approximately 800 in regions with low solar irradiation up to 6,000 in regions with high solar irradiation. The annual energy production (Wh) is calculated by multiplying the capacity (W) by the number of full load hours

Photovoltaic power stations are mostly limited to 50–90 MW. Generally, photovoltaic electricity generation is limited to local electricity production. Solar panels produce an intermittent power, especially in cloudy regions. No electricity can be produced at night. Storage is therefore necessary. The electricity grid is often used as storage, using an inverter to convert the DC current to AC (electricity grids are based on the transportation of AC current, which is generated by the conventional power plants). In stand-alone systems, batteries can be used. Generally, also in stand-alone systems, the DC current would have to be converted to AC, because although most household and office appliances are DC-based, there are by standard equipped with DC/AC inverters (see Sect. 5.5.2).

5.6.3.5 Geothermal Energy

The deeper towards the earth's core, the hotter the temperature. The temperature increases by about 30°C per km – but there are local large departures. This temperature increase is caused by natural nuclear decay processes in the core of the earth. There is therefore a continuous flux of heat from the core to the earth's surface. The use of earth heat can be classified into three categories:

- Low temperature aquifers, mostly at a depth <100 m. This aquifers have too low a temperature to be used for electricity generation. They are used to heat buildings (see Sect. 5.6.9)
- Steam from hot temperature aquifers
- Hot dry rocks, also called Enhanced Geothermal Systems (EGS)

If the temperature of a hot aquifer is above 100°C, steam is produced that can be collected to drive a turbine and therefore to produce electricity by electromagnetic generation. Because the steam temperature is limited, the power generated will be low and this application is suitable for small capacities. There are also developments where much lower aquifer temperatures can be used (down to 60°C) to heat and evaporate a fluid with a much lower boiling point than water, for instance a refrigerant. The refrigerant's vapor can then be used to drive a turbine in a so-called binary cycle power plant.

In hot dry rocks, two boreholes are drilled. High pressure water is injected into one of them at a pressure that produces a fracture in the rock. Then water or liquefied carbon dioxide is pumped down, is heated by the rock's heat and comes up in gaseous form in the second borehole due to pressure differences. There, it passes a

Fig. 5.22 Enhanced
geothermal system

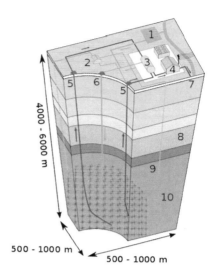

heat exchanger before being returned to the first borehole (see Fig. 5.22). Because of the high temperature, steam can be produced that can drive a turbine. Because of the high investment costs, these enhanced geothermal systems are only suitable for large-scale application at the level of a district.

The efficiency of electricity production with geothermal energy is in the range 0.1–0.23. However $\eta_{electrical}$ can be considered infinite as the resource used is infinite and renewable, but this is true only when the electricity used for water pumping, which may be considerable, comes from a sustainable source (e.g., the geothermal plant itself). Although the heat extraction from earth by geothermal power plants is negligible in comparison with the heat content of the earth, local depletion is possible if plants extract energy at a higher rate than the replenishment rate from deeper layers or if the aquifers themselves are being depleted. Stopping the production for a period would then allow replenishing of the aquifer.

During the operation of a geothermal plant, gases contributing to global warming and acidification (see Chap. 11) are released from deep in the earth. However, the CO_2 production is only 10–12% of the CO_2 production from a conventional power plant. Hot geothermal water may also contain chemicals toxic for human beings and ecosystems.

5.6.4 Combined Heat and Power (CHP)

Different ways of producing electricity were studied in the two former sections. As a result of the second law of thermodynamics (see also Sect. 5.5.3), electricity production always involves heat production. In conventional power plants, this heat is just released to the environment (air or surface water). Combined heat and power

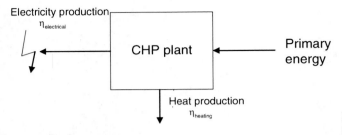

Fig. 5.23 Combined heat and power

plants (see Fig. 5.23), on the contrary use this waste heat as input for heating applications. In electromagnetic power plants, hot water may be produced by heat extraction from the low pressure steam turbine through a heat exchanger or from heat extraction by the cooling water and the flue gas[4]. Fuel cells and concentrated solar power also produce waste heat. With photovoltaic cells, heat is also cogenerated during electricity production and can be used (PVT systems). In contrast, cogeneration is not an option with hydropower and wind power because the low temperature heat resulting from the inefficiency of the turbine (e.g., friction losses) is released in a high velocity stream of air or water and cannot be collected.

Combined heat and power has high saving potentials because the waste heat used does not need to be produced elsewhere. Large-scale CHP plants are mostly designed for electricity production, whereas smaller plants may be designed either for electricity or for heat production depending on the relative values of the heat and the electricity demand, and also depending on economic consideration like oil and electricity prices. Generally, the higher the electrical efficiency of the power plant, the lower its efficiency for heat generation. Typically, $\eta_{\text{heating}} \approx 0.9 - \eta_{\text{electrical}}$.

5.6.4.1 Combined Heat and Power with District Heating

A district heating system distributes hot water from a central CHP plant to buildings in a city up to a distance of 20–30 km from the power plant. This hot water can be used for space heating and hot tap water heating. Because large CHP plants are designed to produce primarily electricity, one can consider the following equations for the primary energy usage for heating and electricity:

$$E_{\text{electrical}} = Q_{\text{electrical}} / \eta_{\text{electrical}} \tag{5.30}$$

Where $Q_{\text{electrical}}$ is the electricity demand of the district.

[4]Note that when the waste heat has a high temperature, as in a gas turbine, it is more efficient to reuse this waste heat to produce steam and therefore additional electricity than to use it for heating applications (e.g., combine steam and gas turbine in Sect. 5.6.2.1).

With a primary energy of $E_{\text{electrical}}$, a quantity of heat $Q_{\text{heatfree}} = E_{\text{electrical}} \times \eta_{\text{heating(CHP)}}$ will be produced.

If the heating demand of the district Q_{heating} is lower than Q_{heatfree}, no additional primary energy is needed to meet the heating demand and therefore

$$E_{\text{heating}} = 0 \qquad (5.31)$$

If the heating demand of the district Q_{heating} is higher than Q_{heatfree}, additional primary energy is needed to meet the heating demand, which must be produced by an additional heat generation system like a boiler. In this case, Eq. 5.31 must be used:

$$E_{\text{heating}} = (Q_{\text{heating}} - Q_{\text{heatfree}}) / \eta_{\text{heating}} \qquad (5.32)$$

where η_{heating} is the efficiency of the additional heat generation system.

In both cases, considerable primary energy savings will be achieved in comparison to separated electricity and heat generation. However, be aware that differing calculation methods may be used in regional, national or local regulation codes.

5.6.4.2 Combined Heat and Power for District Cooling

The heat produced by the CHP plant can be used to power an absorption cooling machine, producing this way cooling, see Sect. 5.6.8.

5.6.4.3 Combined Heat and Power for Large Buildings

Local CHP plants can also be used, for instance in hospitals, large offices or apartment blocks. These CHP units may be designed on the thermal or the electrical capacity. When they are designed on the electrical capacity, Eqs. 5.30–5.32 can be used to calculate the primary energy for electricity and heating. When they are designed on the thermal capacity, Eqs. 5.33–5.36 applied.

$$E_{\text{heating}} = Q_{\text{heating}} / \eta_{\text{heating}} \qquad (5.33)$$

$$Q_{\text{elec,free}} = E_{\text{heating}} \times \eta_{\text{electrical(CHP)}} \qquad (5.34)$$

If the electrical demand of the district $Q_{\text{electrical}}$ is lower than $Q_{\text{elec,free}}$, no additional primary energy is needed to meet the electricity demand and therefore

$$E_{\text{electrical}} = 0 \qquad (5.35)$$

If the electrical demand of the district $Q_{\text{electrical}}$ is higher than $Q_{\text{elec,free}}$, additional primary energy is needed to meet the electricity demand:

$$E_{\text{electrical}} = (Q_{\text{electrical}} - Q_{\text{elec,free}}) / \eta_{\text{electrical}} \qquad (5.36)$$

where $\eta_{\text{electrical}}$ is the efficiency of the additional electricity generation system, mostly electricity from the grid.

5.6.4.4 Micro-CHP

There is ongoing development towards small local CHP plants, so-called micro-CHP, producing electricity and heat at the scale of (small) buildings and dwellings. Fuel cells are expected to cover a large part of this application together with the so-called Stirling engine technology. In a Stirling motor, gas is burnt to produce heat. This heat is supplied to the motor, a closed compartment where air expands, bringing a piston in movement. This piston in turns powers the generator, producing electricity. The electrical efficiency $\eta_{\text{electrical}}$ is around 0.4.

A Stirling motor may also be used with concentrating solar panels producing electricity and heat simultaneously.

We saw in Sect. 5.6.3.4 that the efficiency of PV cells is around 15%, meaning that a lot of energy is lost during the conversion process. In photovoltaic-thermal (PVT) technology, this heat is collected, mostly by water pipes attached at the back of the PV module. This has two advantages: (1) the heat can be used and (2) because the heat is collected, the PV cell cools down, which produces an increase of the electrical conversion process. Typically, the heat production will be two or three times the electricity production.

5.6.5 Heating: Waste Heat

Waste heat is not only provided by CHP plants but can also be provided as waste heat from industrial processes or municipal waste incineration plants and distributed by a district heating system. The primary energy when using waste heat can be considered zero.

$$E_{\text{heating}} = 0 \qquad (5.37)$$

5.6.6 Heating: Electrical Heating

In electrical heating (Fig. 5.24), sometimes referred as electrical boiler, electricity is dissipated in a resistance producing heat. Because electricity can be completely converted to heat, the efficiency of such a system is 1. However, the electricity must be

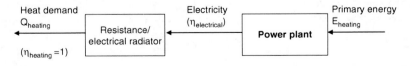

Fig. 5.24 Primary energy with electrical heating

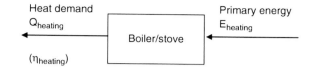

Fig. 5.25 Primary energy when using a boiler for heating

produced by one of the ways studied in the former section. The primary energy for heating is given by Eq. 5.38.

$$E_{heating} = \left(Q_{heating} \,/\, \eta_{heating} \right) \!/\, \eta_{electrical} \tag{5.38}$$

with $\eta_{heating}$ is 1.

Considering the exergy approach and a rational use of energy, the use of electrical heating for low temperature applications as we find them in the built environment should be prohibited. Electricity should only be used for power applications.

5.6.7 Heating: Boilers and Stoves

Boilers and stoves (Fig. 5.25) are fed directly by a primary resource: gas, oil or biomass. The primary energy usage is calculated by Eq. 5.39:

$$E_{heating} = \left(Q_{heating} \,/\, \eta_{heating} \right) \tag{5.39}$$

5.6.7.1 Fossil Fuel and Biomass Boilers

Boilers are the most commonly used heating system. In boilers, a fuel is burnt to produce heat that is passed to a hot water system for space heating (central heating) or hot tap water heating using a closed loop. The air for the combustion process is supplied directly from outdoors (and not from the building) and the flue gases (containing carbon dioxide and monoxide) are exhausted directly outside.

The most common fuels for boilers are gas, oil and (pelleted) wood. Conventional boilers have an efficiency $\eta_{heating}$ around 0.6. In high efficiency boilers, the flue gas exhausted by the combustion process is cooled down, condensed and passes its heat to the hot water system. This way, efficiencies above 1 can be achieved: because the latent heat of condensation of the flue gases is used, more energy can be gained than the net calorific value of the fuel (see Table 5.13). Note that if the upper calorific value is used, in which the latent heat of evaporation of flue gases is taken into account, the efficiency remains below 1. High efficiency boilers have an efficiency in the range 0.95–1.07 based on the net calorific value.

Space heating and hot tap water boilers are often combined into one single boiler, called a combination boiler.

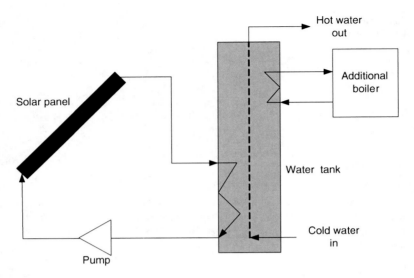

Fig. 5.26 An example of a solar boiler

5.6.7.2 Solar Boilers

Solar boilers may be used for space heating, but they are more often used for hot tap water. In regions with high solar irradiation, stand alone systems can be used, but in more cloudy and cold regions, solar boilers are mostly combined with a secondary system, whether a conventional boiler, an electrical resistance or a heat pump (see Sect. 5.6.8). In a solar boiler, solar radiation is captured by a black collector plate in which water circulates through a pipe. The water is heated by the solar radiation and collected in a storage tank, where additional heating takes place if necessary, see Fig. 5.26. The efficiency of such a solar boiler typically depends on the ratio of heating provided by the solar collector and the additional system. In countries like the UK or the Netherlands, when a solar collector is used about half the hot tap water heating is provided by the solar collector itself. The other half is provided by the additional boiler.

5.6.7.3 Stoves and Local Gas Heaters

Local gas heaters are used for hot tap water, mostly at the kitchen or bathroom taps. They are open combustion systems meaning that combustion air is taken from the room itself and that exhaust gases from combustion are released into the room. They should be avoided because of their negative influence on the indoor air quality.

Gas or (pelleted) wood are used for combustion in stoves (other fuels are also possible). The stoves are placed directly in the space to be heated and are not connected to a central heating system. The combustion heat comes directly free into the

room by convection and radiation. The air needed for the combustion process is taken directly from the room, which may cause a poor air quality if room ventilation is not sufficient (see also Chap. 7). The exhaust gases are removed through a pipe connected to a chimney or to the outside through a wall. Unvented stoves (without an exhaust pipe to outside) can still be found but should not be used, as they represent a real danger to human health. The efficiency of a modern stove may be up to 70%, but generally the efficiency is around 50% (as a comparison, open fire places have an efficiency below 30%).

5.6.8 Heating and Cooling: Cooling Machines and Heat Pumps

Cooling machines and heat pumps are in fact an identical device, working according to the same principle as a refrigerator. In a cooling machine, the heat generated is wasted; in a heat pump, the generated cold is wasted. In so-called bivalent or reversible heat pumps, the device can produce alternately (or sometimes simultaneously) heat or cold. Heat pumps and refrigerators make use of the fact that the condensation/evaporation temperature of fluids depends on their pressure. For instance, water evaporates (and water vapor condensates) at 100°C under atmospheric pressure (1 bar), but at 2 bars, the evaporation temperature is 120°C. A refrigerant like ammonia (NH_3) evaporates/condensates at −10°C at a pressure of 3 bar and at 25°C at a pressure of 10 bar. To evaporate, the refrigerant uses heat from the environment (e.g., air or river/ground water in heat pump mode and room air/inside air in cooling machine/refrigerator mode). When condensing, the refrigerant releases heat to the environment (e.g., room air or floor heating in heat pump mode and outdoor air or river/ground water in cooling machine mode). Figure 5.27 gives the working principle of a heat pump/cooling machine. The compressor is driven by electricity and brings the vapour refrigerant from the low to the high pressure. In the expansion valve, the refrigerant expands from the high to the low pressure, closing the cycle.

The efficiency of a heat pump/cooling machine is expressed by its Coefficient of Performance (COP), which is defined as the ratio of produced heat or cold by the electrical input to the compressor, see Eqs. 5.40 and 5.41. Because a heat pump uses free heat from the environment, the COP is higher than 1.

$$COP_{heating} = Q_{heating} / Q_{elec,comp} \tag{5.40}$$

$$COP_{cooling} = Q_{cooling} / Q_{elec,comp} \tag{5.41}$$

The electricity needed must be produced separately (see Fig. 5.28), therefore the primary energy usage is given by Eqs. 5.42 and 5.43:

$$E_{heating} = Q_{heating} / (COP_{heating} \cdot \eta_{electrical}) \tag{5.42}$$

$$E_{cooling} = Q_{cooling} / (COP_{cooling} \cdot \eta_{electrical}) \tag{5.43}$$

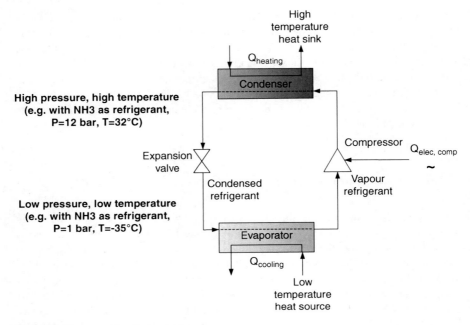

Fig. 5.27 Heat pump/cooling machine

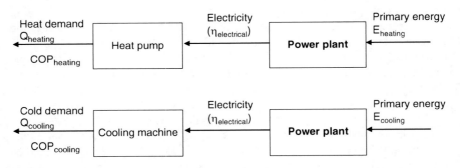

Fig. 5.28 Primary energy usage when a heat pump or a cooling machine is used

When useful heating and cooling are produced simultaneously by a heat pump, either the heat or the cooling energy can be considered as "free."

The COP of heat pumps and cooling machines depends strongly on the temperature difference between the cold side (heat source) and the warm side (heat sink). The lower the temperature difference, the higher the COP. That is why it is important to find heat sources with a temperature as high as possible and heat sinks with a temperature as low as possible (see also Sect. 5.5.1.2). For this reason, heat pumps are always used in combination with low temperature radiators or floor or wall heating. Heat pumps using as source outdoor air will perform less well than heat pumps

using river water because in the winter season river water has a higher temperature than the air. The use of the ground or ground water is a very good option as the temperature of the ground is quite high and remains constant all year (e.g., at approximately 10°C in countries like UK). Heat pumps using exhaust ventilation air (~22°C) are very efficient, although the air flows are mostly not large enough and the ventilation air must be mixed with outdoor air.

The COP of heat pumps varies depending on the heat source and the design between 2 and 5. In cases where the heat pump uses heat storage in the ground or high temperature heat sources, a COP up to 12–20 may be achieved. The COP of cooling machines is always lower than the COP in heating mode and is usually in the range 1.5–5.

Next to electricity-driven cooling machines (so-called compression cooling machines), there are also heat-driven cooling machines that use heat to drive a thermal compressor (so-called absorption systems). It is, for instance, possible to drive a thermal compressor with heat from a district heating system and therefore to use the district heating for cooling (district cooling). Following the same analysis as in Sect. 5.6.4 for combined heat and power, either the electricity production or the cold production may be considered to cost no primary energy.

Note also that, although some of the so-called air conditioners work according the principle described in Sect. 5.6.10, most of them work according to the principle of the cooling machine.

5.6.9 Heating and Cooling: Heat and Cold Storage in Ground

Heat and cold storage in the ground is a seasonal system that does not strictly speaking generate heat or cold but allows for the seasonal storage of waste heat and cold from buildings. The excess heat in the summer is stored in an aquifer and used in the winter. The excess cold in the winter is also stored in the aquifer and used in the summer. This system is only possible when the structure of the ground and the properties of the aquifer (e.g., low water velocity) are suitable. This system is widely applied in the Netherlands.

In summer, "cold" water from the aquifer (e.g., at about 9°C) is used to cool the warm exhaust air from the building (or warm water from cooling pipes for a cooling ceiling). This cold air or water can then be reused to cool the building. The heat transferred to the cold aquifer water through the heat exchanger produces a temperature increase (e.g., up to 20°C) (left part of Fig. 5.29). This warm water is injected into a second well. At the end of the summer, this second well has a temperature of about 20°C. During winter, the "hot" water from this well is used to preheat outdoor air for the building or is used as heat source for a heat pump. During this process, the aquifer water is cooled down to about 9°C in the heat exchanger and is injected into the cold well (right part of Fig. 5.29).

This is a very efficient and cost-effective system since there is only energy needed for the pumps. In cooling mode, an equivalent COP (for comparison with heat pumps) of 12–20 can be achieved.

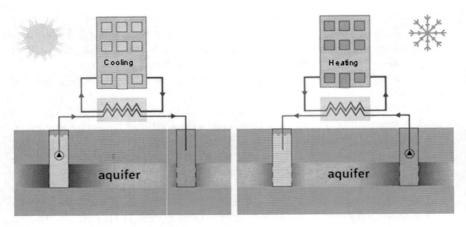

Fig. 5.29 Heat and cold storage in ground (*left*: working in summer; *right*: working in winter)

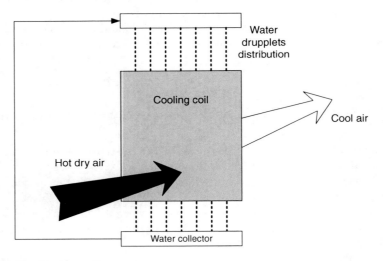

Fig. 5.30 Evaporative cooling

5.6.10 Cooling: Evaporative Cooling

Next to the mechanical ways described in the two former sections (cooling machine and energy storage in the ground), it is also possible to use evaporative cooling to cool buildings. Evaporative cooling (Fig. 5.30) is only efficient in climates with a low relative humidity and requires considerable water flows. In evaporative cooling, water droplets are injected into the supply air flow where they immediately evaporate. The heat needed to evaporate is taken up from the supplied air, which therefore cools down. The thermal efficiency of this system is around 0.8 relating to the electricity

needed for the fans and water pump. To calculate the primary energy, $\eta_{electrical}$ should also be taken into account.

Known disadvantages in comparison with a cooling machine are a high humidity level and possible risks for the growth of legionella bacteria. For these reasons, this system is mostly not used in large buildings.

Evaporative cooling through the presence of fountains or water curtains can also be achieved, although the effect is very local.

5.6.11 Minimizing the Primary Energy Use

For a given energy demand, as calculated for heating, cooling and electricity in Sect. 5.4, the reduction of the primary energy use can be achieved by:

- Using renewable energy sources as much as possible;
- Using cogeneration as much as possible (heat and power, heat and cold, power heat and cold);
- Using waste heat and the cascading principle presented in Sect. 5.5.3.

Additionally, when fossil fuels are used, they should be used in generation systems as efficiently as possible. These steps are also those described in steps 2 and 3 of the three-step strategy described in Sect. 5.2.2.

Note also that, to be able to make use of solar systems at building level (PV cells and solar collectors), the orientation of the building's roof (if not a flat roof) is decisive. Furthermore, combining green roofs with PV cells may increase the efficiency of the cells. For further reading on energy savings in general, see Harvey (2006) and Nicholls et al. (2008).

5.6.12 Environmental Impacts of Energy Use

Some of the environmental impacts of energy generation systems have already been described in the former sections. Most international and national regulations on energy use address the problem of CO_2 emissions (see Chap. 13). However, CO_2 emissions are only one of the environmental problems related to energy use, and for a fair comparison of the different systems, more environmental impacts should be considered (see Chap. 11 for a list of such impacts).

Energy saving in itself is not sufficient to create a sustainable energy system (see Blom 2010; Blom et al. 2010). The type of energy source used determines the environmental impacts as well. Figure 5.31 illustrates this by showing a comparison between the environmental impacts created by the use of an identical quantity of heat (1 MJ), in black when heat is produced by a high efficiency gas boiler, in gray when it is produced by electrical heating, and in light gray when produced by a heat pump with COP = 2.5. For the electricity generation, the Dutch electricity mix was used with $\eta_{electrical} = 0.4$. For the comparison, all environmental impacts for heat

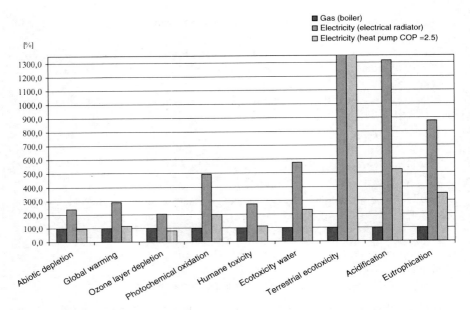

Fig. 5.31 Environmental impacts from the production of 1 MJ heat with a gas boiler, an electrical heating and a heat pump with COP=2.5 (Blom 2010, based on Ecoinvent 2.0 database)

production by the boiler are set to 100%. The larger the staff, the higher is the environmental impact. The Figure shows that the use of electrical heating is not recommended. The environmental impacts of the heat pump are approximately identical to those of the boiler for the category "abiotic depletion" and a bit better for the category "ozone layer depletion." For all other impact categories, they are worse. This poor performance of the heat pump relates to a certain extent to the low COP used (only 2.5), and essentially to the mix of fuels used in the actual average Dutch production process for electricity. This fuel mix consist of 30% oil, 5% coal, 50% gas, 10% nuclear and 5% renewable. A slight shift from a gas demand to an electricity demand (e.g., when a heat pump is used instead of a gas boiler) causes a huge increase in a large number of environmental impacts. This emphasizes the importance of a sustainable electricity production.

As an example, Fig. 5.32 shows the differences between the environmental impact of electricity production in different countries: the Netherlands, France with almost 100% nuclear energy, and Norway with almost 100% hydropower. In addition, the environmental impacts that would occur when electricity is produced by 100% wind and 100% photovoltaic are shown. To make a fair comparison, accounting for nuclear radiation the environmental impact category "Ionizing radiation" is added. These environmental impacts account also for the impact occurring during the production process of the conversion system. The advantages of using renewable energy are evident, although there is room for improvement to reduce the ecotoxicity arising from the use of specific materials in hydro, PV and wind technology. Note that, in general, the environmental impacts of material use are much less than the environmental impacts of operational energy use, except for the toxicity-related impacts.

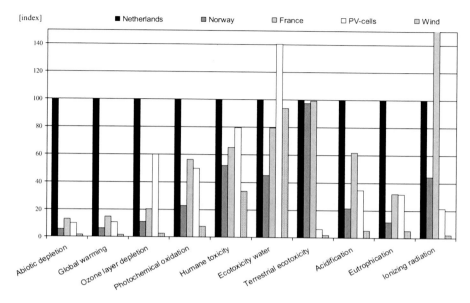

Fig. 5.32 Environmental impacts of several electricity production processes (from Ecoinvent 2.0 database). Note that, for ionizing radiation, the index for France falls out of the scale of the chart (1,082%!)

5.7 Operational and Financial Considerations

The occupant of the building does not pay for primary energy use but for electricity, gas (or biomass) and heat (in case of district heating). When annual operational costs are calculated, the actual quantity of electricity, gas and heat consumed must be calculated and multiplied by the costs of these energy carriers per kWh, m³ or MJ. Generally, these operational costs are compared to the investment costs using the pay-back time method or the net present value method (see, for instance, Blok 2007 for more information).

Energy conversion systems interact with the building itself and its occupants, leading to quite complex systems that are not easy to control or to fine-tune. Little attention has been paid in the past to continuous monitoring and control of HVAC equipment, because former systems were quite simple. Modern energy systems in buildings are much more complex and need to be controlled on three main output: comfort (e.g., temperature, draught, lighting, humidity), environment and costs. The complexity of present systems arises from the fact that several systems are combined in order to ensure low operational energy use and limited investments. Generally, expensive systems like heat pumps are sized in order to work as often as possible (as high as possible number of full load hours), with as high as possible efficiency, and not to meet the peak load. For the peak load, a cheaper system with a lower efficiency is used (e.g., a boiler or an electrical resistance). Because the peak load is needed only a few hours a year, this does not have a large influence on the

energy use, but allows the limiting of the investment costs. Combining systems also means that the risks of failure in the control system are higher. Generally, one can assume that 10–30% energy savings may be achieved by monitoring and controlling the systems continuously during their operation. This can be done by using a computer-aided energy management system. If this is not possible, inspections should be made as often as possible. In a situation where energy prices can vary quickly and often depend on the estimated peak load, an energy management system makes it possible to control costs and to better match the demand side and the production side. For instance, to avoid too large peaks of energy demand (peak shaving), electricity is supplied with different tariffs, the high tariff being when the demand is expected to be high, the lower tariffs when the demand is low. This is a kind of market guidance designed to encourage the energy demander to shift some of his demand to a time with low demand. This way, too high investments in additional energy conversion capacity may be avoided.

Questions

1. What determines the thermal and electrical energy demand of buildings?
2. What determines the primary energy use of buildings?
3. Describe the three-step strategy and give for each step two possible energy saving measures.
4. Explain quantitatively what the influence of glass type and window size is on the energy demand for heating, cooling and electricity.
5. If electricity is generated with an efficiency of 0.4, what is the minimum COP a heat pump should have to be more efficient than a boiler with an efficiency of 0.98?
6. Cooling is mostly achieved by using a cooling machine. Traditionally, boilers are used for heating in northern Europe. Is it better to design a building that needs cooling or a building that needs heating? Make a comparison using a unit heat demand and a unit cooling demand of 1 MJ.
7. Explain why low-temperature heating may lead to energy savings.
8. Give an overview of conversion processes for electricity production.
9. Explain why district heating may be seen as a sustainable option for heating.

References

ASHRAE (1997) Ashrae handbook - fundamentals. www.ashrae.org. Accessed Mar 2011
ASHRAE (2007) Ashrae handbook – HVAC applications. www.ashrae.org. Accessed Mar 2011
ASHRAE (2009) Ashrae handbook – fundamentals. www.ashrae.org. Accessed Mar 2011
ASHRAE standard 62.2 (2010) Ventilation and acceptable indoor air quality in low-rise residential buildings. www.ashrae.org. Accessed Mar 2011
ASHRAE standard 90.1 (2007) Energy standard for buildings, except low-rise residential buildings. www.ashrae.org. Accessed Mar 2011

Blom I (2010) Environmental impacts during the operational phase of residential buildings. Thesis Delft University of Technology, IOS Press, ISBN 978-1-60750-673-7, Nov 2010

Blom I, Itard L, Meijer A (2010) LCA-based environmental assessment of the use and maintenance of heating and ventilation systems in Dutch dwellings. Build Environ 45(11):2362–2372

Clarke JA (2001) Energy simulation in building design, 2nd edn. Butterworth Heinemann, Oxford

Dorp van J (2004) An approach to empirical investigation of performance of passive PCM applications in office buildings based on the T-history method, Arcadis report

Energy-plus (2011) Statistics per hour per month normal direct radiation, diverse locations. http://apps1.eere.energy.gov/buildings/energyplus/weatherdata/6_europe_wmo_region_6/DEU_Berlin.103840_IWEC.stat. Accessed Mar 2011

IEA (2004) Lowex (low exergy systems for heating and cooling) Guidebook, IEA Annex 37. www.lowex.net

IEA (2007) Biomass for power generation and CHP, IEA Energy Technology Essentials ETE03. www.iea.org/techno/essentials3.pdf. Accessed Mar 2011

ISO (2007) Thermal bridges in building construction – Linear thermal transmittance – Simplified methods and default values, Publication 14683. http://www.iso.org/iso/catalogue_detail.htm?csnumber=40964. Accessed Mar 2011

Kristinsson J (2004) Breathing window: a new healthy ventilation, proc. PLEA conference The 21st conference on passive and low energy architecture, Eindhoven, 19–22 Sept

Lehmann B, Dorer V, Koschenz M (2007) Application range of thermally activated building system tabs. Energy Build 39(5):593–598

LPD (2004) A comprehensive source for understanding the lighting models underlying the commercial lighting power limits developed in ASHRAE/IESNA 90.1. http://lpd.ies.org/cgi-bin/lpd/lpdhome.pl. Accessed Mar 2011

Meteonorm (2009) Meteonorm 6.1, edition 2009 or free test version. www.meteonorm.com. Accessed Mar 2011

Natvent, de Gids (1998) Barriers to natural ventilation design in office buildings, TNO (EC). http://projects.bre.co.uk/natvent/reports/barrier/nlbar.pdf. Accessed Mar 2011

NREL (1995) International Energy Agency building simulation test and diagnostic method, NRL/TP-6231, Colorado

NREL (2011) Solar radiation data manual for buildings. http://rredc.nrel.gov/solar/pubs/bluebook/. Accessed Mar 2011

Paassen van AHC (2004) Indoor climate fundamentals, course notes WB4426, chair Energy & Built Environment, Faculty of mechanical engineering, Delft University of Technology

Further Reading

Blok K (2007) Introduction to energy analysis. Techne Press, Amsterdam. ISBN ISBN-13: 978-8594-016-6

EG&G Technical Services (2005) Fuel cell handbook, 7th edn. US Department of Energy, West Virginia, http://www.brennstoffzellen.rwth-aachen.de/Links/FCHandbook7.pdf

Harvey LD (2006) A handbook on low-energy buildings and district-energy systems: Fundamentals, techniques and examples. Earthscan Publications Ltd, London

Nicholls R, Hall K (eds.) (2008) The green building bible, vol 1&2. Green Building Press, Llandysul, www.greenbuildingbible.co.uk

Poul Erik Morthorst (2009) Wind Energy, the facts, vol 1 & 2, Costs and facts. http://www.ewea.org/fileadmin/ewea_documents/documents/publications/WETF/Facts_Volume_2.pdf. Accessed Mar 2011

Chapter 6
Material City: Towards Sustainable Use of Resources

Loriane Icibaci and Michiel Haas

Abstract Environmentally sound materials for building applications is one of the most difficult aspects to be solved in green building practice. There is a lack of available technology to substitute existing materials competitively in durability and price. Moreover, the production of most conventional construction materials is energy intense and based on non-renewable resources. Waste streams management also presents challenges in both quantitative and qualitative aspects. Tools, design strategies and cultural behaviour are a few of the immediate steps towards a shift for a big change, starting from understanding what our built environment is made of and translating it into natural resources and environmental consequences.

6.1 Introduction

The building industry is one of the largest consumers of natural resources, using on average 40% of all extracted materials globally (Kibert and Bradley 2002), and in general it is responsible for producing on average 40–50% of local urban solid waste. Most of these materials are expected to have a life-span required by building standards that could normally reach a minimum of 20–50 years. However, building components, as in other industrial fields, have been designed with little or almost no concern for life cycles, toxicity and extraction of natural resources necessary for

L. Icibaci (✉)
Delft University of Technology, Delft, The Netherlands
e-mail: l.m.icibaci@tudelft.nl

M. Haas
NIBE – Nederlands Instituut voor Bouwbiologie en Ecologie
(Netherlands Institute for Building Biology and Ecology), Bussum, The Netherlands

Delft University of Technology, Delft, The Netherlands
e-mail: e.m.haas@tudelft.nl

E. van Bueren et al. (eds.), *Sustainable Urban Environments: An Ecosystem Approach*,
DOI 10.1007/978-94-007-1294-2_6, © Springer Science+Business Media B.V. 2012

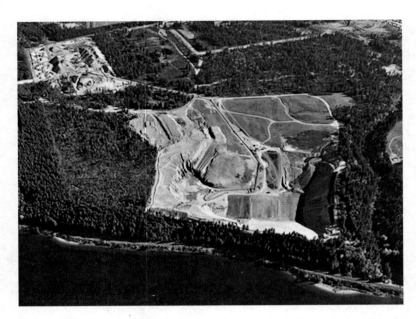

Fig. 6.1 Aerial photograph of mine (Source: http://pavementinteractive.org/index.php?title=Image:
Arial-mine.JPG. Accessed March 2011)

their production. Contemporary buildings are mainly dependent on non-renewable
material sources such as metals and stone.

Cement is a good example with which to illustrate the magnitude of material
cycles in construction. Cement is the main component for concrete production,
which is the second (after water) most consumed substance on earth, with nearly
3 tonnes used annually for each person on the planet (WBCSD 2002). Cement man-
ufacturing requires mainly mineral extraction from quarries (besides water and
energy for its production). Although limestone, granite and clay, the basic compo-
nents of cement, are largely available around the planet's crust (justifying their low
cost), they are still non-renewable. These and other types of quarries cause large-
scale landscape disturbances impacting local ecological cycles (water, fauna, flora,
erosion, etc.) that are usually not restorable to their previous conditions (Fig. 6.1).

The cement industry also contributes about 5% to global anthropogenic CO_2
emissions, of which 50% is from the chemical process, and 40% from burning fuel
(Worrell et al. 2001). The remainder is split between electricity and transport uses
(WBCSD 2002).

Rising cement consumption will result in an increasing need for raw materials.
This demand can be related to population growth and building technologies (mate-
rial intensity) including the way our buildings are designed. CO_2 emissions con-
nected to the transportation of these materials are one important issue to be
considered when thinking about natural resources extraction. The more cities grow,
the larger is the demand for materials and the distances to find natural resources
close to the cities' boundaries. In Toronto, as in many other cities around the world,
aggregates used to be a few kilometres away from the city centre. As these quarries

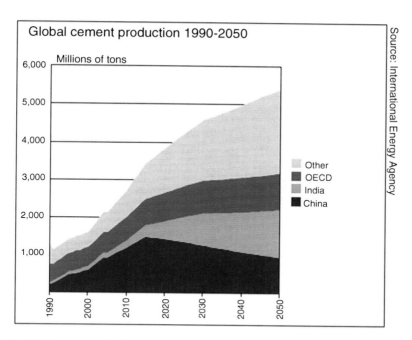

Fig. 6.2 Global cement production by region (Source: IEA, in: WBCSD 2007. Used with permission)

were exhausted, the distances covered to transport the same minerals to the urban area became longer (Kennedy et al. 2007). São Paulo as another case has spread too fast and too widely, growing over possible quarries (Fig. 6.2).

The end of the life-span is another aspect to be taken into account for high volume material use such as construction materials. As mentioned before, Construction and Demolition waste (C&D) is responsible for a large percentage of municipal solid waste in most industrialised countries and developing economies, not to mention countries where illegal dumping is common practice in the absence of waste management and better control. In general, we could list the main problems related to the material construction streams as:

1. The quantity of material demand is very large.
2. The quantity of construction and demolition waste is very large.
3. Landfills strategically located nearby city centres avoid large transportation costs and fuel consumption.
4. Roughly 75% of waste is land-filled, despite its major recycling potential. On average, within the European Union, 25% of waste is recycled (however, Denmark, the Netherlands and Belgium have already achieved recycling rates of more than 80%) (European Commission 2000).
5. Although a large part of C&D is still considered 'inert', meaning harmless to soil, water and air, it is already known that this is not entirely true; for example, heavy metals are present in wall paintings. Most of the waste considered dangerous is not always separated from other forms of waste and thus contaminates landfills or recycled inert wastes (European Commission 2000).

Few of the most commonly used materials applied in buildings and construction are recycled in its full definition. Steel is one of the few highly recycled materials, which has contributed to reducing virgin resources and energy use in the production of new steel. Other materials including concrete are mainly *downcycled* as sub-base for road construction (very common in the Netherlands), with a very small percentage returning for the production of new concrete for building purposes.

Metals are also very important materials for building components. The encroaching shortage of raw materials is already visible on the stock markets. For example, the London Metal Exchange, a combined index that includes metals, almost doubled in the 2 years to the beginning of 2011. Some metals are sensitive to exhaustion as in the case of copper, which for a significant portion of its commercial production already relies on recycling of used manufactured products.

The environmental impact of materials is relatively difficult to reduce. Based on the many GreenCalc calculations conducted at the NIBE, a research institute that was one of the developers of the environmental assessment method GreenCalc (further introduced in Sect. 6.6 of this chapter), it appears that, using existing technology, the environmental impact of materials at the building level can be reduced by only a maximum of a factor of 3 (Haas 2009). This means that we must continue to regard the material component as an important item and that a great deal of further research will be required in order to further reduce the environmental impact caused by the material component in buildings. The reduction of the material component will require thinking outside the box.

6.2 Energy and Materials

The CO_2 problem manifests itself as an energy issue. As long as we continue to use fossil fuels, we will have a problem with CO_2, because fossil fuels involve long-cycle CO_2. This is CO_2 that accumulated millions of years ago and is now being released in the space of a few centuries. If we can generate energy from sustainable sources such as solar or wind power, we will have energy that is essentially CO_2-free (see also Chap. 5).

We may even have developed methods to make it possible to exploit the zero point energy. Zero Point Energy (ZPE) is the amount of energy that remains in the emptiest state of space with the lowest possible energy level. This lowest possible energy level exists at 0 K, which is equal to $-273.15°C$, where, according to Newton's laws, no atomic movement is possible and no energy can be measured. Nonetheless, energy has been measured under these conditions and this is what we call zero point energy.

Several calculations using Life Cycle Analysis (LCA) calculation models have revealed that materials are responsible for only 15–20% of the environmental impact caused by Dutch office buildings during their lifecycle (Haas 2010). Currently, energy consumption is responsible for the most important part of this impact by far, accounting for a share of 75–85% of the total environmental impact across the lifecycle of a

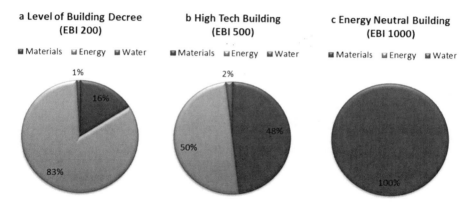

Fig. 6.3 Comparison of environmental impact of three buildings with different designs

building. Figure 6.3a–c shows the proportion of materials, energy and water in the environmental impact of a Dutch building throughout its entire lifecycle.

Figure 6.3a concerns a building complying with regulatory minimum performance requirements. It shows that energy represents the most important component of a building's environmental impact. However, if the building is more energy-efficient (Fig. 6.3b) or even energy-neutral (Fig. 6.3c), the materials are actually responsible for the largest proportion of the environmental impact in relative terms. Figure 6.3a corresponds to a building considered to be sustainable according to Dutch regulations in 2010 [equivalent to an Environmental Building Index (EBI) of 200 in the GreenCalc method]. Figure 6.3b represents a building in which high-tech methods have been used to radically reduce energy consumption (equivalent to an EBI of 500). Figure 6.3c represents an energy-neutral building (equivalent to an EBI of 1,000) which has no environmental impact in terms of energy. These show that materials are the most important source of environmental impact (Haas 2009).

6.2.1 Material and Energy Paradox

In 2009, the Americans Mark Z. Jacobson, professor of civil and environmental engineering at Stanford University, and Mark Delucchi from the University of California, controversially announced that by 2030 we will be able to switch completely to renewable energy and will no longer need fossil fuels (Jacobson et al. 2009). However, to convert solar and wind energy into electricity, certain rare earth metals are required. There are relatively limited supplies of these metals and 95% of what is available is in the hands of China which recently announced severe export restrictions. These rare earth metals include Neodymium (Nd), Lanthanum (La), Samarium (Sm) and Cerium (Ce). They have a very wide range of uses, including in magnets, hard drives, wind turbines, mobile telephones, iPods, electric engines, superconductors, energy-efficient lamps, TV screens, nuclear reactors, fuel cells, lighters and lasers. Annual

Box 6.1 Raw Materials from a Geopolitical Perspective

We are quite accustomed to wars being waged in the Middle East which are actually based on a raw materials issue, i.e. the shortage of oil.

The release of the movie 'Blood Diamonds', starring Leonardo DiCaprio and Jennifer Connelly, has also familiarised the public with the concept of blood diamonds. But fewer people are aware that the civil war in Congo has been largely funded from the proceeds produced by the extraction of rare earth metals in that country, used in the manufacture of computers, smart phones, iPads and other gadgets. According to figures released in 2008 by the International Rescue Committee, the second Congolese civil war is the bloodiest conflict since World War II, with 5.4 million people killed and an estimated 100,000 women raped. These figures are disputed, with other sources suggesting 3.9 million deaths.

Just as international agreements have now been reached on the issue of blood diamonds, it is also necessary for the world to tackle the problem of rare earth metals from Congo. But our focus must not be on Congo alone; there needs to be a geopolitical raw materials policy to prevent this kind of scenario.

production of these metals is limited as are supplies in many cases. Key geopolitical interests are involved in the ownership and trade of these metals, see Box 6.1.

If there is a mass switch towards electric vehicles, we can make 0.25–0.5% of annual car production electric, which would use up the available annual production of lithium and cobalt without any mobile phones or laptops being manufactured, which also require these metals. According to Dr André Diederen (2010) of the Netherlands' Organisation for Applied Scientific Research (TNO), these rare earth metals will have been exhausted in approximately 30–40 years time, given current levels of consumption and a 3% growth of the global economy. If a mass switchover takes place to wind turbines, electric vehicles and so on, this process will be much faster and we will have reached the end point within 8–15 years (Diederen (2010)). In other words, raw materials limit the options for switching to renewable energy en masse.

Fortunately, this limitation will only prove to be a temporary one. These rare earth metals do not occur in nature as free metals, but mostly as compound oxides or salts, such as carbonates or phosphates. Although it was originally thought that these elements were rare, it now seems that they do occur in reasonable quantities in the earth's crust (for example, the amount of cerium in the earth's crust is three times larger than that of copper or lead, both widely-known metals). However, in many cases, they do not occur in recoverable concentrations. Where these rare earth metals are extracted, it is as a by-product of a different metal. In many cases, too, complex processes that pollute the environment are required in order to extract these rare earth metals from the meagre concentrations in which they occur. Many of the metal mines have now closed because they were not economically viable. This means that the by-product is also no longer being sourced. It is likely to take at least another 5–10 years before these mines are reopened and can deliver an economically viable product.

6.3 Concepts

As the world becomes more populated, it is significant to reflect on the large-scale use of non-renewable natural resources. Despite environmental concerns, there has been small or almost no change in general consumption habits reflecting the lack of public awareness (from both professionals and the general public) on environmental implications of material consumption; for example, the European cities of Vienna and Hamburg have become more material intense in recent years (Kennedy et al. 2007). Therefore, demographics, building design combined with lifestyles, hold important answers to understanding the way we consume materials in the built environment.

Sustainable design, industrial ecology and related concepts have developed assessment methods for minimising the environmental impacts caused by material streams applied in diverse applications. In recent years, the materials industry has been very active in promoting innovative sustainable solutions for buildings, but few of them could answer all relevant environmental problems.

Existing material choices for building application that consider minimising non-renewable resources today are still limited in the market. The most common ones are wood and in smaller quantities non-wooden fibre products. Renewable resources even when harvested from certified managed plantations are usually characterised by extensive monoculture land use threatening biodiversity. Another aspect often overlooked is toxic preservation for fire and termite resistance treatment methods.

In this regard, a broader evaluation and contextualisation of material application must be made rather than the misleading search for perfect materials commonly labelled 'green'. While material science will (slowly) bring suitable innovations for the sector, ecological design has proposed intermediate alternatives for short- and long-term sustainable resource usage in products including buildings.

Several authors have developed concepts that are relevant to understanding sustainable material resource use and that can be integrated used as a starting point for design strategies. In Table 6.1 we summarise some of these concepts.

The technical applicability of the requirements mentioned in Table 6.1 is not yet entirely possible in building construction. The six concepts above could even be distributed in a time line from most immediate measures to the longest term attainable ones. Take as an example Biomimicry. It will take some time from now before buildings could be actually built with materials such as corals or bones, with relative structural roles, into a building while being chemically harmless for the environment. Therefore, it is important here to distinguish the difference between a qualitative material able to deliver these sustainable requirements and strategies to design buildings (even with conventional materials) amid the least environmental impacts. Today, design strategies have to offer more immediate practices while perfect materials are not yet available.

Table 6.1 Concepts for understanding resource use and developing design strategies

Concept	Requirements for implementing the concept
Cardinal rules for closing the materials cycle (Kibert 2005, 2006)	Buildings must be deconstructable Products must be disassemblable Materials must be recyclable Products/materials must be harmless in production and in use Materials dissipated from recycling must be harmless
Biomimicry: mimic nature (Benyus 1997)	Runs in sunlight Uses only the energy it needs Fits form to function Recycles everything Rewards cooperation Diversity Local expertise Curbs excesses from within Taps the power of limits
Ecodesign: a promising approach to sustainable production and consumption (Brezet and Van Hemel, United Nations Environment Programme UNEP 1997)	Analysis: how does the product actually fulfil social needs? Production and Supply of Materials and Components: what problems can arise in the production and supply of materials and components? In-House Production: what problems can arise in the production process in your own company? Distribution: what problems arise in the distribution of the product to the customer? Utilisation: what problems arise when using, operating, servicing and repairing the product? Recovery and disposal: what problems can arise in the recovery and disposal of the product
The golden rules for ecodesign (Bringezu 2002)	Potential impacts on the environment should be considered on a life cycle basis or from cradle to grave The intensity of use of processes, products and services should be maximised The intensity of resource use (materials, energy and land) should be minimised Hazardous substances should be eliminated Resource input should be shifted towards renewables
The natural step (Robèrt 2002)	Reduce concentrations of substances extracted from the earth's crust (reducing exploration of scarce minerals) Use efficiently Reduce use of fossil fuel Use substances less unnatural for more natural, and easier to break in nature Rely on well-managed ecosystems pursuing productive and efficient use of land Use of substitution and dematerialisation Reduce substances produced by society Reduce harvesting or other forms of ecosystem manipulation

(continued)

Table 6.1 (continued)

Concept	Requirements for implementing the concept
Cradle to cradle/closed loops for materials (McDonough and Braungart 2002)	Products that, when their useful life is over, do not become useless waste but can be tossed onto the ground to decompose and become food for plants and animals and nutrients for soil; or, alternatively, that can return to industrial cycles to supply high quality raw materials for new products
	Free ourselves from the need to use harmful substances (e.g. PVC, lead, cadmium and mercury).
	Begin comprehensive redesigns: to use only 'known positives', separate materials into biological and technical, and ensure zero waste in all processes and products.
	Reinvent entire processes and industries to produce 'net positives' activities and products that actually improve the environment.

6.3.1 What Are Zero Materials?

We are already familiar with zero-energy buildings (see Chap. 5). These are buildings in which the energy consumption has no impact on the environment. Of course, these buildings do consume energy, but the energy is generated sustainably through solar or wind energy or energy generated from biomass. In any case, the energy generated does not cause an impact on the environment and the building does not use more energy than it generates for itself. By analogy, Michiel Haas, one of the authors of this chapter, is exploring whether it is also possible to talk of zero materials: construction materials that do not have an impact on the environment. The way this could be applied to buildings is that a building would not be permitted to use more materials than it could itself generate in the course of its lifecycle.

In actual fact, we need to take this as a metaphor. Renewable energy also causes an environmental impact, if only during the creation of solar cells or wind turbines and during transport via electricity cables, etc. This is also the case to a comparable extent with zero materials. Perhaps we can regard zero materials as a metaphor, just as CO_2 is seen as a metaphor in the context of the climate issue.

In principle, zero materials are materials that have little or no impact on the environment throughout their lifecycle. The environmental impact is determined by means of an LCA (see also Chap. 11). This involves an analysis of the environmental impact caused in all phases of the material's lifecycle. This begins with the extraction of the raw materials and includes transport and production of the product or construction component, followed by installation in the building. This is followed by maintenance and the possible renovation or redesignation of a building for alternative purposes, which results in an extension of its lifecycle.

In the case of zero materials, little or no environmental impact is identified in the lifecycle analysis. The process begins with the extraction of raw materials. In order to ensure there is no environmental impact, the material must be sourced from

renewable raw materials or from recycling. If a raw material (wood, reed) is grown and harvested annually over an extended period, and it causes no environmental impact during this growth and harvesting, it actually has a positive impact. It absorbs CO_2, cools its immediate environment during hot periods and offers protection during cold periods, thereby saving energy, and it provides a home for animals; so, all in all, it has a positive influence on its environment. An important condition is that these 'regrowable' renewable materials do not take up agricultural land that could be used for food production.

Regrowable materials include the following: wood, reed and bamboo, as well as sheep's wool and clay in delta regions. The Netherlands is a delta region, in which a lot of clay is deposited. Indeed, it has proved possible to harvest clay from old quarries in river meadows again after a period of 40 years. As such, clay may be defined as renewable.

A raw material that originates from agriculture activities is reed. Reeds are used for roofing throughout the world, not just in Europe, but also in Africa, Asia and by Native Americans. One-year-old reed is harvested, but its growth causes no environmental impact. The material is then attached to the roof manually. The reed roof protects the building against the cold, sun and heat. All that is needed is occasional replenishment. Finally, the reed can be removed from the roof and composted or incinerated. This process entails a minimal environmental impact. We need to look at materials in this way if we want to give zero materials a place among construction products. If we move towards bioplastics made from agro-materials (although not yet largely available), they may evolve into a large number of additional products that could be categorised as zero materials. In the longer term, it will be possible to manufacture all types of plastic from agro-materials, ranging from foils to gable coverings.

However, metals can also be considered to be zero materials if we use only recycled metals. This does leave the problem of the energy required for recycling, since this currently almost always comes from fossil sources. But if we use renewable energy to melt down scrap metal, we are actually dealing with a zero material. In order to enable the large-scale use of zero materials, energy must be generated sustainably, which means we need to be able to use the sun as a source of energy.

GreenCalc calculations show that an extremely sustainable building, which we can regard as a zero-energy building, can currently achieve a GreenCalc score of around EBI 1,000.[1] An EBI is an Environmental Building Index (Milieu-Index-Gebouw in Dutch), the result of a GreenCalc calculation. In order to achieve a score that is significantly more sustainable, for example an EBI 2,000, which is an improvement on the Dutch construction method used in 1990 by a factor of 20, progress needs to be made in terms of materials. The materials used need to have much less of an impact on the environment. This is the thinking behind the idea of zero materials. Once the idea has been further developed, which will be essential

[1] GreenCalc calculation of the Watertoren Bussum, made by NIBE, 2010.

since we still have virtually no zero materials, we will be able to further (significantly) reduce the environmental impact of the materials and start to build extremely sustainable buildings.

6.4 Strategies

Various researches tried to formulate more efficient ways to use materials in different parts of the production chain. Based on the concepts described in Sect. 6.6.3, we could derive the main direct strategies to gradually attain sustainable use of materials in construction in two groups: building design strategies and trends in material innovation and use.

Building design strategies involve:

- Waste minimisation: from natural resource harvesting (quarries), manufacturing of components (product development) and building construction (building site). Programs of minimum waste production during construction have also been very successful in developing and developed countries where the last one had a fast boost in prefabricated building components and less wasteful building sites as a result.
- Design for Deconstruction (DFD): design of building components foreseeing disassembling after building use, which emphasises the need for dry connections in building.
- Reuse (reuse here does not necessarily imply DFD): the practice of reuse in buildings does not necessarily indicate that used building components can be reused in new ones, but also any other component from other products rather than buildings could also be used in building.
- Dematerialisation: it is a well-developed practice in many industrial sectors and directly connected to resource – light economies. The goal is to build with less materials, meaning reducing material use per unit of service (Fernandez 2006).

The concepts suggest the following trends in the use, reuse and recycling of materials:

- New materials: materials that could be 100% recyclable or 100% biodegradable, non-toxic, made with renewable materials or that uses resources in real time able to regenerate, requires only energy from sun, and does not contaminate water, air or soil in any phase of its life. Although they are still very scarce, there are today advances in research and even materials already available for use produced by bacteria and other living organisms and are 100% biodegradable (e.g. UV surface coatings and wall insulation).
- Upgrading conventional materials: essential materials for building construction such as cement, steel and glass are huge challenges to be replaced in performance, costs and quantitative availability. Therefore, there are current studies (and already positive results) of more environmental versions of these traditional

materials that may contain more recycled components, or that uses less energy to be manufactured or needs less toxic treatment and so forth.[2]

- Reviewing traditions: this category is related to the 'review' of ancient building concepts such as the use of bamboo, straw, wood, adobe, etc. that could be contextualised and/or upgraded to be produced and consumed on a mass scale in contemporary building systems. These categories of material are still connected to a romantic idea of building construction that should be changed in order to fit in mainstream construction practice.
- Recycling materials: few materials in construction today are fully recyclable. They are mainly downcycled (concrete used for roads). Others may contain particles from different products (sound insulation foam made of used sponges) or may still contain partially recycled components from the same original product (as in the case of steel).
- Materials from renewable resources: materials that are non-toxic and require low processing energies are potentially important to be targeted for the development of environmentally responsible buildings in different areas of the world. In this group, agriculture waste and agriculture products can be identified. Global agriculture waste material has been cited as the largest under-utilised resource in the world today (Fernandez 2006).

6.5 Challenges

The science of sustainable materials is a new discipline and, being so, there are still unanswered questions and space for criticism that should be considered when analysing the built environment. Here is a brief description of some of these concerns.

6.5.1 New Materials

In addition to the fact that buildings have to last for decades and comply with security requirements, the building industry is frequently considered a conservative one. Innovation in construction materials is believed to be the slowest of all industries to be implemented from laboratory research to commercialisation (Fernandez 2006). Cultural barriers are another important factor. Buildings demand initial high investment, making users less prone to take risks in unknown technologies that could bring negative surprises after years.

[2] Chief Scientist Dr Nikolaos Vlasopoulos published that his research can produce cement that absorbs more carbon dioxide than is released during its manufacture. The company estimates that for every tonne of ordinary Portland cement replaced by Novacem, CO_2 emissions will be reduced by around 0.75 tonnes) http://novacem.com/wp-content/uploads/2010/04/Novacem-PR5.Top-10-Emerging-Technology.22-April-2010.pdf Accessed March 2011.

6.5.2 *Deconstruction*

Deconstruction is already an important design measure adopted by various consumer goods industries. In buildings, the procedure will depend on the materials and building systems applied. Concrete and brick construction, both very common building materials, tend to be less attractive to be deconstructed as costs and time involving deconstruction tend to have disadvantages when comparing with building with new materials. Deconstruction should be integrated in new buildings, but it is still complex for existing stock.

6.5.3 *Dematerialisation*

Although dematerialisation is a progressive tendency in the building sector, there are some concerns in dematerialising while losing thermal insulation capacity. A good example is the *Passive House* developed in Europe. They are buildings heavily insulated in order to use little or almost no heating system. Such buildings tend to be more material intense than normal buildings that require more energy to be heated during cold seasons. In this case, dematerialisation is limited. Other aspects of dematerialisation that should be considered are the substitution of lighter materials for heavier ones, or lower material intensity to opt for materials that have more negative environmental impact.

6.5.4 *Building with Super Resistant Materials*

Long-life materials may have initial increased costs, which may be limited to certain parts of the world or certain types of buildings. The life-span of buildings is not only related to their physical decay and their super-resistant materials, but it will also depend on market-driven forces, or the inability to accommodate new functions, values and even aesthetics.

6.5.5 *Building with Renewable Materials*

High volume consumption of any specific type of renewable material will affect natural ecologies by replacing biodiversity for monoculture besides extensive land use. Another concern to arise is the end life of organic matters, which produce gases during decomposition such as methane – one of several greenhouse gases that contribute to global climate change. Large-scale use of biobased material for construction may face the same challenges of the already unclear future of the agriculture industry. Today, in general, life-span importantly restrains renewable materials

applied in construction. Fibres such as organic matter are sensitive to UV, alkaline substances, moisture exposure,[3] termites and microbial agents. Treatments are available to improve the life-span of such materials, which could present certain degrees of toxicity for soil, water and air.

6.5.6 Building with Recycled Material

Recycling, meaning processing construction material after its end use to produce new ones with the same capacity as the old, is still limited. Recycling solid waste to manufacture new products will indeed reduce virgin resources energy consumption, while transportation has to be taken into account.

Many recycling processes have not been able to solve chemical interactions in order to avoid water and soil pollution. Today, several recycled materials can have limited lives before finally being disposed of. Some recycled materials today also include the production of composites, which are frequently very complex to separate all components for further recycling.

6.5.7 Reuse Materials

Although reuse ranks number 2 in the prioritising material sustainable use by the European Environment Commission, it still lacks many steps to make it practically possible in the construction field. It requires guidelines on how to select, where to find, quality control, storage and logistics system and easy information for designers. In general, there is no platform where stakeholders can connect and share information about availability of reusable materials with large-scale capacity-defining networks in an effective production chain with suppliers, technical support, storage, etc. Consumer perception and lack of proper legislative support is still a barrier. Future steps in this development will be hand in hand with the advances of Design for Disassembly.

6.5.8 Biomimicry

The invention of man-made materials that simulate the ones existing in the natural world is a huge challenge. It relies on intense material engineering research with medium- to long-term outputs regarding building construction. It is an enormous step towards creating a waste-free non-toxic environment.

[3] Interview with Professor Bob Ursem at the Faculty of Applied Sciences at TUDelft, 2010.

6.5.9 Incineration

Waste-to-energy has been an often proposed option to avoid landfill. Safe filter systems are not yet available in most countries around the world, leading to higher CO_2 emissions in the overall energy consumption in the country and liberation of other toxins in the air (e.g. paint from wood). Brazil, where sugarcane is cultivated in large quantities for fuel production, has turned by-product bagasse, the remaining fibrous matter after crushing the sugarcane, into a profitable waste-to-energy material for local farmers. However, the incineration process has been responsible for the increase of CO_2 emissions in that same country as a result, when compared with the existing national hydroelectric energy system.[4]

6.6 The Value of Assessment Tools

The GreenCalc calculations show that materials will be a key issue once we have solved the challenges related to the use of non-renewable fossil fuels for energy consumption. It is also clear that we currently do not have the products and knowledge required to develop highly environmentally friendly materials and products. Therefore, tools that can assess the environmental impact of materials are important to help us to develop regulations. For this reason, we have outlined below the various different assessment tools currently used in the Netherlands. These tools have been developed in an international context, and the way in which they are developed and used here is compatible with that in other countries and parts of the world (see also Chaps. 11 and 14).

6.6.1 Development of Assessment Tools in the Netherlands and Other Countries

The development of assessment tools started relatively early in the Netherlands. The development of programmes such as Ecoquantum (now no longer on the market), GPR-Gebouw and GreenCalc all began in the early 1990s. GPR-Gebouw and GreenCalc had already been developed for the market by 1997. A key advantage of these Dutch tools compared to tools from abroad is that they are based on performance requirements for materials rather than on lists advising in favour or against the use of specific materials and products. The non-Dutch tools are also now gradually moving towards performance requirements based on LCA. A key difference

[4] Professor Vanderley John from the Faculty of Civil Engineering of the University of Sao Paulo during interview, 2008.

Table 6.2 Overview of well-known building assessment tools (Changed from DHV 2008)

Assessment method	Country	Based on	Result
BREEAM	UK	List	Certificate
LEED	USA	List	Certificate
Casbee	Japan	LCA/list	Certificate
Green Globes	Canada	List	Certificate
GB-tool	Canada	List	Score
Legeo	Germany	LCA	Score
HQE	France	List	Score
GPR-Gebouw	Netherlands	LCA/list	Score
GreenCalc	Netherlands	LCA	Score

between lists and performance requirements is that a list of measures involves a checklist and is prescriptive. If you do not meet all the criteria and tick every box in the list, the score will be lower. In many cases, the various measures are not balanced against each other, so it is not possible, for example, to choose between draught exclusion in the letterbox or solar cells on the roof. In the case of performance requirements, a specific environmental performance is set by the government – for example, a GreenCalc score of 200 – as a requirement for sustainable procurement. This score can be achieved by taking a range of different energy measures and doing little in terms of materials, but it can also be achieved by adopting fewer energy measures and using highly sustainable materials. This leaves the design team a lot of room to manoeuvre, without having a negative effect on the environmental performance of the final result. However, this is conditional on it being possible to weigh the different measures against each other in terms of their environmental performance, and that can only be done by using an LCA.

Table 6.2 shows the best-known tools used around the world, detailing the country of origin, the basis on which the assessment is made (list or LCA), and the result (certificate or score). This table is partly based on a survey conducted by DHV (2008). In Chap. 11, some of these tools will be compared in more detail.

6.6.2 BREEAM: Dutch Version of the British System

The Dutch Green Building Council (DGBC) is an institute established by the Dutch construction industry to promote sustainable construction, partly through the introduction of a widely-accepted assessment tool. It has developed an assessment system, based on the British BREEAM (Building Research Establishment Environmental Assessment Method). It offers a collection of assessment criteria and tools for designers, developers and advisers to help reduce the environmental impact of buildings and designs. A points system (checklist) can be used to assess the environmental performance of virtually any type of building (offices, residential buildings, industry, shops and schools), including both new and existing buildings.

Table 6.3 Summary of BREEAM categories and main issues (BRE Global 2009: 14. Used with permission)

Categories	Main issues	Categories	Main issues
Management	Commissioning Construction site impacts Security	Waste	Construction waste Recycled aggregates Recycling facilities
Health and wellbeing	Daylight Occupant thermal comfort Acoustics Indoor air and water quality Lighting	Pollution	Refrigerant use and leakage Flood risk NO_x emissions Watercourse pollution External light and noise pollution
Energy	CO_2 emissions Low or zero carbon technologies Energy sub-metering Energy efficient building systems	Land use and ecology	Site selection Protection of ecological features Mitigation/enhancement of ecological value
Transport	Public transport network connectivity Pedestrian and cyclist facilities Access to amenities Travel plans and information	Materials	Embodied life cycle impact of materials Materials re-use Responsible sourcing Robustness
Water	Water consumption Leak detection Water re-use and recycling	Innovation	Exemplary performance levels Use of BREEAM Accredited Professionals New technologies and building processes

In its quest for a suitable measurement tool, the DGBC opted for BREEAM because of the major role it plays internationally, in Europe, the Middle East, Asia and elsewhere. It is the world's most important and most used sustainability label for buildings. Compatibility and uniformity with the rest of the world were the main reasons for the DGBC's choice. The DGBC also considered LEED as an option, but this was ultimately rejected because of its strong connections with American regulations, which makes it more difficult to adapt to local conditions. In addition, BREEAM is a system that has proved relatively easy to adapt to suit the Dutch situation, without compromising on international relevance.

This method involves assessing a building according to nine different aspects. A building is awarded points for each aspect based on its performance for that aspect and whether it meets predetermined criteria. Table 6.3 provides an overview of the different aspects. Weighting is used to determine the total score (Fig. 6.4). This total score can then lead to a certificate: Pass (30%, which means 30% of the total score has been secured), Good (45%), Very Good (55%), Excellent (70%) or Outstanding (85%). The weighting of the scores for the different aspects (for example, management, energy, water, etc.) is determined by construction professionals, lobbyists and scientists.

	Credits Achieved	Credits Available	% of Credits Achieved	Section Weighting	Section score
Management	7	10	70%	0.12	8.40%
Health & Wellbeing	11	14	79%	0.15	11.79%
Energy	10	21	48%	0.19	9.05%
Transport	5	10	50%	0.08	4.00%
Water	4	6	67%	0.06	4.00%
Materials	6	12	50%	0.125	6.25%
Waste	3	7	43%	0.075	3.21%
Land Use & Ecology	4	10	40%	0.10	4.00%
Pollution	5	12	42%	0.10	4.17%
Innovation	1	10	10%	0.10	1%
					55.87%
					VERY GOOD

Man 1 - Commissioning	✓
Hea 4 - High frequency lighting	✓
Hea 12 - Microbial contamination	✓
Ene 2 Sub-metering of substantial energy uses	✓
Wat 1 - Water consumption	✓
Wat 2 - Water meter	✓
LE 4 - Mitigating ecological impact	✓

Fig. 6.4 Example of the relative weightings of the BREEAM scores (Source: BRE Global Ltd. 2009. Used with permission)

The aim of the system is to award a certificate, for which a scheme of assessments and scores has been developed. For organisations, having a certificate is important not only in order to show that it takes environmental issues seriously but also because research shows that a certified building has a higher rental price, is less likely to be vacant and has a higher market value if sold (Kok 2008).

6.6.3 GPR-Gebouw: Communicating About Sustainability

'GPR-Gebouw' (Practical Municipal Building Guideline) was developed by Dutch municipalities in cooperation with project consultants 'W/E adviseurs', in order to identify the sustainability of buildings by awarding a mark. Local municipalities use the tool primarily for residential properties and complexes in order to decide on the aims of the municipalities and developers, assess and optimise the environmental performance of buildings, and communicate between municipalities and developers/construction companies about levels of sustainability. GPR can now be used for existing buildings and new buildings such as offices, schools, etc. The tool covers the following themes: energy, environment, user quality, health and future value. After the data are entered, the performance can be seen for the modules Energy, Environment, Health, User Quality and Future Value. The performance is then expressed on a scale from 1 to 10 for each module. The tool can also be used for existing buildings: this provides information on the quality improvement to be achieved by a proposed intervention (see Fig. 6.5).

The Dutch central government uses the GPR-Gebouw score as a tool. A building meets the criteria for sustainable procurement policy if it achieves a GPR-Gebouw score of 7 for each module (energy, environment, health, user quality and future value). For existing buildings, the environmental performance, calculated using GPR-Gebouw, must either have improved by at least 2 points or the building must have a minimum GPR-Gebouw score of 7 for all modules.

6.6.4 GreenCalc: Measuring Sustainability

The Dutch Ministry of the Environment emphasises the need to be able to make sustainability measurable (Stichting 2009). This measurable unit of sustainability is calculated using the LCA computer program GreenCalc.

GreenCalc is a program widely used by experts, both in the design and implementation phase and after completion, in order to assess or demonstrate sustainability. The method is used primarily in commercial and non-residential construction, both for new and existing buildings.

GreenCalc was originally developed by the Netherlands Government Buildings Agency (Rijksgebouwendienst in Dutch), a public body that builds and manages government buildings, in order to be able to determine whether a building meets the sustainability requirements. The first version was introduced to the market in 1996. It is a fully-fledged LCA program, which means that it shows a building's lifecycle, from the sourcing of raw materials for construction, via energy consumption during operations, to the waste that results when a building is eventually demolished. Shadow prices are used to convert the environmental impacts produced by the LCA into a figure representing the hidden environmental costs (De Bruyn et al. 2010). Shadow prices are artificial prices for environmental goods that represent the value that society attaches to environmental quality. There are two ways of determining

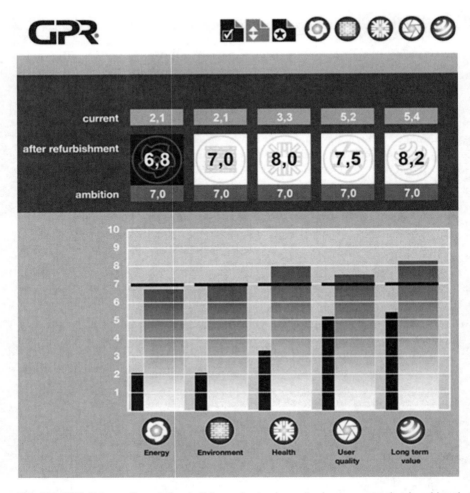

Fig. 6.5 GPR-Gebouw for existing buildings clearly shows the improvement that is achieved (Source: W/E Adviseurs. Used with permission)

shadow prices for environmental quality: prevention costs, the costs incurred in preventing environmental damage from happening, and damage costs, including the costs incurred reversing any damage to the environment. The hidden environmental costs are the costs that are not paid for in the scope of the project, but which are passed on to society, for example in the form of pollution. The result of a GreenCalc calculation is an index called a Building Environmental Index, otherwise known as a EBI score or GreenCalc score.

The program calculates the sustainability of the building based on the schedule of requirements and the work already completed. This is done for three different areas: materials, energy consumption and water consumption. These are all measurable units.

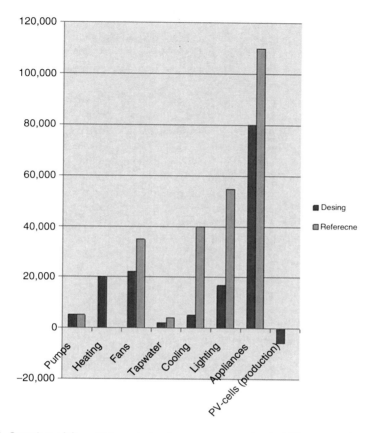

Fig. 6.6 Overview of GreenCalc analysis of energy consumption in kWh per year in a building design and in a reference design (Adapted from GreenCalc calculation by NIBE)

A building that uses limited materials, is slim in construction, has a structure that also serves as a finish and is built using environmentally friendly materials achieves a high score in terms of materials. In terms of energy, it is important that the building requires low levels of energy for heating and cooling and that its users consume as little energy as possible for ventilation, lighting and lifts, as well as for computers, screens, printers, etc. Preferably, the energy required should be generated from renewable sources. Finally, the amount of water consumed by the building's users is determined. If all these areas achieve a minimum environmental impact score, the building can be considered to be a sustainable building.

Figure 6.6 shows that GreenCalc can be used to make simple analyses able to identify where the main cause of a building's environmental impact lies at a glance. It also shows the extent to which the building design that is analysed corresponds to or differs from a similar building (reference design).

However, there are also non-measurable aspects that co-determine the sustainability of a building. These include aspects such as multi-functionality, adaptability and even beauty. This means that an attractive building can also be a sustainable building, but more is required than an attractive and impressive appearance alone. So far things have not yet reached that stage.

The higher the score, the smaller is the impact on the environment. The highest score so far (in 2011) has been awarded to the Watertoren in Bussum, a former water tower, with an EBI of 1,028 (co-designed and occupied by NIBE, the research institute that was one of the developers of GreenCalc), followed by the offices of the Directorate-General for Public Works and Water Management (Rijkswaterstaat) in Terneuzen with a GreenCalc score of 323, and the offices of the Worldwide Fund for Nature with 269: three Dutch buildings which are internationally recognised as exemplary projects. As stated in the previous section, according to Dutch regulations for sustainable procurement, a building is sustainable when it has a GreenCalc score of 200, but truly sustainable buildings will probably achieve GreenCalc scores of 2,000 and higher.

6.6.5 DuboCalc: Measurable Environmental Performance in the Civil Engineering Sector

Starting in 2010, Dutch central government has decided to apply sustainable procurement criteria across the board (100%). In addition, 'Rijkswaterstaat', the public body responsible for construction and management of road and water infrastructure in the Netherlands, has developed DuboCalc, a tool used to assess the sustainability of civil engineering works.

DuboCalc is a computer program that calculates the environmental impact of the use of materials and energy consumption in civil engineering works. Architects can use this tool to determine environmental profiles for various design alternatives. DuboCalc converts the environmental impact into what is known as an Environmental Costs Indicator (ECI; 'MilieuKostenIndicator' or MKI in Dutch). The ECI represents the extent of a project's environmental impact.

DuboCalc is also based on lifecycle analysis, the method that examines all environmental effects ranging from the material use and energy consumption of a building, from sourcing to the demolition and recycling phase.

The DuboCalc score is used in the calculation of the Most Economically Advantageous Tender (EMVI in Dutch). The Most Economically Advantageous Tender is the method now preferred by Rijkswaterstaat for awarding tenders. This method examines not only the price but also attaches a great deal of value to qualitative criteria such as public orientation (minimal possible disruption to traffic and the surrounding area), sustainability (environmental criteria) and/or project management (rapid construction results in reduced inconvenience and is therefore judged to be positive).

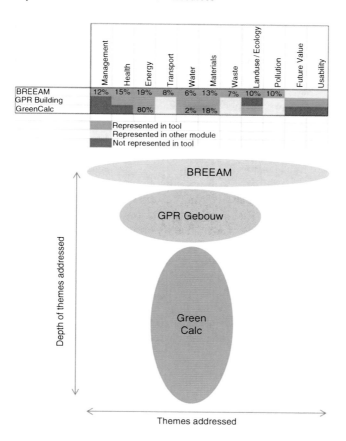

Fig. 6.7 The three Dutch building tools and how they differ

6.6.6 *Conclusion*

Rapid developments are afoot at BREEAM-NL, which has been warmly welcomed in the Netherlands by the DGBC. BREEAM-NL is an excellent system with many uses: starting in the initiative phase, where it serves as a useful checklist, right through to completion of the fully certified building. Above all, BREEAM-NL is an extremely effective checklist, but it is not yet a tool that can be used to monitor and account for measurable objectives. The tool focuses on the final result of whether or not the certificate can be awarded. There are two other tools available for buildings, GPR Gebouw and GreenCalc, both of which have more to offer in terms of perfor-mance objectives than BREEAM-NL; GreenCalc because of its fully scientific structure, based on lifecycle analysis, and GPR Gebouw because of the wide range of aspects it can measure, including more objectives relating to 'People', and the simple way in which it works. Figure 6.7 shows the differences between the three tools.

For the civil engineering sector, only one tool is available, which is DuboCalc. In terms of its scientific underpinnings, it is similar to GreenCalc, although it is much less specific.

Attempts to harmonise all four instruments have been under way for some years. BREEAM-NL aims to become the key language for communicating about sustainability. To achieve this, the other two instruments will adopt parts of BREEAM-NL, which itself will focus on incorporating LCA calculations in areas where this makes sense. However, the four different tools also have very different target groups and, for the time being at least, they will continue to adopt their own course, albeit in consultation.

Until now, the tools have been used by companies and organisations that are highly committed to sustainability. Major companies are explicitly moving towards an increased focus on CSR (corporate social responsibility). Starting out as vague objectives in attractively designed annual reports, printed on high-quality, colourful and glossy paper, these annual reports now increasingly including measurable targets. This is a highly positive development: these companies are setting measurable targets, which must be accounted for, also in terms of their accommodation. In such cases, effective measurement tools are invaluable. This therefore means that the tools will increasingly need to address the issue of how a building is used. BREEAM had already introduced its 'in-use' version and GreenCalc has developed its own index, OEI (Operational Environmental Index or *Milieu-Index-Bedrijfsvoering* in Dutch).

6.7 Selecting Materials

The selection of building materials and products for a high-performance green building project is by far the most difficult and challenging task facing the project team (Kibert 2005: 271). Technology limitations, consumer habits and lack of information are a few of today's barriers for introducing more sustainable building materials that could offer a large range of benefits for both micro- (building) and macro- (regional ecology) scales. Besides understanding the fundaments of sustainable material for now and then, in practical terms it is understood that solutions will have to be contextualised at both cultural and geographic levels. Understanding the dynamic of the reuse practice in an industrialised country will differ from reuse in an agriculture-based developing country, both in scale (amount of available components) and content (types of components, workforce, quality, etc.). If material consumption thinking could evolve to resource consumption thinking, then resource availability and the impacts related to large-scale consumption should be more clearly indicated for users. Material selection requires tools to be visualised and understood, leading to choices that could be more immediately related to improving the way resources are consumed relative to time and space.

6.7.1 Urban Metabolism

One recognised method to combine resource consumption information in a prede-termined location is Urban Metabolism (see, among others, Chaps. 2 and 12). The city described as an organism was described by Wolman (1965). Urban metabolism describes in models material flows as inputs and outputs in a predetermined area defined in time and by function. These flows also recognise resources transformed into built stock. Assessing these databases makes possible a better understanding of resource management within the built environment and therefore of the metabolic flows of cities. For accounting of these flows, the model relies on a database of input and output of several different matters that comprise the urban area.

Material Flow Analysis (MFA) is a method of assessing flows of specific materi-als in a specific geographic area during a certain period of time (Baccini and Brunner 1991). These flows are defined in mass units per time period (Brunner and Rechberger 2004). MFA is a tool of industrial ecology that calculates important indicators for both ecologic and economic knowledge.

Another concept that could support biobased material selection is Landscape Ecology. This is the study of spatial variation in landscapes at a variety of scales (Forman 1995). Through mapping historical local ecology (in special flora), we will be able to establish a *reference* of to what extent local ecosystem and urban develop-ment could coexist in regard to building material demand. There is not yet a single and precise tool to measure resource extraction for buildings that could be *ideal* in the contemporary world. There are other tools and methods that could also be used, for example Urban Ecology (see Chap. 3).

6.8 Conclusion

This chapter aims to suggest the best material choices for building construction by understanding the relationship between micro- and macro-activities and their mag-nitude of environmental and economic impact. Could Urban Metabolism and Landscape Ecology function as holistic material selection tools as a way to bring a systematic understanding of the use of local resources that could produce straight-forward responses to designers' community?

Urban Metabolism and Landscape Ecology could function as powerful tools to map more efficient ways to control material use in a given geographic area, while as material harvesting tools with their focus on optimisation of resources within differ-ent scales (city, national, regional) they can be used for assessment of material flows and for 'restoring' original local ecologies.

Building typologies could be designed according to which materials could be more or less intensely used and more suitable in a specific area. By addressing local waste flows, for instance, a plausible directory of materials could be available to be reused. Or types of plants that could originally grow in the area could be integrated

within the urban fabric for local production of material to be used in buildings, such as reed in some harbour locations.

Questions

1. Why is material construction one of the most complex topics when looking for environmental sound solutions buildings? What are the biggest challenges facing materials streams in civil construction?
2. Describe some design strategies that focus on the minimisation of environmental impacts caused by construction materials.
3. Explain the role of measuring tools for buildings.
4. What are the positive and negative aspects of renewable resources applied in construction?
5. Why is geographic contextualisation of material use important?

References

Baccini P, Brunner PH (1991) Metabolism of the anthroposphere. Springer, Berlin
Benyus J (1997) Biomimicry: innovation inspired by nature. William Morrow &Co, New York
Brezet H, van Hemel C (1997) Eco-design: a promising approach to sustainable production and consumption. Rathenau Institute, TU Delft & UNEP, Paris
BRE Global Ltd. (2009), BREEAM Europe Commercial 2009 Assessor Manual, SD 5066A: ISSUE 1.1http://www.ngbc.no/sites/default/files/SD_5066A_1_1_BREEAM_Europe_Commercial_2009. pdf. Accessed 25 Feb 2011
Bringezu S (2002) Construction ecology and metabolism. In: Kibert CJ, Sendzimir J, Guy GB (eds) Construction ecology: nature as the basis for green building. Spon Press, London
Brunner P, Rechberger H (2004) Practical handbook of material flow analysis. Lewis, Boca Raton
De Bruyn S et al (2010) Shadow prices handbook, valuation and weighting of emissions and environmental impacts. CE, Delft
DHV (2008) Instrumenten beoordeling en promotie duurzame kantoren. SenterNovem, B3991.01.001
Diederen A (2010) Global resource depletion: managed austerity and the elements of hope. Eburon, Delft
European Commission (2000) Management of construction and demolition waste. Directorate General Environment Working Document N 1 DG ENV.E.3
Fernandez J (2006) Material architecture: emerging materials for innovative buildings and ecological construction. Elsevier, Burlington
Forman RTT (1995) Some general principles of landscape and regional ecology. Landsc Ecol 10(3):133–142. SPB Academic Publishing, Amsterdam
Haas M (2009) LCA – Jongleren met milieugetallen. Intreerede ter gelegenheid van de aanvaarding van het ambt van Hoogleraar Materials & Sustainability. Delft University of Technology, Delft
Haas M (2010) Waarom we ons met 0-materialen moeten bezighouden. Duurzaam Gebouwd # 26, http://www.duurzaamgebouwd.nl/expertpanel/c/michiel-haas
Jacobson MZ, Delucchi M (2009) A path to sustainable energy by 2030. Scientific American, Nov 2009

Kennedy C, Cuddihy J, Engel-Yan J (2007) The changing metabolism of cities. J Ind Ecol 11(2):43–59

Kibert CJ (2005) Sustainable construction: green building design and delivery. Wiley, Hoboken

Kibert CJ (2006) Revisiting and reorienting ecological design. Paper presented at the construction ecology symposium. Massachusetts Institute of Technology, Cambridge

Kibert, Charles J, Jan Sendzimir, Bradley Guy G, eds (2002) Construction ecology: narure as the basis for green building. London: Spon Press, New York

Kok N (2008) Corporate governance and sustainability in global property markets, Maastricht University, dissertation

McDonough W, Braungart M (2002) Cradle to cradle: remaking the way we make things. North Point Press, New York

Robèrt KH (2002) The natural step story: seeding a quiet revolution. New Society Publishers, Gabriola Island

Stichting S (2009) One number says it all. Ministry of Housing, Spatial Planning and the Environment (VROM), The Hague

Van Brezet JC, Hemel CG (1997) Ecodesign: a promising approach to sustainable production and consumption. UNEP, Paris

WBCSD (World Business Council for Sustainable Development) (2002) The cement sustainability initiative: our agenda for action. WBCSD, Switzerland

WBCSD (World Business Council for Sustainable Development) (2007) The cement sustainability initiative. WBCSD, Switzerland

Wolman A (1965) The metabolism of cities. Sci Am 213(3):179–190

Worrell E, Price L, Hendricks C, Ozawa Meida L, Worrell E, Price L, Hendricks C, Ozawa Meida L (2001) Industrial energy analysis: carbon dioxide emissions from the Global Cement Industry. Annu Rev Energy Environ 26:303–329, see http://industrial-energy.lbl.gov

Chapter 7
Air Quality and Human Health

Arjen Meijer

Abstract This chapter deals with both the indoor and outdoor air quality of buildings and their effect on the health of the occupants. This is an important topic for sustainability of urban areas and buildings because of the long lifetime of buildings and the large amount of time that people spend inside buildings and in urban areas. Sources and parameters affecting the indoor and outdoor air quality are discussed. Other indoor environmental aspects such as thermal comfort, noise and lighting are also addressed briefly. Then, the effects of these parameters and aspects on the health and comfort of the occupants are described. Finally, guidelines are given for designing buildings with high indoor air quality and for solving existing problems with poor air quality and health complaints.

7.1 Introduction

In urbanised areas, the air quality is often poor because of high concentrations of harmful substances emitted by, for example, traffic or industrial activities. The exposure of the population to these substances is also higher because of the higher population density in urbanised areas. Poor outdoor air quality affects the indoor air quality in buildings because outdoor air is used for ventilation, often without treatment of the incoming air by, for example, filtering.

People live a long part of their lives inside. In developed countries, this can be up to 90% of the lifetime of humans. Problems associated with the indoor environment thus cause a high impact on human well-being. Moreover, pollutant concentrations are often higher inside buildings than outside them. Therefore, a good indoor environment in buildings is very important.

A. Meijer (✉)
OTB Research Institute for the Built Environment, Delft University of Technology,
P.O. Box 5030, 2600 GA, Delft, The Netherlands
e-mail: a.meijer@tudelft.nl

E. van Bueren et al. (eds.), *Sustainable Urban Environments: An Ecosystem Approach*,
DOI 10.1007/978-94-007-1294-2_7, © Springer Science+Business Media B.V. 2012

Sources of problems associated with the indoor environment can be divided into five aspects:

- Chemical pollutants
- Biological pollutants
- Thermal comfort
- Noise
- Lighting

Chemical and biological pollutants are volatile matter, which are adsorbed by the occupants by inhalation, dermal update and, in smaller amounts, ingestion. This can cause many health effects, varying from irritation of skin, eyes and nose to severe illness and death. Thermal comfort, noise and lighting cause external stress on people, resulting in irritation, sleep problems, stress-related symptoms and sometimes heart attacks. These health effects are usually less severe than those caused by chemical and biological pollutants, but people experience more annoyance from bad thermal comfort, high noise levels and bad lighting. Additionally, odours (also a kind of chemical pollution) may have a negative effect on the perceived indoor quality.

In this chapter, the causes and effects of a bad indoor environment are described and measures are given to improve the indoor environment. Section 7.2 deals with the sources and exposure of chemical and biological pollutants. In Sect. 7.3, the problems regarding thermal comfort, noise and lighting are described. Section 7.4 discusses the health effects as a result of bad indoor environmental quality, while in Sect. 7.5, practical guidelines are given to improve the indoor environment of buildings. Finally, in Sect. 7.6, the conclusions of this chapter are presented.

Although outdoor air quality will be discussed in this paper, most emphasis will be given to indoor air quality. The effect of indoor air quality on humans is larger than that of outdoor air quality because of higher pollutant concentrations indoors and the longer time periods spent inside. Furthermore, small-scale measures (at building level) to improve indoor environmental quality are often highly efficient.

7.2 Air Pollutants

Indoor air quality is the most important parameter for health problems inside houses. High concentrations of chemical or biological substances can cause a wide variety of health complaints such as irritation of skin and eyes, asthma and headaches. But exposure to outdoor pollutants also can be a cause of adverse health effects. Harmful substances from outside can be transported to the indoor air by ventilation of the building, where they can affect the health of the occupants.

In this section, first the sources of outdoor air pollutants will be discussed, and then the sources of indoor air pollutants will be dealt with. For indoor air pollutants, a distinction between chemical and biological substances will be made. This distinction is not important for outdoor air pollutants, where chemical substances will be

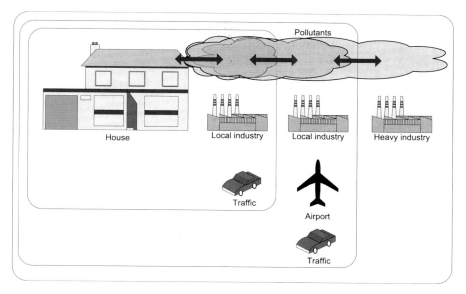

Fig. 7.1 Sources and transport routes of air pollutants

dominant. At the end of this section, the exposure of humans to the air pollutants will be explained. An overview of the sources and transportation routes of air pollutants is given in Fig. 7.1.

7.2.1 Sources of Outdoor Air Pollutants

Traffic is one of the main sources of outdoor air pollutants. Houses close to main roads can be exposed to high concentrations of volatile organic compounds (VOCs), nitrogen oxides (NO_x), sulphur dioxide (SO_2) and particulate matter from the combustion gases. In some cases, houses adjacent to busy intersections of roads need high air tightness and ventilation systems with filters to obtain an acceptable indoor air quality (see also Sect. 5.3.4). In non-OECD countries, pollutant emissions by traffic are often higher than in OECD countries because of the older vehicles being used, which often lack catalytic converters. Outdoor concentrations of these gases can also be high in the vicinity of airports or railroads. More information about urban transport and sustainability can be found in Chap. 9.

The second main source of outdoor air pollutants are *industrial activities*. These can cause high concentrations of NO_x, particulate matter and VOCs. The distance of influence can range from short (petrol stations, laundries) to very long (harbour districts, heavy industries), see also Fig. 7.1.

Emissions from *agricultural activities* can also be present, but these cause mainly only nuisance and are seldom a cause of health problems. The occurrence of some

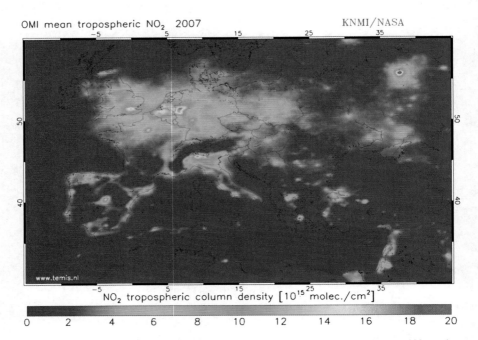

Fig. 7.2 Map of NO$_x$ concentrations in western Europe (Source: www.temis.nl Accessed November 2010)

epidemics, however, such as Q fever or foot-and-mouth disease are associated with biological agents that originate from livestock breeding.

In urban regions and in areas with heavy industry, the background concentrations of harmful substances such as NO$_x$ and particulate matter, is much higher than in rural areas. Figure 7.2 shows that the NO$_x$ concentrations in the harbour area of the Netherlands and in the Ruhr Area in Germany, as well as in the large cities in Europe, are much higher than in the rural parts of Europe. Similar high concentrations can be found in the other parts of the world, such as the east and west coasts of the United States, the coastal areas of China and metropolises around the world. The emissions from local sources such as traffic come on top of these background concentrations.

Outdoor air pollutants can enter the indoor environment of buildings via ventilation, either via the ventilation system or via cracks in the building envelope. Particulate matter can be filtered from the incoming air, but this is not possible for gaseous pollutants such as NO$_x$ or SO$_2$.

Pollutants leave the urban environment by transport via air, by deposition or adsorption on surfaces, or by decay under the influence of ultraviolet radiation or ozone.

7.2.2 Sources of Indoor Air Pollutants

7.2.2.1 Chemical Pollutants

Inside the house, there are many sources of chemical pollutants which may have a negative effect on the health of the occupants. Emissions can originate from four types of sources: building materials, soil, consumer products and combustion gases.

Building materials can emit a wide range of substances. Volatile organic compounds (VOCs), such as xylene or styrene, are emitted from paints, glues and plastics. Formaldehyde is a degradation product of ureaformaldehyde, which is used in glues used in particle board, rock wool and glass wool. Both VOCs and formaldehyde emission rates are high directly after the material is applied and then slowly decrease during its life time.

One should be careful with choosing building materials with low emission rates of harmful substances. Building materials with low emission levels may have a worse overall environmental profile (see Chap. 11) than building materials with high emission rates, when the production of these materials is taken into account. In Chap. 6, the environmental issues of the production of building materials are discussed. One way to compare the health damages as a result of indoor exposure to harmful substances with the health damage associated with the life cycle of the materials causing the emissions of these substances is the DALY method (see Box 7.1).

Stony materials such as concrete, bricks and gypsum emit radon (mainly ^{222}Rn). Radon is a radioactive noble gas with a half-life of 3.8 days. It is a decay product of uranium (^{238}U), which has a half-life of 4.5×10^9 years. Because of this long half-life, the generation rate of radon is constant over time. Radon is an inert gas, which is transported from the pores of the building material to the indoor air. When it is taken up by the occupants by inhalation, it can cause lung problems because of its radioactive decay.

Another natural emission source of radon is the *soil*. In areas with a rock soil, such as certain areas in France or the United States, the radon emission rates from soil can be much higher than the total radon emission rate from building materials. In areas with sand or clay soil, such as the Netherlands, the radon emission rates from soil are low, and the radon in the indoor air originates mainly from building materials. In Sect. 7.5.1, guidelines are given to prevent radon emissions from the soil to enter the building.

VOCs can also be emitted from *consumer products* such as furniture, cleaning agents and electronic equipment. In indoor air modelling and policy making, this is often regarded as user behaviour, which is very difficult to monitor and model. The range of volatile compounds and emission rates from consumer products is very large over the different types of households.

Combustion gases are formed when occupants are preparing their meals on a stove or heating water in a local gas heater (geyser; see also Sect. 5.6.7). When natural gas is completely burnt in a geyser or gas stove, carbon dioxide (CO_2), water and a small amount of NO_x are formed. When the combustion is not complete, carbon

Box 7.1 Disability Adjusted Life Years (DALY)

A widely used method to compare different health damages for modelling purposes is expressing the health damages in disability adjusted life years (DALY), developed by the World Health Organization (Murray and Lopez 1996). DALYs are the weighted sum of years living disabled (YLD) and years of life lost (YLL). It takes into account the severity of the disease (e.g. irritation has a lower severity than cancer), the duration of the disease and the number of people suffering the disease.

DALYs can be added and compared in a linear way. In this way, health damage from different types of illness or caused by different substances can be added together and compared.

monoxide (CO) can also be formed. Carbon monoxide is highly toxic. Burning wood in a wood stove or hearth causes the emissions of a wide range of VOCs, soot (often tar-like), CO, NO_x, particulate matter and other gases. Cooking on an electric stove only emits gases from the food that is prepared.

Harmful substances in *outdoor air* can enter the indoor environment via ventilation of the building. Outdoor air pollutants were discussed in Sect. 7.2.1.

7.2.2.2 Biological Pollutants

Biological pollutants cover the emissions from living organisms, which are all around us, including ourselves. Living organisms need food and water to maintain themselves. This explains for the most part the occurrence of living organisms at several spots within the house.

Moulds are generally found in moist areas such as bathrooms, kitchens and places where leaks are found or condensation takes place. To prevent mould growth, it is important to dry the bathroom and kitchen after use, to repair leaks and to prevent condensation. Condensation takes place when warm indoor air meets a cool surface, such as a poorly insulated outer wall. The water vapour contained in the warm indoor air condenses and deposits on the surface. This can act as a nutrient substrate for moulds.

House dust mites are common in all types of dwellings. They are especially found in mattresses, because of the warm and moist environment in bed when people are sleeping. Other places where house dust mites thrive are carpets and sofas. The mites themselves are harmless and nearly invisible, but people can be allergic to the allergens the house dust mites secrete. The mites live on food found in dust and from water.

People can also be allergic to *plant and pet allergens*. People can have allergic reactions in houses where plants are producing pollen or there are pets with hairs or

feathers, such as cats, dogs, rabbits or birds. Exposure to cat and dog allergens in early childhood is believed to cause fewer cases of asthma-like symptoms, but on the other hand, these allergens can also cause asthma-like symptoms.

The *legionella* bacteria live in water. The optimal conditions for living are in water at 37°C, but keeping water between 25°C and 50°C is regarded as a risk. Inhalation of water vapour contaminated with legionella, for example in the shower, can cause the veterans' disease. The best way to prevent legionella contamination is to keep the water temperature in boilers and ducts above 60°C, and to flush the warm water system with hot water when it has not been used for a longer time.

Biological pollutants from *outside* the house can enter the house via the ventilation system or open doors and windows. Examples are pollen, for which people can be allergic, and odours from agricultural activities such as manuring. However, indoor concentrations are seldom higher than outdoor concentrations, and people sensitive to pollen can have allergic reactions from just the pollen they are exposed to when outside.

The final source of biological pollutants is the *people* in the house themselves. Odours are the main emissions, but especially in crowded rooms with low ventilation rates, this may cause severe problems, together with the moisture emissions from metabolism (see also Sect. 5.3.6).

7.2.3 Exposure

The exposure of the occupants to a chemical or biological substance is dependent of several parameters. In a single room, the concentration of a pollutant in a situation with a constant emission and ventilation rate (steady-state) is:

$$C_{in} = \frac{M - A + D}{vr} + C_{out} \qquad (7.1)$$

where C_{in} is the concentration of the pollutant inside the room (g/m³), M is the total emission rate of the pollutant from all sources (g/s), A is the adsorption rate of the pollutant by materials inside the room (g/s), D is the desorption rate of the pollutant from materials inside the room (g/s), vr is the ventilation rate in the room (m³/s), and C_{out} is the outdoor concentration of the pollutant (g/m³). The adsorption and desorption rate are often equal.

According to Eq. 7.1, the concentration of a pollutant in a room is higher when the emission rate is higher, the ventilation rate is lower or the outdoor concentration is higher. These three parameters can be influenced to a greater or less extend.

The emission rate of a pollutant from a material can be dependent on:

- Concentration in the material;
- Structure of the material: e.g. in porous matter, pollutants are transported faster to the boundaries of the material;

- Temperature: often, emission rates are higher when the temperature is high, because of the faster movement of molecules and the thermal expansion of the material, causing larger cracks and openings;
- Humidity: emission rates can be higher when the humidity is high or low, depending on the pollutant and the material;
- Finishing of the material: a finishing with a fine structure, e.g. lacquer, closes pores and cracks;
- Biological activity of an organism: especially, the emission of allergens is dependent on the biological activity of the organism, which is dependent on temperature and abundance of food and water.

The ventilation rate is dependent on:

- The ventilation flow of the mechanical ventilation system;
- The number, size and location of ventilation grilles or windows: ventilation grilles and windows in opposite façades of a building account for a higher ventilation rate than ventilation grilles or windows in only one façade;
- The air tightness of the building: in many modern houses, the air tightness of buildings is high. This causes less natural ventilation through cracks and demands the use of mechanical ventilation. An incorrect functioning of mechanical ventilation can cause problems because there is no fallback to natural ventilation;
- The use of the ventilation facilities by the occupants.

7.3 Other Indoor Environmental Aspects

These other aspects are thermal comfort, noise and lighting. Although the relationship with health is not as clear as for chemical and biological components, long exposure to thermal, visual or auditory discomfort are known to increase stress which in turn is known to lead to potentially severe health problems.

7.3.1 Thermal Comfort

The parameters determining thermal comfort are:

- The indoor air temperature,
- The surface temperature of walls, ceilings and floors,
- Air movements,
- Humidity,
- The type of activity,
- The type of clothes worn.

Some of these parameters are also used to calculate the energy demand of a building (see Sect. 5.3). They are interrelated: the acceptable air temperature

depends on the temperature of the walls; the acceptable air velocity depends on air temperature (in summer, draughts may be pleasant, whereas they should be avoided when it is cold); the acceptable humidity also depends on air temperature.

Generally, the indoor temperature must be kept between 18°C and 28°C. There are regional preferences depending on the outdoor climate. Also, the type of ventilation system used may influence the acceptation of high indoor temperatures (see Sect. 5.3.7.4). It is also known that keeping a constant indoor air temperature all through the year (e.g. 22°C) is less comfortable than letting the temperature fluctuate with outdoor natural variation. For instance, in northern countries, the winter indoor temperature can be set at 20°C whereas in the summer, a temperature of 24°C will be considered comfortable. Allowing for seasonal temperature fluctuations is also a way to save energy (less heating in winter and less cooling in summer; see Sect. 5.3.7.4).

The surface temperature of walls, ceilings and floors is an important comfort parameter because it determines the quantity of radiation energy received or lost by the human body. The human body is more sensitive to energy flow rates than to temperature itself. The sensation of comfort is determined by the radiation and convection flow rates between the human body and its environment. The convection flow rate is determined by the air temperature and the radiation flow rate by the surface temperature of surrounding walls. A relatively cold indoor air temperature (e.g. 16°C) may be compensated by a high temperature of walls or floor. That is why wall and floor heating are mostly perceived as being very comfortable (for more information, see Van Paassen 2004). Conversely, surfaces with a low temperature (e.g. because of poor insulation) may also cause discomfort (cold sensation) when the air temperature is in the right range. Moreover, moisture in the warm air can condense on the cold surface, which may cause moisture and mould problems.

The velocity and turbulence of indoor air flows influence the convective energy flow rates between the human body and its environment. High velocity and turbulence increase this flow rate, creating a cold sensation, draught, which may be pleasant in summer but feels uncomfortable in winter.

In some circumstances, very low or very high humidity levels can also cause uncomfortable indoor environmental conditions. In periods of low temperatures, the outdoor air is often dry, which can lead to a too low humidity indoors. On the other hand, high moisture levels in the air are often also perceived as uncomfortable. The relative humidity that is perceived as comfortable lies between 30% and 70%.

Finally, the perceived thermal comfort depends strongly on the type of activities (e.g. sitting, standing, materials handling) and the clothes worn (insulation, also known as clo value, and permeability).

Depending on the type of outdoor climate, ensuring a good thermal comfort in the summer and in the winter may lead to conflicting solutions. For example, in a moderate sea climate as in the Netherlands, a well-insulated airtight building with a good thermal comfort in winters can lead to overheating in the summer because the internal heat gains cannot be removed through transmission (see also Sect. 5.3) and because the infiltration flow rates are too low to allow enough fresh air to cool the building.

7.3.2 Noise

Many people suffer annoyance as a result of noise in the building. The main causes are:

- Outside sources, such as road, railroad or air traffic;
- Indoor sources, such as the ventilation equipment or appliances;
- Sources from neighbours, such as music, voices or installations in the neighbours' houses.

Noise problems are often related to problems with air quality within the house. Windows or ventilation ducts may not be opened because of the noise outside, or the ventilation system may be switched off because of the noise it produces.

7.3.3 Lighting

Although too little attention is generally paid to lighting, bad lighting can cause psychological problems, such as discomfort, decrease of productivity or disruption of the biorhythm. Lighting problems can be divided in three categories:

- Glare, for example when sunlight falls directly on television or computer screens;
- Too little light, for example during reading;
- Too little daylight. It is believed that people have fewer psychological problems when they are exposed to direct daylight. Winter depression may be caused by exposure to too little daylight, especially when people are most of the day inside. Even the view from the window is believed to have impact on the health of people.

Lighting can influence the overall environmental performance of dwellings:

- When enough daylight enters the dwelling, less artificial light is needed, and thus the electricity consumption is lower.
- Large windows in the façade of the dwelling facing the sun (on the northern hemisphere, this is the south façade) cause a higher sun irradiation, which reduces the need for heating the house. During the summer, this may cause overheating, but sunshades or vegetation which loses their leaves during winter can solve this problem (see also Sect. 5.3.7.4).

On the other hand, the need for natural light has a negative effect on the insulation of the house, as windows generally have a lower insulation level than walls. This explains the use of small windows in the façade opposite the sun (on the northern hemisphere, this is the north façade) of houses that use passive heating by sunlight (for more details, see Sects. 5.3.5 and 5.3.7.4).

The spectrum of the lighting in a room also determines the comfort level of the room. The spectrum of a light source is expressed as its colour temperature.

This is defined as the temperature of a black body of which the light emitted has the same colour impression as that light source. A candle has a colour temperature of 1,200 K, the afternoon sun of 6,000 K, and a common incandescent lamp of about 2,800 K. The first white LED light bulbs are often perceived as giving uncomfortable cold, purplish light, although the newer types have improved a great deal.

7.4 Health Effects

There is a large variety of health effects as a result of exposure to chemical or biological pollutants and as a result of a poor thermal comfort, high noise levels or poor lighting. A (not limited) list of possible health effects is given in Table 7.1.

It is often difficult to find the cause–response relationships for these health effects, because a particular health problem can have multiple causes, which do not need to be related to the indoor environment (aspecific problems). For example, somebody can have sleeping problems because of working stress. Furthermore, a health problem can be caused at another place than a particular building. For example, someone can have a sore throat because of an allergic reaction to the cat from another house.

The best way to find cause–effect relationships is to carry out large-scale epidemiological experiments with large groups and over a longer time. This is often very time-consuming and costly. Smaller epidemiological experiments are possible to estimate the effect of one or a few parameters on the health of the occupants, but the scientific value of these experiments is smaller.

Table 7.1 Health effects as a result of indoor environmental problems

Health effect	Chemical or biological pollutants	Thermal comfort, noise or lighting
Stopped-up or running nose	✓	✓
Wheezing breathing	✓	
Tightness of the chest	✓	
Shortness of breath	✓	
Hay fever	✓	
Sore throat	✓	✓
Tired or running eyes	✓	✓
Irritation of contact lenses	✓	
Headache	✓	
Extreme fatigue	✓	
Concentration problems	✓	✓
Repeatedly waking up during night	✓	✓
Dry or irritated skin	✓	
Muscular pains	✓	
Heart attacks		✓

7.5 Practical Guidelines

Many problems of bad indoor air quality of houses can easily be solved with some practical guidelines. For each of the aspects of indoor environment, practical guidelines are given in this chapter. A distinction between guidelines for the design phase, the construction phase and the use phase is made. Most of the guidelines described in this section refer to dwellings, but many of them can also be applied to non-residential buildings.

7.5.1 Chemical and Biological Pollutants

7.5.1.1 Design Phase

High concentrations of chemical and biological pollutants can be avoided by using building materials with low emission rates of pollutants rather than materials with high emission rates. A few examples: acrylate paints have a lower VOC content than alkyd paint; wood has a lower radon emission rate than stone materials; and natural wood can be preferred over particle board because of the formaldehyde emissions from the latter.

Moulds and house dust mites need a moist environment to prosper. An effective way to prevent mould growth is to avoid moist areas in the house. Thermal bridges (see Sect. 5.3.3) are a common source of wet spots and mould growth and should thus be avoided. Another common source of moisture is the crawl space of a building. Insulation of the ground floor and adequate ventilation of the crawl space or cellar is necessary to prevent damp rising from the soil. Moreover, this also prevents infiltration of radon and soil pollutants into the indoor environment.

High pollutant concentrations can also be avoided by removing the pollutants from the indoor environment by ventilation. For biological pollutants, a well-designed ventilation system preventing a climate suitable for growth of harmful organisms is necessary for a healthy indoor environment.

The ventilation capacity should be designed not to be too small. Often, the capacity is designed for common use of the house, but in cases of large emissions (e.g. parties, painting), there should be enough capacity to remove all additional pollutants. In most cases, opening a window is enough, but extra capacity can remediate the effects of larger emissions without effort by the occupants. Moreover, during the first months after finishing the construction of the house, extra moisture is emitted into the indoor environment due to the drying process of the concrete. There should be enough capacity to remove this moisture as well as to prevent moisture problems.

In the case of mechanical supply or balanced ventilation, the air ducts should be designed in such a way that there are as few bends as possible that will be difficult to clean during the use phase of the building. The air ducts should also be insulated where needed in order to avoid cold spots leading to condensation in the pipes.

Filters should be provided to avoid outdoor pollutants and dust coming into the system. The filters must be cleaned and replaced regularly during the service life of the system.

Furthermore, the ventilation system should be designed in such way that too high air turbulence, and draughts that cause occupants to experience the ventilation as uncomfortable, should be avoided. Draughts can be avoided by installing ventilation grilles at least 1.80 m above the floor and by using low-turbulence ventilation inlets.

Finally, the ventilation system in a building should be designed in such way that it is easily usable by the occupants. Ventilation grilles should be adjustable continuously. The ventilation ducts and grilles should be easy to clean and should be within reach of the occupants. Large windows should have protection against burglary if they can be reached easily from outside.

7.5.1.2 Construction Phase

A ventilation system should be installed in a correct way to prevent problems during the use phase. There should be no leaks or obstructions in the ducts, while the inlets, outlets and ventilation grilles should be installed in the correct way in the correct place, and short-circuits should be prevented, especially in heat recovery systems.

When a ventilation system is installed, it needs to be tuned for its use in the dwelling. During this process, all ventilation inlets and outlets need to be set to their designed capacity. Problems during the installation of the ventilation system, such as leaks or obstructions, can also be found then. However, this step is often omitted because of ignorance or costs.

A ventilation unit can cause a lot of noise during use, especially in the position with the highest capacity and when the ventilation system is heavily polluted with dust. High noise level may lead to stress and illness of the occupants, and the occupants may choose to turn the ventilation system low or off because of the noise level, thus causing a lower ventilation rate than needed. Therefore, during the installation, measures should be taken to prevent as much noise as possible. Silencers can be installed in the ducts to prevent nuisance as a result of noise from ventilation inlets and outlets. The ventilation unit can be placed in a closed cupboard to reduce noise emissions from the unit. Often, ventilation units are placed in the attic, and when the attic is converted to a bedroom, good insulation of the ventilation unit prevents sleep disturbance.

7.5.1.3 Use Phase

The occupants or facility managers can use building materials and paints with low emission rates of pollutants for maintenance and renovation of their building. The choice of cleaning agents with low emission rates of pollutants is regarded as the choice of the user and seldom a parameter of a dwelling.

A ventilation system needs to be maintained to prevent high indoor concentrations of harmful substances. The ventilation grilles, inlets and outlets need to be cleaned regularly to prevent mould growth. The air filters in a ventilation system with heat recovery need to be replaced regularly (at least once a year). When air filters are packed with dust, the air capacity decreases; many ventilation units increase the rotation speed of the fans, which increases its noise level. The air ducts also need to be cleaned, but because these can often not be reached easily, professional aid is needed here.

The occupants need to be well informed about the ventilation system in their house and how to use it. In dwellings, there are many misunderstandings about the position of the switch of the ventilation unit, when and how to open windows and ventilation grilles, and about the costs and benefits of proper ventilation. Occupants should also be informed about the need for maintenance and replacement of filters. When new occupants move in, they need to be informed as well.

When the layout or use of the building is changed, the ventilation capacity may also need to be adjusted. When a living room is built out from the house, the ventilation inlet capacity needs to be increased accordingly. When an attic is converted to a bedroom, a ventilation grille or inlet is needed here, and the ventilation unit may need to be insulated to prevent noise annoyance.

7.5.2 Thermal Comfort, Noise and Lighting

Many measures described in Sect. 5.1 also help to improve the thermal comfort of a building. Adequate ventilation prevents high moisture levels in the indoor air. And thermal bridges are a source of discomfort as well as a site of mould growth.

For thermal comfort, noise and lighting, the improvement measures can be divided in measures to be taken during the design phase, the construction phase and the use phase.

7.5.2.1 Design Phase

A precondition for a good thermal comfort is a sound design of the building envelope and a sound design of the heating, ventilating and air conditioning (HVAC) equipment. The building envelope must be sufficiently insulated and thermal bridges should be avoided. Enough solar heat gains should be allowed in the winter and prevented in the summer. The design of the HVAC system should be thorough and allow for 'natural' variations in building use. The heating, cooling and ventilating capacities should be calculated according to the basic principles described in Sect. 5.3 and to national and international norms.

If a building is constructed in an area with high noise levels outside, noise insulation measures should be taken to prevent high noise levels inside. Furthermore, building installations such as heating and ventilation systems should also have noise insulation installed, because these can be a large source of noise.

In the design of the building, enough windows should be provided to allow daylight to enter the building. The size and placement of the windows (width, high or low in the façade) are important for a good design and it is recommended to carry out natural lighting calculations (penetration of light, glare) during the design, especially when complex building shapes are used and when the building is surrounded by other buildings.

7.5.2.2 Construction Phase

To avoid problems during the construction phase, on-site supervision of the construction activities should be organised in such a way that possible problems with the realisation of the design and misunderstandings between designers and building contractors are solved in the right way. A high air tightness or the absence of thermal bridges is strongly dependent on a careful construction.

Noise insulation and HVAC equipment should be installed in a correct way to prevent additional generation of noise. For example, when ventilation ducts are not fitted correctly, the ventilation air can cause humming and whistling sounds.

When the building is constructed according to the building design, no problems related to lighting should occur during the construction phase.

7.5.2.3 Use Phase

During the use phase, the thermal comfort depends mainly on the correct management of the HVAC equipment, correct temperature settings, and correct use of sunshades. The use of automated building management systems is recommended, especially in large buildings. However, the occupant should always be able to have direct control of the system. As already emphasised, much attention should be paid to the ventilation system.

High noise levels due to an incorrect use and maintenance of the ventilation system in the building should be avoided. The guidelines described in Sect. 5.1.3 can also be applied here.

Occupants should be informed about the proper use of light-screens or other shading devices in the building. A proper orientation of televisions and computer displays in relation to the windows should avert hindrance by glare.

7.6 Conclusions

Good air quality in urban areas is important, as it has a large influence on the many people living there. Outdoor air quality is strongly related to other aspects of the urban environment, such as traffic, economic aspects (industry) and liveability, and it also influences the quality of the indoor air in buildings.

Because people spend a large part of their time indoors and because indoor concentrations of harmful substances are often higher than those outside, a healthy indoor environment in buildings is very important. This can be achieved by decreasing the emissions of harmful substances or by removal of these substances from the indoor air by good ventilation. However, ventilation of buildings has got worse, mainly because of improved air tightness for energy saving. Technical solutions such as ventilation systems with heat recovery can solve this contradiction, but a robust system which has been designed carefully, which has been installed without errors and which is maintained properly, including provision of information to the occupants, is needed to prevent adverse health effects that are related to these solutions.

In OECD countries, the air quality of urban regions has improved a lot since the beginning of the twentieth century. Factories that emitted large amounts of pollutants have moved out of the cities to industrial areas, and the emissions of these factories have decreased greatly. People do not use coal anymore to heat their houses, and the use of wood as fuel has become much less. Gas boilers, oil heaters and electrical heating devices, all with lower emission rates of pollutants, have become more popular.

On the other hand, the number of cars has increased drastically, which has resulted in an increase of traffic-related emissions such as particulate matter and NO_x. The increase of traffic has led to more traffic jams, thus increasing pollutant emissions even more. Furthermore, the increase of the air tightness of buildings and the decrease of ventilation rates, both mainly related to energy saving, has led to a worse indoor air quality in buildings and health complaints by the occupants.

In non-OECD countries, such as China, India and Brazil, the development of the urban air quality follows a similar trend as in OECD countries, but these developments are several years or even decades behind. The rapid growth of the economy, combined with the abundance of older technology, increases these problems. But non-OECD countries can learn from the mistakes that OECD countries made in their development to prevent common pitfalls in urban air quality.

Questions

1. What are the main sources of outdoor and indoor pollutants in urban environments?
2. What would be the most effective ways to achieve a healthy urban environment concerning indoor pollutants in OECD countries? What would be different for non-OECD countries?
3. Thermal comfort, noise and lighting are in terms of literal definition not forms of indoor pollutants. Do you agree that these aspects need to be addressed when discussing indoor environment of buildings? If not, how and under what topic would you address these aspects?

4. What aspects need one keep in mind when designing, installing and using a ventilation system in a building for a proper working of the system?
5. What differences can be given between urban air quality in OECD countries and in non-OECD countries? What are the differences between the solutions for OECD countries and for non-OECD countries in dealing with problems with urban air quality? How can the non-OECD countries learn from OECD countries regarding urban air quality problems and solutions?

Further Reading and References

Aries M (2005) Human lighting demands: healthy lighting in an office environment. Thesis, University of Eindhoven, Eindhoven, ISBN 90-386-1686-4
De Groot E (1999) Integrated Lighting System Assistant Design of a decision support system for integrating daylight and artificial lighting in the early design stage of office rooms. University of Eindhoven, Eindhoven, ISBN 90-6814-556-8
Fanger PO (1970) Thermal comfort: analysis and applications in environmental engineering. Danish Technical Press, Copenhagen
Hasselaar E (2006) Health performance of housing; indicators and tools. Thesis, Delft University of Technology, Delft, ISBN 1-58603-689-0
ISO (1994) International standard 7730, Moderate thermal environment-determination of the PM V and PPD indices and specifications of the conditions of Thermal Comfort, 2nd edn., International Standards Organization, Geneva
Meijer A (2006) Improvements of the life cycle assessment methodology for dwellings. Thesis, University of Amsterdam, Amsterdam, ISBN 1-58603-690-4
Murray CJL, AD Lopez (1996) The global burden of disease. WHO, World Bank and Harvard School of Public Health, Boston
Van Paassen AHC (2004) Indoor Climate Fundamentals. Course notes WB4426, chair Energy & Built Environment, faculty of mechanical engineering, Delft University of Technology, Delft

Chapter 8
Liveability

Machiel van Dorst

Abstract The ecosystem of the species called human is the living environment. The quality of the match between people and their living environment is known as liveability. In this chapter, the different perspectives on the relationship between people and environment will be clarified as well as the different forms of liveability that we can distinguish. This results in a reflection on the neighbourhood as an ecosystem and the operationalisation of a sustainable liveability. The qualities of a sustainable liveability are basic needs, and part of these needs have a spatial dimension that are of interest for the design of a sustainable liveable neighbourhood. The well-known elements of this sustainable liveability are health, safety and the importance of the green environment. The quality of the social environment may have a more important role in the well-being of people than the physical environment, but there is a clear relationship between both. The explanation is in another basic need: control over the social and physical environment. The relationship is in the fact that the physical environment facilitates the control over the social interaction. So, at the end of this chapter we emphasise the way the built environment facilitates the control over social interaction by the individual. This will be explained with an example and with design guidelines.

8.1 Introduction

Resolving environmental problems is the major focus in the current strife to mitigate climate change. From a technical point of view, this focus is tempting, but it overlooks the driver of unsustainable development and that is human behaviour. Humans are the cause of environmental problems, the victims of environmental problems

M. van Dorst (✉)
Associate Professor Environmental Design, Department of Urbanism, Faculty of Architecture,
TU Delft, P.O. Box 5043, 2600 GA, Delft, The Netherlands

Julianalaan 134, Room GF West 800, 2628 BL, Delft
e-mail: M.J.vanDorst@TUDelft.nl

E. van Bueren et al. (eds.), *Sustainable Urban Environments: An Ecosystem Approach*, 223
DOI 10.1007/978-94-007-1294-2_8, © Springer Science+Business Media B.V. 2012

and – hopefully – the solution to these problems. This complex relationship was recognised for the first time at the Earth Summit in Rio de Janeiro (UN 1992), where the first principle of the conclusions was: 'Human beings are at the centre of concerns for sustainable development. They are entitled to a healthy and productive life in harmony with nature' (UN 1992).

By this time, a sustainable development became the sum of People + Planet + Profit; in a later phase altered into People, Planet and Prosperity (European Commission 2002). People (or social sustainability) is in practice a list of topics like health, poverty, globalisation and emancipation, etc. (UN 2002). These topics all have to do with the well-being of people. In this chapter, we have limited ourselves to the topics within social sustainability that are related to the physical environment. Liveability represents this set of relevant topics. Liveability is defined as 'fit to live in'; it stands for this human perception in relation to the environment. This system-oriented definition fits the ecological approach of this book.

8.2 Methodology

We will be following the ecosystem approach in which (in the broadest sense) humans as a species function in an environment. In the context of sustainability, the appropriate relationship to focus on is that between humanity and the environment. From an ecosystem point of view, liveability is the appropriate relationship between people and their environment. The similarity between sustainability and liveability are evident; research is concentrated on the interaction between organism(s) and the environment. Different fields of science study this interaction from different perspectives. From a psychology perspective, the individual is the subject of research and the environment consists of other individuals from the same species, among the rest of the environment (the natural and the technical environment) (Gifford 1997). The natural environment consists of the biotic and non-biotic, the technical environment is composed of all artefacts made by man. From a sociology perspective, humans are the subject of research and the environment consists of the total cultural setting (Dunlap and Michelson 2002). In the field of science, there is a distinction to be made between research on human beings and research on humanity. The environment of humans include our artefacts, whereas the environment of humanity is limited to our natural habitat.

All these perspectives are ecological by nature, because the subject of research is a species in relation to its living environment. The choice of an object domain (individual organism, population or species) also defines the environmental domain (Bakker et al. 1995, p.10). In all cases, the quality of interaction has our main interest (Fig. 8.1).

Next to the differences in a research approach, there are also different societal perspectives. When, in a design assignment (for example, a neighbourhood), the focus is on an individual or on a population, the relationship between these human being(s) and their environment is researched in a small-scale setting and on a time scale going from one moment to a few years. When the focus is on sustainable

Fig. 8.1 The different perspectives: (**a**) The individual and his or her environment (people, artefacts, nature), (**b**) a community and the environment made of artefacts and nature, (**c**) humanity and our natural environment

development, research may highlight environmental changes over decades that will influence people around the globe. Liveability thus emphasises the here and now, whereas sustainability emphasises the elsewhere and the future. With liveability as an aim, the needs of the next generation can be pushed to the background. A population of a neighbourhood asking for more parking spaces may leave the next generation a living environment with a lack of green. So a liveability approach in itself may not be sustainable at all.

To tackle this problem, the different forms of liveability within the built environment will be discussed in the next section. This will give us some handles and levers to get to an approach for a more sustainable liveability.

8.3 Forms of Liveability

In the ecological approach followed in this chapter, liveability is a statement about the relationship between a subject (an organism, a person or a community) and the environment. This relationship can be approached in different ways.

The perceived liveability – the individual's appreciation of his or her environment (Fig. 8.2)
In research, this perceived liveability is measured by asking users how they appreciate their habitat; a simple and direct method. Individual inhabitants are asked to value statements like: 'If you live in this neighbourhood, you are well of.' The appreciation of an individual for his or her habitat is based upon their daily interaction with this habitat and on the social interaction with other individuals in this setting (so the interaction with the physical and the social environment) (Gifford 1997). The total appraisal for a neighbourhood is the average of the individual scores. So this total appraisal is (inter)subjective.

The apparent liveability – a good match between the organism (person) and the environment, which can subsequently be evaluated in terms of the number of happy years of life (Veenhoven 2000) (Fig 8.3)

Fig. 8.2 Perceived liveability – the appraisal of the individual for his or her habitat

Fig. 8.3 Apparent liveability – the perfect match between species and habitat

Fig. 8.4 Presumed liveability is emphasising the presumed conditions for liveability

We can define the environmental qualities of the optimum habitat for a buttercup or a frog. But to which extent the living environment contributed to the apparent liveability is not simple to determine for humans. The adaptive repertoire of the species called man is complex: we are able to learn, to remember and to adjust to changing circumstances. This implies we cannot specify a clear set of demands for the environment a human lives in. So the apparent liveability – as being defined by the number of happy years of life - can only be measured at the end of a person's life.

The presumed liveability – the degree to which the living environment meets the presumed conditions for liveability (Fig. 8.4)
The physical environment makes certain forms of human behaviour possible and in this way it may contribute to the well-being of people. This form of liveability is called presumed because the actual results are unknown. There is a set of indicators of this possible influence of the physical environment on liveability, but the influence of these indicators is normative and presumed. For example, if the environment is a neighbourhood, the list of indicators that makes up the presumed

liveability consists of: density, spatial quality, nature, noise, safety, mixture of life-styles, proximity of services, etc. (van Dorst 2005a). In measuring the influence of these indicators, it is difficult to establish causal relationships. The following factors of the presumed liveability are related to the perceived liveability: the maintenance of the area, spatial quality, presence of nature, absence of noise, absence of nuisance, common ground in lifestyles (and cultural backgrounds). Still, there is no proof that this set of qualities will add up to a liveable neighbourhood. Next to the spatially related indicators, there are non-spatial indicators that may strongly predict the liveability of an area, but (due to the fact they are non-spatial) are not tools for design. There is, for instance, a strong relationship between the inter-subjective perceived liveability of a neighbourhood and the number of unemployed inhabitants or the average salary (van Dorst 2005a). So adding houses for high-income groups may raise this form of liveability, but not change the liveability of the individuals from the old situation.

Liveability is an ecological interpretation of the 'people' aspect in the triple P approach. From this perspective liveability is part of sustainable development and will be close to basic needs of an individual, of people and of humanity. However, for an operational meaning of the liveability concept, the environment has to be defined in type and scale. In this chapter, the neighbourhood as a living environment will be the context for the operationalisation of liveability. Within this context, liveability will be translated into human needs in the next paragraphs, but first we have a look at a neighbourhood as a habitat for the human species.

8.4 The Neighbourhood as an Ecosystem

If we focus on the well-being of people, the living environment consists of a social and a physical environment. For non-human mammals, the social and physical environment are (on the average) one-to-one related. Their habitat is their territory. Territories are geographical areas that are personalised or marked in some way and that are defended from encroachment (Sommer 1969; Becker 1973). The word 'personalised' is interesting in this definition. Humans express this behaviour in their living environment, most obviously in the way in which they personalise a house to make it a home. A territory involves the mutually exclusive use of areas and objects by persons or groups (Sundstrom and Altman 1974). For a house, these are clear definitions because the borders are recognisable and the ownership is officially established.

On the scale of a neighbourhood, territorial behaviour becomes more problematic for two reasons:

- On the neighbourhood scale, there are no clear boundaries. In the city fabric, we emphasise mobility, and most neighbourhoods are part of a bigger network. For example, neigbourhood streets are also used for passing-by.

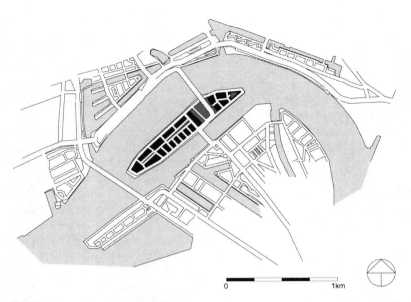

Fig. 8.5 This island in the central district of Rotterdam has – due to the obvious boundaries – a strong identity. This neighbourhood is recognisable for its inhabitants and for all citizens of Rotterdam

- The social and the physical environment are not one-to-one related. People have social networks outside their neighbourhood, on a city-, a regional- or even an international scale. Within the neighbourhood, one can go to a shop or visit some neighbours, but there may well be lots of places where the individual inhabitant never comes.

When the neighbourhood is not a clearly demarcated unit of analysis, why should we emphasis the neighbourhood as a context for social sustainability? To explain this, we start with the opposite; picture an urban area where there are no clear (neighbourhood) boundaries and not a single inhabitant feels any responsibility for a territory within this area. The result is a completely anonymous built environment. This is the perfect setting for anti-social behaviour. The result is more crime and feelings of unsafeness. From the perspective of territorial behaviour, a minimum amount of social cohesion is needed and the physical environment can facilitate this. In this case, if we talk about the liveability of a neighbourhood (or the social sustainability), it is the sum of the liveability of every individual.

So the living environment is not a clear spatially defined setting. Some individuals may leave their house, get into a car and disappear from the public space. Others (like children) regularly use the streets and squares in the surroundings of their houses. In all cases, people experience more or less an attachment to their physical environment. In line with the ecological perspective, a person is located in a specific place; 'to know someone implies to be familiar with his locality' (Lemair 1970). This place

attachment implies the necessity of a positive relationship to a physical and social setting that support identity and provide other psychological benefits. Attachment to the home and the neighbourhood is related to a lower fear of crime and a higher sense of neighbourhood cohesion (Brown and Werner 1985).

A neighbourhood exists by the fact that it is recognisable as a territorial entity at eye-level. This is especially true for the inhabitants, but this may also be experienced by the visitors and people passing by (Fig. 8.5).

Before we get to the sustainable liveable neighbourhood (Sect. 8.6), we have to look into the meaning of sustainable liveability.

8.5 Sustainable Liveability

Sustainable development is addressing the needs of people and in international context these are in fact the basic needs (UN 1992, 2002). The UN Millennium Development Goals are a result of this. For a sustainable liveability, we will also emphasis these basic needs. This is the result of the international context, but also of the durable quality of these needs. Within a sustainable liveability, we have to address those needs that are essential for the present generation but also for future generations.

In this section, we address these basic needs and emphasise the needs that are related to the physical environment. The importance of the following needs is underpinned by theory on behaviour (Maslow 1970; Vroon 1990) and environment-behaviour relationships (Gifford 1997; Bell et al. 2001), and with empirical indicators following on from large-scale and longitudinal research. A primary source is the research on the liveability of nations or the Happiness index (Veenhoven 1999). The basic needs that make up social sustainability in relation to the built environment are:

1. *Health and security (or safety).* These are the most basic needs of every living being. They are the primary goals of building regulation and modern city planning. In the built environment, they are translated into construction demands, road safety, indoor air quality, social safety, etc. These needs are also strong related to environmental issues. The starting point of an ecological awareness is the degradation of our habitat due to pollution. Different forms of pollution like air-, water-, and soil-pollution have resulted in health problems.

2. *Material prosperity, income inequality, inequality in happiness.* These aspects show the individual need to compare oneself with others. They are important needs, but they are less relevant for the design of a sustainable built environment. From the point of view of perceived liveability, we know that people prefer to live in a neighbourhood with a homogeneous group, for example in lifestyle, income or culture. This is not recommendable from a social point of view – because it may imply a discrimination of minority groups – nor from a sustainability point of view, for example because the population of a neighbourhood may change faster than the neighbourhood itself. So indirectly, there is a relationship between these needs and the design of a neighbourhood.

3. *Social relationships.* This need is related to the need for tolerance, participation in labour and association and to individualisation; aspects which are related to the social environment of the inhabitant of a neighbourhood. As stated before, for a social sustainable living environment, a minimum of social cohesion is needed. But there is a limit to this; a living environment that is perceived as a social cage is not liveable. Inhabitants have a preference for weak social relationships in their living environment (Maryanski and Turner 1992).

4. *Control.* This need is related to (perceived) freedom, individualisation, tolerance and identity (Veenhoven 2000; Newman 1972). In the context of this chapter, there are two aspects of control by individual inhabitants of a neighbourhood that matter. First, there is the need to control the amount of social interaction (and the built environment can facilitate this), and secondly, there is control over the physical environment itself (the changeability). Control has a positive influence of the perceived individualisation. This is a positive quality: it contributes to happiness. Control concerning the physical surroundings is not only effectively changing the built environment (such as personalising one's environment or creating your own territory), but also the perceived possibilities of different forms of use of the physical environment (Gibson 1986).

5. *Contact with the natural environment.* The presence of green in a neighbourhood seems to reduce stress and seems to be positively related to the physical well-being of occupants and aesthetic quality. The restorative qualities (restoring from stress) of green are more or less known for the natural environment. The impact of green in the urban environment on well-being is currently being researched.

These needs give us insight into programmatic demands for a socially sustainable living environment. This is an environment that is perceived to be liveable, appears to be liveable and is presumed to be durably liveable. The last aspect is a collection of environmental qualities contributing to health, safety, social relationships, individual control and contact with the natural environment. In the next paragraph, we will look into the implications of these needs for the design of neighbourhoods.

8.6 Sustainable Liveable Neighbourhoods

There is a dynamic relationship between the urban environment as an ecosystem and mankind as the species living in it. From the perspective of this relationship, the needs described in the last paragraph will be put into a spatial context. How does the built environment react to human needs and to what extent are neighbourhoods shaped to facilitate human behaviour?

8.6.1 Healthy Cities

In a historical and global context, the city is a successful living environment that attracts people. As more people move into a dense area, for example to become part

of its success, the liveability declines. This process took place in, for example, ancient Rome, in the medieval cities, and in the industrial towns of the nineteenth century. The central theme is health. A liveable neighbourhood is a living neighbourhood (Jacobs 1961) and this attracts even more people. From a sustainability perspective, this is positive, for example because this may lead to growing prosperity, to a reduction of the need for car mobility and to less pressure on the open landscape to urbanise. The flip side of it is the pressure on and pollution of the local ecosystem. A densely built and populated area may suffer from a declining quality of the microclimate, like less fresh air or sunlight. In non-Western countries, the health conditions of informal neighbourhoods are improved by the same strategy the Western world applied within the modernistic movement; building high-rise. The hygienic improvement is evident, but this does not imply that the liveability is improved: health was being addressed, but what about the other needs? This will be further discussed within the next themes.

8.6.2 A Safe Neighbourhood

Crime prevention and road safety are important objectives on the neighbourhood scale. Crime can be the chance of being victim of violence or the fear of becoming one. There are specific design guidelines for *Crime prevention through environmental design* (CPTED) based on the work of Newman (1972). There is a relationship between territorial behaviour and crime and fear (Ray 1977), which will be addressed in the next paragraph. Road safety is primarily related to the traffic system itself and it concerns the tension between car traffic on one hand and slow traffic and child play on the other. In the same spirit as environmental concerns within safety, it is common to emphasise the position of the vulnerable actor within the ecosystem. For environmental issues, this may be the extinction of a species. In a neighbourhood, this can be the children or the elderly.

8.6.3 The Neighbourhood as a Community

There is a relationship between urban design and social interaction in a neighbourhood. Neighbourhood attachment is stronger in cul-de-sacs (dead-end streets) compared to a through street (Brown and Werner 1985), and when the amount of traffic increases, the amount of social contacts – friends and acquaintances in the street – falls (Rogers 1997). This does not imply that the neighbourhood is a community. A Dutch anthropological research (Blokland-Potters 1998) even states the opposite: a neighbourhood is never a community. However, the complete absence of social interaction (anonymity) is a condition for social problems.

Examples of anonymity are the floating public spaces of the high-rise neighbourhoods constructed in Europe after World War II; a habitat without borders.

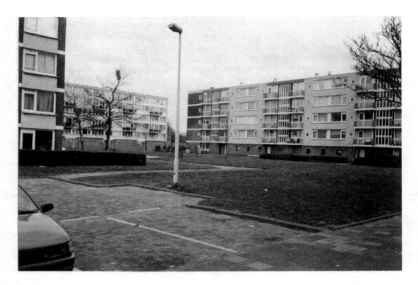

Fig. 8.6 The neighbourhood Hoogvliet (Rotterdam) with multi-storey apartment blocks: the so-called 'floating public space' lacks legible and defensible borders, and the result is an anonymous no-man's land

Borders within the public realm help inhabitants to distinguish the shared territory and this forms the physical condition for social interaction. The implications of this form of social sustainable neighbourhoods for design will be explained in the following section (Fig. 8.6).

8.6.4 Controlling the Environment

Control over the physical environment is the starting point of the design theory of John Habraken (1998). In this theory, the designer sets up a frame (a caring structure) which is open for the users to create a changeable infill. This is what we can perceive in reality: people constantly changing their physical environment. This act of control is a practical one, but also the basic need of sheltering oneself. 'To build' is related to the verbs 'to dwell' and 'to live' (Heidegger 1971). So a sustainable built environment is never finished and is always open for change. A sustainable neighbourhood can incorporate this on different scales. For example, at the neighbourhood level, there can be empty plots in the neighbourhood to be filled in by future generations, and at the building level there can be a distinction between carrying structures – which remain the same over a relatively long period of time – and the infill – such as facades, bathrooms and kitchens – which can be changed by occupants more frequently.

The relation between control over social interaction in the neighbourhood and the design is discussed in the next paragraph.

8.6.5 Sustainable Green

People desire for contact with nature and green in the built environment contribute to health (Van den Berg et al. 2007), so green in the living environment contribute to the liveability. Green refers to parks, but also to trees on a sidewalk street or pots with plants in front of a house. Green in the direct home environment contributes more to the perceived liveability than a park further away (Van Dorst 2005a). Green reduces stress (van den Berg et al. 2007) and facilitates sports, playing or walking the dog. Green has a broader impact on environmental quality due to a positive environmental impact, by providing clean air, by reducing noise and for reducing the heat island effect. The quality of the green environment is also related to the biodiversity in the built environment; the liveability for flora and fauna.

For sustainable green, this results in a set of guidelines in which the different qualities may lead to proposals in opposite directions. More biodiversity may relate to less sport facilities or controlling the microclimate may give different suggestions than designing allotment gardens.

8.7 The Ecological Liveability; Control over Social Environment

Health and safety are accepted themes for a sustainable neighbourhood; they have been leading themes in the majority of guidelines in modern urbanism. Green has been part of this package deal. Control as a primary need for inhabitants has not been acknowledged. A primary reason is the conflicts between formal control (by municipality or other actors) and control by the end-users. Giving control over the physical environment to inhabitants implies less official control. Control by inhabitants is not only of value in relation to the built environment (turning a house into a home) but also in relation to the social environment. Individuals controlling their social environment can be organised officially in a sustainable way, so the control by inhabitants is here emphasised. For this form of control, the built environment plays a role: the built environment facilitates the control of the individual over his or her social interaction. In this chapter, we emphasise this aspect because it is at the centre of what one may call an 'ecological liveability'.

An anonymous living environment is undesirable because it is the perfect setting for antisocial behaviour. An anonymous neighbourhood may function well, provided there is formal supervision. From a sustainable point of view, this is not desirable. In history, there are too many examples in which formal control

failed. The alternative is a neighbourhood facilitating social interaction, but be aware; social interaction is non-compulsory. The best result is a neighbourhood were individuals have control over the amount of social interaction. This freedom of choice (Zimbardo 1969) is the core of the privacy theory of Altman (1975): privacy is selective control of access to the self or to one's group. This definition includes two aspects: physical accessibility to the self and accessibility to information held on you. Following the line of reasoning of this chapter, privacy is related to the amount of social interaction, and it is an important need. Privacy is all about the degree of access to the self. Retreating behind closed doors or visiting a busy café; both are forms of privacy regulation. The desired level of social interaction can vary per person and over time, but the need of control is universal. So, we all strive for a balance between desired and achieved levels of social interaction. If we desire more than we achieve there is loneliness, if we desire less than we achieve there are feelings of crowding. These concepts are relative. Being with one person can be perceived as crowding, for instance when you are with a stranger in a small elevator.

Good fences make good neighbours (Frost 1914)

The built environment is an agent by which the social interaction one desires can be brought into balance with the social interaction one desires. So a neighbourhood can facilitate control over social interaction. The spatial equivalent of privacy control is territories. Territories are geographical areas that are personalised or marked, and territoriality involves the mutually exclusive use of areas and objects by persons or groups. Territorial behaviour is based on the perceived possession of a physical space (Bell et al. 2001). Territoriality leads to the building of walls and fences. This does not imply that this sort of behaviour is undesirable; recognisable territories give a clear compartmentalisation to space and make the built environment legible. A fence along a front garden is not a real physical barrier. This garden fence imparts a message: this is private territory, enter only with permission from the owner. The built environment contains all sorts of signals of the existence of territories at various scales – entrances, borders and areas – and these signals provide clarity. Territories give control to the owner and make the environment legible for visitors and people passing-by.

In practice, territories that support social interaction consist of different zones of privacy. A house is the privacy zone of a family; a street is the privacy zone of a small 'community'. The complexity of this reality is explained with a universal example of a neighbourhood in Delft, the Netherlands, constructed in the 1960s.

8.7.1 Privacy Zoning in Poptahof, Delft

Poptahof is a district with multi-storey flats. In this neighbourhood, privacy zoning has been mapped out by means of an observational study and a survey of 200

Fig. 8.7 The gallery; a
zone with clear boundaries
but not a setting for social
behaviour

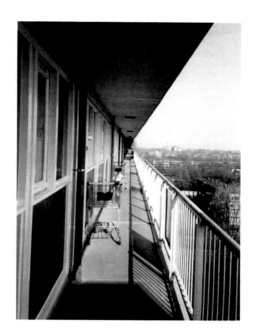

residents of three blocks of flats. The survey demonstrates how control of interaction
is perceived and regulated (van Dorst 2005a, b). Starting in a dwelling consisting
of a high-rise block of flats, this led to the following zoning:

- Zone 1: Dwelling: the zones within the dwelling are not clearly identifiable.
- Zone 2: Gallery: a space shared by 2 or 7 flats.
- Zone 3: Stairwell and lift: shared by 100 flats, but not all residents use all the
 areas.
- Zone 4: Entrance area in the building: a private area for all 100 flats.
- Zone 5: Entrance area outside the building: the 'front garden' of the building,
 where visitors announce their arrival.
- Zone 6: The cul-de-sac where the building is located: for use only by the residents
 and a few passers-by.
- Zone 7: The neighbourhood: a clearly legible territory for 1,000 flats.

This system of nested territories gives a very limited control over the social inter-
action. The limitation lays in the quality of every zone. On the smaller scales, the
zones are only designed for passers-by. There is no space for informal interaction in
a gallery (Fig. 8.7). This zone is not fit for residing. A gallery or a stairwell cannot
be claimed as a territory. On the larger scale, the territorial boundaries of a zone are
not readable. The inhabitants did not perceive Poptahof as liveable. This was related
to a lack of social interaction resulting in anonymity (van Dorst 2005a). For improving
the physical environment of Poptahof, we first have to look at good examples, based

Fig. 8.8 Subtle zones
between private and public
domein

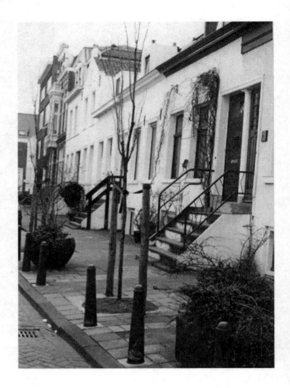

on which design guidelines for privacy zoning can be formulated. The following
guidelines address universal qualities of a sustainable living environment:

A dwelling has a public and a private part
The public part has no direct relationship with the street. In this example (Fig. 8.8),
the house is raised up and the stairs create some distance between the public and the
private space.

A street is the territory of the occupants of that street
The street should be recognisable as a place to stay (Fig. 8.9). So, conditions for
informal social interaction are: limitation of street length, limitation of traffic pass-
ing-by and a non-linear design.

Territoria should be readable for all users
The fence in Fig. 8.10 *is* not always closed, but that makes no difference. The fence
being there makes it clear that one enters the privacy zone of a group of people.
Clarity of design leads to clarity of social interaction.

Contact with nature is related to controlling social interaction
Green is a (ecological) condition for dwellings. A majority of informal social inter-
action starts from the front garden (Fig. 8.11).

Fig. 8.9 The message is clear: this zone is primary for inhabitants and less for passing-by

Fig. 8.10 Obvious boundary: you are entering a new zone

Territorial behaviour is part of the ecology of man and results in universal design guidelines. It depends on the actual assignment how these guidelines are translated into a design. Neighbourhoods like Poptahof are a great challenge in this respect because of the barriers between the front door of the house and the public space. Figure 8.12 gives a suggestion for the problematic gallery.

Fig. 8.11 The front garden as a buffer between public and privacy, but also as a zone where interaction takes place

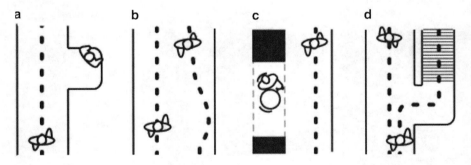

Fig. 8.12 Making a gallery more than a narrow hallway by adding: (**a**) extra balconies for residing, (**b**) more width for respecting privacy, (**c**) more width to add a semi-private zone before the apartment, (**d**) shortcuts between galleries for more freedom in routing

These are small-scale interventions as examples of facilitating control over social interaction by individual persons in his or her habitat. From an ecological liveability perspective, one can think of similar interventions on a larger scale, also from the perspective of groups of people. Both may result in more territorial qualities of a neighbourhood design. In design and maintenance, this type of intervention should be weighed next to suggestions for a healthy and safe living environment.

8.8 Reflection and Conclusions

A sustainable living environment is healthy, safe and supports control over social interaction and contact with the natural environment.

The ultimate goal of a sustainable living environment is happy and healthy inhabitants, now and in the future. This is the objective according the traditional approach towards health in the living environment; what is the average lifespan of the inhabitants? What is the chance of being the victim of a car accident? But happiness is more than being free from suffering. The more positive qualities are being in control over one's life and having a positive relationship with your social and natural environment. Control is on both sides of the same coin. It emphasises a basic human need in the living environment; equivalent to a species wanting to maintain a territory within an ecosystem. But control is more than a static feature of our habitat. Control is also a quality helping us to explore life and redefine our boundaries as we are growing. Breaking new ground and redefining borders is also part of control. Like a young child exploring the street out of sight (control) of a parent.

A built environment facilitating control consists of places where people may interact in relation to transition space. From the viewpoint of an individual, this may be complex. The so-called 'public space' is a shared territory; shared with neighbours and shared with visitors and people passing by. It becomes even more complex if we look more closely at the analogy between outdoor space and an ecosystem; species also act as a group. So the private space of a family is a house and the shared territory of a group of families is a neighbourhood. At the same time, the private space of the neighbourhood community is the physical neighbourhood, and there is also a private space for a city or for the country. So reality is a complex system of nested spaces. The quality is in the usability and the readability of the system. In observing outdoor space you may ask yourself: is it clear who owns this space? Am I welcome in this space?

In practice, not all spaces are informally controlled; this depends on the number of users. Public space with a high number of people passing-by is not controllable by the group of inhabitants, like a shopping street in a central district. But if the inhabitants can control their territory (the majority of outdoor space), the neighbourhood can function as an ecosystem than can sustain itself. This means that in times of trouble (e.g. when conflicts between inhabitants occur), it has the resilience to repair itself and move to a new equilibrium of a liveable system.

Questions

1. In this chapter, there are definitions of different forms of liveability, also in relation to three perspectives on people–environment relationships. This is necessary because liveability without qualification is, from a scientific perspective, ill defined. Look up liveability in sustainability literature and find out the qualification that is implicitly used and discover the perspective on people–environment

relationships that is being used. When we aim for a 'liveable planet', is this from an individual perspective and is this perceived liveability?

2. There are enriching combinations of qualities from different perspectives in the design of a green environment. Make a list of these qualities and discover the reasons why they are not always addressed.

3. Collect examples of clear and legible territories in outdoor space. What physical aspects make them controllable by inhabitants and what aspects make them attractive to visitors? Find out the tensions between those two perspectives.

4. A sustainable neighbourhood may create ecological awareness; so involve the (future) inhabitants in the planning process. What are the possibilities and limitations in a process like this if we look at the need of control for inhabitants, not only in the planning process but also from the perceptive of the management of the final result?

5. Why do we design living environments where the possibilities of control by inhabitants is limited? Whose needs are being addressed here?

References

Altman I (1975) The environment and social behavior: Privacy, personal space, territoriality and crowding. Brooks/Cole, Monterey
Bakker K, Mook JH, van Rhijn JG (1995) Oecologie. Bohn Stafleu Van Loghum, Houten/Diegem
Becker FD (1973) Study of spatial markers. J Pers Soc Psychol 26(3):375–381
Bell PA, Green TC, Fisher JD, Bauw A (2001) Environmental psychology. Harcourt College Publishers, Orlando
Blokland-Potters T (1998) Wat stadsbewoners bindt. Kok Agora, Kampen
Brown BB, Werner CM (1985) Social Cohesiveness, territoriality, and holiday decorations – the influence of cul-de-sacs. Environ Behav 17(5):539–565
Commission E (2002) People, planet, prosperity. European Union, Luxembourg
Dunlap RE, Michelson W (eds.) (2002) Handbook of environmental sociology. Greenwood Press, London
Frost R (1914) Mending Wall, In: North of Boston, collected poems. H. Holt and company, New York
Gibson JJ (1986) The ecological approach to visual perception. Lawrence Erlbaum Ass. Publ, London
Gifford R (1997) Environmental psychology. Allyn and Bacon, Boston
Habraken NJ (1998) The Structure of the ordinary. The MIT Press, Cambridge
Heidegger M (1971) From Poetry, language, thought. Harper Colophon Books, New York
Jabobs J (1961) The death and life of great American cities. Vintage books, New York
Lemaire T (1970) Filosofie van het landschap. Ambo, Baarn
Maryanski A, Turner JH (1992) The social cage – human nature and the evolution of society. Stanford University Press, Stanford
Maslow AH (1970) Motivation and personality. Harper and Row, New York
Newman O (1972) Defensible Space, crime prevention through urban design. Macmillan Publishing Company, New York
Ray JC (1977) Crime prevention through environmental design. Sage Publications, Beverly Hills
Rogers R (1997) Cities for a small planet. Faber and Faber, London
Sommer R (1969) Personal space. Prentice-Hall, Englewood Cliffs

Sundstrom E, Altman I (1974) Field study of dominance and territorial behavior. J Pers Soc Psychol 30(1):115–125

UN (United Nations) (1992) Report of the United Nations conference on environment and development. Rio de Janeiro. United Nations department of Economic and Social Affairs, New York

UN (United Nations) (2002) Report of the United Nations conference on sustainable development, Johannesburg, United Nations, New York

van den Berg AE, van den Hartig T, Staats H (2007) Preference for nature in urbanized societies: stress, restoration, and the pursuit of sustainability. J Soc Issues 63:79–96

van Dorst MJ (2005a) Een duurzaam leefbare woonomgeving. Eburon, Delft

Van Dorst MJ (2005b) Privacy zoning – the different layers of public space. In: Turner P, Davenport E (eds.) Spaces, spatiality and technology. Springer, Dordrecht, pp 97–116

Veenhoven R (1999) Quality-of-life in individualistic society: A comparison of 43 nations in the early 1990s. Soc Indic Res 48:157–186

Veenhoven R (2000) Leefbaarheid, betekenissen en meetmethoden. Erasmus University Rotterdam, Rotterdam

Vroon P (1990) Psychologische aspecten van ziekmakende gebouwen. Ministry of Housing, Spatial Planning and the Environment, Den Haag

Zimbardo PG (1969) The human choices: Individuation, reason and order versus de-individuation, impulse and chaos. In: Arnold WJ, Levine D (eds.) Nebraska symposium on motivation. University of Nebraska Press, Lincoln, pp 237–307

Chapter 9
Urban Transport and Sustainability

Bert van Wee

Abstract Urban traffic makes people move and is a necessity for the urban economy. However, it has negative local and regional environmental effects and contributes to large-scale environmental problems such as climate changes and acidification. Other negative impacts of transport on society include congestion and accidents. Designing urban traffic systems is inherently complex due to trade-offs between all kinds of environmental and non-environmental effects. This chapter presents a conceptual model for the impacts of the transport system on the environment, which then is used to structure the problems and challenges of designing a sustainable transport system. In addition, it presents an overview of policy options to make this system more sustainable, as well as a brief overview of models to forecast the impacts of transport.

9.1 Introduction

Motorized transport makes people move. If in a poor country incomes start to rise, car ownership and car use, and the use of lorries for the transport of goods, rapidly increase. Unfortunately, transport also causes problems for society. The generally accepted recognition of the impact of urban traffic on the environment dates from the 1960s. Since then, due to the rapidly increasing levels of car ownership and car use in western countries, central urban areas increasingly suffered from urban traffic. This suffering included accidents, congestion and noise and air pollution. In addition, in the early 1970s and 1980s the global environmental impacts, such as the

B. van Wee (✉)
Delft University of Technology, Faculty of Technology, Policy and Management,
P.O. Box 5015, 2600 GA, Delft, The Netherlands
e-mail: g.p.vanwee@tudelft.nl

E. van Bueren et al. (eds.), *Sustainable Urban Environments: An Ecosystem Approach*, 243
DOI 10.1007/978-94-007-1294-2_9, © Springer Science+Business Media B.V. 2012

depletion of fossil fuels and climate change, received attention (Meadows 1972; WCED 1987). A major challenge is to find a "right" balance between positive and negative effects on economy, society and environment. We define sustainability as a "healthy" balance between these three categories of impacts. A big challenge is to find a balance: whatever changes are made in the transport system, there are almost always trade-offs between (partly overlapping) indicators in the areas of mobility and accessibility, the economy, the environment, safety, land use and transport costs.

This chapter[1] aims to give an overview of what the impacts of transport on sustainability relevant issues are and which policies can reduce these impacts. Following the scope of this book, the emphasis is on the environment and urban (road) transport. It also aims to give an overview of the determinants of these impacts, an overview of the policy measures to reduce these impacts, as well as models to forecast impacts.

Transport fits very well into the ecosystem perspective of this book (see Chaps. 1 and 2). Firstly, spatial scales are very important for the transport system. People travel at all spatial scales, from visiting their neighbors to traveling intercontinental for business or holidays. Goods are transported from a shop to households, but also worldwide. Secondly, the life cycle concept is important for the evaluation of environmental impacts of transport. Especially if new infrastructure needs to be built, the environmental impact of it should be included in the overall assessment. For example, building new rail infrastructure as an alternative to roads should be evaluated from a life cycle perspective (Van Wee et al. 2005). Thirdly, flows are particularly related to transport. The built environment needs transport for almost all flows of people, goods, waste materials, fuels, etc. Finally, it is impossible to design and study the whole transport system of a city, region or country in one project. Decompositions for partial studies or designs are inevitable, and paying explicit attention to the system boundaries of the part of the transport system under consideration is of major importance in both research and design. Ignoring the importance of system boundaries could easily lead to suboptimal designs or wrong research conclusions.

Some elements of the ecosystem perspective will be included in the remaining part of this chapter. However, it is impossible to present this perspective comprehensively within the length of this chapter.

Section 9.2 describes a conceptual model for the impact of transport on policy relevant impacts. In Sect. 9.3, this model is used to describe the problems and challenges related to designing a sustainable urban transport system. Section 9.4 presents policy options to make the urban transport system more sustainable. Section 9.5 gives an overview of models to forecast the impact of the transport system on the environment, safety and accessibility. Section 9.6 finally summarizes the main conclusions.

[1] Parts of Sects. 9.2–9.4 of this chapter are based on Van Wee (2007).

9.2 A Conceptual Model for the Impacts of The Transport System on the Environment, Accessibility and Safety[2]

In this section, we describe a conceptual model for the impacts of the transport system on the environment, accessibility and safety. This model is presented in Fig. 9.1. We start with explaining trends in transport volumes. Given the population

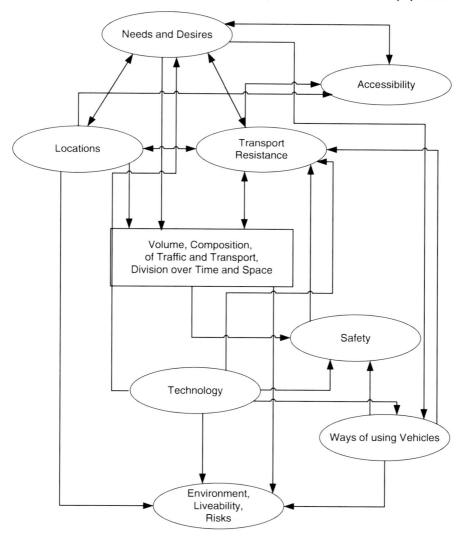

Fig. 9.1 A conceptual framework for the impacts of the transport system on the environment, accessibility and safety (Van Wee 2009)

[2] This section is based on Van Wee (2009).

size and its decomposition by household classes and age, transport volumes and the decomposition by modes and vehicle types result from:

- The wants, needs, preferences and choice options of people and firms.
- The locations of activities such as living, working and shopping.
- Transport resistance,[3] often expressed in time, money costs and other factors, that we refer to as "trouble" and that include risks, reliability of the transport system and effort.

All these three factors have an impact on transport volumes. Besides, they have an impact on each other, in all directions (see Fig. 9.1). To illustrate this: in the past decades in many countries, offices have relocated from central locations to the edge of town, often close to motorways. Therefore, accessibility by public transport has decreased whereas accessibility by car has increased. In other words, changes in locations have an impact on transport resistance of traveling by car and public transport and so may result in an increase of the desire to own a (second) car. We give two more examples. Firstly, because nowadays more and more flight connections to several destinations exist and flying has become cheaper, at several locations tourist facilities were developed that probably would not have been developed assuming no improvements in the airline network and no price decreases. Secondly, because during the past decades in many countries the road network has been greatly improved, commuting distances have also increased. To summarize, a lower transport resistance results in other locations of activities.

Because all three categories of factors change continuously, a stable equilibrium between the three categories of factors does not exist. In addition, the relationships between factors imply that a policy that focuses on one of the factors may have several indirect effects. For example, the direct and short-term effect of higher fuel prices is that people will reduce car use, for example by changing to other modes or choosing closer destinations. An indirect effect that occurs in the longer term is that people might move to a house closer to their job.

The three factors also have an impact on accessibility. We define accessibility as the extent to which people can participate in activities at different locations, and the extent to which goods can be transported between locations. According to this definition, the level of accessibility depends on locations of activities, quality and quantity of infrastructures and the needs of people and companies. Note that our definition is broader, and more activities related, compared to definitions focusing only on the transport system. The latter type of definitions focuses on travel times and congestion levels. We also consider these as relevant for accessibility. If, for example, congestion levels increase, the transport resistance increases, which has a negative impact on accessibility. In addition, note that the modes available vary between countries. For example, within Europe the barge is an alternative mainly in the north-western part of the EU (Germany, Belgium, the Netherlands). For passenger transport in neighborhoods, cities and even regions, motorized private transport is

[3] Note that the term "resistance" has another meaning in this chapter than in Chap. 2 of this book.

the only real alternative, the low-density car-oriented suburbs in the USA with roads without sidewalks being an extreme example. And even if cycling is an option, such as in the UK, it is often (perceived as) too dangerous for many people. In countries such as Denmark and the Netherlands, cycling and walking are important modes and contribute significantly to accessibility.

Figure 9.1 also visualizes that technology and the driving behavior of people (such as expressed by speed and acceleration/deceleration behavior) have an impact of travel times and travel comfort (transport resistance) and therefore on accessibility, and also have an impact on safety and the environment. Driving behavior is influenced by peoples' preferences. Driving fast does not only reduce travel times but people may also like it. The distribution of traffic over space and over time also has an impact on safety, the environment and accessibility. The distribution over space includes the breakdown between traffic within and outside the built-up area and by road class. For example, traffic on a road along which hardly any houses are sited causes less noise nuisance compared to traffic on a road along which many houses are located at close distances. Concentrations of pollutants on pavements are higher if the pavement is located near a (busy) road. For the distribution over time, the breakdown by hour of the day is very relevant for the impact of traffic on noise nuisance since night traffic causes much more noise nuisance than daytime traffic. On the other hand, in most regions, night traffic hardly causes congestion. Figure 9.1 visualizes these factors and their mutual relationships. Only dominant relationships are included.

To summarize, the effects of the transport system on the environment, accessibility, and safety result from complex and dynamic interactions of components of the transport system.

9.3 Problems and Challenges for Designing Sustainable Urban Transport Systems

As visualized in Fig. 9.1, traffic-related environmental problems include the environment, safety, and congestion. In this chapter, we focus on environmental problems. Safety and congestion are dealt with more briefly.

9.3.1 Environmental Problems

With respect to the spatial scale of traffic and environmental effects, a distinction can be made between the urban and non-urban (higher than urban) scale, resulting in a 2×2 table: urban traffic contributes to urban and non-urban environmental problems, as does non-urban traffic. Table 9.1 presents this and includes examples.

Below, we categorize the effects based on spatial scales, starting with urban (local) environmental problems, followed by non-urban problems.

Table 9.1 Relationships between the spatial scale of traffic and environmental effects

	Urban environmental problems	Non-urban environmental problems
Urban traffic	Urban traffic causing noise nuisances and local pollution	Urban traffic emitting CO_2
Non-urban traffic	International road traffic on motorways causing noise nuisance	Aircraft emitting CO_2

9.3.1.1 Urban/Local Environmental Problems

Local air pollution is one of the most important environmental effects. The emissions of road vehicles contribute heavily to especially peak levels of concentrations of pollutants, causing health effects and odor nuisance, but also dirt on windows and other parts of buildings, garden furniture and laundry. For health, the emissions of PM (particulate matter – small particulates), NO_2, VOC and CO are relatively important. Note that traffic is not the only emitter of these pollutants. The overall concentration at a certain location near a road consists of a regional or national background concentration, a local background concentration that is higher at a greater distance from the urban fringe (i.e., in the central parts of a city), and the contribution of a nearby road. Note that, although the regional/national background concentration is the result of the emissions of many sources, traffic also contributes to these background concentrations which often exceed the standards for air quality.

Another dominant effect is noise, especially from road vehicles, rail vehicles and aircraft. Unfortunately, due to methodological inconsistencies, it is hardly or not at all possible to give quantitative numbers on noise nuisance at an international level, such as the EU (Nijland and Van Wee 2005). A little less problematic, though still quite uncertain, are the figures for noise exposure. Berglund et al. (1999) gives numbers for a selection of western (mainly European) countries. The percentage of the population exposed to noise levels over 65 dB(A) due to road transport varies from 3% to 30%. These numbers are also very uncertain. To illustrate this: whereas in Sweden this percentage is only 3%, in the also sparsely populated neighboring country, Norway, the figure is 12%, while the numbers for neighbors Germany and the Netherlands are also 12% and 3%, respectively. Although differences in policy measures or in the land-use and transport system might contribute to the differences in percentages, it is very likely that the differences between these neighbor countries are in practice smaller than these numbers suggest. In almost all countries, the share of the population exposed to high levels of noise from aircraft and rail are lower than from road.

A third local environmental problem is the impact of acidification on buildings: emissions of NO_x, SO_2 and NH_3 contribute to acidification. Traffic does not contribute to NH_3 (which is mainly emitted by agriculture), but it does contribute to SO_2 and especially NO_x. Due to acidifying emissions, statues and some parts of buildings are affected, the results of which include a reduction in the quality or even loss of cultural heritage.

 The health effects of air pollution, effects on buildings and noise are mainly urban problems, not only because in western countries most people live in urban areas but also because emission levels (expressed as per square kilometer emissions) are higher in such areas.

 The environmental problems described so far are generally recognized in overviews of environmental problems as well as in policy documents. Since the mid-1990s, there has been a growing awareness, both in research and policy making, that even if vehicles were completely quiet, did not emit pollutants and only used renewable clean energy, some problems would still remain, problems that are often included in what is called "liveability" (see also Chap. 8). One can think of streets with parked vehicles on both sides, making it impossible for children to play on the street, too much traffic having the same effect, or barrier effects making it difficult or impossible for children or old people to cross streets.

9.3.1.2 Non-urban Environmental Problems

Apart from the urban problems as described above, three other environmental problems related to transport (including urban transport) are of importance. The first is climate change, mainly as a result of the combustion of fossil fuels causing CO_2 emissions. The second problem is the effects of acidification on nature, agriculture and the landscape, while the final one is large-scale air pollution, not only resulting from the emissions themselves but also from complex chemical reactions taking place in the atmosphere, resulting in ozone formation.

9.3.1.3 Transport's Share in Environmental Problems

Table 9.2 presents the share of transport in total emissions of SO_2, NO_x, CO, VOC, PM and CO_2, in the USA and Table 9.3 focuses on the share of transport CO_2 emissions in world regions. It shows that the transport sector emits (way over) half of NO_x and CO emissions, about one-third of HC emissions, and a third of CO_2 emissions. The share of SO_2 seems to be small but emissions of ships at sea are excluded, because these do not occur within a country's boundaries and are therefore not included in national statistics. Worldwide, the share of transport in CO_2 emissions is 18.4%, developed countries on average having a higher share (23.6%) than developing countries (16.4%).

 Tables 9.2 and 9.3 do not fully express transport's share in the health impacts of these pollutants, since, on average, the distance between road traffic and the people exposed is much shorter than for other sources of pollution, such as power plants. Traffic emissions therefore have a greater health impact per kilogram than average emissions (Dorland and Jansen 1997; Eyre et al. 1997; Newton 1997). This is especially the case for road transport, more than for non-road transport. The importance of the distance between the source and the receptor is visualized by the concentrations of pollutants as a function of the distance between a location and the road: the greater the distance, the lower the concentration. Bennett et al. (2002) have introduced the concept of the "intake factor," being the intake of a pollutant by individuals

Table 9.2 Share of transport in emissions in the USA, 2008 (Source: Davis et al. 2010)

Component	Share (%)
SO_2	4.5
NO_x	57.9
CO	73.2
VOC	37.7
PM-2.5	0.2
PM-10	3.2
CO_2	33.2

Table 9.3 Share of transport CO_2 emissions (excluding aircraft, marine ships), 2001, world regions (Source: IEA 2005)

Country	Share (%)
Asia	13.5
Europe	19.2
Middle East and North Africa	18.6
Sub-Saharan Africa	18.4
North America	30.2
Central America and Caribbean	27.0
South America	35.7
Oceania	22.6
Developed	23.6
Developing	16.4
World	18.3

and expressed in mass, divided by the mass of emissions. Evans et al. (2002) give an overview of studies on this subject and refer to a study by Smith (1993a, b) concluding that the intake of emissions of particulates of vehicles is 10 times higher than those of a power plant. For further examples of this concept, see Marshall et al. (2003, 2005). To conclude, the share in emissions of different sectors is only a rough indicator of the share in effects. The impact of distance on effects should be included to give insights into the environmental effects of emissions, resulting in a relatively high share of road transport emissions.

9.3.2 Safety and Congestion

The general awareness of the negative safety impacts of transport mainly originates from the US. In the 1950s, the rapidly increasing numbers of road fatalities raised serious concerns. Partly initiated by activists such as Ralph Nader regulations for the crash-worthiness of road vehicles were introduced in the USA and other western countries. Due to "safer vehicles" (seat belts, energy-absorbing zones, airbags, etc.), "safer infrastructure," the introduction of limits for alcohol levels in blood while driving, and better education in many western countries the transport system has

Table 9.4 Road fatalities for selected EU countries, 1970–2006 (Source: EU 2008)

	Belgium	Germany	France	Italy
1970	2,950	21,332	16,448	11,004
1980	2,396	15,050	13,672	9,220
1990	1,976	11,046	11,215	7,137
2000	1,470	7,503	8,079	6,410
2006	1,069	5,091	4,709	5,669

Table 9.5 (Expected) Road fatalities 2000 and 2020 for selected world regions (Source: Peden et al. 2004, WHO report)

	Absolute number (×1,000)		Per 100,000 inhabitants	
	2000	2020	2000	2020
East Asia and Pacific	188	337	10.9	16.8
East Europe and Central Asia	32	38	19.0	21.2
Latin America and Caribbean	122	180	26.1	31.0
Middle East and North Africa	56	94	19.2	22.3
South Asia	135	330	10.2	18.9
Sub-Saharan Africa	80	144	12.3	14.9
Sub-total	613	1,124	13.3	19.0
High-income countries	110	80	11.8	7.8
Total	723	1,204	13.0	17.4

become safer. In addition, the health care system improved, which also contributed to a decrease in fatalities. As a result, the number of fatalities in many western countries decreased from the 1970s on, despite the increase in vehicle and person kilometers traveled. Table 9.4 visualizes this trend. Note that, in many developing regions and countries, the number of fatalities is increasing because mobility is increasing much faster than is compensated for by the decrease in accident risks (as was the case in many western regions and countries until the late 1960s or early 1970s). As a result, in developing countries, both the absolute number of fatalities as well as the number of fatalities per 1,000 inhabitants is expected to increase between 2000 and 2020, whereas in high income countries, both absolute numbers and fatalities per 100,000 inhabitants are expected to decrease (see Table 9.5).

Historic overviews of congestion often emphasize that congestion already existed some 2,000 years ago, using Rome as an example. Congestion simply occurs when in a certain period of time demand exceeds capacity. In modern times the recognition of congestion also started at the urban scale. Central urban areas could not handle urban (motorized) traffic anymore in the 1960s (Europe) or even before (USA). Car-free shopping streets, one-way streets, car-free squares, parking regulations and other measures successfully tackled the problems in many European cities. Later on, the attention paid to congestion shifted to the inter-urban (main) roads. Comparable statistics for congestion levels are difficult to obtain due to a lack of consistent registrations. As an indication, Tables 9.6 and 9.7, respectively, give

Table 9.6 Travel time losses
(hours) due to congestion on
the main road network in the
Netherlands, 2000–2007
(index 2000 = 100)
(Source: KIM 2010)

Year	Index
2000	100
2001	118
2002	110
2003	113
2004	122
2005	131
2006	143
2007	153
2008	155
2009	140

Table 9.7 Travel time losses
due to congestion, USA,
1982–2009 (Schrank and
Lomax 2010)

Year	Travel delay (billion hours)
1982	1.0
1999	3.8
2007	5.2
2008	4.6
2009	4.8

examples for the Netherlands and the USA. Though the figures differ, the general
pattern is similar: congestion increases in most western (and non-western) countries.
The decrease in 2008–2009 is largely the result of the recession.

9.3.3 Health Effects of Walking and Cycling

Literature on transport and the environment often only focuses on the negative
impacts and much less on the positive health impacts related to exercise due to
being a participant of the transport system. In western countries, many people are
much less active than is healthy for them. This often starts at school age, espe-
cially if parents bring their children to and from school by car, not allowing chil-
dren to walk or cycle. They sometimes have good reasons for that, such as the
risks of children traveling alone or the fact that bringing their children to school
or picking them up from school is combined with the commute, not allowing par-
ents to walk or cycle between home and school. And because a lot of parents bring
their children to school by car, the (perceived) risks near schools are an incentive
for other parents to also bring their children by car. Some schools and local
municipalities have reacted by traffic calming measures (e.g., low speed limits,
speed bumps) or campaigns to persuade parents to bring their children to school
using non-motorized transport modes. Many adults commute by car and also use

their car for most of their other trips. If they do not exercise (sports, jogging, cycling), these adults are rarely physically active, and certainly not active enough from a health perspective. A more sustainable urban transport system cannot only contribute to reducing negative environmental impacts such as noise and air pollution but also to increasing people's health because it encourages them to walk or cycle. Note that, in some developing countries, such as China, people have adapted elements of western lifestyles, including food consumption (more meat and fast food) and less exercise.

9.3.4 The Challenge: Find a Right Balance

A major challenge for developing a more sustainable urban transport system is to find a right balance between all kinds of impacts. Note that from an ecosystem perspective there is not one right balance, but there may be more. Above, we already paid attention to environmental impacts, safety and congestion/accessibility. Other indicators to include in policies for sustainable transport systems that are relevant include the valuation of people, financial aspects, and robustness (Van Wee 2002). The valuation of people relates to the preferences of people, in particular with respect to their living or working environment, and includes characteristics of the residence as well as liveability (see also Chap. 8). Financial aspects include expenditures of people and firms on transport, government expenditures, impacts on Gross Domestic Product (GDP) and the like. Robustness relates to the long-term vulnerability of society, in this case as far as it is related to transport. How vulnerable is society, for example, to an expected or unexpected limitation in energy availability for transport? Such limitations may be the result of political instability in oil-producing countries, much higher prices for fuels or stringent environmental (climate) policies. Also, preferences of consumers and firms might differ in the future. What will happen if sustainably produced energy becomes available at reasonable prices? The question then will change from *how can the transport system contribute to reducing transport problems,* to *how can the land use and transport system enable us to perform activities in different places under different conditions?*

Finding a right balance is not easy, the major challenge being to quantify the trade-offs between indicators. Economists have developed tools to, as much as possible, monetize indicators such as travel time (changes), noise impacts, emissions, and costs of accidents. Note that there is still a lot of debate about several of these valuations. After monetizing as many effects as possible, a Social Cost–Benefit Analysis (CBA) (which includes environmental and social effects) is an often used tool to come to overall conclusions. Of course, the final decision is not to be made by researchers but by democratically chosen politicians. And they might have specific preferences or objectives. It is beyond the scope of this chapter to discuss the issue of valuation and the usefulness of CBA compared to other evaluation methods. Issues for discussion can be found in the literature on transport economics, environmental economics, and evaluation methods.

What is important for this chapter is firstly that the relevant indicators to evaluate transport policies are selected, secondly that the effects of options for these policies on these indicators are understood, and thirdly that – if possible – these effects are (preferably quantitatively) researched. The relevant indicators for evaluation are presented above. The conceptual model as presented in Fig. 9.1 might be helpful for understanding possible changes in the transport system. Below, we will discuss research methods and models. Before discussing them, Sect. 9.4 gives an overview of policy options that can have an impact on relevant indicators.

9.4 Policy Measures and Design

9.4.1 A General Overview of Policy Measures

To have a general overview of the possible impacts of transport, an important question is: what can policy makers do to make the system more sustainable? This section gives an overview of possible policy measures. The impacts of transport depend on a number of determinants – see Fig. 9.1. The first is the overall volume of transport, expressed as passenger kilometers (persons) or tonne kilometers (goods). The second category is the modal split (for passengers, this is car-driver, car passenger, train, bus/tram/metro, walking, cycling, aircraft, ship), and the third is the technology used. Technology relates to environmental and safety characteristics. In the future, vehicle technology may contribute to accessibility improvements by reducing congestion levels, in particular on motorways, e.g., due to the introduction of technologies to safely drive at short distances by shifting driving tasks from the driver to technology. A fourth category is the efficiency of using vehicles (for lorries, this is the load factor, and for cars, trains and buses, it is the occupancy rate). The fifth is the manner in which vehicles are used (speed, acceleration, deceleration). Governments have several types of policy instruments to influence these determinants, including regulations, prices, land-use planning, infrastructure planning, marketing and the provision of information and communication. Table 9.8 shows the relationship between the type of policy instruments and the determinants.

Table 9.8 shows that regulations and pricing measures potentially have the widest range of impacts, followed by land-use and infrastructure measures. We now give examples of the dominant effects as presented in Table 9.1, focusing on environmental impacts. *Restrictions* can reduce overall volume, e.g., due to limiting access to certain areas. If access is limited to certain vehicles only (e.g., motorized transport, which is often the case in central urban areas), it can affect the modal split. Most technological changes in vehicles that reduce emissions or improve safety result from regulations. Restrictions on which lorries are not allowed in certain areas may affect the load factors (and therefore the efficiency of using freight vehicles). The CAFE (Corporate Average Fuel Economy) regulations in the USA

Table 9.8 Dominant relationships between determinants for sustainability relevant impact of transport and policy instruments (Based on Blok and Van Wee 1994)

Transport and policy instruments	Volume	Modal split	Technology	Efficiency of using vehicles	Use of vehicles/ driving behavior
Restrictions	*	*	*	*	*
Prices	*	*	*	*	*
Land-use planning	*	*			*
Marketing		*			
Information and communication	*	*		*	*
Infrastructure	*	*			*

*Dominant effects

have reduced the energy use of cars. Speed limits also reduce energy use and some emissions, and increase safety. Higher fuel prices may reduce overall transport volume, and may lead to a shift to other modes. Higher taxes for vehicles without a three-way catalytic converter in the years before 1993 (the introduction of the Euro 1 standards) increased the sales of "clean" cars in Germany and Holland in those years and therefore led to technological changes in the car fleet. Higher fuel prices increase the share of car use (efficiency) and lead to lower speeds on motorways to save fuel. More compact land use and mixed use may reduce overall transport volume, and increase the share of slow modes. It might also change the distribution of car kilometers over road classes and therefore affect driving behavior. Marketing public transport might increase its share. The provision of information and communication might change people's travel behavior. For example, route information might reduce trip distance, while public transport information might increase its share. Information provided thanks to ICT possibilities might increase the efficiency of freight transport by making it possible to pick up a load on a return trip. Information provided by on-board units might change people's driving behavior. Providing more and faster infrastructure increases transport volumes and driving speeds. Investing more in public transport might increase its share.

The main messages we want to give here is firstly that a broad range of policy measures exist to influence the sustainability relevant impacts of urban transport and secondly that several policy measures may have multiple impacts. These complex relationships have an important impact on decision making with respect to policy making: it is seldom possible to draw policy recommendations based on one-dimensional research focusing on only one (category of) policy measure(s) or only one (category of) impact(s). Policy options should be evaluated using a much wider evaluation framework and a set of indicators. In line with the text on indicators above, indicators must include the impact on emissions, the impact on concentrations or the environment, the impact on health, including those related to the positive effects of cycling and walking, accessibility impacts (including congestion), safety impacts, in terms of land-use measures also the residential preferences of people

and location preferences of firms, and the robustness: can the land-use and transport system be maintained for many decades under different scenarios for energy, preferences, demography, etc.?

9.4.2 Urban Design

Not all policies that are presented above are urban policies. Urban policies mainly relate to the urban transport system and land use. *Transport policies* that reduce negative impacts on the urban environment include the concentration of motorized traffic on fewer roads, the introduction or extension of car-free zones, parking policies (less parking, more paid parking, especially in central urban areas), pricing (road pricing), building safe and pleasant infrastructure for slow modes, and public transport improvements. Although there is still a lot of debate about the effects of *land-use policies*, several studies conclude that some urban forms result in a larger share of slow transport modes (see Meurs and Haaijer (2001) for an example of empirical research; see Handy (1996) for an overview of the literature). Generally speaking, these studies show that an urban form with a high density of buildings with mixed use, an attractive infrastructure for cycling and walking, and a nice environment for walking and cycling results in a higher share of these modes and a positive impact on health. In addition, urbanization near public transport nodal points, such as railway stations, results in a higher share of public transport. Some authors have explicitly linked this impact on travel behavior to an impact on health (Badland and Schofield 2005; Dora 2004; Lumsdon and Mitchel 1999; Morisson et al. 2004; see Handy (2005) for an overview of both theory and empirical evidence). The importance of the possible health impacts of transport policy measures is illustrated by a Norwegian study on the costs and benefits of cycling infrastructure, which showed that the cycle infrastructure examined had much higher benefits for society than costs. The health benefits vary between cities and towns, ranging from 55% to 75% of all benefits (Saelensminde 2004).

Note that many relationships between policies exist, relationships that change over time. Firstly, there are synergy effects related to the content. For example, just improving public transport hardly has any effect on environmental indicators. Some modal shift from car to public transport will occur, but the majority of additional public transport travel is induced demand, resulting in extra environmental pressure. But if the position of the car in central urban areas is reduced, e.g., by parking and road infrastructure policies, if the number of jobs in these areas increases due to land use policies, and if road pricing is introduced, increasing the capacity and quality of the public transport network might even be a necessity without which urban vitality will be endangered. Secondly, linking policies might increase the acceptability of policies. Literature has shown that earmarking revenues of road pricing for expenditures within the transport system (e.g., lowering yearly taxes on cars, or taxes on new cars; improving public transport) increases the acceptability of road pricing (Schade 2003; Schuitema et al. 2008).

Designing and evaluation policies is quite complex, but solving all kinds of institutional barriers is maybe even more complicated. Due to the large number of actors involved (including people as travelers, people being exposed to negative impacts, bus and rail companies, local, regional and national authorities, interest groups) and the many conflicting interests, designing and successfully implementing transport policies is extremely complex. See also Chaps. 13 and 14.

9.5 Models

In order to be able to understand the impacts of transport on sustainability relevant issues, both research methods and models are of great importance. Research methods are relevant to answer questions like: why do people and firms behave as travelers and transporters, as they do? That is the impact of certain concentrations of pollutants or noise levels on people? What is the crash-worthiness of specific vehicles? Here, we do not pay attention to research methods. We limit ourselves to models to estimate the levels of sustainability relevant indicators.

Models include firstly models for developments in the transport system, and secondly impact models. Comprehensive modeling frameworks for the transport system including its impacts on the environment and safety hardly exist. This is the result of the huge complexity that would result. In addition, it is often relatively easy to combine transport models with models for effects on the environment and safety, transport indicators such as intensities per vehicle and road class, and speeds being important output of transport models that are input for environmental and safety impacts. Congestion and travel time indicators are generally calculated by transport models.

Operational transport models are mostly *trip-based* as opposed to *activity-based*. Trip-based models directly model trips of persons and vehicles, for the transport of persons and goods. Activity-based models start with modeling activities and consider trips as derived from activities. Although conceptually speaking, activity-based models are much more elegant than trip-based models, trip-based models are still much more popular because they are much less complex, both with respect to the models themselves and with respect to their data needs. Trip-based models use land-use data for distinguished zones (such as the numbers of people or households and jobs), origin-destination matrices, and characteristics of infrastructure and so-called "level-of-service" indicators (travel times, costs, availability of public transport). For more insights into transport models, we refer to de Dios Ortuzar and Willumsen (2001) and Hensher and Button (2000).

Impact models are manifold and include noise exposure, concentrations of pollutants, and safety. Using traffic indicators as important input, these models combine such indicators with characteristics of the area between roads (in the case of noise exposure: walls, noise screens, distance between roads and houses, etc.; in the case of concentrations of pollutants: distances between roads and locations of concentrations, objects), infrastructure (noise, safety), and wind and background concentrations (concentrations of pollutants). See also Chap. 7.

For reasons of evaluation, price tags are often used to express indicators in monetary terms – see above. These price tags are generally not included in transport or exposure models but externally combined with these models.

For the other indicators as presented, especially for robustness and also for preferences of people, hardly any models exist. In our opinion, developing methods and models in these areas and using them for decision making is a major challenge to make the sustainability evaluation of transport plans more mature.

9.6 Conclusions

The main conclusions of this chapter are presented below.

- The sustainability implications of urban transport are manifold, and include effects on accessibility/congestion, safety, and the environment. For evaluation purposes, additional indicators for the (residential) preferences of people, financial aspects, and robustness are relevant.
- Transport has several negative impacts on society. Firstly, it is a major contributor to environmental problems. Congestion first appeared in central urban areas, but has now shifted to the main motorway network. In many western regions and countries, the number of fatalities peaked a few decades ago. Despite continuing growth in transport volumes since then, the number of fatalities has decreased significantly, expressing the strongly decreasing accident risks (per kilometer).
- Because of the many indicators needed to evaluate transport policies, designing well-balanced policies is very complicated, since many trade-offs exist.
- The environmental, safety, and accessibility impacts of transport depend on transport volume (e.g., vehicle kilometers), technology, the way vehicles are used (speed, acceleration), the distribution of the use of vehicles over space and time, and the locations of exposed people, nature and buildings.
- Policy measures to reduce negative impacts of transport include restrictions, pricing measures, land-use planning, infrastructure measures, marketing, communication and information provision. These measures may have an impact on transport volume, modal split, technology, the efficiency of the use of vehicles (load factors, occupancy rates) as well as the way vehicles are used (speed, aggressive driving).
- For the evaluation of transport policies, trip-based transport models are generally combined with impact models (noise, concentrations of pollutants, safety). For evaluation purposes, impacts are often expressed in monetary terms.

In addition to these conclusions, we want to emphasize the importance of future uncertainties. The most important uncertainties relate to the availability of cheap fossil fuels for the transport system and climate change policies. With respect to fuels, firstly the uncertainties related to the depletion of fossil fuels should be

noticed. The availability of oil itself is highly uncertain, partly because large reserves are owned by countries whose reliability with respect to providing the "right" data with respect to their reserves can be questioned. Secondly, the uncertainty with respect to geopolitical developments is unknown. Even if there may be enough oil, then it is still uncertain whether it will be available. Thirdly, there is uncertainty about the capacity of oil production: will the huge investments to increase the capacity in oil production be made (if not, the peak in world oil production can be expected within a decade – see the literature on the "peak oil" concept). Fourth, there is a lot of uncertainty with respect to future alternatives for oil. These alternatives include solar and wind energy, biofuels and non-oil-based fossil fuels such as coal-to-liquids. Related to uncertainties in these alternatives are the uncertainties with respect to dominant technologies for the future transport system. Will the transport system be based on very efficient internal combustion engines using fossil fuels, or will biofuels become important, or (hybrid)electrical vehicles? If breakthroughs in energy generation appear, resulting in a shift to electric vehicles and traction, then local air pollution and climate change problems will probably be strongly reduced or even solved. Then, a shift in policy attention to urban environmental problems (parking, livability related to driving and parked vehicles) will likely occur. With respect to climate policies in the EU, there are long-term policy targets. But it is uncertain whether the policy measures needed to meet the targets will be implemented, and at what cost. And the position of the transport system in the overall targets is uncertain. And uncertainty with respect to climate change policies in non-western countries and the USA is even greater. To conclude, the future of the transport system and its environmental impacts is deeply uncertain.

Questions

1. Determinants for environmental impacts of transport: describe conceptually the dominant determinants for environmental impacts of transport, and their mutual relationships
2. Policy instruments (1): describe which policy instruments can influence which determinants for environmental impacts of transport (in Table form)
3. Policy instruments (2): give examples of policy instruments that can influence these determinants, and how they influence these determinants
4. Health impacts of emissions: several technological options exist to reduce PM10 emissions and related health impacts. Cost-effectiveness (costs of reducing emissions by 1 kg) is often used as a selection indicator. What are the pros and cons of using this indicator as the only indicator for policy making?
5. Urban design: which are the two dominant categories of urban design policies? Give four examples of policies in each category and describe how they can influence environmental impacts of transport.

References

Badland H, Schofield G (2005) Transport, urban design, and physical activity: an evidence-based update. Transportation Res D 10:177–196

Bennett DH, McKone TE, Evans JS, Nazaroff WW, Margni MD, Jolliet O, Smit KR (2002) Defining intake fraction. Environ Sci Technol 2002:3–7, May

Berglund B, Lindvall T, Schwela DH (eds.) (1999) Guidelines for community noise. World Health Organization, Geneva

Blok P, Van Wee B (1994) Het Verkeersvraagstuk. In: Dietz R, Hafkamp W, Van der Straaten J (eds.) Basisboek milieu-economie. Boom, Amsterdam/Meppel

Davis SC, Diegel SW, Boundy RG (2010) Transportation energy data book. Oak Ridge National Laboratory, Oak Ridge

de Dios Ortuzar J, Willumsen LG (2001) Modelling transport, 3rd edn. Wiley, Chichester

Dora C (2004) A different route to health: implications of transport policies. BMJ 318:1686–1689

Dorland C, Jansen HMA (1997) ExternE Transport – the Netherlands. Dutch case studies on transport externalities. Institute for Environmental Studies (IVM), Free University, Amsterdam

European Union (2008) http://www.irfnet.eu/media/press_release/statistics/erfeuropean_road_statistics_2008_booklet_150×210mm_v08_press_safety.pdf. Accessed 15 Sept 2008

Evans JS, Wolff SK, Phonboon K, Levy JI, Smith KR (2002) Exposure efficiency: an idea whose time has come? Chemosphere 49:1075–1091

Eyre NJ, Ozdemiroglu E, Pearce DW, Steele P (1997) Fuel and location effects on the damage costs of transport emissions. J Transp Econ Policy 31:5–24

Handy S (1996) Methodologies for exploring the link between urban form and travel behaviour. Transp Res D 1:151–165

Handy S (2005) Critical Assessment of the Literature on the Relationships Among Transportation, Land Use, and Physical Activity Resource paper for TRB Special Report 282: Does the built environment influence physical activity? Examining the evidence

Hensher D, Button K (2000) Handbook of transport modelling. Permagon, Amsterdam

IEA (2005) http://earthtrends.wri.org/pdf_library/data_tables/cli2_2005.pdf. Accessed Mar 2011

KIM (Kennisinstituut voor Mobiliteitsbeleid) (2010) Mobiliteitsbalans 2010. KIM, Den Haag

Lumsdon L, Mitchel J (1999) Walking, transport and health: do we have the right prescription? Health Promot Int 14:271–280

Marshall JD, Riley WJ, McKone ThE, Nazaroff W (2003) Intake fraction of primary pollutants: motor vehicle emissions in the South Coast Air Basin. Atmos Environ 37:3455–3468

Marshall JD, Mc Kone TE, Deaking E, Nazaroff WW (2005) Inhalation of motor vehicle emissions: effects of urban population and land area. Atmos Environ 39:283–295

Meadows DL (1972) The Limits to growth – A report for the club of Rome project. Universe Books, New York

Meurs H, Haaijer R (2001) Spatial structure and mobility. Transp Res part D 6:429–446

Morisson DS, Petticrew M, Thomson H (2004) What are the most effective ways of improving population health through transport interventions? Evidence from systematic reviews. J Epidemiol Community Health 57:327–333

Newton PN (ed.) (1997) Reshaping cities for a more sustainable future – exploring the link between urban form, air quality, energy and greenhouse gas emissions. Research Monograph 6, Melbourne: Australian Housing and Research Institute (AHURI). http://www.ea.gov.au/atmosphere/airquality/urban-air/urban air docs.html. Accessed 18 Feb 2009

Nijland H, van Wee GP (2005) Traffic noise in Europe: a comparison of calculation methods, noise indices and noise standards for road and railroad traffic in Europe. Transp Rev 25:591–612

Peden M, Scurfield R, Sleet D, Mohan D, Hyder AA, Jarawan E, Methers C (2004) World report on road traffic injury prevention. World Health Organization, Geneva

Saelensminde K (2004) Cost–benefit analyses of walking and cycling track networks taking into account insecurity, health effects and external costs of motorized traffic. Transp Res A 38:593–606

Schade J (2003) European research results on transport pricing acceptability. In: Schade J, Schlag B (eds.) Acceptability of transport pricing strategies. Elsevier, Amsterdam

Schrank, D, Lomax T (2010) The 2010 urban mobility report. Texas Transportation Institute. http://tti.tamu.edu/documents/mobility_report_2010.pdf. Accessed 1 Mar 2010

Schuitema G, Ubbels B, Steg L, Verhoef E (2008) Car users' acceptability of a kilometre charge. In: Verhoef E, Bliemer M, Steg L, Van Wee B (eds.) Pricing in road transport. A multidisciplinary perspective. Edward Elgar, Cheltenham UK, Northampton, MA, USA

Smith KR (1993a) Fuel combustion, air pollution, and health: The situation in developing countries. Annu Rev Energy Env 18:529–566

Smith KR (1993b) Taking the true measure of air pollution. EPA J 19:6–8

Van Wee B (2002) Land use and transport: research and policy challenges. Transp Geogr 10:259–271

Van Wee B (2007) Environmental effects of urban traffic. In: Garling T, Steg L (eds.) Threats from car traffic to the quality of urban life. Problems, causes, and solutions. Elsevier, Amsterdam

Van Wee B (2009) Verkeer en vervoer: een introductie. In: Van Wee B, Annema JA (eds.) (2009) Verkeer en vervoer in hoofdlijnen. Coutinho, Bussum

Van Wee B, Janse P, Van den Brink R (2005) Comparing environmental performance of land transport modes. Transp Rev 25:3–24

WCED (World Commission on Environment and Development) (1987) Our common future. Oxford University Press, Oxford

Chapter 10
Sustainable Urban Form

Jody Milder

Abstract With more than half of the world's population living in urban areas and climate change, one of the biggest challenges of our times, it is time to turn our attention to cities in order to tackle this challenge. The layout or urban form of a city can influence the environmental impact of the urban settlement to a considerable extent. There are great differences between cities in terms of their urban form and their environmental footprints. Five key elements of urban form can be distinguished: density, surface, land use, road/public transport infrastructure and the economic relationship with the surrounding environment. The compact city is often advocated as a more sustainable urban form but this is not undisputed. Urban form can influence the environmental impact, but it can only facilitate; it is people and their behaviour that ultimately determine the negative or positive environmental impact of urban areas.

10.1 Introduction

With climate change high on the political agenda, there is renewed attention for sustainable cities as an area where environmental stakes are high. The relationship between the layout of a city, its urban form and its environmental performance often, a subject of heated controversy. Some see the compact city as the silver bullet solution, but others do not. On the one hand, the clean logic that a compact city with a high mix of functions has less of a negative impact on its environment than a dispersed mono-functional city might seem very attractive. On the other hand, it has never been convincingly confirmed with empirical data. Moreover, if policy makers

J. Milder (✉)
Delft University of Technology, Delft, The Netherlands
e-mail: jmilder@gmail.com

E. van Bueren et al. (eds.), *Sustainable Urban Environments: An Ecosystem Approach*,
DOI 10.1007/978-94-007-1294-2_10, © Springer Science+Business Media B.V. 2012

keep on focusing on achieving the compact city as they do now, they ignore the current situation in cities with an ever increasing percentage of single family homes lined along the road infrastructure as a reflection of what the market wants.

One point all actors agree upon, however, is that there is a relationship between urban form and the environmental impact of a city. How this relationship exactly works remains the key question. The first part of this chapter gives an overview of the main typologies of urban form that are distinguished in the literature, after which the connection will be made between urban form and environmental performance.

The second part tries to give a brief overview of how urban form is mentioned in several policy documents followed by an analysis of the compact city and the unresolved issues surrounding this urban form. The chapter ends with conclusions about the role of urban form in promoting sustainable development.

10.2 Typologies of Urban Form

To talk about the environmental impact of a city, one needs to know the different forms a city can take. In the literature, a huge array of classifications of urban form can be found, which can be reduced to roughly seven urban form typologies:

1. Dispersed city
2. Compact city
3. Corridor/linear/radial city
4. Multi-nuclear/polycentric city/edge city
5. Fringe city
6. Edge city
7. Satellite city

All the other classifications are mainly sub-divisions of the above main typologies. The dispersed city and the compact city are the two extreme poles, whilst the other classifications can all be found in between.

The *dispersed city*'s main feature is its very low density combined with a separation into distinct zones for residential, commercial or industrial use. The urban fabric is not contained and instead it is continuous until it dissolves. The term contained refers to the physical space a city occupies and whether there is a clear border between the urban area and the rural area. Is it allowed to grow or are there physical (rivers, mountains, etc.) or policy constraints that keep the city from expanding horizontally? Dispersed cities are heavily dependent on the car as the common transport mode and distances are long. The use and availability of public transport forms in these cities is very weak if present at all. The reasons for this can be found in the high car ownership and that, due to the low densities, it is nearly impossible to set up a functioning traditional public transport network. Public transport is usually focused on connecting two or more high concentration nodes of work and people. Dispersed cities, however, lack these high concentrations and therefore lack the

foundation for public transport. The dispersed city is economically independent, as within the vast urban fabric there is ample space for both economic functions as well as living, all interconnected through the road infrastructure. Of course within the current global network society, a city can never be economically independent, but in this definition it signifies that there are sufficient jobs within the city to employ its inhabitants.

The *compact city* is the absolute opposite of the dispersed city and has a very high density. Where in the dispersed city the urban fabric seems to flow on end-lessly in low densities, the compact city has very high densities with a mixed land use within a contained amount of space. Because the concentration of people and jobs is so high, there is a very solid foundation for public transport and one can usually find more than one type of public transport here, from metro, to buses, to trains, to boats. On top of this, the distances are short and there are plenty of facilities for slow traffic making the compact city very suitable for walking, cycling, etc. This mix of functions, many options of public transport or the pos-sibility to walk between the functions makes car ownership very low. Another reason for low car ownership is that roads are usually congested due to the limited space and the large numbers of people moving around, and parking space is limited and expensive, all factors that undo the advantages of owning and using a car. The compact city is economically independent as it forms the centre of the regional economy.

The *corridor* or *linear city* falls somewhere in between the two above typologies as it does have high densities, but less than in the contained compact city. Urban expansion in the corridor city takes place in a linear way along the various main transport axes in and out of the city centre and commonly takes on a radial shape, hence the name radial city in some studies. Commercial facilities can be found directly along or on these axes and housing can usually be found behind this com-mercial strip so there is no mixing of land uses. These cities are more car oriented than the compact city, but can also have a proper public transport network connect-ing the beads of higher concentration along the axis. As the axes originate from the central city, these linear cities are economically dependent upon this central city.

The *edge city* is located on or in the border of the city and usually consists of a nodal point that became the focal point of economic development. Common nodal points are intersections of the ring road with the radial road, i.e. airports, big railway and metro stations, etc. Garreau (1991) distinguishes five criteria that decide if a city is an edge city or not. First of all, it must have more than 465,000 m^2 ft of office space, to house between 20,000 and 50,000 office workers comparable to some traditional down towns. Secondly, it should have more than 56,000 m^2 of retail space, the size of a medium shopping mall, to ensure that the edge city is the centre of recreation and commerce as well as office work. Thirdly the number of jobs should outnumber the number of bedrooms. Fourthly, it must be considered as one place by the population, while the last criteria is that 30 years ago there was nothing like a city on that location, so it could have been a green field or a residential area. As the edge cities are relatively new economic urban areas they do not have a mixed land use. Residential areas surround the edge city, but are not mixed within it.

The *multi-nuclear* or *polycentric city* can be characterised by having more than one (usually nodal) point functioning as centres that are inter-connected. There are two types of multi-nuclear cities. The first is that one city has multiple centres within its jurisdictional borders. These centres are the same as the edge cities mentioned above that can take shape in two ways. In the first place, more and more concentrated economic development takes place on the axes that connect the cities thus creating a network of edge cities. In the second case, the edge cities are located in the shape of a ring along orbital freeways around the central metropolitan centre. The second type of multi-nuclear city consists of multiple cities that form a polycentric urban network; a polycentric network incorporating big and small cities that together form one big metropolitan area capable of competing in a global field. These multi-nuclear cities have mixed densities, with centres with very high concentrations, and the further you move away from these centres, the lower the density will be. These cities offer both public transport and an elaborate network of freeways connecting the nodes. The multi-nuclear city is not necessarily reliant upon one big centre, but has to be seen more as a complete network of cities that are evenly important. If one takes the Randstad, an urbanised delta consisting of four major cities (Amsterdam, Rotterdam, The Hague and Utrecht), in the Netherlands as an example, one can see a great example of a polycentric city where all centres have their specific contribution (politcal center, financial center, transport center, etc.) to the whole of the network. Polycentric cities can be contained or uncontained, something which varies greatly. Sometimes the centres are very compact and there are big open green or agricultural national parks, like in the Randstad with its Green Heart, that contain the urban area. In other cases, the polycentric city could well be more like a dispersed city with several centres surrounded by urban sprawl. Polycentric cities often have areas where the land uses are mixed, in their centres for example, but it also has areas where the land uses are homogenous.

The *fringe cities* are located well outside the borders of the central city but are located on the verges of this central city. They are there due to the outward migration from the central city and thus exist because of this central city and accommodate additional growth. All the jobs and facilities can be found in the central city, thus making the fringe cities usually completely economically dependent on the central city. The fringe cities can be found at the 'end' of the radial infrastructure that people use daily to commute between work in the central city and home in the fringe city. This commuting takes place by car as fringe cities are car dependent and connected to the city by road. They show very similar patterns as dispersed cities and therefore do not occupy a contained space, but are more like a big suburb where land is still cheap, facilitating residential areas with gardens. Fringe cities are dormitory residential cities and therefore do not have a mixed land use.

Satellite cities are 'usually smaller than a city and larger than a village, also located well outside the borders of the central city and independent of its jurisdiction but within its economic and social orbit' (Abrams 1971). These cities are partially economically independent and can be seen as micro-metropolises with their own history that got interconnected to the bigger metropolis due to urban growth. They are usually connected by public transport and road infrastructure to the central

city and can be seen as small- to medium-sized cities. They therefore can be contained or not contained depending on which part of the world they are located. In, for instance, Guelph, Cambridge, Kitchener and Waterloo, Ontario, that are regarded as satellite cities of Toronto, there are few things that stand in the way of an uncontained urban sprawl. In Reading and Luton, both satellites of London, however, things are a bit more European and thus more contained. There are mixed densities with a common concentrated centre surrounded by a less concentrated ring of residential areas. The mix of land use again varies per satellite city. Satellite cities differ from fringe or edge cities by their age. Satellite cities have a longer history, and because of the growing central city and an increased mobility, they partially came within the influence sphere of this central city.

Summarising the main characteristics defining the different typologies of urban form are: density, containment of space in terms of land use, car dependency, good or bad public transport system and economic dependency. Table 10.1 gives a schematic overview of the urban form typologies based on the above criteria summarising the above analysis. These brief descriptions of the various types of urban form show us that this is dominantly affected by transport policy and land-use policy. The lay-out of the infrastructural works dictates all the other developments around it. The radial city takes on its shape because other developments follow the infrastructural lines, edge cities are formed on junctions of big infrastructural works, etc.

As can be seen with the corridor city, it is an urban form that usually appears within a city. The edge city can be found only within a city region close to the outer border of the city. Another point of attention relates to the compact city. A city can be very compact and ideal, but at the same time can lead to a large number of second homes scattered outside the city and thus generate a big amount of leisure traffic.

These 'archetypical forms prove useful in thinking about energy and environmental issues in cities, but their usefulness is limited by their fundamentally static nature. It is important to recognise that no real urban form is determined by the circumstances that exist at one particular point in time, but rather it must reflect events, technologies, policies and preferences over the entire history of the city' (Williams 2000).

10.3 The Policy Relevance of Urban Form

... appropriate city sizes, efficient external and internal accessibility, ordered mobility, appropriate shape and structure of the urban system or the urban hierarchy, and levels of compactness of the settlements prove crucial in determining not just the wellbeing of local populations, but increasingly the attractiveness of the sites with respect to external firms and the efficiency of activities already located. (OECD 2001: 154).

The role of urban form in contributing to sustainable development has been recognised in a range of policy documents over the last two decades, particularly within Europe. For this reason, the main focus of this section is European policy and how urban form features in this policy.

Table 10.1 Urban forms and their main characteristics

1. Compact City	2. Dispersed City	3. Linear City	4. Polycentric City
High density	Low density	Mixed densities	Mixed high and low densities
Contained space	Uncontained space	Contained space	Medium contained space
Mixed land use	No mixed land use	No mixed land use	Mixed land use
No car dependency	High car dependency	Medium car dependency	Medium car dependency
Rich public transport system	Poor public transport system	Medium public transport system	Medium public transport system
Economically independent	Economically independent	Complete economic dependency upon central city	Economically independent
Example: Vienna (Austria)	Example: Los Angeles (USA)	Example: Pomona Freeway 60 in Los Angeles (USA)	Example: Randstad (The Netherlands)

5. Satellite City	6. Fringe City	7. Edge city
Mixed high and low densities	Low densities	Mixed high and low densities
Medium contained space	Uncontained space	Medium contained space
Mixed land use	No mixed land use	Mixed land use
Medium car dependency	Car dependency	Medium car dependency
Medium public transport system	Poor public transport system	Medium public transport system
Medium economic dependence	Complete economic dependency upon central city	Complete economic dependency upon central city
Example: Luton and Reading (England)	Example: Almere (The Netherlands)	Example: Burlington Mall Area of Boston (USA), Zapopan of Guadalajara (Mexico)

A number of these documents have called for a stronger role of land-use planning and argued for denser mixed-use urban development. This type of development generally equates to the idea of the 'compact city', although few documents have explicitly referred to this concept. One exception here is the 1999 European Spatial Development Perspective (ESDP) (CSD 1999), which advocates the compact city concept primarily as a way of managing urban expansion. The merits of denser, mixed-use urban development have been frequently described in European policy documents in terms of environmental benefits although it is also clear that there may also be a variety of social and economic benefits.

The 1990 Green Paper on the Urban Environment argues for denser, more mixed land-uses, taking the traditional European city as its model (CEC 1990). The ESDP advocates the idea of the compact city, or the city of short distances (CSD 1999). The European Commission's 2004 preparatory document on the Urban Thematic Strategy supports high density, mixed-use settlements, the reuse of 'brownfield' land and empty property, and planned expansions of urban areas rather than ad hoc urban sprawl (CEC 2004). The Leipzig Charter on Sustainable European Cities (agreed in 2007 by the European Ministers responsible for urban development) asserts that compact settlement structures form an important basis for the efficient and sustainable use of resources. Mixing housing, employment, education and recreational use in urban neighbourhoods is identified as more sustainable (German Federal Ministry of Transport, Building and Urban Affairs 2007).

Various reasons for managing the urban form can be identified in European policy documents. Many of these present environmental arguments although there are also a variety of social and economic justifications (see above quote). The 1990 Green Paper on the Urban Environment recommends strategies for dense mixed-use developments as a way of increasing local accessibility to jobs and services, stating that dense mixed-use development is more likely to result in people living close to workplaces and the services they need for everyday life. The ESDP argues that spatial development policy 'can make an important contribution to climate protection through energy-saving from traffic-reducing settlement structures and locations' (CSD 1999: 31). The 2006 Thematic Strategy on the Urban Environment asserts that avoiding urban sprawl through high density and mixed-use settlement patterns can help to reduce resource use, including land consumption and transport and heating requirements (CEC 2006).

Many documents regard urban sprawl as a key issue to be addressed through urban development policies. The European Commission's 2004 preparatory document on the Urban Thematic Strategy (CEC 2004), for example, states that poor land-use decisions create urban areas that are environmentally unsustainable and also unattractive to residents. According to the 2007 European Green Paper on Urban Mobility, the suburbanisation of development and the resulting dispersal of home, work and leisure facilities has resulted in increased transport demand (CEC 2007).

The 1990 Green Paper on the Urban Environment argues for 'a fundamental review of the principles on which town planning practice has been based' (CEC 1990: 40), stating that strict zoning policies have led to the separation of land uses

which in turn has contributed to large increases in traffic – one of the main contributors to many urban environmental problems. The Leipzig Charter calls for stronger land supply controls through spatial and urban planning (German Federal Ministry of Transport, Building and Urban Affairs 2007).

A number of policy documents also recognise some of the difficulties in promoting higher density mixed-use development, especially via European policy. The European Commission's 2004 preparatory document on the Urban Thematic Strategy for example recognises that there are limits to acceptable urban densities (and that some urban areas suffer from poor quality environments due to overcrowding) and that reversing urban sprawl or increasing land-use densities is no easy task (CEC 2004). The issues of competence and subsidiarity (taking decisions at the lowest appropriate level) are clearly relevant to European policy in this area. This is also recognised in the European Commission's 2004 preparatory document on the Urban Thematic Strategy, which states that 'it is not for the Community to set a standard system for making land use decisions, or to define the "ideal" settlement pattern as each town and city is unique and the solutions needed to achieve a sustainable urban environment are specific to each case' (CEC 2004: 30).

10.4 The Concept of the Compact City

Academic literature and policy documents that consider urban form frequently focus on the compact city as an ideal form of urbanisation. Four main advantages of the compact city are often cited:

1. A contained compact city protects the rural land;
2. The quality of life and quality of services can be maintained in the city;
3. High urban densities promote more sustainable use of energy (for housing);
4. A short distance city reduces the amount and lengths of trips by modes of transport harmful to the environment.

From the very beginning, the literature indicated that the compact city was the most sustainable urban form even though that claim was not yet proved. This claim was more of a notion, an idea that the compact city would be more sustainable than for instance the dispersed city. However, in the last decade, more and more research has been done on the compact city and now it seems that those claims could prove right. A study in The Netherlands showed that 'Car use is fairly low in the large and medium-sized cities of Randstad Holland, where many trip purposes are within reach by foot or cycle and where public transport is relatively abundant (Fig. 10.1). The combination of density, diversity and the supply of good public transport clearly reduces car use in these residential environments compared with more suburban and rural settings' (Dieleman et al. 2002).

There are also still many issues unresolved related to the other urban form typologies and therefore these unresolved issues are not exclusive to the compact city.

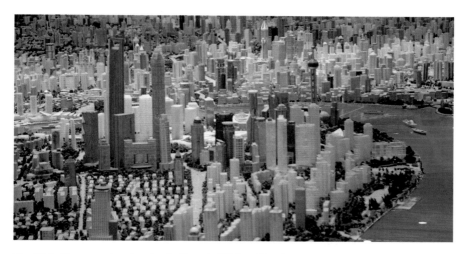

Fig. 10.1 Compact city planning in Shanghai Urban Planning Exhibition Hall (Source: Photo by Jody Milder)

Breheny (1992) distinguishes a list of five conflicts of the compact city:

- Compact city versus energy efficiency
- Compact city versus suburban quality of life
- Compact city versus the green city
- Compact city versus renewable energy sources
- Compact city versus rural economic development

First of all, the compact city versus the energy efficient city refers to the 'most important characteristic of the compact city' that in principle it should reduce the need for travel and therefore would mean a reduction in fuel consumption and GHG emissions. 'It seems to have the merits of short private journey lengths and the greatest prospects for increasing the patronage of public transport'. Another advantage would be that the compact city offers better chances to introduce a communal heat and power system. Breheny also refers to the Green paper on the urban environment (CEC 1990) where it is argued that one of the great merits of the compact city is that it contributes to the environmental sustainability; a conclusion based on no rigorous analysis whatsoever. There have been numerous modelling studies (examples) and statistical correlations tested, but they all have their flaws.

The second point relating the compact city to the suburban quality of life focuses on the desirability to live in high densities, and questions if it is even possible to allocate all the growth on brown fields etc. '…implies that the European Commission's goal of building all new development within existing urban boundaries is simply not possible, unless very drastic policies are introduced. Indeed, the changes of policy and implementation that would be required to push all of this growth into existing urban areas are unthinkable'.

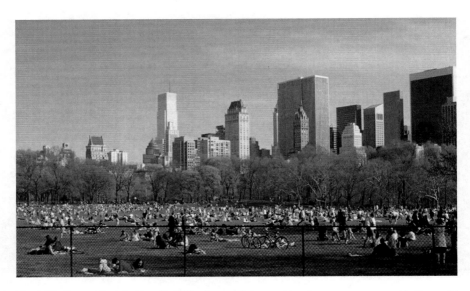

Fig. 10.2 Central Park in New York City is one of the most iconic green open spaces in the world (Source: Photo by Floris Frederix. Used with permission)

The Green Paper does not do subtleties, as it basically denigrates the suburbs whilst being very positive towards the city centres 'The enemies of this source of creativity are on the one hand undifferentiated suburban sprawl in Quasi-rural settings which isolate the Individual'. By taking such a strong position against sub-urbanisation, it denies the qualities of suburban life, although further on, it does pay attention to the major weaknesses of the inner cities: noise, air quality, lack of qualitative open spaces (they are all car parks), etc. Breheny (1992) quotes Osbron and Whittick 1977, who state that urbanity cannot be used as a synonym for high urban densities or crowdedness as it denies the infinite diversity of shape etc. that the world's towns display. In addition, it stands for a quality that most townspeople regard as a drawback and escape from it if they can. Almost everybody would agree with the mission of the Commission on reviving the inner cities; however, the large numbers of people that live in suburbs underline that the suburban lifestyle cannot be ignored.

Thirdly, the compact versus the green city is a contradiction in terms, as the Green Paper speaks of higher densities, but also of the necessity for more greening in the cities. The green and open spaces have recreational uses, but serve an ecological purpose too, as nature in the city, absorbers of CO_2 and other pollutants (Fig. 10.2). One of the 'side effects' of the compact city is the further intensification of the city that can lead to the loss of this same open space.

The fourth conflict distinguished is the conflict between the compact city and the telecommunication-rich dispersal. In the early days of telecommunication, it was believed that it would lead to an 'anti-urban lifestyle that is decentralized both geographically and institutionally' (Breheny 1992). This conflict, however, appears to be out-dated as the rise of communication technology so far has not led to a massive outward migration and dispersion of the city.

The next conflict of the compact city versus renewable energy sources is not very clear. Steadman and Owens (1979, in Breheny 1992) are mentioned with their suggestion that low density development is required for any form of large-scale solar heating or wind energy. This claim, however, is very ambiguous as a compact city also offers great chances for sustainable energy management such as community heating and electricity, etc. Besides multi-family homes are more energy efficient in general than single family homes.

The last conflict, compact city versus rural economic development, addresses the problem that the urban containment leads to a deprivation of development in the rural areas that could otherwise have sustained the rural areas. This deprivation of suburban development in the rural areas due to the containments policy takes away new impulses for these already underdeveloped areas to sustain themselves. The argument now is that this compact city focus counteracts the weakening effect that suburbanisation has on the inner city. Development takes place outside the city centres, leaving the old centres behind in a downward spiral.

Williams (2000) identify a few more additional conflicts and complexities in their work:

- Compact city and affordability of housing
- Compact city and air quality/noise
- Compact city and crime/feasibility/social acceptability
- Strategic benefits and perceived disadvantages

They give the example that the compact city protects the countryside and lowers the emission levels due to reduced vehicle use, while the counter arguments say that there is an increased congestion leading to a greater local air and noise pollution and a loss of urban green space. Another claim is that the compact city can improve the economic attractiveness of an area, but on the other side also drive up land prices threatening affordable housing and offices. Another 'pro' argument states that compact cities stimulate the social and cultural activity making the city more lively, while on the 'contra' side higher densities lead to higher crime rates, low social acceptability due to a loss of privacy, etc. Then, on top of all that, there is the issue of further densifying bringing an advantage on the city level, but leads to NIMBY (not in my back yard) reactions on the local level as it will be at the cost of open spaces.

From all the above conflicts, it can be seen that the compact city is not only an answer but also comes with a new set of problems or challenges. For every argument in favour of the compact city, there is a counter argument. It all depends on where you set your borders. If one looks at a lot of northern European cities, one can see compact cities that seem to do very well in terms of environmental impact. If you then, however, take a look at the bigger region, a different image appears in which there are a lot of leisure trips to second homes, etc., that are scattered over the countryside.

Besides, do you want to have a low carbon footprint city or a liveable city? A very compact city with high densities and no open spaces could have a very low footprint, but at the same time a very poor local air quality, high crime rates, be unpopular to live in, etc. So, depending on the goal and the current reality, you can start working towards a more sustainable city, sustainable in the environmental, economic and social way.

10.5 Urban Form and Environmental Performance

In the preceding text, we have focused on the compact city and its conflicts or unresolved issues. We now broaden the discussion to how urban form types result in different environmental impacts. Although it is recognised that 'urban form has a profound influence on the flows within the city, it does not determine them completely' (Anderson et al. 1996), this influence of urban form should always be seen as it having an impact 'to a certain extent', which comprehends both the limitations as well as the possibilities. '...*the urban form* – affects the ability and desire of individuals to choose alternatives to the automobile in meeting their transport needs' (Anderson et al. 1996).

When reviewing the literature on past and present research related to urban form and environmental performance, many unresolved issues surface that reveal the clash between theory and practice. Below, one can find a summary of some of these unclear issues.

10.5.1 Sustainable Travel and Transport

One of these issues that need to be recognised is that in many cases people do not have a free choice to live close to their work due to their financial or personal situation, or to market conditions that constrain their choice of finding an optimum live and work location. So, where in theory 'more efficient commuting patterns might even be achieved without any change in urban form if people can be encouraged to place greater emphasis on efficiency in their locational decisions' (Anderson et al. 1996), practice shows the limitation of this theory through the constraints faced in everyday reality.

A second issue addresses the conflict between urban design and peoples' behaviour. Theory relies heavily on density, and a mix of functions in design that should lead to more congestion making it less attractive to use the car and more appealing to use public transport or non-motorised forms of mobility. Additionally, as there is a high mix of functions within a relatively contained space, it would in theory lead to more short trips between work, home and leisure activities. In contrast, so far studies have shown that in practice income has a much more significant impact on mobility than city design. The higher the income, the more car-dependent people become.

This leads to the third unresolved issue on the level of compactness and leisure travel. A study in Oslo explored this possible relationship between the level of compactness of a city and the increase in leisure-related mobility. People living in city centres seem to have a higher need to travel by car and plane in their free time than people living in houses with a garden, who seem to find enough leisure opportunities in their gardens. On the one side, the daily travel rates appear to be lower in a compact city than in a dispersed city, whilst on the other side, leisure traffic seems to increase in compact cities. This aspect can perhaps also be linked to the difference in the type of people that live in suburbs and inner cities which brings us to the fourth issue.

When looking at only the suburbs, the issue of car dependency becomes of importance. 'The largest reduction in car use is theoretically possible in suburban and rural communities (where most people live) because current car use is so extensive there…. We have shown that an increase in the number of households with two workers does not necessarily lead to an increase in car use. The presence of children, especially in combination with two partners who have paid work, is a far more important factor in influencing car use than straightforward participation in the labour market. The combination of work and family leads to more people experiencing the time pressures which evidently lead to more frequent use of the private car. Car use is especially high in residential environments where the distances to service locations have become longer as a result of the enlargement of scale and suburbanisation of functions' (Dieleman et al. 2002). So, in general, it can be concluded that a combination of the type of people and their needs combined with urban form leads to a higher car dependency in the suburbs.

A fifth issue becomes apparent when analysing the limits of planning as an instrument to reach broader goals. A study in the UK concludes that 'Some aspects of intensification, in some places, have contributed to sustainability, whilst other clearly have not' (Williams 2000). The latter refers to the fact that a traffic reduction was not realised, leading to a degradation of quality of life aspects such as noise and air quality. As 'policy outcomes are often reliant on a range of intervening variables, which are not within the control of the planning system', planning struggled to achieve more broad economic, social and environmental aims whereas it is successful in terms of managing the location of development and hence promoting a sustainable use of land. When it comes to the other aims, it can be said that it offers potential, but is not sustainable per se.

10.5.2 Efficient Use of Land and Energy

The discussion above leads to a sixth very much related issue, the issue of land consumption. This is a very basic issue but sometimes tends to move more towards the background '…urban form directly affects habitat, ecosystems, endangered species, and water quality through land consumption, habitat fragmentation, and replacement of natural cover with impervious surfaces' (Jabareen 2006). Ultimately, dispersed cities do consume more land than compact cities, land which is not easily converted back to its original state.

When looking at the difference between multi-family houses and single family houses, a seventh issue comes up. Some studies have shown that the difference between the energy use of single and multi-family homes has been reduced for houses built after 1980 and that therefore this argument no longer holds. This could lead to the situation where the homes in the suburbs are more energy efficient than homes in the city centres. However, if one compares new multi-family homes with new single family homes, different results might show as development has also not stopped in the construction of multi-family homes.

An eighth unresolved issue becomes apparent when taking a look at the conflict between finding the ultimate environmentally sustainable urban form and other optimums for other fields such as the economic or social. It is impossible to determine the most desirable urban form based only on energy and environmental issues as this does not answer questions related to economics, social equity, desirability, etc. Moreover, even if it would be hypothetically possible to determine this utopian urban form, it would remain unclear how to reach this as urban form is not solely a question of design but the result of a complex range of processes that go on for long periods of time.

A commonly heard statement is that 'it has never been established that residential densities per se reduce the consumption of energy or greenhouse emissions resulting from travel behaviour' (Christoff and Low 2000). 'At worst, sprawl angst masks aesthetic not scientific complaint with the suburban form' (Christoff and Low 2000).

A relatively new trend is the trend of resilient cities. 'In the fight against global warming, planning's prime contribution is adaption in search of climate-resilient cities. This means the creation of urban environments that will withstand the vagaries of a harmed climate and rising resource shortages' (Gleeson 2008).

Urban form is just a facilitator, but does not guarantee that people will indeed all start biking to work, for example. The reach and impact of urban form is limited. 'Even the most vigorous proponents of a compact city emphasises that the path toward a short-trip city is long and arduous and can only succeed if additional strategies are pursued in parallel' (Jessen 1997).

'A multifunctional and compact settlement structure comprises an essential prerequisite for travel-efficient behaviour patterns. However, a short-trip city or region is not solely based on these structural prerequisites, but must complement them with assistance towards travel efficient behaviour at the level of the individual. Otherwise, a multifunctional and compact short-trip city remains a city of unused travel reduction potential'. In general, it can be said that, although urban form does seem to have a certain amount of influence on the environmental impact of a city by influencing the behaviour of people, it is not clear what urban form leads to the least environmental impact.

10.5.3 The Environmental Quality of Cities

Coming back to the basics again, environmental impact and urban form, what environmental impacts do the different typologies of urban form have? Below, we will follow a much generalised overview of the different urban forms and their general environmental impacts based on: *urban greening, water, liveability, energy, building materials, air quality* and *urban transport.*

The above terms need to be briefly elaborated on in order to understand what is meant by them. *Urban greening* refers to the amount of green and open spaces within cities as they have a positive effect on the air quality and liveability of cities.

Fig. 10.3 Examples of different forms of compact development in Berlin and Porto. *Left*: East Berlin's Karl-Marx Allee; *right*: Porto's dense historic inner city (Source: Photos by Jody Milder)

If the green urban areas are connected through a web of green infrastructure, it enhances the biodiversity and therefore can be marked as more sustainable.

When looking at Material Flow Analysis of cities (in the light of urban metabolism), *water* forms the most substantial flow through urban systems and can therefore be considered as the main flow '...it is clear that water is the single largest material flux in urban ecosystems. Cities are consuming around 1,000 kt of water daily on average. This dwarfs the 10,124 kt. Of fuel consumed annually in Mexico City or the 17,530 kt per year in São Paulo by factors of 36 and 21, respectively' (Decker et al. 2000). However the bulk of the flow relates to active inputs (distant watersheds and aquifer) instead of the passive inputs (precipitation and surface flows). If one wants to focus on a water flow, the passive flow is very interesting as the built environment has a profound influence on that water cycle. The built environment can increase urban evaporation and precipitation and, in combination with the increasing percentage of pavement and constructions, the infiltration of water is virtually impossible, leading to extremely low water levels below the city and heat islands above the city. If one looks at the energy flow, it could also help to be focussed, unless you have unlimited time, resources and data availability. One could, for instance, only focus on the energy performance of houses, instead of looking into all the energy flows within the urban fabric. Another substantial flow is the *construction materials* needed to build all the housing, offices, infrastructure, etc. *Air quality* is an issue that speaks for itself, as smog and other forms of air pollution are known all over the world. The *liveability* of cities is a composed criterion that exists of many other sub-criteria, such as cultural, social, economic, environmental, etc. aspects. *Urban transport* distinguishes the form of transport used and the amount and length of trips. One other aspect of urban transport is the difference between energy performances per transport mode; a train has a better energy performance per person than a car, for instance. The compact city is always used as a very uniform header while there are great differences between compact cities as you can reach high densities in various ways (Fig. 10.3).

You can plant high-rise buildings in a green environment as was done in the vertical garden city (LeCorbusier, e.g. in Besset 1987) or more recently was explored in the Vertical City (Yeang 1999) through high rise buildings that are

compact cities in themselves, and speak of a compact city, whilst any of the historic city centres of the big capitals of Europe reach the same densities through very different urban patterns.

10.6 An Assessment of Urban Form

Taking the above into account, in general the compact city traditionally has problems scoring high on the urban greening scale as it struggles to keep the right balance between high density building and urban greening. The lack of urban green and the high densities have a negative effect on the local air quality. The air tends to clog together in the streets due to a lack of ventilation between the buildings. On top of that, there is no filtering capacity due to the absence of the trees (see Fig. 2.25 on street canyons in Chap. 2). This, combined with the frequently congested roads in the inner city, lead to very poor local air quality. In terms of urban transport, a higher number of short city trips are done by public transport compared to any other urban form, will have a less big impact on the environment than trips by car. The only thesis, which has not yet been proved, that lurks in the background is that people in compact cities undertake more long-distance leisure trips to second homes or other recreational activities in the countryside. In terms of material use, fewer construction materials are used per person in a multi-family home than in a single family home. Besides this, multi-family homes are also more energy efficient. Compact cities also score high points when it comes to the ground it 'consumes', the footprint. The compact city occupies the minimum amount of land. The drawback is that there is a relatively high percentage of paved, concrete surface (roofs and roads) leading to a disturbed water flow. Water is collected in the sewer system, taking the pollution of the roofs and streets with it and being rapidly transported out of the city through pipelines ending in the river. This creates a drought directly under the city as water flows away without infiltrating and refilling the ground water level, also affecting the ground water level in the vicinity of the city. Furthermore, it will lead to rivers transforming from glacier-fed rivers, or mixed rivers to more rain-fed rivers. Rain-fed rivers are notorious for their extreme variation in water levels leading to floods and droughts. Another side effect of the compact city is the creation of heat islands directly above the city (Fig. 10.4) that lead to a concentration of pollution and to chemical substances reacting with one another. All this combined, leads to high mortality rates (see also Chap. 7). Another disadvantage is that compact cities are believed to lead to an increase in leisure traffic and an increase in second homes in the surrounding countryside (see also Chap. 9).

The dispersed city has very low scores in terms of land use (footprint) and transport. Distances are longer within the city and the inhabitants are very car dependent. Therefore, trips are longer and more often take place by car, while the public transport use stays behind. The amounts of construction material used are very high. Single family homes require more construction materials and the vast road network that comes with dispersed cities is a major consumer of land and materials. Single

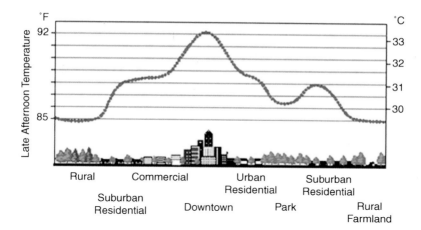

Fig. 10.4 The urban heat island effect (Source: Heat Island Group at Lawrence Berkeley National Lab. Used with permission)

family homes are also less energy efficient. The dispersed city, however, scores well on urban ecology as there is a lot of open green space within the city in the forms of gardens, parks, etc., making up a network of natural or semi-natural urban green spaces. Here, water can infiltrate the bottom and can keep the ground water level on par. Water thus has a better chance of reaching the rivers in a more natural pace filtering out the pollution when it drains into the soil. The overall air pollution created by a dispersed city is bigger than that of a compact city; however, the local air quality is better in a dispersed city. There is more green to absorb the GHG, and mobility takes place within a bigger area of land also dispersing the traffic and pollution. Within this comparison of urban forms, it is very important to keep in mind that the geographical situation of cities is not taken into account, meaning that a dispersed city like Santiago de Chile can still have a very bad local air quality due to the fact that it is surrounded by mountains preventing the polluted air from dispersing.

 The linear city is like a bead on an infrastructural string often leading to the city centre. Therefore, the mobility in linear cities is high as they are fed through the main infrastructural artery. A linear city can be built along combined infrastructural works, where a train or metro line runs parallel to a highway, for example. In that case, part of the trips is done with public transport and another part takes place using the car. However, in many cases, linear cities are built along big road infrastructure only and therefore are completely car dependent. Behind the first strip of commercial or industrial facilities, the residential area is located usually in low densities. Because of this configuration, it lacks good public transport to connect the residential area to the economic area making them very car dependent leading to a poor transport energy performance. There is enough open space, but in the commercial strip this mainly consists of parking lots. Behind this commercial strip, the residential area can take on different lay outs, but commonly consists of single family homes. This is explained by the lower ground prices the further you get from the

centre, leading to big plots for business along the infrastructure and the opportunity for single family homes. Water flows in the commercial strip are therefore disturbed by all the paved surfaces, but in the residential areas they are similar to the dispersed city. Construction material use is high, not only by the massive road infrastructure but also in the single family homes.

Edge cities are more like nodal points in the border of cities that, because of a big infrastructural intersection of radial roads originating from the city and a ring-road or orbital road that crosses it, grew out to focal points of economic development. They are thus mainly fed by roads, but in some cases one of the infrastructural lines could also be a railway line outward from the city. Depending on the continent, the edge cities are more or less car dependent. Whereas in a European country the edge city could also be formed around a railway station, in the Americas it is more likely to be formed on an intersection of highways. In the case of more car dependency, the energy costs in transport are high due to the economic dependency of edge cities upon the city centre and between them. This leads to an intense feed of people and goods towards and from these centres. There is a high concentration of jobs and retail leading to a high percentage of paved surface and roofs and thus disturbed water flows similar to that of a compact city. As the density is high, the material use is efficient, but due to the lack of urban greening the air quality can be very poor, also taken into account that a lot of edge cities are airport locations.

In the case of polycentric cities, there are big differences again, as a polycentric city could be the Randstad (The Netherlands) or the Ruhr Area (Germany), comprised of big cities that together make up a polycentric metropolitan region. However, it could also be a single city that has several economic nodes all serving their purpose. The historic centre is there for culture and leisure, whereas the airport forms a logistic and business centre where people meet. At the same time, it can have another business centre where the two main highways cross, etc., whilst at the intersection of public transport forms there could be an academic centre. Therefore, a polycentric city is dependent upon all forms of transport, car as well as public transport. The trafficking between nodes can be facilitated by public transport, whereas the other trafficking is more oriented towards the car. Therefore, the energy used in transport is medium high. The use of construction materials is diverse and the same goes for the energy efficiency of housing. Air quality within the city centres is usually poor, but in between the different centres is very good as there is a lot of open space or low density housing.

Due to their (partial) economic independency, satellite cities can function on their own. They are, however, located within the economic orbit of the central city and therefore a certain amount of economic traffic does take place between the metropolitan area and its satellite cities. Satellite cities are small cities that have their own proper centre, but due to the lower ground prices a lot of single family housing can be found around the centre. Distances are short within the city itself, but if one needs to commute to the central city the distance is very large. Sometimes, satellite cities are connected by train to the metropolitan area, but in many cases they are connected through a highway. As there is in general more single housing than multi-family housing, the construction materials used and the energy consumed by

the houses is high. Water flows in the city centre are poor due to the high percentage of paved surface but are good in the residential areas because of the single family houses.

The fringe city can be compared very well to the dispersed city as it can be seen more or less as a dispersed settlement outside the jurisdictional border of the central city. This settlement is completely dependent upon the central city and therefore generates a huge amount of long-distance commuting between the central city and the fringe city by car. In terms of water, urban greening, materials and air quality it scores similar to dispersed cities.

In a less complex world, the urban form types would be placed in a table and scored on the aspects of urban greening, water, energy, materials, air quality, liveability and urban transport to come to a ranking of urban form types. To do so, however, is a very tedious job where one walks on thin ice as it is hard to make and prove causal relationships between urban form and the environmental performance of a city based on empirical research (done so far). There are just too many aspects and variations to take into account that even if it would be possible to make such a table the value would be questionable.

When assessing urban forms on their environmental performance, one should just always keep in mind that urban form can only facilitate a more efficient and less environmentally stressful functioning of the city or to use Keyes' words: 'Making adjustments to urban form does not in itself constitute a direct energy conservation, but rather a facilitating strategy which makes a variety of conservation activities possible' (Williams 2000); however, urban form does not control behaviour.

10.7 Concluding Remarks

Currently, the debate and policy are all pointing in one direction, the compact city as the silver bullet; this, however, has never been properly backed up by unequivocal evidence. So far, all the environmental qualities debate attaches to the different types of urban form are mainly driven by logic reasoning. If the claims of the compact city supporters are true, then the first necessary step would be to validate this theory through empirical research and to compare the different urban forms between and against one another. If then one of the urban forms indeed has clear advantages above the others in terms of environmental impact, the next step would be to look at how this can be achieved and how this relates to the current situation found in the different cities all around the world.

The following challenge should be to tackle a change in behaviour of its inhabitants in order to adapt a more environmental friendly lifestyle. In order for this to become a realistic possibility, the facilities for adopting this new lifestyle have to be put in place first. It would perhaps go too far to want to convert all the cities in the world into compact cities or whatever urban form type that turns out to be the most environmental friendly, as the different characteristics of cities create a sense of identity and are a reflection of what the local populations wants. A solution needs to

be rooted in practice for it to work. This, however, should not prevent policy makers from trying to achieve the most sustainable urban form, but should be an impulse and inspiration to make policy that combines and balances the market and the environmental interests.

If the ideal form type would be the compact city one option for example could be to try to include several elements of the compact city into the other (non-compact) cities, such as a higher mix of functions, or create higher density nodes on intersections of public transport, etc. In that way, a step forward can be made in terms of sustainability without ignoring the current identity of the city. Furthermore, one could also argue that the existing compact cities should be revised in order to lower the amount of people with second homes on the countryside for example. In the field of urban form, it is not valuable to look at just the city without taking a look at a higher aggregation level; the impact of the city can hardly be called exclusively local.

Questions

1. Is the compact city the most sustainable urban form in relation to the other types of urban form? What are advantages and disadvantages of other types of urban form?
2. What types of policy are the most important for achieving more sustainable cities? How important are planning policies in achieving more sustainable cities?
3. What are the links between ecological, economic and social sustainability? Can all three be achieved in the context of sustainable urban development?
4. Consider your hometown (or a town nearby) and identify its predominant urban form and the ways in which it could be developed more sustainably in the future.
5. What kind of urban form prevails in your country? Discuss the main factors that have contributed to the prevalence of this type of urban form.

Acknowledgments This chapter has been prepared in parallel with a European Commission funded research project on urban metabolism – Sustainable Metabolism in Europe (SUME; EU project number 212034). The author is grateful to the members of the SUME consortium for their contributions to the project to the content of this chapter. In particular, Dominic Stead, from Delft University of Technology, has provided various comments and inputs to this paper.

References

Abrams C (1971) The Language of cities, a glossary of terms. The Viking Press, New York
Anderson WP, Kanaroglou PS, Miller EJ (1996) Urban form, energy and the environment: a review of issues, evidence and policy. Urban Stud 33(1):7–35
Besset M (1987) LeCorbusier, to live with the light. The Architectural Press, London
Breheny M (1992) The contradictions of the compact city: A review. In: Breheny M (ed.) Sustainable development and urban form. Pion, London, pp 138–159
CEC (Commission of the European Communities) (1990) Green paper on the urban environment, COM(90)218 final. Office for Official Publications of the European Communities, Luxembourg

CEC (Commission of the European Communities) (2004) Towards a thematic strategy on the urban environment, COM(2004) 60 final. Office for Official Publications of the European Communities, Luxembourg

CEC (Commission of the European Communities) (2006) Thematic strategy on the urban environment, COM(2005) 718 final. Office for Official Publications of the European Communities, Luxembourg

CEC (Commission of the European Communities) (2007) Green Paper. Towards a new culture for urban mobility (presented by the Commission), COM(2007)551 final. Office for Official Publications of the European Communities, Luxembourg

Christoff P, Low N (2000) Recent Australian urban policy and the environment. In: Low NP, Gleeson B, Elander I, Lidskog R (eds.) Consuming Cities: the urban environment in the global economy after the Rio declaration. Routledge, London, pp 241–264

CSD (Committee on Spatial Development) (1999) European spatial development perspective: Towards balanced and sustainable development of the territory of the EU. Office for Official Publications of the European Community, Luxembourg

Decker EH, Elliott S, Smith FA, Blake DR, Rowland FS (2000) Energy and material flow through the urban ecosystem. Annu Rev Energy Environ 25:685–740

Dieleman FM, Dijst M, Burghouwt G (2002) Urban form and travel behaviour: Micro-level household attributes and residential context. Urban Stud 39(3):507–527. doi:10.1080/00420980220112801

Garreau J (1991) Edge city: life on the new frontier. Doubleday, New York

German Federal Ministry of Transport, Building and Urban Affairs (2007) Leipzig charter on sustainable European cities. agreed at the occasion of the informal ministerial meeting on urban development and territorial cohesion on 24/25 May 2007, www.bmvbs.de/en/dokumente/-,1872.982774/Artikel/dokument.htm Accessed 14 Apr 2009

Gleeson B (2008) Critical Commentary, walking from the dream: an Australian perspective on urban resilience. Urban Stud 45(13):2653–2668

Jabareen YR (2006) Sustainable urban forms: their typologies, models, and concepts. J Plan Educ Res 2006(26):38

Jessen J (1997) Führt das städtebauliche Leitbild der kompakten und durchmischten Stadt zur Stadt der kurzen Wege? In: Bose M (ed.) Die unaufhaltsame Auflösung der Stadt in die Region? Kritische Betrachtungen neuer Leitbilder, Konzepte, Kooperationsstrategien und Verwaltungsstrukturen für Stadtregionen. Harburger Berichte zur Stadtplanung Band 9, Hamburg

OECD (2001) Territorial outlook. OECD, Paris

Williams K (2000) Does intensifying cities make them more sustainable? In: Williams K, Burton E, Jenks M (eds.) Achieving sustainable urban form. E & FN Spon, London, pp 30–45

Yeang K (1999) K. Yeang, Planning the sustainable city as the vertical-city-in-the-sky. In: Foo AF, Yuen B (eds.) Sustainable cities in the 21st century. National University of Singapore, Singapore

Further reading

Borrego C et al (2006) How urban structure can affect city sustainability from an air quality perspective. Environ Modell Softw 21:461–467

Drummond P, Swain C (1992) The compact city and urban sustainability: conflicts and complexities. In: Burton E, Williams K, Jenks M (eds.) The compact city, A sustainable urban form. E & FN Spon, London, pp 231–248

Forsyth A, Oakes JM, Schmitz KH, Hearst M (2007) Does residential density increase walking and other physical activity? Urban Stud 44:679–697. doi:10.1080/00420980601184729

Holden E, Norland IT (2005) Three challenges for the compact city as a sustainable urban form: Household consumption of energy and transport in eight residential areas in the greater Oslo region. Urban Stud 42(12):2145–2166

Marshall S (2005) Urban pattern specification. Institute of Community Studies, London paper presented at Solutions symposium, Cambridge

Schwanen T, Dijst M, Dieleman FM (2008) Policies for urban form and their impact on travel: The Netherlands experience. Urban Stud 41(3):579–603

Newton P (2000) Urban form and environmental performance. In: Williams K, Burton E, Jenks M (eds.) Achieving a sustainable urban form. E & FN Spon, London, pp 46–52

Chapter 11
Environmental Strategies and Tools for Integrated Design

Laure Itard

Abstract This chapter gives an overview of possible design strategies to achieve a sustainable built environment. It provides the reader with basic knowledge of quantitative assessment methods, with a strong accent on life cycle analysis, which is currently the scientifically accepted method for environmental impact assessment. In addition, qualitative assessment methods (rating schemes) are handled. Finally, design methods dealing with interdisciplinary and multi-actor systems are briefly dealt with.

11.1 Introduction

The challenges of sustainable engineering and design of the built environment are complex. Integrating sustainability issues into one design proves to be a big challenge, not least because of three actual characteristics of sustainability and environmental sciences.

First, sustainability may be interpreted in very different ways, e.g., social sustainability, economic sustainability or environmental sustainability, generally specified as the triple bottom-line or triple P: People (social sustainability), Planet (ecological sustainability) and Profit (economical sustainability), all of these being legitimate. A sustainable design brings together many different disciplines and therefore collaborative strategies and interdisciplinary approaches are needed.

L. Itard (✉)
OTB Research Institute of the Buil Environment, Delft University of Technology,
Jaffalaan 9, Delft 2628 BX, The Netherlands

The Hague University of Applied Science, The Hague, The Netherlands
e-mail: L.C.M.Itard@tudelft.nl

E. van Bueren et al. (eds.), *Sustainable Urban Environments: An Ecosystem Approach*,
DOI 10.1007/978-94-007-1294-2_11, © Springer Science+Business Media B.V. 2012

Second, within the different interpretations, there is no general agreement about precise definitions. For instance, environmental sustainability may be understood from the viewpoints of preserving ecosystems, reducing CO_2 emissions or reducing the uses of non-renewable natural resources, using natural materials or using sustainable transport.

Third, the aim of sustainable engineering and design of the built environment is to solve environmental problems that arise in the pursuit of fulfilling basic needs like shelter and food, wealth, health, comfort or economic gains for a still-growing world population. Designers also have to solve new environmental problems created by these technologies. It is not always possible to predict what sort of problems may arise, especially because environmental sciences themselves are developing rapidly. This progress also means that knowledge gets out-dated rapidly.

This chapter introduces methods how to cope with these difficulties. First, general environmental strategies that have proven to work are described, followed by a description of quantitative assessment methods. These methods are needed for a well-founded comparison of design alternatives. However, a quantitative assessment is not always possible due to methodological limitations and to process limitations (time and costs). Qualitative assessment methods are less hindered by such limitations and are described in Sect. 11.4. Finally, integrated design methods are briefly described in Sect. 11.5. Whereas assessment methods tend to be used to assess design choices after they have been made, strategic integrated design methods aim to take sustainability considerations into account upfront.

11.2 Environmental Strategies

The interrelationships between the natural and human ecosystems were studied in Chaps. 2 and 5 (see also Fig. 11.1). Maintaining a sustainable ecosystem is about suppressing the sink "non-biodegradable waste", about achieving an equilibrium between the extraction of resources from the sinks "inorganic nutrients" and "organic matter" and the emissions of wastes to these sinks, and finally about achieving an equilibrium between extraction and growth of producers and consumers, as well as reducing the emissions to these compartments.

There is no real difference between the way to handle the compartment inorganic nutrients and the producers[1] (forests and plants), but the rate of natural replenishment is very different in both cases. Where approximately 30 years are needed to grow a pine, millions of years are needed to make coal from vegetal waste. Compared to the rate of the use of resources, this means that we can probably adjust our consumption of producers (biotic products) to their natural growth by thorough supply chain

[1] See definitions of producers and consumers in Sect. 5.1.1.

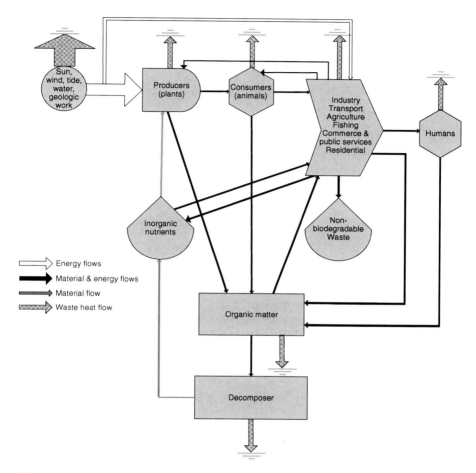

Fig. 11.1 Relationship between the natural and human ecosystems

management. In contrast, consuming inorganic nutrients and organic matter like fossil fuels means that they cannot be replenished at the same rate, and not being infinite, they are therefore depleted.

11.2.1 The Ecodevice Model

The Ecodevice model (Tjallingii 1996) is based on the same type of considerations: in order to be sustainable a system must use as less as possible resources – to avoid the depletion of natural resources – and must retain as much as possible to avoid damageable emissions – including waste – to the environment (see Fig. 11.2, and Chaps. 1, 2 and 4).

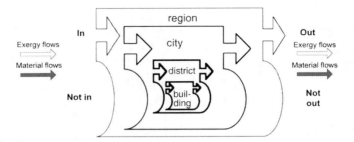

Fig. 11.2 Ecodevice model: general strategy to increase the sustainability of systems (Based on Tjallingii 1996: 197)

This model leads to two strategies for a sustainable urban area:

- Close and optimize cycles and chains within the systems and between different scales in order to decrease as much as possible materials and exergy[2] flows in the environment.
- Look for solutions that do not use finite resources. This may range from putting on a sweater when it is cold instead of turning the thermostat higher, to insulating buildings or using light construction methods (like using load-bearing columns instead of load-bearing walls) or building flexible buildings that can be adapted to the changed needs of the user without demolishing it.

11.2.2 The Three Steps Strategy

The three steps strategy, developed by Duijvestein and others (Duijvestein 1993, Hendriks 2001; Rovers 2003–oral communication; Brouwers and Entrop 2005) in the 1980s and nowadays widely accepted, is based on the Ecodevice model.

The aim of the Three Steps Strategy is to limit the inflow and outflow of resources and to retain for a longer time the incoming flows within the system (Hendriks 2001). Three steps must be followed:

1. Reduce incoming and outgoing flows,
2. Use renewable or infinite sources, and
3. Use finite resources as efficiently and wisely as possible.

The Three Steps Strategy therefore introduces a prioritization of measures that leads to maximum environmental benefits. This is a way to achieve sustainable chain management.[3] The effect of step 1 is to reduce the demand for energy, materials or

[2]Exergy is the quality of energy, see Sect. 5.5.3 for a definition.

[3]Sustainable chain management outlines the ecological, economic and social impacts that occur during the life cycle of a product and focuses on measures to improve the sustainability of the product (Verhagen 2004).

water and to reduce emissions and waste. Step 2 affects the supply side by ensuring that energy, material or water are supplied from renewable sources. Finally step 3 accounts for current practical limitations (e.g., costs and availability) by stating that if it is not possible to use only renewable and infinite sources, the finite sources should be used as efficiently as possible. The three steps strategy is worked out in next sections for energy, material and water flows.

11.2.2.1 The Three Steps Strategy for Energy Flows

The first step of the strategy is about reducing the energy demand. The second step refers to the primary energy use and the last step is about using an energy conversion process that is as efficient as possible when non-renewable resources are used. For more information, see Chap. 5.

1. Reduce the energy demand
2. Use renewable energy
3. Use efficiently energy from fossil fuels

A decrease of the energy demand in the built environment may be achieved under certain conditions by insulating the building, using high efficiency glazing, and diverse other measures described in Sect. 5.3.7.4. Note that the use of waste heat flows within a system can also be used to reduce the energy demand (e.g., mechanical ventilation with heat recovery reduces the heating demand of buildings).

Renewable energy systems are described extensively in Sect. 5.6. Considering the efficient use of fossil fuels, it is important to use systems with an as high as possible efficiency (see Sect. 5.6.11), but also to use waste heat from other (industrial) processes as much as possible. The use of heat produced by cogeneration power plants in district heating is a good example of the reuse of waste heat.

11.2.2.2 The Three Steps Strategy for Material Flows

The Three Steps Strategy for material flows can be formulated as follows:

1. Limit the use of materials (dematerialization)
2. Use renewable, or recovered materials
3. Use materials with low environmental impacts

Complementary information can be found in Chap. 6.

Step 1: Dematerialization

Dematerialization can be achieved in two main ways:

- By lengthening the service life of materials, components and buildings,
- By using light construction methods.

Lengthening the service life of materials, components and buildings is about controlling and slowing down their decay process. The longer the service life, the less often materials and components must be replaced by new ones. This way, the use of new materials is avoided. This can be achieved by proper maintenance of buildings (e.g., paint works, cleaning and general maintenance). During design of a building, much attention should be paid to details that will influence the service life and maintenance of building parts. For instance, a wooden window frame exposed to wind and rain demands more frequent painting activities and will show a quicker decay than the same window frame protected by a shade. Generally, the renovation of buildings should be preferred over demolishing and rebuilding new ones because it greatly reduces the use of materials and demolition waste (see Chap. 6).

By making buildings flexible and adaptable, the need to demolish or to refurbish them extensively when they no longer meet current needs is much reduced. Generally, flexibility and adaptability are achieved by a certain degree of over-sizing. Reserving enough space between the load-bearing elements and the floors is essential to make buildings adaptable; think of reusing office buildings as apartments or the opposite. There are also specific types of buildings like hospitals that require frequent redistribution of the spaces. So each space should be dimensioned in such a way that it can accommodate more demanding functions. Flexibility and adaptability can be increased by avoiding the use of load-bearing inner walls and replacing them by load-bearing columns for instance. The lay-out for the electricity, data and telecommunication cables and the water and heating pipes must be well-thought out, too. In a general way, the separation of the building's skeleton and the built-in parts is recommended. Piping and cables laid through walls and floors should be avoided because it makes maintenance and renovation almost impossible without breaking walls and floors. In contrast, cables laid in special trenches and pipes laid in underfloor trenches or hollow floors allow for easy maintenance.

Light construction methods refers to constructions where no load-bearing walls are used, but, for example, steel columns and hollow walls and floors. Such systems may save up to 50% of material weight. Timber-frame building skeletons also fall under light construction systems.

Step 2: Use Renewable or Recovered Materials

Renewable materials are those that can be artificially or naturally replenished at a rate that meets or exceeds the rate of human consumption. Materials that belong to this category are, for instance, (FSC) wood, shells, cotton and wool.

Recovered materials are those that have been reused, recycled or down-cycled after previous use in a different building or industry. Reused materials are those that are used again for the same original purpose with only light processing. There is therefore no extra consumption of resources and the products are not degraded. One example is a door that has been reused, or a window frame. Recycled materials are those that have been reprocessed in order to be used for their original purpose in a new construction, for instance a PVC window frame made of recycled PVC window frames.

Down-cycled materials are those that have been reprocessed in order to be used again for a lower quality purpose, for example, iron from concrete structures that can be recycled and used for hinges but cannot be used for structural elements (Guerra Santin 2008). It is important to reuse materials at an as high as possible level.

Step 3: Use Materials with Low Environmental Impacts

The environmental performance of materials not only depends on the origin of the material but also on the impact of manufacturing process on the environment. Low impact materials are those that have a low impact or no impact at all on the environment during their manufacture. In this way, the contribution to energy and water consumption and emissions is minimal, although the contribution to material depletion may still be significant if the materials are not renewable. Natural materials often require less processing than artificial materials. Less processing leads to less embodied energy and toxicity, and less damage to the environment. The embodied energy of a material refers to the total energy required to produce that material (Jong-Jin and Rigdon 2007). For example, traditional adobe bricks are sun-dried, therefore there are no emissions or consumption of resources during their manufacture. Stone, adobe, earth, sand and pebbles belong to this category when they are not manufactured for construction products like concrete (Guerra Santin 2008).

High impact materials are those whose manufacture requires significant use of resources, high embodied energy and high production of emissions. The materials considered in this category are mainly metals and plastics, due to the high environmental impact that they present in their manufacture. Examples of these materials are: aluminum, wallpaper, copper, iron, textile, zinc, foam, glass, concrete, PVC, steel, gypsum, paint, ceramic, plastic and bitumen.

11.2.2.3 The Three Steps Strategy for Water Flows

When the Three Steps Strategy is applied to water flows, the following steps must be followed:

1. Prevent/reduce the use of water and organize the built environment in such a way that surface water and ground water are not being polluted by contaminants.
2. Separate clean and polluted water flows.
3. Apply waste or sewage water treatment only on the polluted flows.

For complementary information see Chap. 4.

Examples of preventing the use of water are the use of water-saving taps and showers, that may save 50% in comparison to standard equipment, and the use of water-saving or water-free toilets.

Step 2 can be achieved for both incoming and outgoing flows. For incoming flows, separating drinking water flows from other domestic water flows (washing, cleaning up) may be an option although much attention must be paid to potential

health risks by misuse of the other domestic water flows (e.g., by children or people who are unaware of the presence of a double pipe system). For outgoing flows, the separation of the rainwater flow drainage from the polluted domestic water flow drainage is a main issue. As seen in Chap. 4, the use of infiltration and natural filtering by plants is a valuable solution for rain water. This way it does not need to be conveyed through the sewage pipes, where it would be unnecessarily mixed with polluted water and would increase the water flow rates to be handled in the wastewater treatment plant.

Step 3 remains necessary for the polluted streams. The efficiency of a water treatment plant depends mainly on the water flow rate and its quality. Too high flow rates decrease the efficiency of the treatment because water flows quicker through the settling tanks, and therefore less sludge settles and the purification degree of the water is less.

11.2.3 Cradle to Cradle (C2C)

The Cradle-to-Cradle (C2C) approach developed by McDonough and Braungart (2002) is based on closing cycles, in C2C-terms referred to as "waste is food". This approach also directly follows from the Ecodevice model (retaining more within a system and making use of outgoing flows from one system to another, see Fig. 4.2). Products can be categorized as belonging to the biosphere ("natural" products) or belonging to the technosphere (manufactured products). Products that fall under the category biosphere can be put to decompose after their life cycle (see also Fig. 4.1). The products that fall under the category technosphere should be reused or recycled or even up-cycled. The C2C philosophy focuses on material flows and should be carefully applied: when up-cycling, and also when recycling, manufacturing processes are unavoidable, leading to the use of auxiliary materials, additional energy and possibly emissions, that should be taken into account. Strategies related to the C2C approach are for instance "Design for re-use" or "Design for deconstruction".

11.3 Quantitative Assessment Methods

Strategies are needed to give a direction to the design process of buildings and the built environment. A strategy, however, does not result in one set of solutions. Many different solutions may result from one strategy. To determine what solutions are environmentally better, it is necessary to assess them against their level of sustainability. This means that the sustainability of options must be quantified. But how to quantify ecological sustainability?

In the current state of the art, four main quantification methods are used for environmental impact assessment: simple indicators based on the Three Steps Strategy; mass flow analysis and its derivatives; environmental footprint; and finally life cycle assessment (LCA).

11.3.1 Indicators Based on the Three Steps Strategy

The quantification is based on the use of simple indicators, based on the Three Steps Strategy for materials, like low environmental impact materials, high environmental impact materials, renewability, recoverability, recyclability, down-cyclability, and dismantleability of materials and components used. However, the question is on what criteria materials are classified as low or high impact and to what extent materials may be recovered, reused or recycled. Mostly checklists are used. They may be very useful, but keeping these checklists up-to-date and using transparent classification methods are challenging.

11.3.2 Mass Flow Analysis

This method is based on the use of quantities of materials and energy: the fewer kilograms of materials and the fewer megajoules (MJ) of energy are used, the more sustainable the design. This is known as Material Flow Analysis or Input/Output analysis (e.g., Daniels and Moore 2002; Treolar et al. 2000; Yokoyama 2005). The main advantage is the relative simplicity of the method and the fact that it leads to thinking about dematerialization: how to achieve the same function with less materials? This led to developments like the use of steel bearing constructions in combination with cavity floors and walls instead of traditional bearing walls, see Sect. 11.2. The major drawback of this method is that the use a few grams of a harmful or energy intensive material (like steel) may be more detrimental to the environment than the use a few kilograms of a less harmful or energy intensive material, but these considerations are not caught in the analysis. In Sect. 5.6.12, we also saw that 1 MJ of energy may cause very differing environmental impacts, depending on the energy source.

11.3.3 Environmental Footprint

The environmental footprint gives the biologically productive land and water area needed to produce or extract the natural resources needed (plants, mineral resources, animals) to produce materials (including food) and energy (Wackernagel and Rees 1996). One of the greatest advantages of the environmental footprint is that it is a very communicative instrument and a good measure for land use. A major drawback is that it does not cover environmental impacts, like depletion of resources, toxicity or CO_2 emissions. However, the collection of data necessary to calculate the environmental footprint requires an inventory of materials, energy and production processes used, just like in a material flow analysis and an environmental impact assessment.

11.3.4 Life Cycle Assessment (LCA)

Finally, environmental impacts can be quantified by life cycle assessment (LCA) (Guinee 2002; ISO 2006a).

11.3.4.1 Brief Description of the LCA

The impacts of the production, use and disposal of building components on the environment are calculated by first making an inventory of the flows of all substances to and from the environment over the component's complete life cycle. Each substance's potential contribution to environmental impacts is calculated. The complete set of environmental effects is known as the "environmental profile" (e.g., Blom 2010). Future developments in eco-labeling tools will be generally based on LCA considerations. Two examples are the European Eco-Design Directive (2009) and the development of Environmental Product Declarations (EPD) according to international standards (ISO 2006b, 2007).

11.3.4.2 The Life Cycle of Building Components

From cradle to grave, building components pass through different phases: extraction of raw materials, transport to the factory, manufacture to (half-)product, transport to the building site, construction at the building site, operation and maintenance, renovation, demolition and finally waste-processing phase: landfill, incineration, recycling, or direct re-use (Fig. 11.3).

11.3.4.3 Environmental Impact Categories

Indicators for environmental impacts may be endpoint indicators or midpoint indicators (Blom 2010).

Endpoint indicators refer to the three environmental problems threatening the conditions of life: damage to human health, damage to ecosystems, and damage to resource availability. They reveal the "endpoint" of a possible chain of causes and effects. The quantification of these endpoints is subject to high uncertainties, because they result from the effects and interaction of multiple impacts. That is why the preferred method in LCA is to work with so-called midpoint indicators.

Midpoint indicators are a measure for reasonably well understood environmental mechanisms, the so-called impact categories. There are different methods to quantify these impact categories, e.g., the SimaPro 7.2 software provides 20 different methods to choose from, each with its own calculation methods, such as CML, Eco-indicator, ReCiPe, etc. (Pre 2008). In the CML 2000 method, 10 impact categories are used: abiotic depletion, global warming, ozone layer depletion, photochemical oxidation, human toxicity, terrestrial ecotoxicity, freshwater aquatic toxicity, marine aquatic toxicity, acidification and eutrophication. In the new ReCiPe, 18 categories are used (Blom 2010).

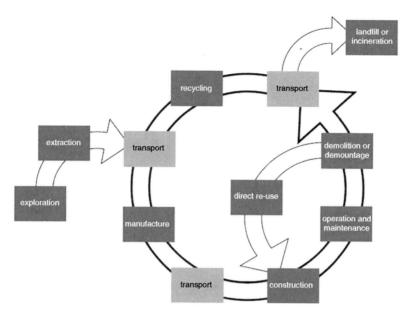

Fig. 11.3 Life cycle phases of building components (Source: Van den Dobbelsteen 2004, 2008. Used with permission)

The impact of each substance flow is calculated by comparing it to the impact of a reference substance in each impact category, then adding the impact of all substances to obtain an impact score. The exact calculation of the environmental impact scores and alternative methods can be found in the Handbook on Life Cycle Assessment (Guinée 2002).

The contribution to an environmental impact category represents a potential effect on the environment. Each particle of substance flows may contribute to several of the considered environmental problems, but generally not at the same time. For example, some ozone-depleting substances are also greenhouse gases. However, ozone layer depletion is a chemical process in which the ozone layer-depleting substance is transformed, after which it is no longer a greenhouse gas. However, the entire substance flow is counted in both environmental impact categories (Blom 2010).

Abiotic depletion, global warming and ozone layer depletion are global impacts. Acidification and photochemical oxidation occur more at regional/local level. Eutrophication and the different toxicity effects are mostly local.

Abiotic Depletion

The impact category abiotic depletion is a measure for the global depletion of natural, non-living resources. The consequences of abiotic resource depletion are that the resources are no longer available and the extraction may cause severe disruptions to ecosystems. The impact score is expressed in kg antimony equivalent (kg Sb eq).

Global Warming

The global warming impact category is a measure for the emission of substances that absorb infrared (IR) heat radiation reflected by the earth surface, resulting in an increase of temperature in the lower atmosphere (greenhouse effect). The emission of these substances may have an adverse effect on the health of ecosystems and humans. The impact score is expressed in kg carbon dioxide (CO_2) equivalents (kg CO_2-eq).

Ozone Layer Depletion

The impact category ozone layer depletion is a measure for the emission of substances that can deplete ozone in the stratosphere. This causes the ozone layer to thin, which will lead to higher fractions of solar UV-B radiation reaching the earth's surface. UV-B radiation is harmful to human health and ecosystems. The impact score is expressed in kg CFC-11 equivalents (kg CFC-11 eq).

Photochemical Oxidation

In contrast with ozone layer depletion in the stratosphere, photochemical oxidation deals with the formation of ozone and other reactive chemicals in the troposphere, near the earth's surface. Photo-oxidants may be formed through photochemical oxidation of volatile organic compounds and carbon monoxide in the presence of ultraviolet light and nitrogen oxides. Photo-oxidant formation is also known as summer smog. It can affect the health of humans and ecosystems and crops may be damaged. The reference substance for photochemical oxidation is ethylene (C_2H_4) and the impact score is expressed in kg C_2H_4 eq.

Human Toxicity

The impact category human toxicity covers the effect of toxic substances on human health. Toxic substances may influence humans health directly by breathing in air bound substances or drinking contaminated water, or indirectly through consumption of plants and animals that have taken up toxins from the environment. The effect of toxins depends on concentration of substances, exposure to them, the risk of exposure, and physical characteristics of people. The reference substance for the ecotoxicity impact categories is 1,4 dichlorobenzene (1,4-DB). The impact score is expressed in kg 1,4-DB eq.

Freshwater Aquatic Ecotoxicity and Terrestrial Ecotoxicity

The freshwater aquatic and terrestrial ecotoxicity impact categories refer to the impact of toxic substances on freshwater and terrestrial (soil) ecosystems. The ecotoxicity impact categories are complicated and subject of ongoing scientific debate, because

toxic substances tend to travel through different types of ecosystems (air, water, soil), spread out and some may degrade. Furthermore, many species are affected in several ways. The impact score is expressed in kg 1,4-DB eq.

Acidification

The acidification impact category is a measure for the local presence of acidic elements in ecosystems. The most important acidic elements are sulfur dioxide, nitrogen oxides and nitrogen-hydrogen compounds. Depending on the ecosystem involved, the consequences of acidification range from degrading building materials, forest decline and fish mortality. The reference substance for this impact category is sulfur dioxide (SO_2). The impact score is expressed in kg SO_2 eq.

Eutrophication

The eutrophication impact category is a measure for substances' potential contribution to the formation of biomass. It covers the impact of local high levels of nutrients in ecosystems, the most important of which are the chemical elements nitrogen and phosphorus coming from fertilizers. A high level of nutrients may cause increased biomass production in aquatic ecosystems, such as algae in water systems, at the expense of other organisms. Consequentially, freshwater may become unsuitable as a source of drinking water and the composition of species in a certain area may change. The reference substance for this impact category is phosphate (PO_4^3). The impact score is expressed in kg PO_4^3 eq.

11.3.4.4 LCA Methodology

A life cycle analysis consists of four steps, described in the ISO 14044 standard (2006); see also short description in Blom (2010).

The first step is to define the goal and scope of the assessment in order to determine the questions the assessment must answer. For instance, is it a comparative analysis of products or a study to improve a production process? During this first step, the functional unit must be determined. The functional unit is a description of the assessment object in measurable units, which allows for comparison of alternatives. The scope of the study determines the processes to be included in the next step, the inventory phase.

The second step is the inventory phase, which involves an inventory of the flows of all substances to and from the functional unit during its life span or the period of interest.

In the third step, the impact assessment, the potential contribution made by each substance to predefined environmental impact categories (see Sect. 11.3.4.3) is calculated. This is done by comparing the impact of a particular substance flow with that of a reference substance for each category.

Once the environmental impacts have been determined, the last step in the assessment is to interpret the results of the calculations and determine the sensitivity of the results to changes in the input variables. The process is iterative: the interpretation phase of the assessment may highlight unanswered questions or inconsistencies in the study which need to be addressed.

11.3.4.5 Considerations with Regard to LCA

Life Cycle Assessment is currently the most complete method to quantify impacts on the environment. Detractors of the method argue that it is too complex and too time consuming to gather accurate data, especially in buildings, which contain hundreds or thousands of components that must be replaced at different moments of the buildings' service life. This results in large uncertainties. Furthermore, the list of environmental effects is not complete and there are differences between the impact assessment methods. For instance, a drawback of the CML method is that it does not include depletion of biotic resources or radiation. In addition, some believe it is too difficult to deal with multiple indicators and to communicate complex results; indicators should be weighted and summed to one environmental indicator. However, it makes more sense to use multi-criteria analysis and multi-objective models than to try to compare apples with oranges. LCA methods are still under development and one can expect a greater degree of completeness and harmonization in the future. Furthermore, one should be aware that the determination of low or high environmental impact materials (Sect. 11.3.1) or mass flow analysis (Sect. 11.3.2) or the determination of the ecological footprint (Sect. 11.3.3) can only be achieved by using LCA-like methods.

11.3.4.6 An Example of the Use of LCA to Determine Best Renovation Alternatives

An example of using LCA to quantify and compare the sustainability of different solutions for electricity production was proposed in Sect. 5.6.12. In the work of Blom (2010), many examples about renovation and maintenance activities can be found. In this section, several energy conservation measures for a renovation of a dwelling are assessed using LCA. A complete analysis of the case can be found in Itard (2009). The analysis was carried out with LCA software EcoQuantum.

Different options for the renovation of a Dutch terraced house built in the 1970s are studied and compared. The non-renovated dwelling is heated by a gas combination boiler with a standard efficiency. Six renovation variants are studied.

- *Variant 1*: the façades (including roofs and ground floor, but excluding windows) are insulated with mineral wool.
- *Variant 2*: the single and double glass windows are replaced by high efficiency insulating glazing.

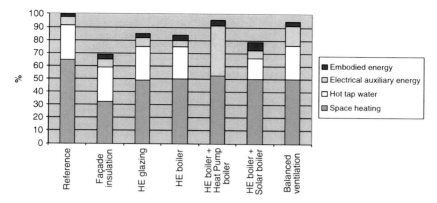

Fig. 11.4 Energy savings for the six variants

- *Variant 3*: the gas combination boiler with a standard efficiency is replaced by a high efficiency gas combination boiler.
- *Variant 4*: the standard gas combination boiler is replaced by a high efficiency gas boiler combined with a heat pump boiler for hot tap water, with a coefficient of performance (COP) of 2.5. The heat source of the heat pump boiler is indoor air and electricity is used to run the heat pump.
- *Variant 5*: the standard gas combination boiler is replaced by a high efficiency gas boiler and by a 2.7 m² solar collector and a stainless steel buffer tank for hot tap water.
- *Variant 6*: the natural ventilation is replaced by a mechanical ventilation system with heat recovery. This system uses electricity to power the ventilators.

The energy savings achieved by each of these variants are shown in Fig. 11.4. They include operational energy for space and hot tap water heating and the energy embodied in the components used for the renovation (energy used during the production process of the component, including extraction of raw materials and transport). Energy is saved in all variants, façade insulation being the most efficient, with savings of more than 30%, and the heat pump boiler and mechanical ventilation systems the less efficient, with savings of 8%.

Figure 11.5 shows the effects of the six variants on each of the environmental impact categories defined in the CML 2000 method. For each environmental impact, the results of the six variants are compared. It can be observed that the impact category "abiotic depletion" is the only one that produces results similar to those obtained for energy savings (Fig. 11.4). For all other impact categories, the results are quite different, especially for variants 4 and 6 that cause a particularly large worsening (up to more than 3 times the environmental effect of the reference) for six of the ten impact categories. This worsening is directly related to the fact that in these variants more electricity is used than in the other variants because of the use of the heat pump boiler (variant 4) and the ventilators (variant 6). The performances of variant 5 (solar boilers) are also disappointing. This is due to the presence of the

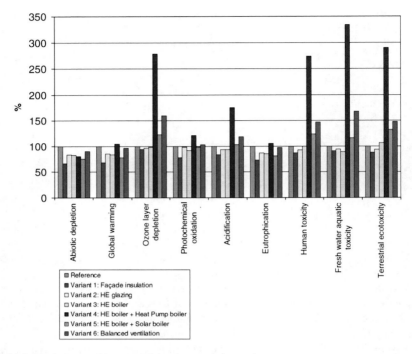

Fig. 11.5 Environmental impacts of the six renovation variants

stainless steel vessel for hot tap water. Does this mean we should not use solar boilers or heat pumps? No, but it does mean that more environmentally friendly materials should be used for the solar boiler vessel and that we should be careful when switching from gas-powered appliances to electricity-powered appliances when the electricity mix is not sustainable (see also Chap. 5.6.12).

11.4 Qualitative Assessment Methods

A quantitative assessment is not always possible within the design process of a building or an urban area, because the expertise to conduct such assessments is not present in the design team, or because it is too time consuming or too expensive. For this reason, qualitative assessment tools are commonly used instead of quantitative tools. These qualitative tools are also often referred as environmental labeling or rating tools, although a labeling tool may also be quantitative.

Qualitative assessment tools have mostly a broad scope and are usually based on simple check lists reflecting what is believed to be current best practices. Most labeling systems award points for the achievement of various specific requirements.

There are many labeling tools for buildings around the world, the most popular ones are: BREEAM (UK), LEED (North America), GREENSTAR (Australia), GPR, DCBA (The Netherlands), DGNB (Germany), CASBEE (Japan), HQE (France) and SB-tool, developed by an international team. Some of these tools are partly based on calculations, measurements of energy performance and emissions and the others are based on more subjective points-based system. There is competition between the different sustainability assessment tools. First of all, it is a relatively recent market and all the proponents want their tool to be the most popular one. Some tools such as SB-tool, BREEAM and LEED are trying to be as flexible as possible by creating many different variations adapted to different requirements, so that they can be used for a variety of buildings and in different settings. In many cases, tool-builders have introduced variations depending on the country in which they are used. Many other regional or national methods are also used; see also Chap. 6. In the next section, a few of these tools are briefly described to illustrate the diverse possibilities and Sect. 11.4.4 gives a comparison of LEED, BREEAM and GPR in order to familiarize the reader with the large differences in the approaches used in different tools.

11.4.1 BREEAM

BREEAM results from the UK Code for Sustainable Homes, which has been mandatory since May 2008 and represents a national standard. The Code measures the sustainability of a home against design categories, rating the "whole home" as a complete package. The Code uses a 1–6 star rating system to communicate the overall sustainability performance of a new home; and it has been extended to non-residential buildings.

The BREEAM assessment tool calculates an environmental rating by awarding points/credits, for meeting the requirements of a series of criteria. Each of the criteria is usually worth a single credit except where there is a large variation in the performance of buildings which meet the requirements of the criteria. For example, reduction of CO_2 emissions is assigned credits awarded on a scale which runs from one credit for a building just above the minimum level required to meet UK Building Regulations, up to 15 credits for a building which has net carbon emissions of zero. The criteria are grouped into issue categories (Energy, Water, Materials etc., see Table 11.1). Each of these environmental issue categories is weighted according to the perceived importance of the environmental issues that the section aims to address. The weightings are applied to the percentage score for each issue category. Once added together this gives the environmental score. The BREEAM rating is then awarded based on the score achieved.

There is some slight variation between the rating bands for each version but the majority of ratings are awarded on the following scale: Unclassified (<30%), Pass (≥30%), Good (≥45%), Very Good (≥55%), Excellent (≥70%), and Outstanding (≥85%) (Casas 2010).

302 L. Itard

Table 11.1 Comparison of LEED, BREEAM, SB Tool and GPR

LEED	BREEAM	SB Tool	GPR
		Social and economic aspects	
		Social aspects	
		Cost and economics	
		Cultural and perceptual aspects	
		Culture and heritage	
		Perceptual	
		Site selection, project planning and development	
		Site selection, project planning	
		Urban design and site development	
Sustainable sites (14 points, 16.4% of total rate)	**Ecology (12% of total rate)**		
Construction activity pollution prevention plan (required)	Ecological value of site		
Site selection	Ecological enhancement		
Development density and community connectivity	Protection of ecological features		
Brownfield redevelopment	Change in ecological value of site		
Alternative transportation availability	Building footprint		
Reduced site disturbance			
Stormwater management			
Reduce heat islands			
Light pollution reduction			
Water efficiency (5 points, 5.8% of total rate)	**Water (9%)**		
Water efficient landscaping	Indoor potable water use		
Innovative wastewater technologies	External water use		
Water use reduction	**Surface water run-off (2.2%)**		
	Management of surface water run-off from developments		
	Flood risk		

Energy and atmosphere (17 points, 20% of total rate)	Energy and CO$_2$ emissions (36.4%)	Energy and resource consumption	Energy
Fundamental commissioning (required)	Dwelling emission rate	Total life cycle non-renewable energy	Building physics & HVAC equipment (EPC)
Minimum (code) energy performance (required)	Building fabric	Electrical peak demand for facility operations	Saving measures
Fundamental refrigerant management (required)	Internal lighting	Renewable energy	Renewable energy
Optimize energy performance by 14% (new) or 7% (existing) buildings	Drying space	Materials	
Energy optimization	Energy-labeled white goods	Potable water	
On-site renewable energy	External lighting		
Ozone depletion	Low or zero carbon (LZC) energy technologies		
Measurement and verification	Cycle storage		
Green power	Home office		
Materials and resources (13 points, 15.2% of total rate)	**Materials (7.2%)**		**Environment**
Storage and collection of recyclables (required)	Environmental impact of Materials		Materials
Building reuse	Responsible sourcing of materials – basic building elements		Water used (checklists)
Construction waste reuse or recycling (by weight or volume)	Responsible sourcing of materials – finishing elements		Environmental quality plan
Reuse of existing materials (by cost)			Waste quantities (checklists)
Recycled content			
Use of local materials			
Rapidly renewable materials			
Certified Wood			

(continued)

Table 11.1 (continued)

LEED	BREEAM	SB Tool	GPR
Indoor environmental quality (15 points, 17.6% of total rate)	**Health and well-being (14.0%)**	**Indoor environmental quality**	**Health (check list)**
Minimum indoor air quality (required)	Day lighting	Indoor air quality	Indoor air quality
Environmental tobacco smoke control (required)	Sound insulation	Ventilation	
Outdoor air delivery monitoring	Private space	Air temperature and relative humidity	Thermal comfort
Increased ventilation	Lifetime homes	Day lighting and illumination	Light and visual comfort
Construction indoor air quality management		Noise and acoustics	Noise
Indoor chemical and pollutant source control			
Controllability of systems			
Thermal comfort			
Daylight and views			
Innovation and design process (5 points, 5.8% of total rate)	**Waste (6.4%)**		
	Storage of non-recyclable waste and recyclable household waste		
	Construction site waste management		
	Composting		
	Pollution (2.8%)	**Environmental loadings**	
	Global warming potential (GWP) of insulation materials	Greenhouse gas emissions	

NOx emissions
Other atmospheric emissions
Solid wastes
Rain water, storm water and wastewater
Impacts on site
Other local and regional impacts

Service quality
Safety and security during operations
Functionality and efficiency
Controllability
Flexibility and adaptability
Commissioning of facility systems
Maintenance of operation performance

Quality of use
accessibility

Social security

Management (10%)
Home user guide

Considerate constructors scheme
Construction site impacts
Security

Future value
Flexibility

11.4.2 LEED

The Leadership in Energy and Environmental Design (LEED) Green Building Rating System, developed by the U.S. Green Building Council provides a suite of standards for environmentally sustainable construction. LEED uses an assessment method based on BREEAM. LEED evaluation is based on various rating systems, for new and existing buildings. To maintain LEED for Existing Buildings certification, a re-certification application needs to be filed at least once every 5 years. LEED for Existing Buildings re-certification applications can be filed as often as once per year. Annual re-certification allows building owners, managers and occupants to have the ability to incorporate LEED for Existing Buildings into annual performance reviews.

The grading system is as follows: No rating (39 points or less), Certified (40–49 points), Silver (50–69 points), Gold (70–79 points, Platinum (80 points or more).

The rating system addresses five major areas: sustainable site, water efficiency, energy and atmosphere, materials and resources, indoor environmental quality, innovation in design and regional priority (Casas 2010; Majcen 2009).

11.4.3 SB TOOL

In both tools described above, some issues were awarded more points than others (for example, weight of water efficiency is less than weight of energy efficiency). Those tools thus predefine the weights of environmental impacts. The advantage of such systems is simplicity, but the disadvantage is that the weightings have a local character often only valid for a specific location. The tool, however, is used for many other locations, for which the weighting factors used may be unsuitable.

SBTool, previously known as GBTool, is a comprehensive assessment tool, developed for the biannual international Green Building Challenge. The SBTool system is a rating framework or toolbox, designed to allow countries to design their own locally relevant rating system so one can calibrate it according to one's own needs.

11.4.4 CASBEE

CASBEE was developed to follow the architectural design process, starting from the pre-design stage and continuing through design and post-design stages. CASBEE is composed of four assessment tools corresponding to the building lifecycle: Pre-design, New Construction, Existing Building and Renovation. Each tool is intended for a separate purpose and target user, and is designed to accommodate a wide range of building functions (offices, schools, apartments, etc.).

CASBEE covers the following four assessment fields: energy efficiency, resource efficiency, local environment and indoor environment. The assessment categories contained within these four fields are classified into qualities Q and loads L. Q is further divided into three items: Indoor environment, Quality of services and Outdoor environment on site. Similarly, L is divided into Energy, Resources & Materials and Off-site Environment. The Building Environmental Efficiency (BEE) is calculated as the ratio of Q by L. BEE values are represented on a graph by plotting L on the x axis and Q on the y axis. The higher the Q value and the lower the L value, the steeper the gradient and the more sustainable is the building. Using this approach, it becomes possible to graphically present the results of building environmental assessments using areas bounded by these gradients .The different labels are class C (poor), class B⁻, class B⁺, class A, and class S (excellent), in order of increasing BEE value.

11.4.5 Comparison of a Few Tools

Table 11.1 give a comparison of the different aspects weighted in four different rating tools: LEED, BREEAM, SB-tool and GPR, as an illustration of the diversity of approaches.

It is clear from this Table that many differing approaches are used, which makes comparison between tools difficult and shows that labels obtained with one tool cannot easily be translated to another tool. International comparison of buildings is therefore not straightforward.

11.5 Design Methods for Integrated Design

The design of buildings and the built environment is a complex decision-making process, which involves many actors performing different tasks and having diverse points of view. The actors concerned have often conflicting expectations, background and foci. Urban design consists mostly of the following phases:

- The Vision Plan, which is the beginning of any urban planning process, decides on general development of a particular area.
- Land-use and Zoning Plans are the official long-term plans for sustainable development of a municipality. They define the planned land use and the allowed future developments.
- The Master Plan is a large-scale plan that shows the future shaping of the area emphasizing the important spatial relationships. It is a sketch plan and usually altered in gradual steps. It also gives the social and economic character of the design.

- The Urban Plan is the detailed plan for the development of an area. It is often a collection of sketches and description in a real scale plan, making distinctively clear what should happen in the area.
- The Specialization Urban Plan indicates the functions and the detailed volumetric structure of the buildings.
- The Architectonic-quality plan shows architectural aspects and form and shape of the buildings. It represents the architectural aspiration of the project area as when implemented. Details such as window openings, doors, facades, etc. are clearly represented.

Actors involved in each of those phases are quite different. While in the first three phases more urban planners and local authorities are involved, in the last three phases architects and citizens are more prominent. From the moment a specific building is designed, three additional steps must be added:

- The building's master plan, presenting general ideas and possible concepts for the building.
- The preliminary design, in which one or two concepts are worked out on feasibility aspects.
- The definitive design in which the chosen solution is technically worked out. This definitive design will result in the specification of all components, materials and costs.

The actors in urban design and planning can generally be subdivided in two large groups with respect to their involvement in the design process:

- Design Professionals: urban planners in municipalities, private architecture and urban design firms, technical experts (e.g., internal departments, project developers, and construction firms, building physics and HVAC consultants, energy consultants, and energy companies).
- Non-design Professionals: the municipality, politicians, citizens.

Setting clear sustainability targets at the start of a project is a precondition for sustainable design. In addition, the involved actors must develop skills to work together towards an integrated design. This is necessary because choices in an early design phases determine the possibilities in a later design phase, and choices in one discipline may affect decisions in other disciplines; see also Chap. 10.

Labeling and rating schemes described in Sect. 11.4.3 may help in setting clear sustainability targets. For instance, one can decide on achieving a building with a platinum label in LEED or label Excellent in CASBEE. This is a clear aim. However, sustainability cannot be achieved by summing measures that are not consistent with each other and will not form an integrated whole. Rating methods are useful to set targets and to evaluate designs, but they cannot support the production of an integrated design: this is the task of the design team, with all its different experts.

The so-called DCBA method (Aalbers et al. 2001) can also be used to set sustainability targets. The DCBA method, also called the four-variant method, entails four levels of sustainability:

- D: The normal situation, where there is no environmental concern at all.
- C: Corrected normal consumption, where the environment is taken into account.
- B: Restrict damage to a minimum, taking the environment as the point of departure.
- A: The absolute best situation, where maximum sustainability is reached as regards to a particular aspect.

The DCBA method can help the designer in a structured manner to deal with the numerous possibilities he has. In consultation with the whole building team, target levels are laid down per subject. Using the checklist, one can verify per phase which measures are applicable in that phase. In the preliminary design, for instance, there are not yet very many measures to take, but the measures that are taken do have a considerable impact on the use of materials and energy in the following phases. By selecting the measures for the pre-design only, one can ensure that the project has sufficient potential to become a sustainable project. However, this is no guarantee of a good result in the following phases. For instance, one can take into account the compactness of the building in the draft design and, this way, score good marks, but if the final design does not provide for sufficient insulation, one will lose marks there and the level of sustainability will go down.

It is therefore clear that multi-stakeholder design methods using collaborative strategies and interdisciplinary approaches are needed to achieve sustainability (Robinson 2004). This is treated more in detail in Chap. 14. An interesting actual development is the use of morphological overviews and methodical design to achieve a sustainable integrated design (Zeiler et al. 2007; Savanovic 2009).

This method helps building teams by decision-making throughout the process by means of workshops. The first step in the method is to record and structure the design team's interpretation of the design task, resulting in a dynamic list of functions and aspects. The simultaneous generation of sub-solutions takes place based on individual disciplines in order to result in an overview of the design team's knowledge. This process is assisted by morphological charts structuring the problem and showing influences between different elements of the design. The morphological overviews represent a transparent record of the design process, which external parties can refer to in order to determine whether all necessary functions and aspects are adequately addressed. The last step of the method concerns the combination of generated sub-solutions, resulting in redesigns, and/or transformation of generated sub-solutions, resulting in new integrated concepts (Savanovic 2009).

Questions

1. What is the Three Step Strategy and how does it relate to the Ecodevice model?
2. What is the difference between endpoint indicators and midpoint indicators? Name at least 6 midpoint indicators.
3. Which steps must be followed when carrying out a life cycle analysis?
4. Name a few reasons why a qualitative environmental analysis may be preferred on a quantitative one.
5. Name two important aspects of an integrated design process.

Acknowledgments With thanks to A. van den Dobbelsteen and I. Blom who provided data for Sect. 11.3.4 and D. Majcen and M. Casas who provided data for Sect. 11.4.

References

Aalbers K, Duijvestein C, van der Wagt M (2001) DCBA-kwartet Duurzaam Bouwen: duurzame ideeën volgens de viervarianten-methode. BOOM/SOM, Faculty of Architecture, Delft University of Technology, Nationaal DuBo Centrum, Rotterdam, Aug 2001, ISBN 90-75365-45-4

Blom I (2010) Environmental impacts during the operational phase of residential buildings. Thesis Delft University of Technology, IOS Press, Amsterdam

Brouwers HJH, Entrop AG (2005) New triplet visions on sustainable building. In: Proceedings of the World sustainable building conference, Tokyo, 27–29 Sept 2005, pp 4330–4335

Casas M (2010) Reaching a higher level of sustainability: a new generation of green buildings. Master thesis, Faculty of Civil Engineering, Delft University of Technology, Delft

Daniels PL, Moore S (2002) Approaches for quantifying the metabolism of physical economies, part I: methodological overview. J Ind Ecol 5(4):69–93

Duijvestein CAJ (1993) Ecologisch Bouwen 3.0, SOM, Faculty of Architecture, Delft University of Technology, Delft

Guerra Santin O (2008) Environmental indicators for building design: development and application on Mexican dwellings. Delft University Press (IOS), Delft

Guinée JB (2002) Handbook on life cycle assessment – operational guide to the ISO standards, eco-efficiency in industry and science. Kluwer, Dordrecht

Hendriks ChF (2001) Sustainable construction. Aeneas, Boxtel, the Netherlands

ISO (2006a) ISO 14044: environmental management – life cycle assessment – requirements and guidelines, International Organization for Standardization, ISO, Geneva, Switzerland

ISO (2006b) ISO 14025, Environmental labels and declarations – Type III environmental declarations – principles and procedures, International Organization for Standardization

ISO (2007) ISO 12930: Sustainability in building construction – Environmental declaration of building products, International Organization for Standardization

Itard L (2009) Embodied and operational energy use of buildings. In: Proceedings CMS conference, CIB, Twente

Jong-Jin K, Rigdon B (2007) Sustainable architecture module: quality, use and example of sustainable building materials, College of Architecture and Urban Planning, University of Michigan, National Pollution Prevention Center for Higher Education, Department of Architecture, University of Idaho. www.umich.edu/nppcpub/. Accessed Mar 2011

Majcen D (2009) Sustainability of building flat roofs: LCA based scenario study. Master thesis, Delft University of Technology, the Netherlands and University of Nova Gorica, Slovenia

McDonough W, Braungart M (2002) Cradle to cradle: remaking the way we make things. North Point Press, a division of Farrar, Straus and Giroux, New York

PRE Consultants (2008) Simapro database manual, methods library. http://www.pre.nl/simapro/impact_assessment_methods.htm. Accessed Mar 2011

Robinson J (2004) Squaring the circle? Some thoughts on the idea of sustainable development. Ecol Econ 48:369–384

Savanovic P (2009) Integral design method in the context of sustainable building design: closing the gap between design theory and practice. Thesis, Eindhoven University of Technology, the Netherlands

Tjallingii SP (1996) Ecological Conditions, strategies and structures in environmental planning. Dissertation, IBN-DLO, Wageningen

Treolar GJ, Love PED, Faniran OO, Iyer-Raniga OO (2000) A hybrid life cycle assessment method for construction. Construct Manage Econ 18:5–9

Van den Dobbelsteen A (2004) The Sustainable Office – an exploration of the potential for factor 20 environmental improvement of office accommodation. Dissertation, Delft University of Technology, Delft

Van den Dobbelsteen A (2008) Apples, oranges & bananas. The gentle art of ecological comparison in the built environment. University of Technology, Faculty of architecture, Delft

Verhagen H (2004) International sustainable chain development, bulletin 360. Series Bulletins of the Royal Tropical Institute, Amsterdam

Wackernagel M, Rees W (1996) Our ecological footprint: reducing human impact on the earth. New Society Publishers, Gabriola Island

Yokoyama K (2005) Resource consumption for buildings based on input-output analysis. In: Proceedings 2005 world sustainable building conference, Tokyo, 27–29 Sept (SB05Tokyo), pp 1227–1234

Zeiler W, van Houten R, Savanović P (2007) Workshops for professionals as basis for students' workshops for sustainable design. www.iasdr2009.org. Accessed Mar 2011

Chapter 12
Climate Integrated Design and Closing Cycles

Solutions for a Sustainable 'Urban Metabolism'

Arjan van Timmeren

Abstract Composite measures of sustainability provide useful insights into the environmental impacts associated with human activities but, in themselves, are not the solutions for abandoning traditional paradigms. Sustainable spatial planning and development must be able to conduct the spatial consequences of changes. Therefore, it is necessary to look beyond boundaries: not only physical boundaries (between areas or countries), but especially boundaries of the various scale levels of solutions, the interrelated networks (energy, water, waste/nutrients), the public space and, particularly, their mutuality. It induces an exploration of the 'urban metabolism' with underlying social needs and the finding of solutions that allow the urban areas and infrastructure to fit the changing objectives, especially sustainability. This chapter promotes sustainable management of the environment and its resources through a renewed focus on existing, mostly ignored resources and local 'quality-cascading', together with niche planning to improve knowledge of the interactions between natural resources, human activities and environmental impact. Especially, the introduction of solutions on an intermediate scale-level of the neighbourhood or urban district offer opportunities. With respect to this, several recent innovative projects will be explained.

12.1 Introduction

Cities are like organisms, sucking in resources and emitting waste. The larger and the more complex they become, the greater the necessity of infrastructures, the greater their dependence on surrounding areas and, last but not least, the greater their vulnerability to change around them. With recent and coming perturbations of

A. van Timmeren (✉)
Delft University of Technology, Delft, The Netherlands
e-mail: A.vanTimmeren@tudelft.nl

E. van Bueren et al. (eds.), *Sustainable Urban Environments: An Ecosystem Approach*,
DOI 10.1007/978-94-007-1294-2_12, © Springer Science+Business Media B.V. 2012

the weather as well as a constantly increasing demand for energy, water and materials, this aspect of vulnerability and dependence is becoming essential for sustainability, as the world may be entering a period of scarcity. Therefore, a renewed look at 'urban metabolism' is necessary.

Sustainable development is a moving target: knowledge, technologies and skills are still being developed every day. At the moment, few integrated theories for achieving sustainability in the built environment can be identified. In fact, sustainability often relies in the management of transitions – a shift to doing things differently – that tends to be specific to each site, rather than a constant recipe or 'one size fits all' type solution. One way of addressing the complexity of the task at hand is through certification standards. Certification programs can cover most of the aspects of urban property development, including setting targets for site decontamination, use of recycled materials, brownfield redevelopment, provision of public transport, options to discourage fossil transport use, energy consumption and efficiency in buildings, water recycling and waste management. As for policies, the best-known directives at the moment concern CO_2 and are energy performance directives. An example of the latter in the Netherlands is the EPC directive. In addition, sustainability approaches often are based on corporate responsibility theories. Some examples here are the 'Triple Bottom Line' approach (John Elkington 1998), the 'Creating Shared Value' strategy by Michael Porter and Mark Kramer (2006), and 'The Natural Step', developed in 1989 by Dr. Karl Henrik Robert (2002).

In recent years, local governments have embarked on a passionate race to achieve climate goals before their neighbour. Largely due to incentives in public funding, cities have appropriated sustainability at large as a standard for competitiveness and means to attract various types of investment. International examples include the 10 Melbourne Principles, the Vancouver Climate Leadership and the Chicago Climate Action Plan. At building and project development levels, the application of building certification programs is getting to the forefront more and more. Their purpose is to encourage measures in all possible areas of sustainable development beyond actual design and construction, from the sourcing of materials to the management of a building (or area) once completed. The UK-based Building Research Establishment (BRE) issued the first BRE Environmental Assessment Method (BREEAM) in 1990. It is based on nine categories, including management, health and well-being and transport. At the same time, the U.S. Green Building Council established the Leadership in Energy and Environmental Design (LEED) program in 1993, issuing its first certification standard in 1998. Since their inception, BREEAM and LEED have become the dominant standards in building certification across the globe. Equivalents often follow a similar score-based rating scheme, including among others: Green Star (Australia), EcoEffects (Sweden), HQE (France), CASBEE (Japan), and VERDE (Spain). (See also Chaps. 6 and 11.)

In this chapter, the approach to sustainable development of urban areas will be illustrated with projects and case studies of attempts to contribute to 'cyclic thinking' and 'cyclic design' in the (actual) built environment with as little as possible extra work, energy and capital as a starting point. The chapter focuses mainly on the second step within the 'Trias Energetica' (or: 'Trias Ecologica' or

'Three Step Strategy'; see also Chap. 11). With respect to the Trias, as previously explained in this book, an improved Trias has been developed in 2009 by the TU Delft for application in practice (REAP method, Municipality of Rotterdam; Dobbelsteen et al. 2009). It is based on the skipping of the final step, while introducing a new in-between step. This 'New Trias' concerns: (1) extending energy, water and material consumption; (2) reusing waste flows; and (3) filling in the remaining demand with renewables and apply a 'waste = food' approach.

This 'New Trias' recognises the importance of the specific site bio-climate- or 'genius-loci'-related qualities and the importance of applying solutions and cycles as close as possible to the source of problems and demands.

Cycles are the key condition for stability in nature to come into existence. For example, life is characterised by a cycle of matter in combination with a flow of energy coming in as sunlight and disappearing as radiation, among other aspects. In a closed system, matter cannot go beyond its boundaries. In principle, energy can go beyond a system's boundaries. A cycle may be part of one or more ecosystems. In this chapter, ecosystems are considered as natural parts of technical systems (e.g. buildings, districts or towns), and in turn they are elements (parts) of larger ecosystems. The basis of the presented elaboration lies in the interaction between integrated ecosystems and ecosystems in which the created technical system performs. A sustainable built environment will not be completely reached until the flows of materials can be closed and the cycle can be managed without too many manoeuvres and losses of energy and other materials.

The scope of the presented solutions is formed by the most important flows related to the first necessities of life, being energy and sanitation, which imply energy, water and waste. Materials and transportation will be addressed. For these flows, attempts are made to reduce the size of these flows and to improve their quality by separating them into the different qualities for reuse (usually called 'saving'), even though saving is perhaps not the right term as is the case in 'energy saving'. However, according to the first law of thermodynamics 'energy cannot be created or destroyed'. Consequently, it is fundamentally incorrect to speak of energy saving, since according to the first main law energy cannot be 'used up' nor can it be 'saved'. Energy consumption can be defined as the reduction of exergy of the energy stored in the primary energy source, as a result of changing it into heat, work or chemical energy by human activities (cf. Chap. 5). The urban environment is a high activity, densely populated area. These areas inevitable require low-entropy concentrated energy supply.

To a certain extent, the quality aspect also applies to water flows. Water can be described as 'the carrier of life'. Water is the largest bulk material turning over throughout the biosphere in a 10-day average cycle time. This hydrological cycle is one of the largest soft energy systems used by all living creatures. In the water cycle, there is an unbreakable relationship between drinking-water and waste water (cf. Chap. 4). The urban water cycle is defined as a cycle, but is not a (necessary closed) cycle: it is a part of larger cycles. Drinking-water and wastewater form the elements of the so-called 'small hydrological cycle' within the 'large hydrological cycle' of vaporisation, precipitation and drainage via ground water and surface water.

Urban areas have big responsibilities within ecosystems, which they could fulfil by establishing a water environment district, also referred to as a 'water metabolic space', where cities take autonomous responsibility within the hydrological cycle, with a clear boundary drawn between the conservation area (natural system) and the controlled area (urban system). This can be called the urban/regional water metabolic system.

In this chapter, for reasons of the importance of the organic part of the solid waste, we adhere to the general definition of sanitation: wastewater systems and solid waste. By now, waste can be considered a product, since it has come to represent an important market value, and there are markets at regional, national and international levels. This applies especially to Europe, and to a lesser extent to the United States, where 'Peak Waste', as for domestic waste, has already been passed (Bardi and Pagani 2007). It shows that urban (solid) waste and existing products, buildings and their materials, are becoming more and more a new source of materials within the increasing necessity of 'Urban Mining'.

12.2 Relevant References of a Sustainable and Interconnected Energy and Sanitation Facility

In general, reference projects of semi-autonomy and quasi-autarky involve individual solutions for the various sub-flows. Additional energy is only (if at all) needed for purification of, e.g., black water or for more pumps, and is generated in a sustainable way. Therefore these projects are to be considered as an integrated and sustainable solution of the flows. However, they cannot be considered as integration based on the *interconnection of the flows*, or as *Climate Integrated Design* with the aim of an *'urban metabolism'*, the focus of this chapter.

In the past few years, various centralised and decentralised projects have been initiated investigating the possibilities of further interconnection and integration of flows and their related systems. As for sanitation-focused projects, often the emphasis is on the recovery of clean water, energy and nutrients from (organic) waste flows. For the decentralised systems, the main emphasis is on the waste(water) cycle, consisting of the long carbon cycle, the water cycle, the mineral cycle and possibly even energy recovery and elaborations of exergy. The centralised solutions still focus on the solid waste and energy flows. In the former, the energy generated is considered as a benefit and is used for optimising the energy balance. Usually, the closing of the energy chain at the site is no aim in itself. The production of food as part of the nutrients cycle is also of importance for achieving autonomy, particularly at smaller scale levels. If food production on site is included in a project, it can recycle part of the clean water and oxygen (or even all of it) needed for "supporting" human life at the same time. In other words, food production can solve the relative discharge of carbon dioxide within the project boundaries.

With regard to the direct link between energy generation, wastewater treatment and – indirectly – food production, there are two reference projects that are

Fig. 12.1 The Vauban project on scales 1,000×1,000 m, 300×300 m, 100×100 m and 30×30 m

considered to be advanced from a viewpoint of environmental technology, town and country planning and social structures: the (North) German district of Flintenbreite in Lübeck and an apartment building in the (South) German district of Vauban in Freiburg.

12.2.1 Living-Working Apartment Building, Vauban, Freiburg (Germany)

The Freiburg district of Vauban in Germany is a project that has been running for some years now and that involves a more integral approach of the development, construction and maintenance of buildings, infrastructures and accompanying services. There is no (full) autarky or autonomy in the sub-flows. Compared to conventional projects, 40% of the electricity and 50% of the (drinking-)water is supplied through the centralised infrastructure. When the development of the district started, inhabitants who were interested in the project were encouraged to gather in groups for submitting plans for unmarked areas in the district (Fig. 12.1).

Along with this participation of citizens, far-reaching environmental requirements at the level of the district were also formulated by the municipality for energy, water and transport and traffic at this stage. The energy standard achieved is 65 kW/m², thus being far below average. Its basis was established by applying the principle of 'Passiv Häuser' (see Chap. 5), in this district connected to a hot-water grid. The measures for the theme of transport focused on making the district a non-traffic area together with well-planned systems of public transport and car-sharing (Panesar and Lange 2001). One of the circa 30 groups of (future) inhabitants has focused on 'Wohnen and Arbeiten' ('Living and working') and built a block of 20 apartments in 1999 (Fig. 12.2). In all, 40 persons are living in the building, including 10 children. The 25 toilets use 1 l of flush water per toilet a time, and 20–40 l of air (for the vacuum system). The average reduction in water consumption in the vacuum system is approximately 35% (Zang 2005).

In addition to the 'usual' energy measures in Vauban, an integrated wastewater system with recovery of nutrients and energy (biogas) was implemented. In the

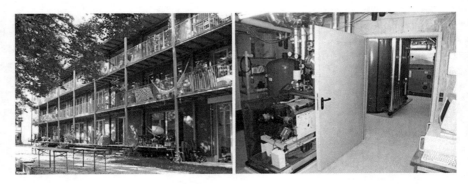

Fig. 12.2 The working/living block of apartments in the district of Vauban, and its service room

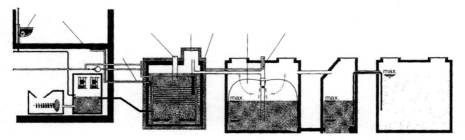

Fig. 12.3 System configuration of the biogas system; from left to right: vacuum toilet and green waste collection; boiler; fermentation tank, biogas (methane) storage (under foil) with liquid sludge below; separated tanks for liquid effluent and sludge (Panesar and Lange 2001)

preparation phase of the project, there was a 'pilot system' for about 6 months. In summer, 100% of the hot water consumption in Vauban is taken care of by a thermal solar-energy installation connected to the hot-water grid. In winter, this is complemented with a co-generator (combined heat – power station on natural gas), that provides for 50% of the electricity consumption at the same time. In addition to this, 10% of the electricity consumption is generated with a photovoltaic system. The remaining 40% of the electricity consumption is still supplied centrally. Because of far-reaching measures (triple glazing, 80% reduction of loss through heat radiation, etc.), the primary electricity consumption has been reduced to 20% of that of conventional houses.

Through a system of vacuum toilets, the black water is connected to a small (6 m³) anaerobic fermenter (digester), a combined gas/substrate depot (3 m³), a manure storage tank (14 m³) and a gas storage facility (9 m³). In the fermenter, the wastewater is turned into methane (for cookery purposes in 16 flats) and substrate, that is used as an agricultural nutrient (fertiliser) in the immediate surroundings (Fig. 12.3). For this purpose, the tank with separated sludge is periodically drained and the sludge is transported to farmland nearby by a truck, where it is applied as soil improvement after further composting.

Fig. 12.4 Flintenbreite project on scales 1,000×1,000 m, 300×300 m, 100×100 m and 30×30 m

In an elaborate analysis of the system and a comparison with conventional systems, it turned out that water consumption had been halved, along with far-reaching emission reductions. It seems that the combination and interconnection of separate treatment of grey and black wastewater and the generation of energy and the reuse of nutrients in agriculture offers an energy-efficient long-term solution to sustainable water management.

12.2.2 Residential Area Flintenbreite, Lübeck (Germany)

In Flintenbreite, the principle of separating the sub-flows at source and sub-flow-dependent treatment has been carried out further. Moreover, the principle of interconnection of the (waste) water, energy and nutrients sub-flow has been applied at a level higher than of block of flats and of house (Fig. 12.4). Flintenbreite covers an area of approximately 5.6 ha (2.77 ha built-up area and 2.87 ha green and water). The original plan consisted of terraced houses, semi-detached houses and blocks of apartments, all together 111 units for approximately 350 persons. Only one-third of the planned amount of houses have been built and about 100 people are living there, while the project is on a hold.

The sanitation system includes a vacuum toilet and transport system similar to the Vauban system. The most important difference is that organic kitchen waste is also used (through a shredder) and introduced into the vacuum system via a rubbish chute and shutter, and that the biogas is not used for cooking purposes but is converted into heat and electricity in a combined heat – power station.

Because of the larger scale of application (more houses), the system is not any longer integrated in the buildings. It was decided to build a connecting, central 'infra-box' situated mainly under the (terraced) houses, through which the various drainpipes and supply-pipes run carrying the waste (water) flows that were separated at source (Fig. 12.5). Eventually, the 'infra-box' leads to a central technical room with the various systems (the combined heat – power station, the vacuum station, the anaerobic fermenter and all control and distribution facilities), which is located in a cellar under the community house. In this way, a traditional lay-out with

Fig. 12.5 The 'infra-box' (*left, middle*) during the construction phase of the project, and the model of the neighbourhood (*right*)

technical infrastructure underneath the streets could be avoided, and so the streets could become less wide and heavy (semi-paved, no major soil improvements, etc.).

The terraced houses have an energy consumption of 48–52 kwh/m², the semi-detached houses 48 kwh/m². The system of vacuum toilets applied here differs from the type of system built in Vauban. Water (0.7 l) and energy consumption is lower due to intermediate storage in a cylinder integrated behind the toilet water reservoir which is not emptied after each flush. The system also saves much water, and waste and nutrients separation is effective.

The percentage of operational problems or malfunctions resulting from the incorrect use of the system is very low. When malfunctions did occur, it turned out that the problems and their causes could be found quite easily due to its convenient size and the accessible design (Wendland and Oldenburg 2003).

12.3 Integrated Concepts: Combined Infrastructural, Spatial and Ecological Functions

More and more often, decentralised concepts of energy flows and (waste) water flows are left visible and sometimes even integrated into traffic rooms or rooms for the occupants. In this respect, water in urban areas can be made attractive from an aesthetic (visual, auditory and even related to touch and/or experience) point of view but also its use within 'healing environments' and as a form of regenerative design. It can be used for improving the comfort and indoor climate when applied properly, along with the original function of storage or purification. This is the case for the supplying flow (e.g. rainwater system) as well as the removing flow (wastewater treatment).

The quality requirements set for the (original) technical room, its materialisation, together with requirements for hygiene and safety, determine the possibilities for

Fig. 12.6 The Kolding project on scales 1,000×1,000 m, 300×300 m, 100×100 m and 30×30 m

integration of the technical system into existing rooms or the dual use of technical rooms with other functions. In case of the energy flow, it may be the integration of heat installations or passive or active solar energy and wind energy applications. Integrated purification installations in shared rooms occur less frequently, but recent examples show the attractive possibilities.

12.3.1 Biovaerk, Kolding (Denmark)

The Biovaerk project in Kolding is a renovation project. As part of a more extensive urban retrofit project based on ecological principles, one building block of 45 families (Fig. 12.6) has decentralised waste water purification running in a glass, pyramid-shaped greenhouse of 400 m² (Fig. 12.7).

Before the urban renewal, there were private gardens in the courtyard of this building block. In consultation with the occupants, slightly more than half of this private area (around 4,000 m²) has been made (semi-)collective. The water purification system was integrated into this collective part. The decentralised water purification installation is partly underground, partly positioned in the glass pyramid. The pyramid in the courtyard is 20×20 m and 12 m high. It has been decided to place the first purification steps, which are more sensitive to their surroundings, underground and to separate them from the follow-up treatment, which is more focused on reuse (in the pyramid).

The water that leaves the pyramid is further purified in an adjacent helophytes filter. The glass pyramid shows the purification and the reuse of wastewater, and occupies a prominent place in the courtyard. On the ground floor of the pyramid, there is a combination of fish, algae and zooplankton; on the other floors, there is a plant nursery. The various parts of the rainwater and wastewater systems have clearly been designed together and form an attractive whole. Doubt may be cast on the (environment – technical) function of the pyramid in the total purification process, as most of the (essential) purification steps are situated outside the pyramid and the energy use of the building is quite heavy. Nevertheless, it adds a new function that is at least as interesting: a reuse phase in the form of a plant nursery.

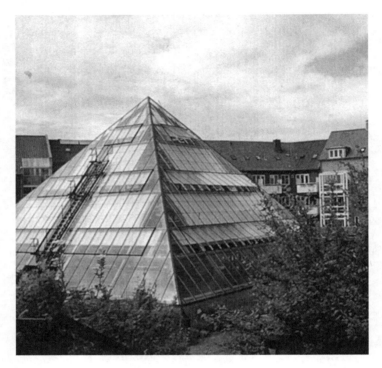

Fig. 12.7 The glass pyramid with (fenced-off) retention pond and helophytes purification

Adaptations in the houses for the (waste) water purification system are restricted to the installation of water-saving measures and a second piping grid for using rainwater as flush water.

12.3.2 Urban Agriculture and Regenerative Systems (Natural Technology) to Sustain the Urban Metabolism: The Zonneterp Project, The Netherlands

All over the world, the function of agricultural areas has changed due to urbanisation. The larger part involved a change from green to red use (urbanisation in the form of buildings and infrastructure), only a small part was changed from agricultural area into 'new' nature (mostly fenced-off). In general, however, urbanisation leads to an increased pressure on the remaining natural areas all over the world, which are needed for agriculture to feed the world. The character of these peri-urban areas changes as a result of expansion and the introduction of other functions, such as greenhouses and recreation. The (agricultural) landscape offers (too) little

resistance to urbanisation in many instances. At the same time, nature offers (too) little resistance to agriculture. Land prices play an important role in this.

The integration of natural (and/or agricultural) characteristics that are typical for the landscape, together with the closure of cycles and the maintenance of decentralised or autonomous systems or structures (whether or not partly based on nature), offers chances for synergy; a principle which goes back to the old mutual relationship between city and hinterland (Röling and Van Timmeren 2005). Within this context, research is carried out more and more frequently into how (urban) systems can be developed which have nature as their basis. The most well-known examples are to be found in the work of the American John Todd , who takes the 'self-regulating, self-maintaining, self-repairing' and even 'self-designing systems' as starting points of – what he calls – the 'ecological design of Living Machines' (Todd and Josephson 1996). The Living Machine is a system of water purification in a (partly) acclimatised room. Usually, Living Machines are glass greenhouses comprising 'solar aquatic systems', where wastewater is purified in one or more parallel systems of closed and open tanks using a combination of techniques. The purification process in the Living Machine is as visible to spectators as possible. The open tanks are planted with a variety of usually attractive plants. Sometimes, there are also fish that are kept or produced there. All around the world, there are already many Living Machines. One of the first and most appealing was the Living Machine in the Ecovillage Findhorn (Scotland). Most Living Machines are (still) applied for specific purposes, such as concentrated wastewater treatment from certain industries.

A changed way of dealing with sustainable energy and ecological sanitation is an important link in the transformation of a society from one that is based on linear connections between sources and sinks to one based on sustainable cycles. Connected solutions of sustainable energy and ecological sanitation offer added value, since a better use of the ecological basis is made possible. Basically, there are two ways of working out ecological sanitation that are of interest for the built-up environment, which are the separation of urine and (anaerobic) composting. The former method offers good perspectives for the reuse of nutrients, the latter for the reuse of nutrients and energy. For both, it is possible to reuse urine, faeces or excreta with little or no water at all.

Ecological sanitation with energy recovery and reuse of nutrients is valuable for several reasons, ranging from a better support of local food production to secondary advantages such as improving the soil structure and retaining water. In order to secure the ecologically safe treatment of excreta and to exploit the ecological potential of waste to a maximum extent, it is important to link this type of solution to energy production, for example, coming from biogas, and, as a result, to integrated food production, either in a direct (in greenhouses) or in an indirect way (integrated urban agriculture within urban settlements).

In the Netherlands, the 'Zonneterp' project (Wortmann and Kruseman 2005) is a recent concept using the principle of urban agriculture and working it out into process optimisation and large-scale application of solar energy and productive use of residual flows. In this concept, housing is linked with greenhouse gardening (Fig. 12.8). Solar heat is extracted in a greenhouse, while the greenhouse uses water

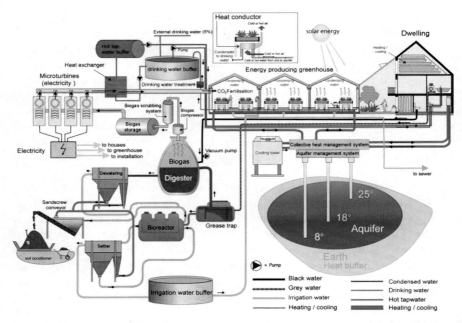

Fig. 12.8 Schematic representation of the 'Zonneterp' project and the cycles within the connected greenhouse and houses. (Wortmann and Kruseman 2005. Used with permission)

that is rich in nutrients, fertile substrate and (during the day) carbon dioxide. The warmth is retained to a maximum by keeping the greenhouse closed. Water from condensation and carbon dioxide must be removed, and the greenhouse must be heated and cooled.

There are four main systems in the 'Zonneterp' project:

1. The heat system, that comprises the storage of the surplus heat and its use for heating the greenhouse and the surrounding houses;
2. The carbon cycle, that is based on biomass (green waste and black water) which is fermented for heat and electricity, and CO_2 fertilisation for the greenhouse at the same time;
3. The water system, that processes the grey water and the fermentation effluent for water for the plants in the greenhouse and reclamation of clean water; and
4. The nutrients system, with nutrients and digestate from the fermenter for growing the plants in the greenhouse.

The project is a clear interpretation of integration between 'open green management' and 'green' agriculture on the one hand and building (houses) on the other. There are some restrictions of use. Peaks in energy consumption must be avoided. Additionally, spraying in the greenhouses is not possible. Various chemical substances must not be used because of the natural processes and the fragile dynamic balance within the cycles. In addition, the concept starts from the application of very low

Fig. 12.9 EVA Lanxmeer project on scales 1,000×1,000 m, 300×300 m, 100×100 m and 30×30 m

temperature heating. Not all houses, installations and constructions are appropriate for this. This results in comfort-restricting aspects (as perceived by users): the houses may be 'open' only to a certain extent because of the necessary balanced ventilation (see also Chaps. 5 and 7).

At first, the size of the 'Zonneterp' concept was made dependent on the economic cost-recovery time of the heat system (1). This has lead to a size of approximately 2 ha of greenhouse for 200 occupants' equivalents (Wortmann and Kruseman 2005). This relatively large use of space resulted from the – additional – choice to close the other three subsystems (2, 3 and 4).

A direct connection and return of biogas extracted to a combined heat – power station for the houses made it possible to reduce the use of hardened space; otherwise, more external biomass would have to be added to the fermenter (cover fermentation) of the concept and the carbon balance would not have been reduced so much. In its present design, the amount of external biomass is as much as 50% and is based on CO_2 from the living cycle.

12.3.3 EVA Lanxmeer, Culemborg, The Netherlands

The urban district EVA Lanxmeer (EVA is a Dutch acronym for Education, Information and Advice) concerns an ecological settlement in the small-scale town of Culemborg. The location is near the central railway station of Culemborg, on 24 ha of agricultural land and some orchards (Fig. 12.9).

This was the first time in the Netherlands that permission was given to build in the vicinity of, and partially even within the protection zone of, a drinking water extraction area. The regional government allowed building at this site on the condition that it would be carefully built according to modern 'deep green' principles (Fig. 12.10).

The district has a low housing density. Because half the district has the status 'water catchment area', and the entire district has been designed in accordance with strict environmental conditions, it was difficult to build compactly. Instead of a high density, the aim here was to create multi-functional spaces, which has already been achieved by building in a water-catchment area where urban construction had previously been forbidden.

Fig. 12.10 Lanxmeer district with orchard, drinking water extraction area, retention ponds and helophytes (*left*) and housing cluster organised around semi-open court yards (*right*); for more information (Dutch only): www.eva-lanxmeer.nl Accessed March 2011

The (future) residents had a central position in the urban design process. This participatory model is conducive to bringing important environmental matters to the fore at an early stage. The structure of the urban plan is mainly based on the record of the existing landscape. Especially, the subterranean structure has been used for the overall plan, the water zoning plan and the ecological plan. In addition, general principles of Permaculture (see also Chap. 2) affected the spatial structure of the plan, especially the green zoning. There is a gradual transition from private, semi-private, and public space towards a more natural landscape in the zone protected by the water board. Together, the green zones form an environment that displays the diversity and resilience of natural ecosystems. The project has been carried out in different small-scale phases and will consist of approximately 250 homes, collective permaculture gardens, business premises and offices. In addition to special functions such as a biological city farm, an education, information and conference centre (EVA Centre) will also be situated in the district, along with a hotel and 'Sustainable Implant' facilities.

12.3.3.1 The Concept of the EVA Centre with Sustainable Implant

At first, the district's energy concept had completely autarkic living as its main principle. During the process of development, this was found to be difficult to achieve within the available budget. Because of the original concept of autarky and, consequently, the requirement for energy being available 'on demand', it was also decided to use chemically bound energy, in the form of biogas at the district level. The production of gas from (green) waste flows in the district has two positive effects: gas becomes available, and there is no need for a connection to and/or upgrading of the (surrounding) public sewage system. For the production processes of the gas, it is important that the percentage of solid substance in the fermenter is as high as possible; the energy content of black water is determined by the solid mass.

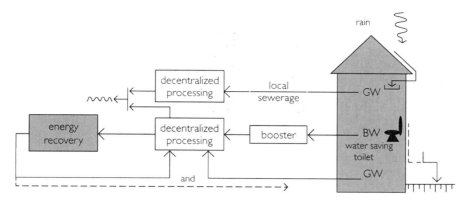

Fig. 12.11 The chosen transportation and processing option for different flows of waste waters (*GW* grey water, *BW* black water, *GW* green/organic domestic waste)

Therefore, it is important to decrease the quantity of flushing water as much as possible. To achieve this, different configurations for the waste (water) infrastructure (and processing) were analysed and assessed by environmental criteria, spatial criteria and social criteria.

Although the option of separated infrastructure systems for grey water and black water, with a vacuum black water sewerage system came out best, the second-best option of using a booster for each eight houses was chosen by the municipality – in its role as project developer (Fig. 12.11). This was mainly due to the strongly phased realisation of the district and the connection to the existing sewerage infrastructure at first.

The combination of black water and green waste offers advantages. Firstly, the amount of biomass available will be higher and therefore the gas proceeds will be larger; secondly, the 'fresh black water' implies a constant supply of fermenting biomass, which is good for the stability of the fermentation process. The fermentation of waste is not the end of the process. Other integral parts of the process include using the gas for energy generation and purifying the liquid effluent of the fermenter to a level that it can be discharged into the surface water without major problems, and processing the sludge without odour nuisance into fertiliser. Because of the E for Education in EVA, a Living Machine was also integrated for the purification of small part of the effluent (of the hotel and spa and leisure facilities). With respect to the necessary exploitation of the system, two additional decentralised concepts for the district were added: a facility for further separating anorganic waste fractions (called 'Retourette'), and the 'E-Fulfilment' for joint e-commerce supply. The total system is called the 'Sustainable Implant' or, in short: SI (Fig 12.12).

The SI has been planned in the transition area between the district and the surrounding (urban) areas, at the same lot where the EVA Centre and the hotel are to be built. The technical installations will be integrated in an architectural solution, in such a manner that they will take up as little space as possible.

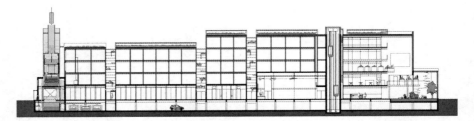

Fig. 12.12 Longitudinal section over the EVA Centre with integrated Sustainable Implant, SI (*left*) and Living Machine integrated in the entrance area (*right*)

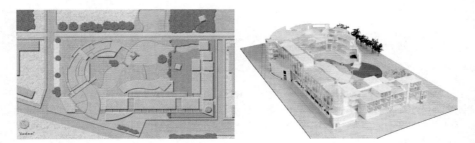

Fig. 12.13 Conceptual plan of the EVA Centre with Sustainable Implant and model of the building

The triad 'City Farm Caetshage', 'Sustainable Implant' (SI) and the 'EVA Centre' will be located at the ends (or beginnings) of the main east/west greenbelt that forms the backbone of the Lanxmeer district (cf. Fig. 12.10). The City Farm is situated in the agricultural area adjacent to the water extraction area. By buying houses, the residents have contributed to the realisation costs. In return, the residents can visit the farm freely, and if desired they can even help with the maintenance of fields. Nevertheless, the City Farm is supposed to work economically independently from the district. However, an important role is set aside for the maintenance aspects and collection of green waste by the city farmer. Together with the green waste of the other green areas of Lanxmeer, the kitchen and green waste of the houses ('garden waste') and Lanxmeer's sewage effluent, this is transported to the SI by the farmer (Fig. 12.13).

As indicated in the previous section, the SI can be divided into two main components. The first main component consists of the anaerobic fermenter, CHP, composting room, Retourette and e-fulfilment miniload (a climate-conditioned locker-based facility where e-deliveries can be dropped for citizens).

This part of the installation is situated in a closed, garage-like volume in the southwest corner of the building complex. On top of this mainly closed volume, the new 'water tower' is situated, with storage of biogas (in inflatable bags) in the centre of the tower and encircled by a transparent retention facility for the water effluent, which is cascading down in five (repeating) levels.

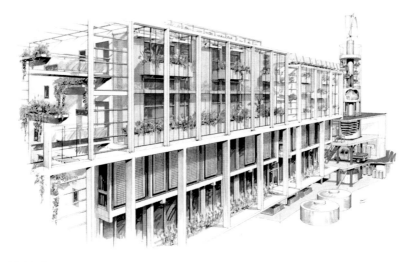

Fig. 12.14 Impression of the Sustainable Implant (Subcomponent I, to the *right*, and sub-component II, in *front*) integrated into the EVA Centre, in the EVA Lanxmeer district, Culemborg

The second main component of the SI consists of the water retention cisterns, a sealed double-skin façade with wastewater treatment of the EVA Centre (Fig. 12.14), the agricultural glasshouses and 'hanging gardens' and the heat recovery installations with seasonal storage in an aquifer.

Three of the installations within this second main component (the façade, the solar-cavity spaces with hanging gardens and the agricultural glasshouses on top of the building) are fully integrated into the design of the EVA Centre. Most visible is the double-skin façade: in fact, it can better be defined as a 'vertical glasshouse'. Inside this glasshouse, wastewater of the EVA Centre is being treated in a Living Machine-like configuration. By making the water treatment stacked, considerable space is won. The façade is situated in a noise nuisance zone due to its location parallel to railways, which supported the decision to also realise a double façade.

Specific local circumstances, such as the ones in Lanxmeer, are often a strong stimulus for the implementation of decentralised systems for closing cycles on a local basis. However, the Sustainable Implant cannot be regarded as a fixed design that can be repeated.

The approach comprises a guiding principle for designing a sustainable solution for the mainly non-sustainable flows in new or existing neighbourhoods. On a neighbourhood level, the SI entails the design of a more sustainable main structure for the transportation of water, nutrients, energy, materials and waste.

Still, a central grid connection will be needed for starting up and back-up purposes. A connection to the centralised sewerage is also required, mainly due to the fact that the first phases of the Lanxmeer district have been realised before the SI

was built. In addition, the process of anaerobic digestion is a continuous process, that actually needs most of the calculated flows to become stable (and efficient).

At the moment, in 2011, the EVA Centre project is on hold. This is due to a change in the local municipality and a changed program for the building site. The aim is to realise an adapted project (function) with attached SI, which in that way will prove the flexibility of the SI concept.

12.3.4 Other Recent Reference Projects

Hammarby Sjostad, Stockholm, Sweden (200 ha Pop. 25,000; 9,000 apartments and 400,000 m² for business, new canals and quays, a water-lock, several bridges and a tramway; completed 1992–2012).

Hammarby Sjostad can be seen as another pioneering project, being one of the first comprehensive sustainable mixed-use districts. The transformation of the former industrial and harbour area around the Hammarby Lake in Stockholm has been one of the most extensive urban development ventures in Europe in the last two decades. It was originally conceived as an Olympic Village (demonstration site) and has, similar to the long maturing time of other innovative ecological settlements (like Lanxmeer, Culemborg, the Netherlands, and Lübeck, Flintenbreite, Germany), matured over 18 years since the first phase was completed.

The project incorporates a set of urban infrastructure systems working at the district scale. Two energy plants, a CHP plant and a thermal power station, deliver district heating, district cooling and electricity. In order to produce energy, the plants receive solar input from building-integrated photovoltaics, and cycle biogas from a local wastewater treatment facility and biofuels from organic waste collected in the neighbourhood. Servicing an average of 1,000 housing units at a time, the scale of the urban networks is consistent with the demand they have to cover. After 15 years of operation, there is proof that planning, education programs for residents and facility sharing (such as water recycling and district heating) are commonsense features that pay for themselves and should be implemented in every urban development project. An important aspect of this success is the partnership with the energy company 'Fortum' and the Stockholm Water Company, which has made the infrastructure exceptions possible via shared investments, and allows users to continuously monitor their own consumption levels, and costs, online.

Major private developers participated actively in the creation of the environmental program, a fact that secured political consensus surrounding the project and made the right-wing parties accept the major sustainability features required. The city then decided to promote open tenders for a variety of development packages, plots and sizes, instead of contracting a single consortium. Although this decision led to increased management complexity, the city was able to reduce risks and lower costs through the practice of competitive bidding among developers and contractors.

It can be considered one of the actual most successful practices in terms of energy, water and waste cycle design, as well as participatory process, for it has

achieved its primary goal of 50% carbon reduction. Stockholm is rated by the World Bank as one of the three most sustainable cities in the world (next to Curitiba, Brazil, cf. Sect. 12.4, and Yokohama, Japan).

Bo01 neighbourhood, Malmö, Sweden (approx. 1,000 apartments and including an iconic high-rise, the 'Turning Torso', in a previously economically dead area; completed 2001).

The concept and ambitions were driven by the City of Malmo and carried out in cooperation with developers. In the planning process, the government met with the 16 developers who would work in the area. Despite being finished in 2001, it is still one of the best case studies for sustainable development.

Bo01 claims '100% local renewable energy'. Space warming is delivered by a neighbourhood heating network (~70°C). The sources of the heat are 15% from 1,400 m^2 of solar thermal collectors, a limestone thermal aquifer, and a heat pump that upgrades a slight energy gradient difference from seawater. The neighbourhood is also connected to the city-wide heat network. Electricity is not actually produced in the neighbourhood (there is only 120 m^2 of solar PV on one building), but is offset by a large wind turbine offshore. It is difficult to produce all the electricity within the neighbourhood, so offsetting with an external source such as a wind turbine may be an option, though it is not completely honest, because the energy problem is removed from the living area, so it is not tangible.

All of the energy infrastructure is owned, operated, and maintained by the E-ON corporation. The City of Malmo and the inhabitants are satisfied with this arrangement because the energy infrastructure is not their responsibility, which was important when a large number of solar collectors simultaneously broke, and E-ON was able to fix them rapidly. Notably, all cooking is with electric stoves and ovens, which is the standard in Sweden.

Stormwater is mitigated by green roofs and green spaces and directed to surface water by an attractive surface drainage system consisting of open concrete gutters beside the streets. From the households, black water and grey water are collected in conventional sewers and processed in the Malmo WWTP. The Malmo WWTP is an advanced treatment centre featuring anaerobic digestion of all sewerage for biogas, which is used in the city bus network.

Paper and plastic are separated into household bins, which are collected by recycling trucks in the neighbourhood. Mixed waste is dropped off within the district into a vacuum shoot which takes it to the edge of the neighbourhood, where it can be picked up by the municipality. Organic waste is disposed of in two ways; either it can dropped in a separate vacuum shoot in the neighbourhood or some dwellings have kitchen waste grinders. In practice, it has been found that the organic waste stream from the street drop-off locations is severely polluted by plastic bags despite education, while the kitchen grinders provide a clean stream. Grinders have been successful in the 147 dwellings of the Turning Torso tower. All the organic waste from the city is taken to the central WWTP for processing into biogas.

A major critique of Bo01 is that it is 'eco-luxury' because it caters exclusively for the wealthy. The City of Malmo has noticed that most of the current inhabitants

do not know about their highly advanced energy system, but just enjoy the prime location next to the harbour and the attractive buildings.

Masdar City, Abu Dhabi, United Arab Emirates (650 ha Pop. 40,000 and 50,000 commuters – first phase under construction).

Although still a project, Masdar City is at the moment one of the most interesting developments and is also one of the largest developments to claim a zero-carbon footprint to date. The goal is to position the United Arab Emirates (UAE) through this project as a global hub in the renewable energy sector. Masdar City is a 'New Town' designed from scratch (by Foster and Partners together with the Masdar Institute of Science and Technology).

Masdar City concerns an integrated concept, also including mobility. Actually, this is the key to the zero-carbon footprint calculation: this calculation is based on an integrated mix of measures including bioclimatic and energy-efficient design, renewable energy sources, waste conversion, carbon capture and, above all, a car-free environment. The combined measures make it possible to reach an estimated 80–100% reduction in GHG emissions, approximating carbon neutrality within the boundaries of the city. Many of the energy-saving benefits are obtained through a combination of centuries-old urban design features: shaded outdoor spaces, streets with correct orientation towards prevailing winds, building walls with appropriate thermal storage capacity, water elements and greenery for thermal buffering and cooling.

An important component of the development is that Masdar provides the first opportunity to evaluate an electric PRT, or Personal Rapid Transit system, using 'Free Range on Grid' technology (FROG, a driverless navigation technology) for the transport of both people and goods. This system will, in principle, be implemented throughout the entire city below street level, similar to a metro system, to ensure operability.

Masdar City has been designed in close cooperation between the design team and government. Also, the Masdar Institute was involved, as well as government-sponsored companies and start-ups. Masdar PV, for example, is the city's on-site manufacturer of photovoltaic modules. These companies expect to capitalise on the demands of the city and the sector and translate them into market-ready technologies.

Especially, the ambitious energy-positive building of the Masdar Headquarters is appealing. It is important to notice that, at the moment, due to the economic crisis, its sustainability targets have been changed (the PRT-system will not be implemented throughout the entire city, so that the city will not be a car-free environment and the target of 100% self-generated renewable energy supply for the entire city is also being questioned).

Regardless of the business case, Masdar's greatest success may be its role as a strategic vehicle for the diversification of the UAE economy into the area of renewable energy. Already today, and while largely unbuilt, Masdar City is the most quoted *green* city in online media, signalling to the success of its visibility and communication strategy.

12.4 Curitiba: Integrating Social and Technical Solutions

Curitiba, capital of the state of Paraná, sometimes also referred to as the ecological capital of Brazil, is a city of approximately 1.8 million inhabitants and is worldwide considered as one of the best examples of consistent and integrated sustainable city planning. This is especially due to the coherence between spatial planning, water management, ecology, and socio-economic policies. The initiator and inspirator of this integrated approach to urban planning was Jaime Lerner, an architect who was mayor for three periods between 1971 and 1993, which assured continuity of planning and implementation. In Curitiba, spatial planning and environmental policies have been connected strategically, and have aimed to also improve the social and economic position of the urban poor living in the favelas (shanty towns). The approach focused on the needs of these citizens, and projects almost started at the level of individuals. The most famous examples concern the system of public transportation and waste management.

In Curitiba, the environmental quality is not a goal in itself, but only a means to create an integral quality and spatial and social conditions for improved liveability and participation. To generate support for (large) projects, visible results at short notice were always part of the approach. The idea behind this is that people will feel respected when they notice a (direct) improvement in their living environment, which encourages them to take responsibility for their living areas, while being proud of tangible results.

The 'Rede Integrada de Transporte' forms the basis of the public transportation system. This system consists entirely of buses. Both the bus network, consisting of reserved lanes, and the spatial constellation of the city, are tuned to each other in an ingenious way, with transport hubs strategically located which prevent passengers travelling to the city centre having to change buses. Together with other low-cost changes, special bus stations and buses have been designed to make the buses easily and quickly accessible, including for disabled people (Fig. 12.15). The designs of the, sometimes bi-articulated, buses have been tuned to different kinds of trips. There are fast lane (Bus Trans Rapid) buses with few stops, which at each stop have excellent connections with so-called tangential buses that connect the different districts. The scheduling is of high frequency and the offered comfort level is high at low cost (1 Real, which equals about 90 Eurocents for unlimited use in the city centre). The result is that people with little money from the 'favelas' can travel throughout almost the entire city. Besides that, approximately 20% of all car-owners use public transportation for inner city mobility.

In the 'favelas', garbage collection is normally not provided (as garbage trucks cannot enter these densely populated squatter areas). With the money that was normally used for the (minimal) cleaning of the favelas, a garbage-exchange project has been set up. Residents can collect (domestic) waste and hand in this waste in the provided garbage bags at collection centres. The municipality registers the amount of bags handed in per person. Once every week, the municipality provides food packages: for every four garbage bags, it hands out one bag of rice, potatoes and

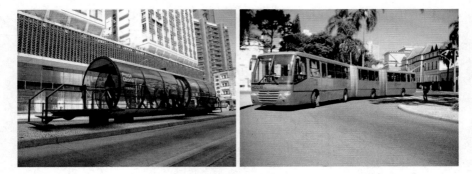

Fig. 12.15 The recognisable bus stops (*left*) in the city (similar to above-ground tube stations –without thresholds between bus and platform) and large fast-lane buses (*right*)

vegetables. In the case of more garbage bags, a bonus is provided (e.g. fruit, eggs, soya milk). Also, bus tickets are provided to make it easier for people to travel to other areas, for example to find a job. Especially, the urban poor in the favelas participate successfully in this garbage exchange project. Not only does it result in cleaner favelas but the health of the people of Curitiba and especially the people living in the favelas has also improved significantly, not just through better nutrition and a cleaner city but also due to the larger amount of public transportation instead of polluting car traffic.

In addition to both these solutions (public transportation and garbage-exchange project), the municipality also takes an active role in the improvement of the 'favelas'. In Curitiba, approximately 200,000–300,000 people live in these areas. A threefold approach has been chosen: sustained moving, tolerating or legalising. The first approach especially is applied to houses in areas that were vulnerable to flooding, pollution, etc. Parts of Curitiba, especially where some of the favelas were located, used to be flooded each year. People in these areas were re-located in affordable houses in 'safe' areas, while in the original areas, the houses were demolished and public parks realised, which provided the city with a water-buffering capacity for periods of heavy rainfall. To save on maintenance costs, the parks were ecologically managed, for example with sheep. This resulted in a sustainable water management system, improved housing conditions and a significant number of square meters of green space for each citizen.

The 'Curitiba solution' consists of many other projects aimed at improving the metabolism of the city and the living conditions of its citizens. Some examples are educational projects in the field of ecology and waste, and green job creation, including a project for small farmers in the city's periphery aiming to integrate the city's food supply. Part of the success is that the projects were relatively low cost. Investments were made especially to improve infrastructures for public transportation, energy and sanitation. Modest but adequate solutions were preferred over more eye-catching solutions. For example, a bus system is much cheaper and easier to realise than a metro system, even though the latter is often preferred by politicians.

In Curitiba, a final step will be to offer low cost building plots to people and to inform them about self-building principles of houses and use of low-cost sustainable materials. This project, unfortunately, is not yet very successful (approximately 3,500 building plots are provided each year, while some 1,500 houses are being built).

12.5 Challenges for Realising a Sustainable Urban Metabolism

To be able to change the built environment in accordance with the principles of sustainable development, there is a need to turn around the inter-relationship between the infrastructures and the societal needs. Decisive aspects in a continuing urbanising, and connected world with crucial dependency on integrated networks, will be the cognitive flexibility of the concept of generation, treatment and transport of the critical flows; the adaptability to alternative technologies; the size of space; and the overall independence and resiliency to failure, inaccurate use and sabotage. Differentiation and urban flexibility (for buildings and infrastructures) are pre-conditions for anticipating long-term uncertainties, due to actual liberalisation processes, rising complexities and even sabotage. Sustainable starting points are suppressed more and more by these changes. However, at the same time, the urban scale especially can begin the necessary process of transformation towards real sustainable development, for it takes the best of two worlds. At present, however, technical infrastructures are still leading to urban development, often even to societal needs. It is important to change the general attitude towards the different components of design, development, use and management of urban areas. A way to do so is the 'interconnection' of different cycles and solutions within cities, and addressed to cities and their hinterland from the point of view of an 'urban metabolism'. The introduction of elaborations of combined urban development and green agriculture gives many opportunities with respect to this.

This may be the basis for new varieties of Permaculture and Urban Agriculture in urbanised areas, and it may help decrease the pressure from other functions (Röling and Timmeren 2005):

- It connects the closing of the energy and water cycles to the essential cycle of nutrients in environmental planning;
- It links up ecological solutions to economic developments;
- It initiates solutions for the increasing problem of (urban sprawl) urbanisation and (agricultural) monocultures;
- It offers instruments for the connection of urbanisation to greenbelt development;
- It contributes to more efficient sanitation systems based on separated waste flows and the accompanying energy and nutrients recycling from cradle to cradle; waste and pollution can be avoided and sustainable energy is relatively cheap and abundant.

There are also various disadvantages and potential problems with respect to interconnection and integration of solutions and smaller scales of implementation. As yet, there are no or few 'economies of scale' in the production of components

and the management of technical units of new decentralised concepts due to the restricted number of pilot projects.

The main problem is that sanitation is largely a social phenomenon, rather than a technical one. Additionally, systems based on industrial ecology, natural technologies and natural processes are particularly vulnerable to incorrect use or sabotage, although possible negative effects will restrict themselves to a relatively small area or a small number of users, because of their decentralised character. Another problem is how reuse of nutrients from black water can be accomplished in practice. This reuse depends on a market for its residues or products (fertiliser, soil enrichment, etc.). Although there is a surplus of manure in many (developed) countries, artificial fertilisers are still much in use. Raw materials, particularly P (phosphorus) and K (potassium) are finite, and the production of artificial fertiliser costs energy and transport. The residuals of black water (compost and urine with a urine-separating toilet, or sludge after treatment in an anaerobic fermenter) have the right composition for use as artificial fertiliser (Werner 2000).

Experiments are being carried out in a number of underdeveloped countries, but also in Sweden, Germany and, recently initiated, the Netherlands. In the context of developed countries, one may wonder if human manure is likely to be used. Also, there may be logistic problems. In this respect, human manure seems interesting only if it is used at the spot where it is produced (an alternative is gathering the sludge and processing it centrally, but one may wonder if the amount of transport needed for it can be justified from a viewpoint of sustainability). Other aspects that may impede such a system and process integration originate from the complex organisation and current regulatory frameworks. Usually, various permits or exemptions will be needed, and, because of the integral nature, one lacking element will obstruct the realisation of the whole system.

Finally, there is the problem that this type of project almost always makes use of systems that depend on (day) light, which implies a relatively large use of space. When linked to other functions, they may get in each other's way, resulting in types of function integration, multiple land use and compact town centres with high densities near green areas. Within such an approach, the most important points of interest and subjects for improvement are the optimisation of daylight use and the possibility of various types of function integration; in short, the spatial planning and organisation of daylight-related areas (on street level, roofs, façades, etc.).

Decentralised systems turn out to be able to gain efficiency advantages as compared to fully centralised systems, particularly through the design of an integrated system of energy generation and supply, and through the connection of this system to a wastewater treatment system coupled to nutrient recycling. In addition, they offer a solution in places where traditional sewers are not possible, because of soil conditions, available budget, water conditions, consequential upgrading of existing infrastructures or related rules and regulations. In general, in the case of the introduction of new sustainable technologies, a protected environment for development and (first years of use and monitoring) is evident. As for system configuration, the choices arise mainly from technical and social optimisation. In fact, the social, or user-related, criteria will be decisive for enduring sustainability.

There are several reasons for the decreasing level of ambition for closing, for instance, the local (waste) water flows in case of larger scales of application. Occupants turn out to have more commitment when systems perform on the scale of a house or apartment, as compared to the scales larger than a district. As scale size increases, the supply and removal of waste (water) and similar flows get more and more anonymous and give fewer possibilities for integration with its source/users (the buildings/houses), with decreasing commitment and certain hygiene risks as a consequence. The introduction of solutions on an intermediate scale-level offers opportunities for elaborations in which (clusters of) buildings or even entire districts can be self-sufficient based on sustainable technologies while addressing best to user-related awareness and participation.

In doing so, the following has proven to be essential:

- Respect all stakeholders, especially (end-)users. This goes for the design and development phases, as well as for the application and use-related phases;
- Take a positive approach when addressing sustainability issues (or as Jaime Lerner states: 'If you predict tragedy, you get tragedy'). A positive approach influences the attitude of people towards the (radical or not) plans and in doing so allows improved level of ambition;
- Make changes simple and realise tangible effects at short notice. All people desire improvement (especially environment-related); however, few people like to change…;
- Take care of an integrated approach; not only for different essential services and 'flows' (water and energy supply, waste management, etc.) but also of policy – legislation, security and responsibilities – and spatial planning, liveability and economical development); and finally,
- The human scale is unique, try to address as much as possible to this scale-level of implementation.

Questions

1. Why is it wrong to speak of an energy cycle? Describe the 'New Trias Energetica'.
2. What are the four main systems in the autarkical 'Zonneterp' project?
3. Name some reasons for the use of an 'infra-box' within the Flintenbreite project (Lübeck, Germany). What is the main condition for the sewerage?
4. What is considered as a weak point of the Kolding project (in Denmark)?
5. Name the key elements of the Curitiba mobility concept with respect to the improvement of chances of the urban poor?

References

Bardi U, Pagani M (2007) Peak minerals. In: The oil drum Europe. http://www.theoildrum.com/node/3086. Accessed Mar 2011
Elkington J (1998) Cannibals with Forks: the triple bottom line of 21st century business. New Society Publishers, Stony Creek

Panesar A, Lange J (2001) Innovative sanitation concept shows way towards sustainable urban development. Experiences from the model project "Wohnen & Arbeiten" in Freiburg, Germany, IWA 2nd international conference on ecological sanitation. www.gtz.de/ecosan/download/Freiburg-Vauban-Apanesar.pdf en http://www.vauban.de/wa

Porter ME, Kramer MR (2006) Strategy and society: the link between competitive advantage and corporate social responsibility. Harvard Business Review 84:78–92

Robèrt KH (2002) The natural step story: seeding a quiet revolution. New Society Publishers, Gabriola Island

Röling LC, Timmeren A van (2005) Close with comfort, printed version of lecture international conference sustainable building (SB05), Tokyo

Todd J, Josephson B (1996) The design of living technologies for waste treatment, Ecological engineering, nr. 6

van den Dobbelsteen A, Doepel D, Tillie N (2009) REAP Rotterdam Energy Approach and Planning: towards CO_2-neutral urban development. Pieter Kers Duurzaam Uitgeven.nl, Rotterdam

Wendland C, Oldenburg M (2003) Operation experiences with a source-separating project, 2nd international symposium on ecological sanitation EcoSan'03, Lübeck

Werner C (2000) A holistic approach to material-flow-management in sanitation, Ecosan (ecological sanitation) conference closing the loop in wastewater management and sanitation, plenary session 2, Bonn

Wortmann EJSA, Kruseman IEL (2005) De Zonneterp – een grootschalig zonproject, InnovatieNetwerk Groene Ruimte en Agrocluster, Project Agropolis, InnovatieNetwerk, Utrecht

Zang V (2005) Inzameling- en transportsystemen voor brongescheiden inzameling, Roediger Vakuum und Haustechnik GmbH, PAO cursusmap Brongescheiden inzameling en behandeling van stedelijk afvalwater, Wageningen/Delft

Further Reading

de Jong TM, Moens MJ, van den Akker C, Steenbergen CM (eds) (2004) Sun wind water earth life and living; legends for design. Faculty of Architecture, Delft University of Technology, Delft

Freeman C (1992) A green techno-economic paradigm for the world economy, lecture given to the Netherlands directorate-general for the environment, Leidschendam, 5th February. Reprinted in The Economics of Hope, Pinter, London

Giradet H (1999) Creating sustainable cities, Schumacher briefings 2. Green books, the Schumacher Society, Bristol

Hasselaar BLH, de Graaf PA, van Timmeren A (2006) Decentralised sanitation within the built environment casu quo integrated in living environments. In: The architectural annual 2005/2006. Delft University of Technology (TUD), Delft

Mollison B (1990) Permaculture: a designers manual. Island press, Tagari Publications, Tyalgum

Rogers R (1997) Cities for a small planet. Faber and Faber, London

Röling N (2000) Gateway to the global garden; Beta/Gamma science for dealing with ecological rationality, Eighth annual Hopper Lecture. University of Guelph, Guelph

Sagoff M (1988) The economy of the earth. Philosophy, Law and the Environment, Cambridge

Sassen S (2004) The global city: New York, London, Tokyo. Princeton University Press, Oxford

Timmeren A van, Kristinsson J (2001) Urban lightness & reduction of infrastructure. The first step in sustainable building, international conference on Passive and Low Energy in Architecture (PLEA01), Florianopolis

Timmeren A van, Sidler D (2005) Decentralised generation of energy and interconnection with treatment of waste and wastewater flows in an urban context, proceedings CISBAT conference, École Polytechnique Fédérale de Lausanne (EPFL), Lausanne

van Timmeren A (2006) Autonomie & Heteronomie. Integratie en verduurzaming van essentiële stromen in de gebouwde omgeving. Eburon Publishers, Delft

van Timmeren A (2007) Waste equals energy: decentralized anaerobic waste treatment and local reuse of return flows, energy and sustainability. WIT Press, Southampton

van Timmeren A, Eble J, Verhaagen H, Kaptein M (2004) The 'Park of the 21st century'; agriculture in the city. In: the sustainable city III: urban regeneration and sustainability. Wessex Institute of Technology, WIT Press, Southampton

Yaneske P (2003) Visions of sustainability, In: Frey HW, The search for a sustainable city. An account of current debate and research, Department of Architecture and Building Science, University of Strathclyde, international conference on Passive and Low Energy Architecture (PLEA04), Eindhoven

Chapter 13
Governance Tools

Lorraine Murphy, Frits Meijer, and Henk Visscher

Abstract The development of sustainable built environments requires a range of factors including tools to create and support favourable conditions. Tools include voluntary agreements, environment management systems, eco-labels and old style regulations undergoing new consultation and implementation arrangements. Tools should cultivate cooperation between actors in governance processes. Governance tools should operate across scales, from neighbourhoods to the international arena, to link and advance actions for sustainable built environments. Central to governance tools should be the aim to protect and support the natural capital on which life systems depend. The defining role of natural laws is often side-lined with the myopic view that primacy should be attached to economic capital. Ecosystems thinking can identify factors and dynamics to be considered in designing and implementing governance tools. Using ecosystems thinking as a lens allows us to appreciate the extent to which the environment has been modified. Furthermore, ecosystems thinking can elucidate whether past and current tools developed to deal with consequences of this modification reflect the complexities and dynamics of the natural and built environment.

13.1 Introduction

Understanding the distinctive environmental, social, economic and political processes of a built environment and the interactions and complexities among these processes are essential to pursuing sustainability. Central to translating the principles of sustainable development into reality are the tools that are developed and implemented

L. Murphy (✉) • F. Meijer • H. Visscher
OTB Research Institute for the Built Environment, Delft University of Technology,
Delft, The Netherlands
e-mail: l.c.murphy@tudelft.nl

E. van Bueren et al. (eds.), *Sustainable Urban Environments: An Ecosystem Approach*,
DOI 10.1007/978-94-007-1294-2_13, © Springer Science+Business Media B.V. 2012

by different actors cooperating in a system of governance. Tools can be developed to protect ecosystems and to adapt to the effects of ecosystem modification. Governance tools can take on a variety of forms, for example:

- International agreements can create formal frameworks and enshrine 'shared responsibility' for dealing with pressing global issues;
- Emission trading schemes can offer industries a competitive means of reducing greenhouse gas emissions;
- Metering household water use can promote sustainable resource use;
- Planning regulations can deflect development from floodplains ensuring that natural processes are not compromised;
- Eco-labels can inform consumers of more sustainable product choices;
- Road charging schemes can reduce the use of private modes of transport in congested and polluted urban centres.

With a myriad of processes interacting in the built environment and a wide range of actors with a variety of roles and motivations, the choice of tool is complex. This choice depends on, among other things, the actors present and the diagnoses of the problem for which a solution is sought. Tools can be discussed in terms of first and second generation (Gunningham 2007) reflecting the political culture in which they were formed (Fiorino 2006). First-generation tools reflect the traditional command and control type regulations of government. Second-generation tools, also termed new environmental policy instruments (Jordan et al. 2003a), include voluntary codes, eco-labels and performance-based standards (Fiorino 2006).

In the following section, the shift from government to governance is discussed to assist with understanding the evolution of tools. In Sect. 13.3, the various spatial scales from which governance tools can emanate are described with examples and notes on how the quality of the tools is assured. In Sect. 13.4, individual tools are described and illustrated with examples. Section 13.5 will include discussion of some themes relating to governance tools in the context of ecosystems thinking. Lastly, in the conclusions, the defining features and challenges of current tools are summarised.

13.2 Government and Governance

Recent decades have witnessed a shift in what is described as the old-fashioned role of government to a process of governance. Government can be perceived as confined to state institutions and politicians where a common tool is command and control regulations. Government engenders a top-down approach to regulation where government departments appear to act unilaterally in the decision-making process. Governance, on the other hand, can be conceptualised as a flexible process with the public, private companies and government institutions involved in the shaping, delivery and appraisal of policies (EC 2001). Governance promises to link across policy fields, institutions and actors to provide joined-up approaches to tackling

problems in a process of horizontal integration (Brown 2009). In addition, governance promotes vertical integration whereby tools and institutions at different scales are linked (Brown 2009). Tools used within a system of governance can be developed and implemented from a bottom-up approach by actors such as non-government organisations (NGOs) and private companies.

Governance can be further subdivided into public governance, private governance and public – private governance. Public governance occurs when authority principally rests with government in developing policies and tools. Private governance exists when authority rests outside the formal political structure (Pattberg 2005) with private actors developing standards and rules that affect the quality of life of the public (Rudder 2008). Public – private governance can be understood as a hybrid form where public and private parties engage in governance together (Engel 2001). Alternatively, a government–governance continuum can be conceptualised where tools exhibiting traits of government and governance, to various degrees, can be distributed (Jordan et al. 2003b)

A number of factors can explain the shift from government to governance tools. A general governance turn was evident in the 1980s, particularly among industrialised countries, when the scope of government responsibility and regulation in areas from welfare to environment was questioned (Jordan et al. 2003b; Golub 1998). Additionally, debates on sustainable development with associated ramifications of seeking balance and understanding dynamics between social, environmental and economic objectives exposed traditional government approaches to regulation as amateurish. Alongside this was a general dissatisfaction with regulations (Fiorino 2006; Jordan et al. 2003a). A pervading view was that traditional regulation was costly in social and economic terms and ineffective in environmental terms (Gunningham et al. 1998). While problems such as point source pollution could be controlled by setting limits and prescribing technology, the same approach was ill equipped to deal with diffuse sources of pollution and complex, systemic problems like biodiversity loss and climate change (cited in Gunningham et al. 1998). Another significant factor was the argument that command and control models of regulation did not encourage innovation or challenge regulated parties to improve performance beyond legal minimum requirements (Fiorino 2006). Second generation tools on the other hand were conceived as representing flexibility and driving innovation more suitable for protecting the sanctity of competition in an era of globalisation.

While governance represents a departure from the concept of government, it does not negate its importance. It is argued that government provides collective stability, security and direction (Sjöberg 1997). In theory, it is governments that hold wide-ranging responsibility and interest in all the issues relevant to the sustainable development debate. Many actors engaged in the process will, by reason of their political agendas or resources, be focused on singular or a limited number of issues. Therefore, governments should act as gatekeepers ensuring that all issues are attended to and all voices are heard. Furthermore, governments are often urged by actors such as environmental groups to enact tougher tools to deal with pressing issues. Appealing to governments in this way recognises the legitimacy they hold

across a range of policy issues and the ability they possess to extend their reach across public and private spheres and governance levels.

It should be recognised that governance is multidimensional and contested (Adger and Jordan 2009) with the uptake of governance tools highly differentiated between countries (Golub 1998). This chapter deals mainly with the empirical aspect of governance but theoretical debate on this subject is expansive (see Adger and Jordan 2009; Jordan 2008). In this chapter, governance is conceptualised as a process operating across scales and including actors at key junctions of policy making such as tool design. Although typically associated with first generation tools regulations are included in this chapter. While regulations typically veer towards the government side of the government – governance continuum, they can exhibit characteristics of governance tools, e.g. self-regulation. Regulations representing such characteristics are therefore included in order to provide a complete picture of governance tools.

13.3 Levels of Governance

The notion of 'shared responsibility' is a common theme in discourse on sustainable development. This notion recognises that actors from local to international level should share the responsibility for their input into problems such as climate change and work in parallel to find solutions. Another common notion is that of 'integration'. Vertical integration denotes a situation whereby tools should operate at various spatial scales but they should be mutually reinforcing, as action at each level should be linked to and support action at another level. The main characteristics of governance at different 'vertical' levels are described below and elucidated by way of examples. In addition, the quality assurance regimes associated with tools at various levels are briefly described.

13.3.1 International

13.3.1.1 Background

As many major sustainability challenges transcend the boundaries of nation states, the need for international collaboration is clear. This co-operation is enshrined in Principle 7 of the Rio Declaration agreed at the United Nation's (UN) 1992 Earth Summit (UNEP 1992). Through co-operation, nations can pool resources, build capacity and share knowledge. The main public governance tools operating at international level are conventions such as treaties and protocols, often termed 'hard law', and resolutions, statements and declarations, often known as 'soft law' (Brady 2005).

One tool at international level with influence on the global built environment is the Agenda 21 declaration. Signed by world leaders after the Rio Earth Summit in 1992,

Box 13.1 Environmental Management Systems

Representatives from industry, standards organisations, environmental groups and government created standards for business and industry in the form of ISO 14001 which was originally publicised at the Rio Earth Summit. ISO 14001 offers a structured framework to identify, evaluate, manage and improve environmental performance. A central feature of EMSs is the focus on continual improvement of environmental performance, an aspect which command and control tools failed to encompass (Sources: Brady 2005; Cascio et al. 1996).

Agenda 21 represented a defining time for the acceptance of sustainable development as a concept to guide the twenty-first century. Agenda 21 contains agreements such as the Convention on Climate Change and the Convention on Biodiversity which recognise the truly global nature of climate change and biodiversity loss, respectively. Emanating from the Convention on Climate Change, the Kyoto Protocol developed binding targets for greenhouse gas emission reductions for the nations that ratified it.

The international stage is also important in the development of second generation tools acting outside or at the margins of public governance. Examples include certification schemes operated by the various National Green Building Councils and the Forest Stewardship Council (FSC) which aim to transform the market towards more sustainable construction and materials respectively. Another example is Environmental Management Systems (EMSs) see Box 13.1, of which ISO 14001 has arguably become the most influential (Fiorino 2006).

13.3.1.2 Quality Assurance

Governance tools originating from the international level are often criticised, as they can be reliant on moral commitment (O'Riordan and Jordan 2000). In the absence of a regulatory authority in the traditional sense, organisations such as the UN are compared to courts of international public opinion and moral persuasion (Canan and Reichman 2002). A significant issue for quality assurance of agreements is the fact that participating governments often verify their own implementation (Hanf 1996).

For many observers, credibility of governance tools is based on enforcement action in cases of non-compliance. In recognition, bespoke compliance arrangements can form part of agreements. The UN touts the Kyoto Protocol as enjoying one of the most rigorous compliance systems (UNFCC 2008). One aspect of compliance control deals with the exceeding of emission reduction targets by parties to the Protocol. If emission targets during the first period are exceeded, this amount, plus a 30% emission deduction commitment, is added during the second period (UNFCC 2008).

Box 13.2 ASEAN Agreement on Transboundary Haze Pollution

Transboundary haze pollution is described as one of the most pressing issues in south-east Asia. Drainage of peatlands, uncontrolled land and forest fires cause massive environmental, economic and social problems. ASEAN member states signed the Agreement on Transboundary Haze Pollution in 2002. The Agreement provides a framework to examine the causes behind haze pollution and develop initiatives to find solutions and share information and resources (Source: ASEAN Secretariat 2006).

In the case of tools such as EMSs, quality can be assured through third party certification. Independent certification can demonstrate a company's commitment to environmental performance. Research identifies mixed results concerning the quality and impact of this tool. A UK study found that EMSs helped firms identify opportunities for improvement, but compliance between companies with and without EMSs displayed little difference (Fiorino 2006). Conversely, a US study found that EMSs led to improved compliance and environmental performance (Fiorino 2006).

13.3.2 Supranational

13.3.2.1 Background

Following the same principles found at international level, countries with shared objectives can address issues collectively at the supranational level. Examples include the Association of Southeast Asian Nations (ASEAN), the African Union (AU) and the European Union (EU). Common tools at this level include agreements and conventions and, for the EU, directives, regulations and decisions.

The supranational level can assume the objectives of international tools affording these with strategic regional direction. This materialises at EU level where the objectives of the Kyoto Protocol are channelled into legislation such as the EU Emissions Trading Scheme. At AU level, the revised African Convention on Nature and Natural Resources was inspired by the Earth Summit and recognises the need for supranational commitment against the degradation of the environment and natural resources (IUCN 2006). Tools are also developed in reaction to specific problems within regions, e.g., a supranational agreement provides a framework for countries in south-east Asia to deal with haze pollution, see Box 13.2 (ASEAN Secretariat 2006).

13.3.2.2 Quality Assurance

As with international tools, tools at supranational level commonly provide a framework, with implementation and enforcement required by member states. Enforcement arrangements are specific to individual organisations, and common mechanisms include naming-and-shaming and sanctions. Compliance issues can revolve around the political will of member states, resources and capacity. In terms of resources, the AU issued a statement endorsing sustainable development but cautioned that many members do not have the capacity to enforce tools such as multi-lateral environmental agreements (AU 2009). This admission emphasises a crucial issue for governance tools. While the supranational level forms an important influence on sustainable built environments, it too depends on actions at lower levels. This point is further illustrated by the European Commission who emphasise that it is principally by the member states, regions and cities that more sustainable urban and land use policies must be created and carried out which are tailored to that specific situation (EC 2004).

13.3.3 National/Federal

13.3.3.1 Background

With influences emanating from international and supranational level, the strength of the national/federal level is often questioned. A suggestion that policy competencies have moved up to international bodies, down to regional organisations and out to third parties suggests a dilution of national/federal power (cited in Jordan 2008). While some powers may have been relinquished, the national/federal level remains important for sustainable built environments. It is at this level that collective direction is provided (Sjöberg 1997), international agreements are accepted, and supranational policies are adopted, and it remains the central level for regulation formulation in many countries. This can also form the arena where information and economic instruments are designed. At this level, common public law tools include acts, decrees, ordinances and regulations covering issues such as air and water quality, planning, building and transport.

While tools emanating from international and supranational level percolate to national/federal level, the opposite is also true. Countries which are front-runners in terms of particular governance tools can influence other countries and supranational organisations, e.g. tradable permits in the U.S. inspired the EU's Emission Trading Scheme (Golub 1998). The national/federal level also witnesses some powerful examples of non-state actors influencing policy processes from a bottom-up approach, as illustrated by the Friends of the Earth (FoE) example in Box 13.3 below.

Box 13.3 Climate Change Act

In 2005, FoE submitted a climate change bill suggesting CO_2 emission cuts of 80% by 2050 to the UK parliament. To create public support, FoE launched the 'The Big Ask' campaign. Major NGOs joined FoE to form the Stop Climate Change Alliance to further galvanise efforts. In 2008, in what is hailed as an unprecedented lobbying campaign, parliament voted in favour of a bill setting legal limits on CO_2 emissions in the UK (Source: FoE 2009).

13.3.3.2 Quality Assurance

At national/federal level, enforcement and quality assurance of tools has often been the preserve of structures and procedures established for this end, e.g. Environmental Protection Agencies. Nonetheless, a host of ministries and administrative bodies at national and sub-national levels can hold responsibilities for tools with overlapping objectives. The tendency to divide tasks among institutions can give rise to fragmented approaches which is a criticism in terms of the overall performance of tools. In response, some governments create structures specifically to assess how policies operate, e.g. the Sustainable Development Commission in the UK. Moreover, NGOs often assume the role of 'auditor' for particular issues.

13.3.4 Subnational

13.3.4.1 Background

Principles negotiated at international level and subsumed in legislation at supranational and national/federal level eventually percolate to state, provincial and local level. At sub-national level, land-use planning and transport are organised in many countries. Strategic planning at these scales in terms of transport infrastructure and energy distribution can determine the sustainability of built environments. Moreover, in federal republics such as the U.S. and Germany, states are the foci of power in terms of developing governance tools. Public governance at these scales can take a strong lead in developing tools, e.g. states in the eastern United States developed a mandatory 'cap and trade' greenhouse gas emission scheme in the absence of federal legislation, see Box 13.4 (Gardner 2008).

Box 13.4 Regional Greenhouse Gas Initiative

Ten north-eastern and mid-Atlantic U.S. states joined forces to form a regional 'cap and trade' (also known as emission trading) scheme known as the Regional Greenhouse Gas Initiative (RGGI). Guided by a common rule, states capped CO_2 emissions from the power sector and committed to a 10% reduction in emissions by 2018. The program is implemented through the regulations of each participating state (Source: RGGI 2009).

Box 13.5 The Green Map System

The Green Map System provides information on aspects of sustainable living from cycle routes to organic food providers. Since 1995, the Green Map System has spread to over 500 urban areas. Volunteers manage the project and central ambitions are to; strengthen local-global sustainability networks; increase demand for healthier and greener choices; and disseminate information (Source: Green Map 2007).

At the local level, the city has emerged as a powerful force in the sustainable built environment debate emphasised by the statement that, 'Cities are becoming the places to deliver new ideas and innovative projects …. Cities are also the public spaces where it is possible to find multicultural, cross-sectoral solutions, where necessary conciliation between private and public interests may be found' (EC 2008). Various governance networks unit cities in action towards common problems, e.g. Cities for Climate Protection (ICLEI 2009). Furthermore, at the local level, bottom-up approaches to creating sustainable built environments outside the realm of public governance can be witnessed. Grassroots efforts such as the Green Map System described in Box 13.5 are represented by self-governing networks of actors and epitomise the slogan 'think global act local'.

13.3.4.2 Quality Assurance

Systems of implementation and enforcement of tools at sub-national level correspond to the variety of tools found. The traditional public law tools at this level can be enforced by provincial or local governments in the form of planning and building control offices. The refinement of governance tools and the move towards a more risk-based approach has witnessed a shift in the way tools are enforced. The onus for proving compliance is placed on the 'regulated' in many countries. Certified actors can therefore act as quasi-enforcement bodies, e.g. in the UK, competent persons can certify certain activities, e.g. boiler installation, instead of householders applying for a building permit (DCLG 2008b).

In terms of tools veering towards the governance side of the spectrum, procedures for implementation are typically bespoke in nature. In terms of Cities for Climate Protection, participating local governments pass a resolution indicating their support (ICLEI 2009). As is the case with all tools, it is action after resolution that determines the actual contribution towards sustainable development. In this regard, research has shown that lack of action can seriously affect the powerful imagery of cities united in pursuit of sustainable development (Murphy 2002).

13.4 Governance Tools

In the previous section, it was demonstrated that the level at which tools are developed can characterise the nature of tools. In the following section, the specifics of first and second generation tools are described. First generation tools such as direct regulations are witnessing a reconfiguration in recognition of the need to simplify, reduce administrative costs associated with implementation and enforcement and adapt to an increasingly sophisticated understanding of the issues facing the built environment. Second generation tools such as voluntary agreements and emissions trading schemes come with the promise of being more flexible, cost effective and more amenable to innovation.

The choice or mix of tools is dependent on political acceptability and existing institutional and legal frameworks (Brady 2005). Neither is tool choice necessarily value free as actors champion particular approaches (Golub 1998). Furthermore, tools are heavily influenced by problem perceptions (Golub 1998) which may differ depending on actors involved or spatial and temporal scales. A mix of tools is the most common approach as combinations seek to offset inherent weaknesses associated with individual tools (Gunningham et al. 1998; Gunningham 2007). In addition, combining tools can advance the objectives of an individual tool; for example, linking an economic tool to regulation can improve acceptance. Tools rarely start from a blank canvas but are introduced to 'brownfield' sites already occupied by tools, programmes and agencies (Rose 2001: 16). Tools need to interact in positive and cost effective ways in such 'crowded' policy contexts (Sorrell 2003).

In the following section, key characteristics and examples of tools are described. A typology based on regulations, economic/market-based tools, agreements and information tools is adopted. In reality, tools do not adhere rigidly to categories but contain elements and perform functions from different typologies. In addition, tools move between the public and private governance realms, for example in the Netherlands, a firm with a certified EMS can be exempt from an environmental permit under certain conditions.

13.4.1 Regulations

While many countries are gripped by deregulation fervour and fully embrace the power of market forces, there are cases when direct intervention remains the preferred option.

This is particularly the case when little flexibility in the nature or timing of an outcome is acceptable (Defra 2002). When scientific certainty and strong public and political opinion are prevalent and a process or product requires prohibition or limitation, a tool with legal grounding and the threat of penalty in times of violation is favoured. Regulatory tools include planning regulations, waste management licences and minimum product standards.

The style and substance of regulations have been subject to change in recent years. Regulations are no longer the sole preserve of government but can involve sophisticated processes of third party consultation, implementation and enforcement. Regulations have evolved from prescriptive requirements to performance-based standards in many countries in an effort to foster innovation and flexibility (Beerepoot 2007). Taking the case of building regulations, prescriptive standards issue requirements for building components, affording designers limited flexibility. Alternatively, performance-based standards state desired outcomes for aspects such as energy performance leaving methods of reaching these to designers.

While regulatory tools have been subject to a revamp, they remain plagued by criticisms. A common citation is that regulations are resource intensive, particularly in terms of enforcement costs (Ürge-Vorsatz et al. 2007). Moreover, poor enforcement of regulations is damaging to credibility. In this regard, recent research in the Netherlands found that energy calculations submitted with a selection of building permit applications were incorrect in 25% of cases while the performance of built houses was found to be unsatisfactory in 47% of homes (cited in Visscher and Meijer 2008). Results such as this point to the importance of adequate and regular systems of monitoring, evaluation and revision of tools, elements of the policy process which are often conspicuous because of their absence.

13.4.1.1 Planning Regulation

As a control on the form and design of the built environment and land use, the planning system is heralded as a pivotal mechanism to achieve social, environmental and economic objectives (Bell and McGillivray 2000). In practice, planning has struggled to balance the three pillars of sustainable development. This is evident with new town developments without essential services, and out of town shopping centres favouring private transport use, pushing built environments further from sustainability ideals. Furthermore, planning regulations have routinely failed to anticipate the cumulative effects of ecosystem modification with development crowding alongside watercourses, exacerbating flooding and eliminating ecological corridors.

Efforts to instil the principles of sustainable development more firmly into planning practice are evident in some countries. For example, at EU level, member states must adhere to Strategic Environmental Assessment (SEA) at the level of development/zoning plans and Environmental Impact Assessment (EIA) at project level in an effort to infuse different decision-making levels with sustainability principles. Furthermore, planning regulations can be used to react to unsustainable development patterns of the past, as is the case with the example in Box 13.6 below.

Box 13.6 Planning Regulation

Paving domestic gardens was traditionally exempt from planning regulation in the UK. The scale of the trend to pave gardens led to biodiversity loss, surface water flooding and pollution which was publicised by third parties such as horticultural societies and wildlife NGOs. In 2008, regulations were changed so that permission is required if over 5 m² of ground surface is to be paved with impermeable material. With application fees at £150, the more sustainable option of using permeable paving, exempt from planning permission, immediately appears the more attractive option with the result that this item of regulation may be self-enforcing (Source: DCLG 2008a; Gray 2007).

13.4.2 Economic Instruments

Tools that rely on financial influence rather than direct regulation are referred to as economic or market-based instruments. Economic tools are perceived to allow greater flexibility of response than direct regulations and are therefore viewed by advocates as more cost effective (Defra 2002). This perception comes from economic theory which suggests that flexible tools allow businesses to improve environmental performance at most benefit and least cost, as in theory they have greater knowledge of their production processes than a regulator (Welch and Hibiki 2002). At the level of the individual, the self-interested rational actor model of human motivation suggests that people will react rationally to price signals (Dobson 2009). Economic instruments include taxes and charges, tax refund schemes, subsidies and tradable permits (cited in EEA 2005).

Economic instruments can be framed in terms of the desired outcome such that taxes can trigger a change in lifestyle while subsidies can assist with the mainstreaming of products deemed to offer societal benefit. Economic tools can have an additional benefit of revenue generation; for example, revenue raised from the London Congestion Charge programme is used to improve transport in the city (TfL 2009).

Various criticisms are associated with individual economic tools as discussed further below. One significant issue is the role of economic tools in creating sustainable built environments in the long term. In this regard, Dobson (2009) stresses that behavioural change lasts as long as the incentives or disincentives with underlying attitudes of companies/individuals unchanged. Another issue is the lack of research on the effects of market-based tools with the result that many advantages are perceived. In this regard, Toke (2008) suggests that market-based tools do not achieve the stature promised in theory. Three types of economic tools: eco-taxes, subsidies and emissions trading, are discussed in more detail below.

Box 13.7 Tax Credits

In a move to promote sustainable buildings, the state of New Mexico in the US provides tax credits to buildings which receive LEED (Leadership in Energy and Environmental Design) certification. LEED is a private governance certification program and the nationally accepted benchmark for the design, construction and operation of green buildings. Tax credits are performance based and therefore depend on the level achieved, i.e. silver, gold or platinum. The state of New Mexico is integrating a public tool with a private tool by pursuing this approach (Source: USGBC 2008).

13.4.2.1 Eco-Taxes and Tax Refunds

Eco-taxes are tools that respond to false market signals by incorporating the often hidden costs of environmental pollution (EEA 1996). Therefore, eco-taxes are said to internalise the external costs of environmental damage (Sunikka 2006) and allow the polluter pays principle to take effect. A market-based instrument such as an eco-tax is viewed by many as providing a stronger incentive than regulation in stimulating more environmentally responsible behaviour and technological innovation (EEA 2005). However, taxes are subject to criticism, particularly if they lead to the further marginalisation of the economically disadvantaged or if they are designed to purely raise revenue. An alternative to the imposition of a tax is the provision of tax credits to reward positive environmental action as described in Box 13.7.

13.4.2.2 Emission Trading

Emission trading is a market-based instrument which aims to control pollution by setting a limit on a substance (e.g. CO_2 emissions) for a certain sector (e.g. industry) with trade possible between participants who exceed the limit and those who emit under the limit. Allowing industries to trade among themselves is viewed to be more cost effective than regulation and more agreeable to innovation (Jordan et al 2003a). Jurisdictions such as the European Union have implemented an emissions scheme as a means towards meeting targets under the Kyoto Protocol. In the case of the EU Emission Trading Scheme, member states assign carbon allowances among the most energy intensive industries relative to each member state's emission reduction target.

The Clean Development Mechanism (CDM) is a feature of the Kyoto Protocol which promotes a form of emissions trading. Under the CDM, flexibility is provided to developed countries in meeting emission reduction targets by allowing investment in projects in developing countries that contribute to emission reduction or removal, see example in Box 13.8. CDM aims to stimulate sustainable development, greenhouse gas emission reductions and affords economic flexibility to developed countries in realising their reduction targets (Jordan et al 2003a).

Box 13.8 CDM Project – Biogas Support Programme

Nepal has witnessed the growth of the biogas sector, a clean and efficient household energy source. Biogas digesters utilise animal waste which produces energy by bacterial action and bio-slurry as waste. The use of animal waste instead of firewood and kerosene displaces CO_2 emissions. Greenhouse gases, methane and nitrous oxide, are reduced by transforming animal waste and using the bio-slurry as fertiliser. Social benefits include quality of life and health improvement for women who are typically responsible for collecting firewood and for cooking (Source: Biogas Sector Partnership 2008).

Emission trading is subject to criticism as the calculation of carbon credits can be problematic and it is viewed as a poor substitute for direct emission reductions (O'Riordan 2000). Another criticism is that projects under CDM are a form of neo-colonialism allowing developed countries to offset much of their pollution in the form of projects sometimes of questionable sustainability qualification (Bullock et al. 2009). An alternative emission trading model, named 'contract and converge', has been put forward by the Global Commons Institute (Porritt 2007). Under such a scheme, developed nations reduce emissions as developing nations produce emissions until per capita emissions converge at the same level (Porritt 2007). Developed nations would purchase carbon credits from developing nations as part of a wider campaign for global economic justice (Porritt 2007).

The application of emissions trading for the public has been researched by some governments (Defra 2008). Under such a scheme, known as personal carbon budgets or personal carbon trading, emitting rights would be distributed among individuals over a certain age (Defra 2008). Allowances could be traded during activity causing emissions with trade possible between those in surplus and deficit credit (Defra 2008). Such schemes remain conceptual due to supposed complexity and political acceptability (Defra 2008).

13.4.2.3 Subsidies

Subsidies act as both direct and indirect financial incentives from public and private sources which lower market prices for consumers of a product or service. Subsides are sometimes called a negative tax and they can assist in the creation of markets and/or stimulate increased diffusion of a product, see Box 13.9. Subsidies can be offered for developments that go beyond regulations therefore stimulating innovation and creating an evidence base for future regulation (Sustainable Energy Ireland 2008). Subsidy programmes can be subtly linked to awareness raising, for example; the increased use of solar panels due to subsidies can increase visibility and dissemination of this technology.

Box 13.9 Green Roof Subsidies

Germany is the traditional vanguard of the green roof industry. Federal laws provide an overall framework for green roof policies with innovative customisation at state and municipal level. Subsidies are typically funded by municipalities and depend on specific municipal objectives. In the case of municipal aims to improve stormwater management, revenue from wastewater taxes can be used to provide subsidies for green roofs. Other municipalities offer indirect subsidies such as discounts on stormwater fees as green roofs are proven to reduce strain on municipal drainage systems (Source: Ngan 2004).

Box 13.10 Corporate Responsibility Reporting

The cosmetics company Natura Cosméticos believes that business growth does not need to entail social and environmental trade-offs. Natura uses initiatives and instruments developed to legitimise the CR process. Global Reporting Initiative (GRI) guidelines are followed, an external auditor verifies the report and data are checked by GRI. Partnerships are formed, e.g. with Global Compact, a UN initiative that brings together companies, workers and civil society, to promote sustainable growth and civic awareness (Source: Natura Cosméticos 2008).

Subsidies attract criticism especially in terms of costs to society (Ürge-Vorsatz et al. 2007). While subsidies can help lower income households, a reoccurring complaint is the 'free rider effect' where subsidies are received by those who would have implemented a measure in the absence of this tool (Ürge-Vorsatz et al. 2007).

13.4.3 Voluntary Agreements

Voluntary agreements (VAs) adopt a variety of guises with subdivision into unilateral commitments, public voluntary schemes and negotiated agreements. Unilateral commitments are developed by a business or association thereof and are characterised by Corporate Responsibility (CR) schemes, see Box 13.10 or Codes of Conduct (cited in Jordan et al. 2003b). Public voluntary schemes are developed by public bodies while negotiated agreements can be formal contracts between third parties and public authorities which can be legally binding (Jordan et al. 2003b). A characteristic of VAs is that parties are bound to conditions by consent (Bell and McGillivray 2000). The threat of regulatory action can, however, encourage involvement (Golub 1998).

VAs vary depending on the context. In the Netherlands, VAs often supplement regulation as legal contracts known as covenants (Glasbergen 1998). In Japan, VAs

arose due to a weak national regulation (Ringquist 1993). As a second generation tool, VAs come with the promise of being less expensive and invasive (Welch and Hibiki 2002). Glasbergen (1998) notes that covenants in the Netherlands changed the relationship between industry and government with industry becoming participants in a search for solutions as opposed to objects of regulation. In addition, VAs offer a long-term perspective which is often lacking from other tools. A benefit of VAs such as CR schemes is that they offer transparency and a platform for third parties to demand more ethical standards from corporations.

VAs receive a share of criticism particularly in terms of effectiveness. An observation is that VAs issue bold promises often associated with inaction and compounded by the absence of penalties (Welch and Hibiki 2002). VAs are viewed by some as representing soft measures which delay the introduction of definite measures (Golub 1998). In addition, reliance on the cooperation of actors and voluntarism can be viewed as a limiting factor (Van Bueren and De Jong 2007). In the case of VAs in the US and Europe, a common criticism is that civil society is excluded from the process (Van Bueren and De Jong 2007) which is not in the spirit of a governance tool. A criticism of CR is that companies only engage in programmes if it makes business sense (Vogel 2005). In this way, CR will not force companies to make socially beneficial decisions that are unprofitable as regulation will (Vogel 2005). CR schemes can also be undermined if the underlying business model remains unsustainable (Porritt 2007) or if corporations self-declare their responsible behaviour.

13.5 Information and Communication Tools

Information provision remains critical for actors to both understand and act on issues relating to sustainable built environments. Improving the environmental awareness of consumers can be viewed as a complement to tools driving market transformation towards more sustainable products (Welch and Hibiki 2002). Tools such as the Toxic Release Inventory in the US keeps local communities informed of activities of industries and have been linked to the improved industrial environmental performance (Fiorino 2006). Information provision through media campaigns can inform citizens of pressing sustainability issues. Communicative instruments are often adopted when it comes to addressing information problems and are generally perceived as supplementary tools to regulation or economic tools (Sunikka 2006). Communication tools take the form of certificates or labels, see Box 13.11.

Like many governance tools, information and communication tools experience a dearth of ex-post analysis. Additionally, analysing the actual long-term effect of information and communication tools is notoriously difficult. Another weakness is that tools rely on environmentally aware consumers yet research indicates widespread confusion about what actions to take and what products to buy (cited in O'Riordan 2009). While there are accreditation procedures attached to labels, there are cases when businesses self-declare products and services to represent certain sustainability criteria. Moreover, labels portraying one particular sustainability aspect can give an incomplete picture sending false or confusing signals to consumers.

> **Box 13.11** Energy Performance Certificates
>
> Energy Performance Certificates (EPCs) are required at the construction, sale and rental of a property by the EU Energy Performance of Buildings Directive. EPCs indicate the energy rating of the building and recommendations for efficiency improvements. The intention is that energy efficient buildings will gain a marketable advantage, stimulating investments in improvements. In many member states, awareness of EPCs and low priority attached to energy concerns have caused this tool to falter. Potential is nonetheless recognised and the strengthening of EPCs is taking place (Source: EC 2003).

13.6 Governance Tools and Sustainable Built Environments

A key interest remains as to how governance tools restore ecological balance and create sustainable built environments. Ecosystems thinking provides a useful lens to view how tools operate and the challenges which they face. Two themes are presented below which explore this further. The first theme relates to the operation of tools in relation to some key principles of ecosystems thinking. The second theme concerns how governance tools reflect the complexity and dynamics of the built and natural environment.

13.6.1 Operation of Governance Tools

The following elements from ecosystems thinking can assist with an understanding of how governance tools should operate:

- Holistic approaches
- Understanding linkages
- Adequate feedback mechanisms
- Adaptive management

In particular, these elements highlight how; governance tools can be weakened by fragmented policy domains, that linkages between tools need to be fully explored and that tools need to be subject to monitoring and evaluation and adapted depending on the results.

Ecosystems thinking emphasises that the essential parts of a system will be understood from looking at the whole (Waltner-Toews et al. 2008). Yet the administration of governance tools can be highly fragmented between and within different authorities, committees and accreditation boards. In reality, no one institution or actor has responsibility for or knowledge of the system as a whole, which presents challenges for the design, operation and evaluation of governance tools.

It is emphasised that tools should act in concert towards shared goals. Under-standing the linkages between tools, actors, and institutions often proves an onerous task with one result being that associating causality with a specific tool is difficult (Weale 2009; Golub 1998). Yet without understanding how tools work together, designing the optimum combination of tools to create synergy and offset the inherent weaknesses attached to individual tools is a challenge. It remains, however, that the interaction of tools is not considered in a systematic manner (Sorrell 2003) and optimising links between tools is therefore not routinely carried out.

In addition to links between tools, ecosystems thinking promotes understanding of links between ecosystems (Secretariat of the Convention on Biological Diversity 2010). Regularly, however, single sector solutions are posed for problems at a late stage in the problem development. The effects of a single issue response can be seen with zealous campaigns to improve the energy efficiency of existing houses by intensive draught proofing without factoring in aspects such as indoor air quality or bird nesting sites, vital habitats in some urban areas.

A key part of ecosystem thinking is the role of feedback in providing response signals on the operation of the system. Yet governance tools are often not associated with monitoring and evaluation schemes (Itard and Meijer 2008). Without adequate feedback driven by monitoring and evaluation, little is known about whether and how tools are achieving objectives.

A related aspect is that of adaptive management which appreciates how ecosystems evolve and adjust to changing environments. Adopting such an approach means that governance tools can be responsive to changing situations and not remain rigidly fixed to their original defining parameters (UNU/IAS 2003)

13.6.2 Complexity and Dynamics of Built and Natural Environments

Against the background of tools operating in fragmented systems, without full understanding of linkages between tools and without adequate feedback and adapta-tion, there is a wider issue whereby the synergies and complexities between the built and natural environment are imperfectly understood (Alberti 2008).

Alberti (2008) notes the effects of urban development on ecological processes such as reductions in biodiversity, soil quality and quantity, air and water quality and increasing surface run-off rates. While many of the effects of urban development are understood, the specifics are not, e.g., whether an increase in urban development has a linear effect on ecological processes (Alberti 2008). Furthermore, we have very limited knowledge of entire subsystems in the biosphere (Waltner-Toews et al. 2008). Our understanding of coupled human – ecological systems is at such as embryonic stage (Alberti 2008) that the operation and effect of governance tools are often imperfectly understood.

Despite the challenges, there are examples of standards, projects and concepts that are grounded in an understanding of the complexity and dynamics of the built

and natural environment. Examples include standards developed by the Passive House Institute which demonstrate that buildings do not have to be a strain on the earth's resources (Passivhaus Institut 2009). The Passive House Standard requires that energy from natural sources be fully integrated into the design of a house through principles like orientation. On a larger scale, developments such as Hammerby Sjöstad in Sweden demonstrate how the environmental impact of a district can be halved by utilising interactions between energy, waste sewage and water cycles (GlashusEtt 2007). On a still larger scale, the Cradle-to-Cradle (C2C) concept looks at products, buildings and cities as biological and technical nutrients (McDonough and Braungart 2002). C2C expounds principles based on designing in harmony with nature where energy is optimised and waste does not exist. C2C shifts the focus from dealing with problems to accepting natural boundaries as fundamental from the outset of the design process. Many of the tools illustrated throughout this chapter espouse elements from the above three examples to varying levels of commitment, yet they often fail to come together, to underpin decisions and to motivate the actors who determine how the built environment develops.

13.7 Conclusions

Recent decades has witnessed a change in the style and substance of tools used by public and private sectors. Tools arose from the understanding that standard setting alone was an ineffective response to problems in the built environment. A key characteristic of tools is how relationships between actors are conceptualised. Adoption of the principle of shared responsibility views actors as participants towards finding solutions to problems across appropriate spatial scales.

The use and continued refinement of tools places our decisions and actions within broader contexts and principles (Brady 2005). Governance tools and the processes on which they depend should be subject to continued questioning such as: what compels homeowners to improve their environmental performance? What concepts can be used as a guide to ensure actions reflect the dynamics of built and natural environments? Are tools working together in a balanced way providing an optimal response to a situation? Such questioning goes beyond dealing with problems as they are experienced, but seeks to influence a grander process recognising non-linear systems, independencies and natural limits.

Governance tools are associated with a range of weaknesses. Tools form part of complex systems associated with legacies of unsustainable development, apathetic actors, antiquated institutions and imperfect knowledge. Often it seems that tools are more warm words and empty rhetoric than concrete mechanisms for action. Moreover, there is a dearth of knowledge on the actual effectiveness of tools. For instance, it is widely accepted that to maximise strengths and offset weaknesses tools should be combined. However, the practice of combining tools is fraught with uncertainties compounded by an absence of monitoring and evaluation programmes.

Of critical importance is whether tools are developed with the knowledge and appreciation for the system in which the tool is to operate. Central to this should be the acceptance that the biosphere is the system which limits the sub-systems of society and economy (Porritt 2007). Yet many tools form reactions to adverse effects of ecosystem modification displaying a failure to understand the natural environment from an early and strategic stage. Tools which balance social, economic and environment objectives across spatial and temporal scales can work towards sustainable built environments. Ecosystem thinking elucidates the complexities and elements involved in developing and adapting such tools while concomitantly demonstrating that current tools and our knowledge thereof have some distance to go.

Questions

1. Describe some of the factors which contributed to a shift to governance?
2. How can action across spatial scales advance sustainability objectives?
3. Explain the role of market-based tools in meeting climate change objectives?
4. What are the advantages and disadvantages of regulations?
5. What governance tools in place (in a country/state/city of your choice) can influence the construction and use of a sustainable building?

References

Adger WN, Jordan A (2009) Sustainability: exploring the processes and outcomes of governance. In: Adger WN, Jordan A (eds.) Governing sustainability. Cambridge University Press, Cambridge, pp 3–31

Alberti M (2008) Advances in urban ecology: integrating humans and ecological processes in urban ecosystems. Springer, New York

ASEAN Secretariat (2006) Third ASEAN state of the environment report 2006. ASEAN Secretariat, Jakarta

Beerepoot M (2007) Energy policy instruments and technical change in the residential building sector. Ios Press, Amsterdam

Bell S, McGillivray D (2000) Environmental law – the law and policy relation to the protection of the environment, 5th edn. Blackstone Press, London

Biogas Sector Partnership (2008). http://www.bspnepal.org.np/. Accessed 19 Sept 2008

Brady J (ed.) (2005) Environment management in organisations. The IEMA handbook. Earthscan, London

Brown K (2009) Human development and environmental governance: a reality check. In: Adger WN, Jordan A (eds.) Governing sustainability. Cambridge University Press, Cambridge, pp 32–51

Bullock S, Childs M, Picken T (2009) A dangerous distraction. Why offsetting is failing the climate and people: the evidence. FoE, London

Canan O, Reichman N (2002) Ozone connections expert networks in global environmental governance. Greenleaf Publishing, Sheffield

Cascio J, Woodside G, Mitchell P (1996) ISO 14000 guide. The new international environmental management standards. McGraw-Hill, New York

DCLG (2008b) Building work, replacements and repairs to your home. http://www.communities. gov.uk/publications/planningandbuilding/buildingworkleaflet. Accessed 11 Feb 2009

DCLG (Department for Communities and Local Government) (2008a) Guidance on the permeable surfacing of front gardens. http://www.communities.gov.uk/documents/planningandbuilding/ pdf/pavingfrontgardens.pdf. Accessed 11 Feb 2009

Defra (2002) The government's strategic review of diffuse water pollution from agriculture in England: typesofenvironmentalpolicyinstruments.http://www.defra.gov.uk/ENVIRONMENT/ water/quality/diffuse/agri/reports/pdf/dwpa03.pdf. Accessed 1 Sept 2008

Defra (2008) An analysis of the technical feasibility and potential cost of a personal carbon trading scheme. http://www.defra.gov.uk/ENVIRONMENT/climatechange/uk/individual/carbontrading/. Accessed 9 Feb 2009

Dobson A (2009) Citizens, citizenship and governance for sustainability. In: Adger WN, Jordan A (eds.) Governing sustainability. Cambridge University Press, Cambridge, pp 125–141

EC (2003) Council directive 2002/91/EC of 16 December 2002 on the energy performance of buildings. Off JEur Communities L 1:65–71, 04/01/2003

EC (2004) Sustaining Europe: EU research for sustainable urban development and land use. Office for Official Publications of the European Communities, Luxembourg

EC (2008) Sustainable energy cities take the lead on climate change: the European commission launches the covenant of mayors. Europa Pressroom. http://europa.eu/rapid/pressReleasesAction. do?reference=IP/08/103&format=HTML&aged=0&language=EN&guiLanguage=en. Accessed 4 Sept 2008

EC (European Commission) (2001) European governance a white paper. European Commission, Brussels

EEA (1996) Environmental taxes implementation and environmental effectiveness. EEA, Copenhagen

EEA (2005) Market-based instruments for environmental policy in Europe. EEA, Copenhagen

Engel C (2001) A constitutional framework for private governance. Preprints aus der Max-Planck-Projektgruppe Recht der Gemeinschaftsgüter, 2001/4. Bonn: Max-Planck-Projektgruppe Recht der Gemeinschaftsgüter

Fiorino DJ (2006) The new environmental regulation. The MIT Press, Cambridge

FoE (2009) History of the big ask. http://www.foe.co.uk/campaigns/climate/news/big_ask_ history_15798.html. Accessed 12 Feb 2009

Gardner T (2008) Northeastern United States begins cap and trade experiment. International Herald Tribune September 24 2008

Glasbergen P (1998) Partnership as a learning process. Environmental covenants in the Netherlands. In: Glasbergen P (ed.) Co-operative environmental governance. Public-private agreements as a policy strategy. Kluwer, Dordrecht

GlashusEtt (2007) Hammarby Sjöstad – a unique environmental project in Stockholm. http://www. hammarbysjostad.se/. Accessed 12 Aug 2009

Golub J (1998) New instruments for environmental policy in the EU. Routledge, London

Gray (2007) Paving craze runs urban wildlife out of town. The Telegraph 7 April 2007

Greenmap (2007) Think global, map local. http://www.greenmap.org/greenhouse/en/about. Accessed 13 Feb 2009

Gunningham N (2007) Reconfiguring environment regulation next generation policy instruments. In: Parto S, Herbert-Copley B (eds.) Industrial innovation and environmental regulation: developing workable solutions. United Nations University Office at the United Nations, New York

Gunningham N, Grabosky PN, Sinclair D (1998) Smart regulation: designing environmental policy. Oxford socio-legal studies. Clarendon, Oxford

Hanf K (1996) Implementing international environmental policies. In: Blowers A, Glasbergen P (eds.) Environmental policy in an international context – prospects for environmental change. Arnold, London

ICLEI (2009) Cities for climate protection. http://www.iclei.org/index.php?id=800. Accessed 12 Aug 2009

Itard L, Meijer F (2008) Towards a sustainable northern European housing stock: figures, facts and future. IOS Press BV, Amsterdam

IUCN (2006) An introduction to the African convention on the conservation of nature and natural resources, 2nd edn. IUCN environmental policy and law paper no. 56 Rev. IUCN, Gland

Jordan A (2008) The governance of sustainable development: taking stock and looking forwards. Envir Plan C 26:17–33

Jordan A, Wurzel RKW, Zito AR (2003a) New instruments of environmental governance: patterns and pathways of change. Environ Polit 12(1):1–24

Jordan A, Wurzel RKW, Zito AR (2003b) Has governance eclipsed government? Patterns of environmental instrument selection and use in eight states and the EU. Centre for Social and Economic Research on the Global Environment, Norwich

McDonough W, Braungart M (2002) Cradle to cradle: remaking the way we make things. North Point Press, New York

Murphy L (2002) Is Dublin a city moving towards sustainable development? Unpublished master's thesis, Trinity College Dublin

Natura Cosméticos (2008) Annual report natura 2008. http://natura.infoinvest.com.br/enu/s-15-enu. html. Accessed 11 Aug 2009

Ngan G (2004) Green roof policies: tools for encouraging sustainable design. http://www.gnla.ca/ library.htm. Accessed 9 Feb 2009

O'Riordan T (2000) Climate change. In: O' Riordan T (ed.) Environmental science for environmental management, 2nd edn. Pearson Education Limited, Essex

O'Riordan T (2009) Reflections on the pathways to sustainability. In: Adger WN, Jordan A (eds.) Governing sustainability. Cambridge University Press, Cambridge, pp 307–328

O'Riordan T, Jordan A (2000) Managing the global commons. In: O' Riordan T (ed.) Environmental science for environmental management, 2nd edn. Pearson Education Limited, Essex

Passivhaus Institut (2009) Information on passive houses. http://www.passivhaustagung.de/ Passive_House_E/passivehouse.html. Accessed 13 Aug 2009

Pattberg P (2005) The institutionalization of private governance: how business and non-profit organizations agree on transnational rules. Govn Int J Policy Admin Inst 18(4):589–610

Porritt J (2007) Capitalism as if the world matters. Earthcan, London

Regional Greenhouse Gas Initiative (RGGI) (2009) About RGGI. http://www.rggi.org/about. Accessed 12 Aug 2009

Ringquist EJ (1993) Environmental protection at the state level: politics and progress in controlling pollution. Sharpe, New York

Rose R (2001) Ten steps in learning lessons from Abroad. ESRC Future governance programme. Discussion paper. http://www.hull.ac.uk/futgov/, viewed. Accessed 26 June 2009

Rudder CE (2008) Private governance as public policy: a paradigmatic shift. J Polit 70(4):899–913

Secretariat of the Convention on Biological Diversity (2010) The ecosystem approach advanced user guide http://www.cbd.int/ecosystem/sourcebook/tools/. Accessed 7 Apr 2010

Sjöberg H (1997) Introduction: the challenge of global environmental governance. In: Rolén M, Sjöberg H, Svedin U et al (eds.) International governance on environmental issues. Kluwer, Dordrecht

Sörrell S (2003) Interaction in EU climate policy. Final report to DG research under the fifth framework programme SPRU

Sunikka MM (2006) Policies for improving energy efficiency in the European housing stock. IOS Press BV, Amsterdam

Sustainable Energy Ireland (2008) Funding for low carbon homes. http://www.sei.ie/index. asp?locID=665&docID=−1. Accessed 1 Sept 2008

TfL (Transport for London) (2009) Benefits. http://www.tfl.gov.uk/roadusers/congestioncharging/6723. aspx. Accessed 9 Feb 2009

Toke D (2008) Trading schemes, risks, and costs: the cases of the European Union emissions trading scheme and the renewables obligation. Environ Plan C 26:938–953

UNEP (1992) Rio declaration on environment and development. http://www.unep.org/Documents. Multilingual/Default.asp?DocumentID=78&ArticleID=1163&l=en. Accessed 4 Sept 2008

UNFCC (2008) United Nations Framework Convention on Climate Change http://unfccc.int/2860. php. Accessed 19 Sept 2008

AU (African Union) (2009) Press release No 152/2009. Workshop on EC-ACP Capacity Building Project on Multilateral Environmental Agreements, Addis Ababa, 11 August 2009. http://www.africa-union.org/root/au/index/index.htm. Accessed 12 Aug 2009

UNU/IAS (United Nations University Institute of Advanced Studies (2003) Defining an ecosystem approach to urban management and policy development. http://www.ias.unu.edu/sub_page.aspx?catID=111&ddlID=169, Accessed 20 June 2011

Ürge-Vorsatz D, Koeppel S, Mirasgedis S (2007) Appraisal of policy instruments for reducing buildings' CO_2 emissions. Build Res Inf 35(4):458–477

USGBC (2008) Summary of government LEED® incentives – July, 2008. http://www.usgbc.org/DisplayPage.aspx?CMSPageID=1852. Accessed 17 Sept 2008

Van Bueren E, De Jong J (2007) Establishing sustainability: policy successes and failures. Build Res Inf 35(5):543–556

Visscher H, Meijer F (2008) The growing importance of an accurate system of building control. Paper presented at the construction and building research conference of the Royal Institution of Chartered Surveyors, Dublin, 4–5 September 2008

Vogel D (2005) The market for virtue: the potential and limits of corporate social responsibility. Brookings Institute Press, Washington, DC

Waltner-Toews D, Kay J, Lister NME (2008) The ecosystem approach: complexity, uncertainty, and managing for sustainability. Columbia University Press, New York

Weale A (2009) Governance, government and the pursuit of sustainability. In: Adger WN, Jordan A (eds.) Governing sustainability. Cambridge University Press, Cambridge, pp 55–75

Welch EW, Hibiki A (2002) Japanese voluntary environmental agreements: bargaining power and reciprocity as contributors to effectiveness. Policy Sci 35(4):401–424

Chapter 14
Managing Change

Anke van Hal and Ellen van Bueren

Abstract The urban environment consists of physical and social systems; sustainable urban development requires change of both. The challenges encountered when managing such change are presented in this chapter. A theoretical understanding of these challenges helps to identify how organisations involved in building, construction and urban planning and design can respond to these challenges and develop a road map for change with short- and long-term goals and ambitions. This chapter gives an account of how different initiatives and groups of actors can take up the challenge of managing change, ranging from innovation diffusion in housing, modes of improved collaboration amongst professional stakeholders and citizen participation to a model identifying the short- and long-term business opportunities of acting sustainably. Together, these initiatives can contribute to fundamental change of the physical and social systems comprising urban areas.

14.1 Introduction

The previous chapters have shown a host of opportunities to develop urban environments towards a sustainable steady state. However, experiences in past decades have shown that the road between innovation, the development of new designs, techniques and technologies, and diffusion, the adoption of the innovations

A. van Hal (✉)
Neyenrode Business University, Breukelen, The Netherlands

Faculty of Architecture, Delft University of Technology,
Julianalaan 134, 2628 BL, Delft, The Netherlands
e-mail: j.d.m.vanhal@tudelft.nl

E. van Bueren
Faculty of Technology, Policy and Management, Delft University of Technology,
Jaffalaan 5, 2628 BX Delft, The Netherlands
e-mail: e.m.vanbueren@tudelft.nl

E. van Bueren et al. (eds.), *Sustainable Urban Environments: An Ecosystem Approach*,
DOI 10.1007/978-94-007-1294-2_14, © Springer Science+Business Media B.V. 2012

by users, can be long, even when innovations have been tested positively for their technical and economic feasibility. For example, it took 15 years before the high-efficiency heater succeeded in penetrating the private household market, in spite of the apparent financial benefits for home owners (Brezet 1994). Delaying factors were the lack of knowledge of home owners of this new type of heater and a risk-averse attitude of the installers, who were more familiar with the existing heaters. Also, the costs of the new heater had to be paid up front, while the benefits would be spread over a number of years.

This example illustrates that there are many challenges in the process of change towards sustainable urban environments. Although change, especially systems change, is very difficult to enforce, there are a number of ways in which such processes can be stimulated, facilitated, speeded up and, to some extent, governed. This chapter will discuss promising opportunities for the management of fundamental change and conditions that may contribute to success. Before we do so, Sect. 14.2 hones in on the specific management challenges encountered in attempting to change urban systems. Section 14.3 discusses theoretical concepts that help to understand, explain and address these challenges. Sections 14.4–14.7 give a variety of insights and examples of how different groups of actors involved in the design and management of urban environments, ranging from property developers to tenants, have successfully taken steps towards sustainable urban areas. Section 14.8 presents a strategic framework that can help actors to identify the steps that they can take in the short term to reduce costs and improve quality to achieve a sustainable urban environment in the long run. Section 14.9 concludes with a reflection on the extent to which change towards sustainability can be managed.

14.2 Challenges in the Urban Environment

When actors want to develop urban areas sustainably, they stumble upon a number of challenges. This section discusses some well-known challenges (e.g., Van Bueren and De Jong 2007; Hoffman and Henn 2008), which have also been hinted at in previous chapters.

14.2.1 Ambiguity: Absence of Tangible, Uncontested Sustainability Goals

At a conceptual level, 'sustainable development' bridges multiple values that are possibly conflicting or competing. On a conceptual level, everybody will support sustainability, but when the concept is made tangible, when priorities are set and costs and benefits allocated, support for the tangible goals that support sustainability is likely to decline. A neutral, authoritative definition of sustainability is absent. Actors will often try to frame sustainability in a way that is compatible with their goals.

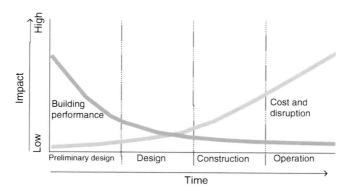

Fig. 14.1 The benefits of early integration (WBCSD 2007: 27. Used with permission)

This will increase support for that particular kind of sustainability, but may also lead to sub-optimisation of sustainability, when such a frame is made without considering specific opportunities for sustainability.

14.2.2 Agenda-Setting: Interventions Are Suggested Too Early or Too Late

To avoid decline of support for sustainability in processes of planning, building and construction, sustainability is often not made tangible, or at a late stage, when many decisions are already made, the costs of disruption are considerable while the potential benefits are smaller (Fig. 14.1). For example, when the urban plan for a district is being developed, it can be decided to power a district with geothermal energy and to make car-free neighbourhoods, but when the plan has already been formalised by local authorities, architects can only limit the energy needs of the buildings. Figure 14.1 illustrates the importance of putting sustainability early on the agenda.

The opposite can happen as well: actors want to achieve a specific form of sustainability, for example, the aim can be to include a sustainable water management system in the development of an area, or they focus on applying specific solutions or technologies, such as solar panels. The result may be an early fixation or premature closure of the process, in which other opportunities for sustainability are overlooked.

14.2.3 Rebound Effect

Sometimes interventions aimed to support sustainability have undesired effects. Standby opportunities for appliances are well-known examples of how technological innovation aimed to save energy can backfire. Instead of turning off the appliances, people left the appliances running on standby mode. Similar processes

are occurring in building and construction. Water-saving taps do not have much effect when people take longer showers and water their gardens with drinking water. Constructing energy-efficient buildings designed for cool climate zones in warm climates leads to excessive cooling demands. Relatively, houses have become more energy efficient over the years, but use of energy, materials and land has increased. The size of the average residential unit in many industrialised countries has doubled in the past decades, while occupancy rate considerably reduced.

14.2.4 Product Characteristics: Inflexibility, Long Lifetime, On-Site Production

Some characteristics of buildings and constructions make it difficult to produce these 'products' more sustainably. First, buildings are produced on site instead of in factories, which makes it more difficult to implement innovations in the production process. In many other industries, process innovations are accountable for the first big steps towards sustainability. In addition, each site has different characteristics, for example, in terms of climate and soil conditions, accessibility, size, surrounding buildings, etc., which makes it difficult to produce large quantities of building components and thus make use of economies of scale. Second, buildings have a long life time, ranging from decades to centuries. A lot of our knowledge of sustainable building is aimed at the design and construction of new buildings, while most of the future building stock, for example, in 2030 or 2050, is already there and in need of retrofitting. Figure 14.1 has shown the challenges involved in retrofitting: more costs, less effect. Third, related to this, buildings are not very flexible. With the solid walls and roofs and inaccessible wiring and piping, it is not easy to make changes once a building has been completed. Again, this points to the need to include sustainability considerations in the design stage. For example, when the different lifetimes of parts of buildings and constructions have been taken into account, the design can be made flexible, allowing the buildings to adapt to new technologies and changed user demands.

14.2.5 Supply Chain Characteristics: Coordination Problems

Many actors take part in the development, construction, management and redevelopment of urban environments. Figure 14.2 illustrates important groups of actors involved in building and construction and their relationships. Usually the lifecycle of buildings is considered to consist of the following stages: initiative, design, construction, operation and use, renovation, demolition, including reuse and recycling of building parts. Note that from a cradle-to-cradle point of view (McDonough and Braungart 2002), this lifecycle is considered not to end in demolition but in decomposition and reuse. In each of the lifecycle stages, different actors are involved. Together, they constitute the value chain of building and construction. The traditionally functional separation of professional

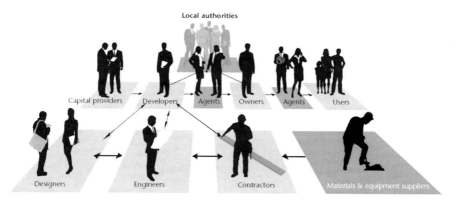

Fig. 14.2 Key-players in the supply chain for building and construction (WBCSD 2007: 14. Used with permission)

and trade responsibilities and the staged decision-making process leads to management discontinuities and operational islands in which decisions are made about the design, construction and use of the building or construction. Traditionally, there is no general director of decision making in the value chain. Most actors are involved in decision making in only one or two links of the chain. Their decisions are often dominated by concerns for cost efficiency and liability.

14.2.6 Perceptions of Costs and Benefits: 'Sustainability Is Expensive'

The perception of costs and benefits of sustainability measures also plays a role in investment decisions of actors. Research has shown that, all over the world, groups of actors in the supply chain tend to overestimate costs and underestimate benefits. On average, actors estimated the contribution of buildings to total emissions to be about 20%, while buildings contribute about 40%. Perceptions of costs suffer from a similar distortion. While a certified building only requires 5% additional investment, the respondents in this research thought that the buildings would cost about 17% more compared to a normal building (WBCSD 2007).

14.2.7 Conservative, Risk Averse Attitude: Small Innovation Capacity

The traditional character of the building and construction sector forms a barrier to sustainable building. The innovative capacity of the industry is low, which can be explained by the high percentage of small and medium-sized enterprises (SME), in the European construction industry SME. In Europe, 83% of the value

in construction is added by SMEs and about half of this share concerns micro-enterprises employing less than 10 persons (Schiemann 2008). These firms have small budgets for research and development and training. Also, out of liability concerns, they adhere to proven products, processes and technologies.

The next section presents some theoretical concepts which help us to understand the challenges listed above and the responses to these challenges from public and private actors involved in making urban areas sustainable.

14.3 Theoretical Understanding of Managing Change

Einstein stated already: 'You cannot solve a problem with the same kind of thinking that has created the problem'. So everything should alter; including the way of thinking of the people involved. This plea of Einstein to think out of the box calls for systematic change of urban areas, not just of the physical system, but also of the social system that consists of the people and their organisations and institutions that occupy and decide about urban areas.

Bringing about change of complex systems is difficult. Stable systems have a capacity to resist change and are resilient (see Chap. 2). In addition, due to the systems complexity, the effects of interventions are unpredictable; positive feedback can bring about a process of drastic change which is beyond control. In different scientific disciplines, ecology, computer science, economics, political science, studies of innovation, organisation and management, etc., complex systems are analysed in an attempt to understand systems' dynamics and ways to influence and control system change. With regards to sustainable urban change, there are some interesting schools of thought that help to understand the challenges and to develop management approaches.

Transition management is a governance approach that has its roots in complex system theories, such as science and technology studies and studies of socio-technical systems (Grin et al. 2010; Kemp and Loorbach 2006; Shove and Walker 2007). These system theories emphasise the relationship between change of social, environmental and technical or technological systems, which develop in a process of co-evolution, i.e. change of one system will lead to a change of the other system (see also Fig. 2.16) (Smith 2007). Transition refers to a system-wide change. Such changes tend to take a long time, usually over one generation, and contain processes of slow and fast development (Loorbach and Rotmans 2006). Management of the change process is complicated due to the many uncertainties involved in how systems will react to interventions, not least because human behaviour seems to be irrational and unpredictable. Transitions are processes with uncertain progress and outcomes. People are used to things often going differently than expected ('Life is what happened, while making other plans', John Lennon wrote). That changing circumstances may lead to extremely unpredictable and unsure situations is shown by the economic crisis that started in 2007.

Nevertheless, transition management aims to set out a path of gradual change which is likely to contribute to the change as foreseen, supported by back casting

(Kemp and Rotmans 2005). This method invites stakeholders to develop a set of possibly desirable future states of their system, to allow for innovations and developments that are unimaginable at present. An analysis of how the present situation can be connected to the desired future, and an analysis of the mechanisms that obstruct or enhance change, will lead to a road map (Van Hal 2009). Backward and forward mapping will help to identify a series of small steps that together will cause a system to change (Kemp and Rotmans 2005). The strength of transition management is that it connects short-term, incremental change to system change that can happen in the long run.

Transition processes are inextricably linked with institutional change. Institutions are all those conventions and rules – written and unwritten, formal and informal, explicit and tacit – that direct our daily behaviour. We take the existence of these organisations and the rules according to which they operate for granted, and by doing so, institutions facilitate our interactions in society. Institutions are therefore often referred to as 'the rules of the game' (March and Olsen 2006). There are rules within an organisation, but also for interaction between organisations. In turn, these rules are embedded in federal, national and international rule regimes. These include the formal institutions of the state, such as a government, parliament, senate, a judicial system, the constitution, etc. Laws and regulations, a tax regime, and systems for health care and education are all examples of institutions. Examples of informal rules are organisational routines, traditions, and codes of conduct. Institutions are thus ways of working and thinking that guide our actions and help to make sense of the world around us. They make life more predictable and thus easier.

By acting in line with institutions, we confirm and reconfirm these institutions time and again. Institutions become deeply rooted in our behaviour, which makes them difficult to change. Institutional change implies that the responses to our actions by others lose predictability, and the results of our actions become uncertain.

Grabbing opportunities calls for a radical change in both thinking and doing. But change is difficult. Our brains are not geared for change. Our dislike of institutional change is also related to the transaction costs of such change, a concept that is central to neo-institutional economics (Williamson 2000). The predictability and trustworthiness of institutions significantly lowers transaction costs. If you want to buy bread at the bakery, we have agreed that money can be used as a means for exchange, and you do not have to spend time on negotiating the transaction. That is why people and the organisational structures in which they operate do not like rules or institutions to change. Even when we are dissatisfied with existing institutions, the known benefits of predictability outweigh the potential costs of uncertainty. In times of crisis, when trust in institutions declines and when the capability of institutions to solve our problems is questioned, people are more open to institutional change and initiatives to make radical changes are more likely to succeed. However, in times of stability, people and organisations are reluctant to change and change tends to be incremental.

Institutions can thus be considered as the rules of the game within our social system, the system of human beings and their interactions. Our social systems are embedded in other systems. If we look at the urban environment as an ecosystem, we can

discover various subsystems, which are either defined by geographical boundaries, such as regions, cities, districts, neighbourhoods, and buildings, or by functional boundaries, such as transport, ecology, water and energy. Transition of urban environments towards a sustainable equilibrium is often a process of gradual change, with accelerations and temporisations, of the different constituting subsystems. However, sometimes change happens quickly and unexpectedly. Ideas and behaviour and messages and products sometimes behave just like outbreaks of infectious diseases. They are social epidemics. Small changes can make a huge difference (Gladwell 2002).

Against the background of this theoretical understanding of (social system) change, different developments in the management of (parts of) the processes in which urban environments are created and modified are discussed to show that each in its own way successfully contributes to sustainable urban areas and tackles some of the challenges presented in Sect. 14.2.

14.4 The Diffusion of Environmental Innovations

14.4.1 Factors Contributing to Successful Diffusion

For a long period of time, there used to be a focus on technology in trying to improve the environmental performance of urban areas. Many sustainable technologies and designs have been developed in the past decades. All over the world, demonstration projects showed that many of these innovations are technically and economically feasible. Nevertheless, many of these innovations are scarcely applied in other projects of buildings, constructions and developments. How can this be explained?

Over the years, scholars have tried to answer this question. They agree that barriers to applying these innovations have to do with the social and institutional context in which the building projects are realised (see Sect. 14.2). People that have to adopt the innovation hold the key to a sustainable built environment.

In 2000, research led to a model that described the diffusion of environmental innovations in housing (Van Hal 2000). Factors which this research identified as having determining influence on the diffusion of environmental innovations in housing are:

1. Quality of the innovation
2. Organisation of the demonstration project
3. Organisation of the information transfer
4. Influences of government

A requirement for the diffusion of an environmental innovation in housing is that the innovation not only has environmental qualities but also financial qualities; i.e. costs are equal to or less expensive than alternatives. Other qualities of the innovation, such as comfort, liveability, status and flexibility, play a role too, but have a considerable less influence on the diffusion.

 The chance of success in a demonstration project, thus the chance of diffusion of the innovation, increases when at least one of the members of the project team, the team in which the architect, constructor and various specialists work together on a project, acts as an innovation champion (equals a person using all their power to get the innovations implemented). Research points to the importance of multi-disciplinary cooperation within a project organisation. The involvement of an opinion leader, an individual able to influence others, such as a prestigious architect or a well-known project-developer, also contributes to the diffusion.

14.4.2 A Case of Successful Diffusion: The GWL Site, Amsterdam

The GWL project illustrates the role and importance of a demonstration project. The project lies on the outskirts of the city centre of Amsterdam on the former Municipal Waterworks Site and is developed as a car-free and environmentally friendly area. On the site, a number of existing historical buildings have been maintained. The density is very high: 271 rental houses and 330 owner-occupied properties have been realised in 17 multi-storey blocks. The initiative to turn the neighbourhood into an environmental neighbourhood came from the residents in the adjacent neighbourhood called 'Staatsliedenbuurt'. In 1992, local politicians picked up this initiative and started the development of an urban program of requirements in which many environmental issues have been incorporated. In 1993, the urban development plan was completed. Five very popular architects, having no experience with sustainable building, were selected to design the houses. Besides sustainability, architectural quality was also an important issue. From the start of the planning process, environmental advisors were connected to the project. The whole project received a 'green affidavit' from the Ministry of Housing, Spatial Planning and the Environment. The buyers of the property were entitled to a 'green mortgage', a tax benefit, and indirectly the tenants of the rental housing in the estate were also able to profit from this green mortgage.
 This project has been evaluated very well and many of the experiences have been used in other projects. Some of the results of this project are discussed below.

Results related to the innovation

The whole project had a high ambition level for that time. All experiences have been evaluated. Especially in the housing design, many problems came up in budgeting. There were various reasons for this. At the moment that the costs could best be influenced, in the starting phase, insufficient attention had been devoted to the quality of the design because the project team had to hurry to apply for subsidies. The environmental measures were not integrated in the design but added at a later stage, which led to the unforeseen and unnecessarily high exceeding of the budget. Regarding some environmentally friendly building materials, namely wood, availability formed an important bottle-neck.

Results related to the information transfer

The experiences of the GWL site clearly showed that there is a large need for information. It turned out to be difficult to access practical information in time. Specialised staff helped out. In developing the urban plan, an environmental advisor was part of the project team and was asked many concrete questions. In the housing design phase, budgets were made available in order to also ask the environmental advisor questions, but given the fact that there was no longer any personal contact, the possibility was only sporadically used. Three months before the first completion, a neighbourhood administrator was appointed to advise the residents. This worked very well.

Results related to the adopter

A variety of lessons clearly came forward. For example, the importance of the involvement of prominent architects (opinion leaders) contributed to the acceptance of environmental measures in the buildings in general. Another eye-catcher is that cooperation in a pluriform team in which an innovation champion takes part contributes to the succeeding of the project. Also, this project showed the value of laying down ambitions in formalised agreements.

The GWL site is one of the few projects that has also been evaluated a long period after completion. When the neighbourhood had existed for 10 years, the whole process was evaluated with all the people involved. It became clear that after such a period of time the innovations were no longer innovations; many products which were new during the design process had become standard. The environmental innovations had clearly diffused.

The main value of the project now lies in the car-free character which makes it possible for children to play safely outside and which resulted in a strong feeling of social cohesion. Also, the involvement of the star architects is still one of the strongest elements of the neighbourhood. Many people are still visiting the neighbourhood because of its architectural and social quality. It is a very popular place to live in Amsterdam.

14.4.3 The Role of Change Agents

Diffusion of environmental innovations in housing is furthered when innovation experiences gained are evaluated. Moreover, the research results also point out that information transfer must be based on unambiguous evaluations having similar composition and that information transfer must target different professional groups within the building industry individually. Also important is the role of a change agent in the form of a public authority, responsible for informing the building sector of innovations.

As an adopter of new technologies, this agent challenges others, competitors and actors further up and down the chain, such as suppliers and consumers, to follow his example (Rogers 1995). The diffusion is also furthered by the prospect of publicity

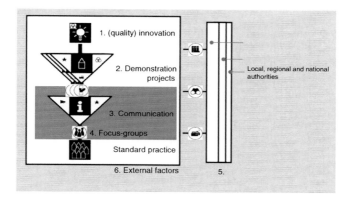

Fig. 14.3 The diffusion of environmental innovation in housing (Van Hal 2000)

for projects where the innovation is applied. The involvement of opinion leaders in the target group to which information is transferred also has a positive influence.

Government – as a regulator, initiator, stimulator and change agent – has great influence on the diffusion of environmental innovations in housing. When regulation has a flexible composition, i.e. performance-based instead of specifying how to comply, it furthers diffusion (see also Chap. 13). A long-term perspective determined by government (national, regional and local) also supports diffusion, just as do large schemes of subsidies and research budgets. Tax incentives can also have a positive influence.

14.4.4 A Model of the Diffusion of Environmental Innovation in Housing

The research results are visualised in a model in which all mentioned elements can be found (Fig. 14.3). The impression exist that this model seems not only to be true for houses but also for other elements of the built environment. Comparing this model, which was based on experiences in the 1990s, with experiences in recent times the conclusion can be drawn that market forces have become of much more influence. In the 2000 model, consumers and commercial parties like building developers are mainly seen as focus groups that have to be 'seduced' to sustainable building by change agents and governments. However, in the past few years, a new vision on sustainable entrepreneurship has risen. Trendsetter businesses are starting to spot the opportunities offered by sustainability issues for the introduction of new products and services (see Sect. 14.7) Collaboration between public and private actors has also become more important (see Sect. 14.5).

Another remark can be made about the focus of this model on newly built houses. In the new millennium, the focus is much more oriented towards the existing housing stock. The long-term perspective of the national and supranational

governments, influenced by international agreements, is a driving force behind this change of focus. For example, the goals of the European government in reaction to global climate change are ambitious. In 2020, CO_2 emissions must be reduced by 20% compared to 1990. Both European and Dutch governments are also aiming for 20% of the energy used is produced sustainably by 2020. A large part of these goals need to be met by retrofitting the existing housing stock. For example, the Dutch Housing stock is responsible for 20% of the Dutch CO_2 emissions. Almost 70% of the Dutch housing stock needs extra insulation of floors, roofs, façades and windows (Van Hal 2008). More and more market initiatives are focussed on this challenge.

14.5 Improving Collaboration

14.5.1 Introduction

In the Netherlands, on one of the well-known 'Loesje' posters, which are posters of an anonymous organisation with a little girl's name that aimed to make people think, a maxim was written which perfectly describes the need for collaboration:

> Why make it difficult when you can make it together?

Cooperation can lead to a reduction in costs; that is a practical argument for cooperation. However, there is another argument that explains why cooperation is increasingly appreciated by market parties. Environmental issues are no longer viewed at a local but at a global scale. Almost everyone is aware of the globalisation of the world economy and the interdependence between chains of suppliers, partners and clients. The realisation that companies may only make a difference through cooperation with other parties grows. There is a third reason for being fond of cooperation. New cooperative forms are fertile soil for innovations of products, services and processes (Van Hal 2009).

The collaborative forms discussed in this section have to do with the design and construction of buildings or the design and realisation of urban plans. Supply chain management aimed at integrating activities of upstream and downstream supply chain members - not discussed in this book – is another way in which collaboration between actors in the supply chain can contribute to sustainability. The improved coordination between supply and demand can make processes more efficient in many respects, in terms of time, energy, costs, waste, etc.

14.5.2 Forms and Benefits of Collaboration

To bridge the gaps between the operational islands in the supply chain (see Sect. 14.2), several forms of collaboration have been developed over the years. Essence of these collaborations or partnerships is that they aim to create a common goal that guides the

decisions of the partners. Because of these partnerships, actors' responsibility and involvement extend a single stage of the building process or of the value chain. This leads to a different assessment of risks and responsibilities, of costs and benefits.

Partnerships or collaborations usually include agreements on how to share risks and responsibilities and costs and benefits. These agreements can be formalised into contracts, or have a more informal basis in the form of a covenant or a letter of intent. On an operational level, actors involved work together in a project organisation, which creates a loyalty of the individual team members to the project and the project goals, in addition to the loyalty to the goals of the respective organisations of which they are part (Puha 2004). This facilitates the exchange of knowledge and the development of an integrated design. For example, for building design, it is common that a project coalition or project team is formed, a temporary cooperation in which the architect and specialists such as structural engineers, mechanical engineers, electrical engineers, and surveyors, collaborate. In this way, they can make use of the expertise of the various disciplines needed to make a design for a building or construction. It prevents a design created by the architect from being presented in a final stage to the mechanical engineers to include building technology, leaving only opportunities for add-on technologies.

In their role as commissioner, public authorities or public organisations can stimulate private actors to collaborate. They can demand such collaborations in a tender or concession. Especially for public works, this is a promising way. Public works tend to be contracted out to the contractor with the lowest bid. Opportunistic behaviour by contractors, aiming to reduce costs, often leads to a quality reduction of the product or service delivered. For example, a contractor can decide to cut production costs by using materials that are less durable and need intensive maintenance. The higher maintenance costs will be paid for by another party, but will also lead to more use of materials and waste production.

To prevent opportunism, but also to improve efficiency and innovation, actors commissioning buildings or public works can decide to simultaneously contract out multiple parts of the value chain. *Design and Construct* is an example of how the responsibility for design and construction is put in hand. These two phases in the building cycle are usually separated, which leads to traditional designs that can be carried out by any contractor. By bringing design and construction together, i.e. into the hand of one actor capable of doing both or into the hands of architects or engineers and constructors who closely cooperate, room is created for an adaptive design process in which design and construction are optimised, and innovations, including environmental ones, in both design and construction can be achieved.

'Design, Build, Finance, Operate/Manage', 'Design, Build, Operate, Transfer' or 'Build, Own, Operate, Transfer' are forms of contracting out that aim to make a single actor responsible for the design and construction of the works as well as their operation (Winch 2002). The contractor usually consists of a consortium of actors, who together possess the knowledge and expertise needed to deliver the project. Because these actors collaborate in a consortium, which can take different legal forms, it is in their joint interest to make maximum use of the knowledge and expertise present within the consortium. Also, they are assumed to seek opportunities

to reduce costs, which may stimulate innovation, especially if the consortium is allowed benefit from (part) of the reduced costs.

The longer-term involvement and the innovative capacity of such consortia create favourable conditions for sustainability. For example, the long-term involvement enables actors to assess investment decisions by their lifecycle costs, the costs of a product throughout its lifetime, instead of the up-front capital costs. Especially, technologies or materials that are not produced on a large scale (yet) are more expensive than traditional ones when the payback time extends the involvement of the investor. When actors are involved for longer, it is more attractive to base investments on lifecycle costing. The contribution to sustainability of these types of contracting could be further enhanced if the actor contracting out includes sustainability in the project requirements, for example by requiring a LEED silver rating for an office building. And when a project is put on the market through a competition, which is often done for the design of public buildings, sustainability could play a prominent role in the assessment of the designs. Again, systems of labelling and certification of materials, designs and processes can support this (see also Chaps. 6, 11 and 13).

The experiences with various forms of supply chain management in the building sector are limited. Some positive experiences, which focussed on the reduction of failure costs, can be found in the UK. For example, due to supply chain management, the construction costs of Terminal 4 of Heathrow have been reduced by 40% and the period of construction was shortened by 30%. Statistics of the University of Bath show an overrunning of the budget and/or construction period in 75% of regular projects. When supply chain management is introduced, only 10% of the projects are confronted with an overrunning of the budget and/or the construction period (Bijsterveld 2005).

Recent research shows the importance of cooperation within the supply chain when it comes to energy efficiency of the existing housing stock owned by housing associations (Van Hal et al. 2009). Supply chain cooperation reduced the costs (as a result of scale advantages, reduced failure costs, and accelerated processes) and raised the knowledge level of the cooperating actors. It also triggered rescheduling of process organisations. Trust among the cooperating actors and transparency of decision-making are key words.

The experiences with contracting out public works by the UK Highways Agency and, more recently, by its Dutch counterpart 'Rijkswaterstaat', reveal a pitfall when contracting out. When the principal (the commissioning actor), and the agent (the contractor), are not familiar with each other, or when they have no experience with their role in the contractual relationships, a usual reflex is that principal and agent start to formalise the relationship. Lawyers take over negotiations between actors and the costs and benefits are captured in purely monetary values. Such a legalistic environment leaves little room for creativity and innovation, especially in unknown fields of environmental innovation.

To our knowledge, there are few empirical studies of the contribution of supply chain management to sustainable development, although attention is growing for this field of study. It would definitely be interesting to see the advantages and

disadvantages of the various management forms for sustainability besides 'good housekeeping' by making more efficient use of resources. The limited number of empirical studies may be explained by the low availability of projects. In practice, it is already difficult enough to initiate supply chain management. Cooperation needs a broad field of interest of the people involved and a long-term perspective. Neither characteristic is common in the building industry (Bijsterveld 2005).

14.5.3 Methods and Tools to Support Collaborative Decision-Making

Collaborative decision-making is easier said than done. People from various disciplines suddenly have to exchange ideas, knowledge and information. They have to use languages that they are not familiar with, and they have to rely on the outcomes of methods and tools unknown to them, which is even more complicated when you remember that some of these people work for competing organisations. The schedule often leaves little time to get to know each other and to explore different design options, leading to parallel trajectories in which project members do what they are good at without taking notice of possible synergies or conflicts with decisions made by others.

In acknowledgement of this problem, working methods and tools to support decision-making have been developed which help actors to formulate a shared vision and goals and make decisions consistent with the vision and goals. In workshop-like settings, collaborative partners explore and identify opportunities for common ground. Again, when they are relatively unfamiliar with sustainability, they can be supported with knowledge provided by change agents. By making sustainability explicitly part of decision-making, project members are forced to inform themselves. Examples of qualitative workshop methods are the DCBA method which help actors to formulate and specify shared ambition levels for a number of goals (see Chap. 11) and the Environment Maximisation Method, in which actors first jointly make designs that aim to maximise the performance of specific flows (energy, water, materials, mobility/transport, etc.), followed by the development of an integrated design. Splitting the design process into these two steps prevents project members focusing on the constraints instead of on the opportunities (cf. Mayer et al. 2005).

In the last decade, the increased opportunities and availability of software tools for simulation and gaming have given such joint design exercises more credibility. Design alternatives could be based on information immediately available which sheds a light on the consequences of alternatives for urban areas. For example, programs simulating the effects of urban development on road congestion, external safety and noise and pollution levels make it possible to determine at a glance whether the suggested design meets regulatory requirements and fits the project goals. Especially when these programs have a visual GIS (Geographical Information System)-based interface, such information can strongly support decision-making (Mayer et al. 2007).

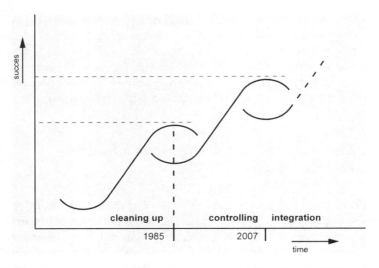

Fig. 14.4 Historical perspective on phases relating to sustainability (Van Hal 2009)

14.6 Which Actors Can Make the Change?

Despite the complexity and uncertainty of fundamental change, different groups of actors in the built environment try to influence this process. In the past 20 years, public and private actors have played different roles in sustainable urban development. Their roles or approaches to sustainability can be divided into three periods (Fig. 14.4) (Van Hal 2009):

1. The phase of cleaning up, pre-1985;
2. The phase of controlling from 1985 to 2007;
3. The phase of integration, apparent since 2007.

The approach in the phase of cleaning up was characterised by a fairly passive role for private companies. Care for the environment – the term sustainability was not yet used – was seen as a task for the government. Emphasis lay on laws and jurisdiction. For the construction sector, the Lekkerkerk-affair of 1980 is a good example in the Netherlands of this time. It was discovered that houses had been built on contaminated ground with consequences for health and house prices. But at that time, few parties in the Netherlands were actively involved with what was then named ecological building. The first exemplary projects were realised by these leaders.

However, the success of this approach appeared finite. Even before the success reached its climax, a new era began. In this phase of controlling, socially responsible entrepreneurship entered the business world. Companies became accountable. This period is characterised by detailed measures and agreements. In the Netherlands, in the mid- and late 1990s, the so-called packages for sustainable building, lists of measures that could be applied in the design and maintenance of buildings and public

works, are a good example of the spirit of this age. Looking at those lists you realise a lot has happened. Much of what was not yet accepted then has become standard.

However, this phase has also passed its climax. In recent years, the phase of integration has started. In this phase, companies further acknowledge that there are company profits to be made from working sustainably. An entrepreneurial approach towards sustainability arises. Worries about and care for the future are important motivations. Climate change and the exhaustion of resources are increasingly being taken seriously. Through this, the problems are viewed from a broader perspective. A growing number of parties search for the earlier mentioned merger of interests. The problem is no longer approached as local but as global. The realisation grows that a company may only make a difference by cooperating with other parties. Cooperation throughout the supply chain forms a new focal point.

14.6.1 Actors Suitable for Cooperation for Fundamental Change

Which actors are suitable for cooperation? Naturally, actors from within the construction sector, but as shown in Fig. 14.5, these parties are many and diverse. The figure makes use of the different groups of stakeholders distinguished in the figure on stakeholder mapping by Esty and Winston (2009: 97).

The target group varies from producers to government, from local contractor to multinational. Are all these actors evenly suited to cooperate in the direction of fundamental change? They are for their knowledge and background. Actors are needed from the whole chain. The vision of these actors determines whether they are suitable partners in making steps towards fundamental change. Therefore, the Centre for Sustainability of Nyenrode Business University developed a way to identify the target group that is based on the vision on sustainability of the actors involved (Fig. 14.6) (Van Hal 2009). This division of actors on either side of the axes is, amongst others, based on the innovation – adaptor – diffusion theory by Rogers (1995) and on the sustainability classification within small and medium-sized enterprises by Bos-Brouwers et al. (2008). Also inspirational were the axes system on which Gruis (2008) based his typology of leadership styles at housing associations and an article by Van Marrewijk (2003).

In daily life, the four quarters in the figure should be used with some shading. People cannot be put into categories. And since companies are formed by many different people, companies cannot be put into categories either. In a very conservative company, you may find early adaptors and vice versa. But for clarity, we will forget about the shading and explain the division with key words. Starting with the first quarter: these are the actors that still work with the cleaning up viewpoint on sustainability problems and that regard the government as the party that should take the initiative for change. Actors that fall within this category may see that things are changing but they do not take the initiative. They tune their actions to laws and jurisdiction and to the demands of their contractors. This category is labelled 'the traditional craftsman'.

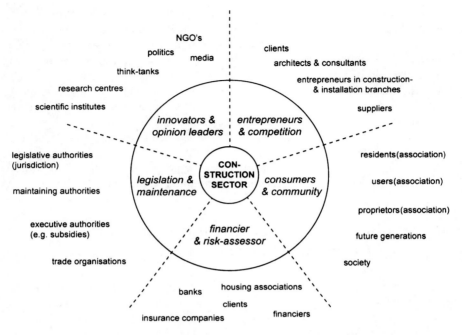

Fig. 14.5 Overview of stakeholders in the construction sector (Van Hal 2009)

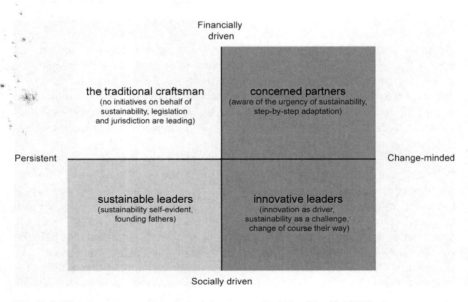

Fig. 14.6 Target groups sorted out by opinion on sustainability (Van Hal 2009)

There are parties that equally hold on to their old beliefs but in a very different manner, and these are the parties that have always seen that the usual way of working in construction contributes to the ecological crisis. This category of companies and people has for years now been active in the specific area of sustainable building. They see working from a sustainable viewpoint as self-evident. The parties that were busy with what was then called ecological building during the phase of cleaning up certainly belong to this group. Actors that have become active only recently largely profit from the work of these forerunners. You could call them the traditional sustainable builders, since they have made sustainable construction a tradition for years. However, because it needs courage and leadership to play such a forerunner role, the choice has been made to label them 'sustainable leaders' in this division.

The third category is formed by actors whose work is led by their need for innovation. Actors that fall within this category find themselves challenged by the conjunction of the economic and ecological crisis and they consciously make sustainable entrepreneurship their business. They choose to change course. These parties have been labelled 'innovative leaders'.

The last general category within this figure relates to actors that have been labelled 'concerned partners'. These are people and companies that are aware of the fact that they find themselves in a transition phase, but who, for whatever reason, are not capable to rigorously break with the familiar working manner. They find their way towards a new working manner via adaptation in steps. They often try to follow the road that was scouted and outlined by the earlier mentioned leaders.

So, which parties are suitable for cooperation focused on a fundamental change? The category of the sustainable leader is an obvious target group because these parties have already worked from a sustainable viewpoint towards fundamental change for quite some time. The innovative leader is, in view of this goal, also an evident partner, as is the category that is labelled 'the concerned partner' in the division. In working with this last category, it is important to outline the obstacles these people experience, and to research – preferably in conjunction – how these obstacles may be overcome. Compared to innovation leaders 'the concerned partner' is less inclined to neglect these obstacles which for that reason form an important hindrance for diffusion.

There is only one group less evident as a target group for cooperation. The traditional craftsman is a category that is hardly susceptible to a new working manner. Generally, they await (legal) regulations.

The next two sections discuss how two specific groups of actors, end-users and private enterprises, can contribute to small and larger steps on the road towards sustainable urban areas.

14.7 End-User Participation

The above forms of collaboration focused on improved collaboration of professional actors. This section focuses on the involvement of a specific group of actors: the end-users of the built environment, of the buildings, roads, parks, and the living area

that together they form. This can range from residents and office employees to kids playing in the streets and people on sidewalks. Involvement of end-users in the design is important for a number of reasons.

First, end-user participation may improve the quality of the design. For example, citizens may have specific knowledge of the local area for which a design is prepared. The designers, who are often living and working elsewhere, sometimes even in different countries or continents, can use this knowledge to improve the plan. Second, this may extend the lifetime of the design. For example, a hospital that has been designed without involvement of the medical staff and the patients is likely to soon be in need of renovation to improve its functioning. Third, involving end-users can improve the acceptance of the design during its use stage; for example when a company board decides that its employees are to work in a 'flexible workspace' with fewer desks than employees, since in many lines of business the occupancy rate of desks is far from 100%. A flexible office concept saves considerable space, and thus construction materials, energy for operating the building, office furniture and, last but not least, money. But such concepts also involve a behavioural change of the employees. When employees are confronted with the design without understanding it, they will not use it as intended – e.g. when people start to 'occupy' desks – and the concept will fail. The office will be turned in a traditional workplace and additional space is needed.

Besides the advantage for the end-user, an improved acceptance is also beneficial for the decision-making process. The benefits of end-user participation tend to outweigh the investments if done properly. The preparation of a design or a plan may take longer, but end-users are less inclined to start formal procedures to contest a plan or design when they have had the opportunity to participate in the process, even when they do not like the outcome. When end-user participation has been taken seriously by both the end-users and the actors responsible for the development of the plan or design, participation contributes to the legitimacy of decision-making processes and their outcomes (De Bruijn et al. 2010).

The participation ladder ranks different forms of citizen participation on the extent to which participants can influence plans (Arnstein 1969):

- Information: end-users are informed about the initiative and the consequences for them.
- Consultation: end-users are informed about the initiative and they are consulted on specific issues. It is clear what these issues are about and what can and cannot be changed. The opportunities to change are often predefined in a number of options.
- Interactive decision-making: end-users are encouraged to participate and come up with ideas and options that can improve the initiative. Together, end-users and planners or designers engage in a joint learning process that influences the decision-making by the initiators.
- Co-decision: end-users and initiators jointly decide.
- Partnership: end-users also play an active role in the implementation of the plan.
- Delegated power and autonomy: end-user organisations are supported to make their own decisions.

The first two steps, information and consultation, are often part of formal procedures to inform people and get some feedback on specific parts of the plan concerned. In interactive decision-making, citizens can influence the agenda and the content of the debate, and although their input cannot be discarded by decision-makers, they have no formal decision-making power. In a co-decision and partnership model, citizens or end-users do have such formal power and sometimes they actively take part in carrying out the plan. Ultimately, citizens can be delegated power to make autonomous decisions.

The ladder shows that there are several forms in which end-users can participate. In some forms they have little influence on the plan concerned, while in other forms their influence can be substantial. The following paragraphs present examples of how resident participation can contribute to sustainable urban areas.

14.7.1 How Reliable Are Representative Organisations?[1]

Representative organisations may be unreliable partners when they do not represent all (groups of) end-users. In a class on the management of urban areas, a manager of a district of an average Dutch town told of his disappointment when a neighbourhood board withdrew its support for a hang-out for the local youth. An article about the project in the local newspaper mobilised a large number of residents that previously had refrained from participation. The district manager was utterly disappointed. He had been working on the project for months and had arranged budget and consent from his superiors and the city council. He still wanted to try to come to an agreement with the neighbourhood board, on the condition that they would approve of a hang-out or an alternative solution. However, actors are not likely to commit themselves beforehand to specific outcomes of a process. At best, the manager could try to get the neighbourhood board to commit to continue participation in the process, which, over time, may also induce commitment to the outcome of the process.

14.7.2 Reward Tenants for Participating, Helsinki, Finland[2]

A housing association in Finland has good experiences with tenant participation. This participation can take various forms: the involvement in a tenant committee to influence decision-making for the estate where they live; gardening; or 'jobs' that

[1] Class on 'Process Management' for neighbourhood managers, given by Ellen van Bueren for the 'School voor Gebiedsgericht Werken', 13 March 2010.

[2] The project described was part of the Sureuro (Sustainable Refurbishment in Europe) project, carried out under the 5th Framework Programme of the European Commission between 2000 and 2004. In the project, housing companies involved in refurbishment projects in seven European countries identified and exchanged best practices. For more information, see www.sureuro.com. Accessed March 2011.

require vocational training, such as an energy consultant who monitors the energy performance of the estate and advises tenants on their energy use. In return for their volunteer work, tenants earned credits for which they could request a new wooden floor, a new kitchen, or a new bathroom. There were various positive effects of this participation: the number of tenants involved increased and tenants that had participated and exerted influence on their home were more satisfied with their home, took better care of it, and stayed longer than average.

14.7.3 Frustrations of Co-decisions by Tenants and Landlord, Copenhagen, Denmark[3]

In Denmark, residential estates are collectively 'owned' by the tenants living in the estate. Management and maintenance of the estates is put in the hands of a housing association. Although in everyday practice the relationship is more recognisable as a traditional one between landlord and tenant, the formal relationship is important when key decisions have to be taken. The tenants have to approve of initiatives for renovation and restructuring. This may lead to inertia. Interests of individual tenants today might be conflicting with the interests of future tenants. Tenants may prefer low rents over an improved overall quality of the estate, safeguarding its future value. Also, it takes a lot of effort to explain the decisions that have to be made to tenants. And when tenants understand the choices they are being presented with, they have to have the opportunity to bring in their own points of view. There is a tension between the slow and uncertain progress of decision-making by tenants and the process dynamics of professional actors involved in the development of plans, who are looking for concrete goals and work according to fixed plans and budgets. Processes of co-decision in this case involved for tenants and landlord a lot of hard work, frustrations, patience and understanding.

14.7.4 Residents' Initiative in Bogota, Colombia (Palacio 2008)

In Bogotá, a new residential district was developed at the city outskirts in a wetland called Conejera in the early 1990s. When the first part of this district was finished, residents moved in. Because the area was still being developed, people had to walk about 1 km to access the urban transportation system. In the morning they used to wake up with the sounds of the countryside, birds, cows and roosters and they began to appreciate the beautiful place. To save the wetland from further urbanisation, they formed an interest group. They discovered that the building plans were not complying

[3] See footnote 2 of this chapter.

with regulations and successfully contested the plans. The initiative has taken root in the Conejera Wetland Foundation, which has become an important player in the management of the wetland.

14.7.5 How an Eco-Garden Contributed to Improved Housing, Sevran, France[4]

A district with high-rise apartment blocks in the north-west of Paris was suffering from low quality housing, vandalism, and criminal behaviour. Tenants were reluctant to cooperate with suggested improvements by the housing company. By chance, the local school discussed the opportunities for a gardening project with the housing association owning property in the district. They obtained a subsidy for the project. Housing association and tenants together realised and maintained the garden. The garden was used to educate the people living in the district about ecology and environment. The garden improved the tenants' sense of belonging. Feelings of alienation decreased. The caretaker of the estate, who had been forced to leave the neighbourhood for safety and efficiency reasons, returned to the estate. This also created an opportunity for tenants and the housing association to discuss physical improvements of the estate and the apartments.

For successful participation of citizens, but this also applies to the participation in decision-making of professional actors, two issues are important (cf. De Bruijn et al. 2010). The first is the management of expectations. For example, a consultation round in the development of an urban plan can backfire if participants expected to have more influence. Out of disappointment, they may object to the plan. Second, the question of representation is important: do the participants represent the group(s) of end-users? For example, in the Netherlands, white, retired males are overrepresented in processes of public participation. Also, tenant organisations tend to have a representation problem, as only a few tenants are actively involved. Planners or designers should therefore be aware of the group that participants represent. If important groups are not represented, they should try to safeguard the interests of these groups in other ways to improve the legitimacy of the process and the quality of the plan.

14.8 Business Opportunities: Sustainability Pays

Section 14.4 showed that, during the research period of the described research into the process of the diffusion of environmental innovations in housing (1996–2000), the private sector played a very passive role. The involvement of the private sector was

[4] See footnote 2 of this chapter.

in general limited. Being green was not an issue at all for most businesses at that time. However, times have changed in an extremely rapid way. The entrepreneurial approach is nowadays becoming more and more the standard. As Daniel C. Esty and Andrew S. Winston (2009), authors of '*Green to Gold*', state in the preface of the latest edition of their bestselling book:

> When *Green to Gold* came out in the fall of 2006, we hoped that business leaders would recognise the importance of folding environmental thinking into strategy. But we did not anticipate how big the Green Wave sweeping across society and the business world would be. In the past few years, thousands of companies have gone green. Historically, corporate interest in the environmental arena tends to rise and then fall, but this time seems different. Instead of focusing mainly on environmental costs and risks or corporate social responsibility, more and more companies have come to see opportunities for growth and profit through a focus on environmental sustainability.

What are these opportunities when talking about sustainable building? How can the private sector influence the transition process? And what is the role of benchmarks and labelling in this respect? These are the questions that will be answered in this section.

14.8.1 Business Opportunities of Sustainable Building

One of the most important conditions to create business opportunities is a critical view from a sustainable perspective on existing convictions on how to promote business. This perspective is, according to the Centre for Sustainability of Nyenrode Business University (Van Hal 2009), taking care for both the interests of people and the environment, and for economic interests. Business opportunities are not created by somewhat adjusting existing manners of working but by working differently. By striving for a simultaneous care for several interests, a change in perspective appears, a paradigm shift. And because the old ways of thinking and doing then become almost impossible, such a shift in perspective leads almost naturally to innovation, both in regard to products and to processes. This is not about an angle of thinking, Profit whilst looking out for People and Planet, but about focusing on the point where the interests of People, Planet and Profit come together, the place where a merger of interests arises, a situation where the outcome is more than the total sum of parts (Fig. 14.7).

This somewhat abstract description of this business opportunities-oriented approach can be illustrated with two elements from the well-known competitive strategies by business guru, Michael Porter. Porter (1998) distinguishes two strategies in reaching top achievements in a certain branch of business: cost control (making smaller costs than the competition) and differentiation (by distinguishing the qualities of a product, for example its uniqueness or service). A focus on these two strategies from a sustainable perspective results in the following vision. To explain this vision, a matrix (Fig. 14.8) has been made in which the terms 'cost reduction' and 'creating quality' are significant. This view is very familiar to the construction

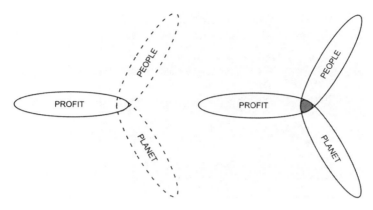

Fig. 14.7 The traditional approach 'thinking profit' versus the merger of interests (Van Hal 2009)

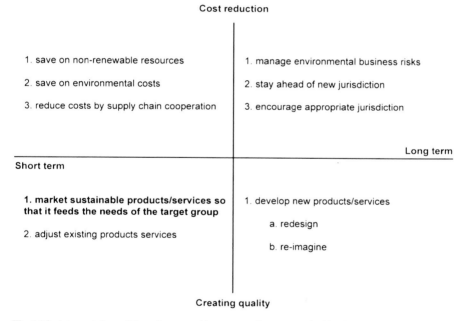

Cost reduction

1. save on non-renewable resources

2. save on environmental costs

3. reduce costs by supply chain cooperation

1. manage environmental business risks

2. stay ahead of new jurisdiction

3. encourage appropriate jurisdiction

Long term

Short term

1. **market sustainable products/services so that it feeds the needs of the target group**

2. adjust existing products services

1. develop new products/services

 a. redesign

 b. re-imagine

Creating quality

Fig. 14.8 Interpretation of Porter's competitive strategy from a sustainable viewpoint (Van Hal 2009)

sector, for parties in construction mainly differentiate themselves on the basis of costs and/or quality.

How do we fill this figure from our sustainable viewpoint? When filling in this matrix, we were inspired by the description of 'strategies for building eco-advantage' as found in Esty and Winston (2009). Below, the quadrants will be explained (Van Hal 2009).

14.8.2 Short-Term Cost Reduction

There are three possibilities for cost reduction in the short term. Each of these will be illustrated with an example of a realised sustainable construction project.

(a) Save on non-renewable resources,
(b) Save on environmental costs,
(c) Reduce costs by supply chain cooperation.

14.8.2.1 Save on Non-renewable Resources

A much-used example within this framework is making existing housing energy-saving. By doing this, the comfort for the tenants improves (People), the pressure on the environment is reduced by saving on fossil fuels and reducing CO_2 emission (Planet) and the costs of living are lower for the tenants (Profit). However, there are more non-renewable resources than just energy. For example, raw materials for construction (see Chap. 6). 'Cirkelstad Rotterdam' ('circular town') is an initiative in which the demolition company, Oranje Demontage, cooperates with other companies. The aim of this initiative is realising high-grade re-use of materials that come from demolition. Re-usable materials are extracted from the buildings that are to be demolished and offered as raw material for construction, preferably at the same site. Demolition company Oranje expects to be able to completely deconstruct a house and offer it as new construction material within 10 years. By this manner of working, transport of materials is minimised and a large CO_2 reduction realised (Planet). Oranje employs people from the lower end of the labour market, educates them and offers them help in paying off their debts when necessary (People). The company seems able to do this against a competitive price and without being dependent on subsidies (Profit).

14.8.2.2 Save on Environmental Costs

One of the first projects in which the abstract Cradle-to-Cradle thoughts of McDonough and Braungart (2002) were put into practice, was the renovation of the Ford Rouge Center in Dearbron, Michigan. The Rouge Center was rebuilt into a kind of industrial nature park. An important adjustment to the terrain was the factory roof. Actually, the roof was changed to a landscape of vegetation. This remarkable roof enhances the well-being of the people that look out on it (People), buffers rainwater and creates a biotope for many plants and animals (Planet) but on top of that saves Ford millions of dollars (Profit): the life span of the roof was doubled, maintenance costs were lowered substantially, the green roof protected from ultraviolet-rays and the energy costs were reduced due to better isolation. However, the main financial advantage came from the absorbing and filtering working of the roof, so that the usually obligatory filtering system could be left out.

14.8.2.3 Reduce Costs by Supply Chain Cooperation

A good example of reducing costs by *supply chain cooperation* (see also Sect. 14.5) is the Cooperative Union Q and their Q-construction method in the Netherlands. By a transparent cooperative working manner between many partners, they build comfortable (People), sustainable (Planet) and affordable (Profit) housing of a steady high quality. That quality is laid down in a specified code that the union assembled from several independent criteria such as the ones from a green financing regulation. Their houses are for 90% made out of renewable materials, are energy-saving but also very affordable. In comparison with a traditional house with similar results, this type of house is about 5–15% cheaper. The cost reduction comes from a shorter building time and from minimal failure costs and is a direct result of the cooperative working manner that was chosen.

14.8.3 Long-Term Cost Reduction

Considering the possibilities of cost reduction in the long term, there are also three possibilities to explain:

(a) Manage environmental business risks
(b) Stay ahead of new regulation
(c) Encourage appropriate regulation

14.8.3.1 Manage Environmental Business Risks

It is well known that producers of toys suffer great damages when somewhere along the production chain a harmful substance is found. In construction, there is a similar situation with the material asbestos. What will appear to be harmful in the future is yet not known. A negative remark about the bio-industry by Oprah Winfrey in 1996 in America led to great losses in the meat industry. The construction sector is equally vulnerable. In the Netherlands, the image of balanced ventilation has been heavily damaged as a result of health complaints of residents of newly constructed houses with this system. Recently, it is not unthinkable that in the future more such developments will take place and that companies will be made accountable for things that were earlier hardly given any attention. The only thing companies can do to brace themselves for future public emotions is to carefully analyse the supply chain for possible future problems. As worded in the book *Green to Gold*: 'Finding the risk before it finds you'. For this reason, IKEA scrutinises the entire supply chain to prevent wood from tropical rainforests being used in its products. Should construction companies do the same, it will cost effort, time and money with no insurance that the investment will pay back. Problems that do not arise form a strange kind of success. But imagine the use of tropical hardwood suddenly becoming a widely spread great shame in the public's opinion, and it is immediately clear which companies will profit: those that had foreseen this.

14.8.3.2 Stay Ahead of New Regulation

An example: future tightening of the demands for energy-saving in new buildings is something most parties in construction already take into account. But the possibility that similar demands may be put to existing buildings is hardly considered as being realistic, whilst it is not unthinkable, considering many international developments. The consequences of such new regulations will be huge for the construction sector. Parties that are prepared for such developments will profit in the future.

Another appealing example is property developer Seinen from Leeuwarden in the Netherlands, who has, anticipating more strict energy-saving demands for new housing, developed a financing scheme through which even energy-producing houses become affordable.

14.8.3.3 Encourage Appropriate Regulation

Proactively developing instruments within the area of sustainable construction reduces the chance that governmental instruments that the construction sector does not wish for are imposed. This idea partly formed the grounds for the introduction of the (UK) benchmark BREEAM by the Dutch Green Building Council in 2009, and its predecessors, the (Dutch) Toolkits for Sustainable Construction, which were initiated by a large contractor and developed in cooperation with several other market parties. There were Toolkits for newly built houses, for existing houses and for office buildings. In these Toolkits, the complexity of sustainable construction was translated into concrete manageable concepts. These gave users the possibility of employing the Toolkits in an integral way and technically correct.

14.8.4 Creating Quality in the Short Term

Distinguishing yourself from the competition by quality on the short term, may be done in two ways:

(a) Market sustainable products/services so that it feeds the needs of the target group
(b) Adjust existing products/services

14.8.4.1 Market Sustainable Products/Services So That It Feeds the Needs of the Target Group

This working manner is not emphasised without reason in the figure. It is definitively not the clincher it may seem at first sight. Look to the past. In 2001, we found ourselves in the era of control. Companies were made accountable for their responsibility towards the environment. In those days, it was common to work with long lists of do's and don'ts. Guilt and responsibility formed the leading motives of actors active

in the field of sustainable building. Parties that were not convinced saw those sustainable construction lists mainly as a burden.

Nowadays, a new working manner is coming up. Instead of introducing rules, looking for mutual benefits became leading. So instead of sending, listening has become a goal. And that makes a crucial difference. By listening, you get information that may not at first sight seem relative to sustainable construction, but may be crucial for an enthusiastic response to the subject. And this is essential because in making sustainable construction a success you must really want it. 'Nothing great was ever achieved without enthusiasm', quoting the American philosopher Emerson. This is in fact the same as 'offering products and services in a manner that feeds the needs of the target group'. Only by listening carefully to what moves the target group, will those needs become clear. And those needs are often very different to what is expected before entering the conversation. Sustainable construction is such a large area of expertise that nearly always a point of contact can be found from which a problem may be solved or a dream realised.

The power of this method can be illustrated with a practical example. The Genzyme-office in Cambridge near Boston. The location of this building is a former industrial site hidden behind an energy plant. Five architects were invited to present their views on this building during the preliminary phase. Four of them came with impressive models. But the fifth, Stephan Behnisch from Germany, came empty-handed. He came to listen instead of to talk. He appeared very good at it and by listening he got a clear picture of the needs of those involved. The entrepreneur wanted the building to show the character of the company. Therefore, Behnisch concluded that the building should be nothing but very sustainable, since Genzyme is active in health care. The company develops new products aimed at the treatment of very complex diseases. This development requires much innovation, patience and attention, but upon success the products create a sustainable lifestyle. Making concessions on quality during this product development is out of the question. Therefore, no concessions on quality should be made at developing the building. Sustainability became self-evident for both the architect and the entrepreneur.

Since its construction in 2002, the building has proven to mirror the character of the company. The focus on sustainability defines the radiance of the building and, according to the Chief Executive Officer (CEO), has proven to contribute to the good name of the company. Technically, it was not difficult to reach this level and the ease grew at subsequent projects. The extra costs were reduced with the growing familiarity of the company with this building method. Genzyme now only builds with the highest standards for sustainable construction. Looking back, the CEO can only conclude that the choice for a building with a very high sustainable standard has raised the level of the entire company and has led to a striving for sustainability as the leading element for all the activities of the company since then. He even states: 'Companies that take themselves seriously and con-sequently strive for quality in their dealings and organisation, cannot really allow themselves to develop buildings that do not apply to high sustainability standards. When you wish to radiate the quality you stand for as a company, sustainable construction is self-evident'.

In this case, the careful listening by the architect had a great impact. But each group of people that has been involved in a sustainable project gives a different story and as such a different bridge towards sustainable construction. The building blocks for that bridge require creativity every single time. Therefore, they look different every time. Made-to-measure is required.

14.8.4.2 Adjust Existing Products/Services

Two practical examples are given. The first is the ClickBrick, a brick that no longer needs mortar. Both use and re-use become much easier. The second is the 'carefree-concept', a service with which a growing number of companies try to make privately owned housing sustainable. The service is the offer of an integrated constructional and technical installation advice, made-to-measure, for making a house sustainable. This advice comes with a plan of execution for which tenant/owners will have only one contact person to deal with. This person can also help them with applying for a loan and all other related matters. Tenant/owners are relieved of many worries which reduces the chance of it going no further than plans, and in practice not being executed. Already several companies have such a concept on the market.

14.8.5 Creating Quality in the Long Term

There seem to be two possibilities that are both based on the development of new products or services:

(a) Redesign
(b) Re-imagine

14.8.5.1 Redesign

Redesign means that existing products, services or manners of working are completely reviewed. A great example is the 'ultra-fine-particle-sound-screen', developed by contractor BAM and TU Delft. This screen can be put alongside highways and does not only reduce sound but also improves the air quality. Another great example is the concept of the sun terp: a greenhouse, in which plants and vegetables are grown, is part of the energy concept of the building (Wortmann 2005). The greenhouse also improves the air quality and reduces CO_2 emissions from the building since the plants need CO_2. The vegetables may be used in a local restaurant and the greenhouse can contribute to the architectonic quality (See Chap. 12).

14.8.5.2 Re-imagine

Re-imagine has to do with the development of totally new products, services or working methods. A nice example of such a product is the Living Machine developed

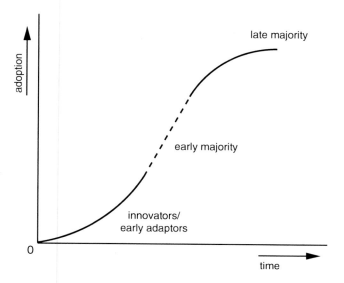

Fig. 14.9 In small enterprises, the S-curve of innovation diffusion is interrupted (Van Hal 2009, based on Rogers 1995)

by Jonathan Todd (see Chap. 12). A project in China clearly demonstrates the three fold functionality of the principle of Living Machine: a polluted canal in a city is transformed into an attractive recreational area (People), the heavily polluted water is naturally purified (Planet), which saves the costs for a traditional water purification system (Profit).

An example of re-imagination in services is to be found in the Dutch multiple prize-winning project 'Wallisblok' in Rotterdam. In this project, the local government granted a totally run-down housing block to the current and future tenant/owners for free, with the condition that they would invest in their houses. Under the guidance of architect Ineke Hulshof, the tenants together transformed the housing block into an architectonic highlight that uplifted the whole neighbourhood while living costs for the owner/occupants were relatively low . For each apartment, much attention was paid to the environment, which entitled them to the tax benefits of 'green financing'.

With this last example, the matrix is filled. Generally, a selection of these possibilities will present themselves in any specific project.

14.8.6 To Round Up: The Influence of the Private Sector on the Transition Process

The large-scale implementation of innovations tends to follow a certain process of diffusion. The American Rogers extensively researched these processes. After studying the story behind many innovations, he concluded that there is a standard process following an S-shaped curve (Fig. 14.9). First, a few front runners, named

innovators, adopt an innovation. When the innovation has proven its value, it is used more often, until the time that the majority of people have opted for the innovation (Rogers 1995). Research into the role of small enterprises in the building sector in the Netherlands, however, shows that this diffusion process is often interrupted (Van Hal 2008). It seems hard for the middle group of the so-called early majority to follow the example set by the innovators. More research should be done in this field, but the impression exists that the standard way of contracting is one of the main obstacles.

14.9 Conclusions

This chapter has shed a light on why so many of the great innovations presented in this book have not yet resulted in sustainable urban areas. We now understand why system changes are difficult, but we have also seen that system changes are not entirely impossible to influence and to manage. With a great deal of enthusiasm and knowledge, projects can be realised that are made-to-measure for the urban system in which they are constructed and the social system of which they become part.

In the many examples addressed in this chapter, we have seen a number of factors that can support change, of which we will highlight two. First, and most obvious, government support is an important factor, although this does not necessarily have to imply interventions in the form of regulations and subsidies. Facilitating information exchange, setting the example, and developing long-term policy goals are equally important. Most notably, it was during the financial crisis, when public funding of sustainable technologies was no longer available, that the private sector took responsibility for sustainable building and sustainable urban development at a scale that has been unprecedented.

A second factor that supports the opportunities to manage change concerns an increased awareness of interdependencies on resources and on actors, sometimes painfully pointed out to actors by natural disasters or man-made crises. This increased awareness made it possible for organisations to really open up for opportunities to make their actions more sustainable. Clients and suppliers, commissioners and end-users seem to understand the individual and collective benefits of joint action. Improved forms of collaboration and stakeholder involvement, combined with useful decision-support tools, help to map the consequences of design choices and make better informed decisions that are better supported.

The future will tell whether this trend of private sector initiative will continue to flourish. Strategies like the ones presented in Sect. 14.8 are important for developing a road map towards sustainable urban areas. The axes chosen, one ranging from short-term to long-term strategies, and one with quality and costs at the extremes, match the language of both business and ecosystems and can therefore provide common ground for delivering the first steps on the road map.

Questions

1. Describe how the concept of co-evolution of social and technical systems can be of help when explaining the effects of the large-scale introduction of innovations such as electric-powered vehicles?
2. Why would a private enterprise be willing to invest in the construction of an office building that receives a sustainable label such as BREEAM and LEED?
3. Why is it important to focus on the general interests of people involved in a sustainable building project?
4. Take an urban (re)development project in the place where you live or a project that you are familiar with (e.g. a refurbishment project, an urban renewal project, the construction of a public park, etc.). Try to answer or imagine: what kind of stakeholders are involved? What kind of experts are involved? How are citizens involved? Which opportunities do you see for sustainability and to what extent do the participating actors make use of these opportunities?
5. What is a change agent and how could this role be fulfilled in the project for which you answered question 4?

References

Arnstein S (1969) A ladder of public participation. J Am Plann Assoc 35(4):216–224
Bijsterveld K (2005) Interview with Marcel Noordhuis and Jack van der Veen, In: Building Business, August http://www.buildingbusiness.com/artikel.asp?ID=1329 (Accessed June 22, 2011)
Bos-Brouwers H (2008) Negen typen midden- en kleinbedrijf. In: De Preekstoel voorbij, duurzaam innoveren in het MKB. Koninklijke Van Gorcum, Assen
Brezet H (1994) Van prototype tot standaard; de diffusie van energiebesparende technologie. Uitgeverij Denhatex BV, Rotterdam
De Bruijn H, Ten Heuvelhof E, In 't Veld R (2010) Process management: why project management fails in complex decision making processes. Springer, Berlin
Esty DC, Winston AS (2009) Green to gold. Wiley, Hoboken
Gladwell M (2002) The tipping point: how little things can make a big difference. Little Brown and Company, Boston
Grin J, Rotmans J, Schot J (eds.) (2010) Transitions to sustainable development. New directions in the study of long term transformative change. Routledge, London
Gruis V (2008) Organisational archetypes of Dutch housing associations. Environ Plann C 26:1077–1092
Hoffman AJ, Henn R (2008) Overcoming the social and psychological barriers to green building. Organ Environ 21(4):390–419
Kemp R, Loorbach D (2006) Transition management: a reflexive governance approach. In: Voss JP, Bauknecht D, Kemp R (eds.) Reflexive governance for sustainable development. Edward Elgar, Cheltenham
Kemp R, Rotmans J (2005) The management of the co-evolution of technical, environmental and social systems. In: Weber M, Hemmelskamp J (eds.) Towards environmental innovation systems, part one. Springer, Dordrecht, pp 33–55, DOI: 10.1007/3-540-27298-4_3
Loorbach D, Rotmans J (2006) Managing transitions for sustainable development. In: Olsthoorn X, Wieczorek AJ (eds.) Understanding industrial transformation: views from different disciplines. Springer, Dordrecht

March JG, Olsen JP (2006) Elaborating the "New Institutionalism". In: Rhodes RAW, Binder S, Rockman B (eds.) The Oxford handbook of political institutions. Oxford University Press, Oxford, pp 3–22

Mayer IS, van Bueren EM, Bots PWG, Van der Voort HG, Seijdel RR (2005) Collaborative decision-making for sustainable urban renewal projects: a simulation-gaming approach. Environ Plann B Plann Des 32:403–423

Mayer IS, Van Bilsen A, Van Bueren E, Goetgeluk R (2007) The playful city: serious games for sustainable urban development, book of abstracts, Workshop November 2007. Delft University of Technology, Delft

McDonough W, Braungart M (2002) Cradle to cradle: remaking the way we make things. North Point Press, New York

Palacio DC (2008) Social-networks to defend Bogota's Wetlands: a participatory policy building effort for urban protected areas. In: Proceedings EcoCity World Summit, San Francisco

Porter ME (1998) The competitive advantage: creating and sustaining superior performance, 1st edn. Free Press, New York

Puha F (2004) Improving construction cooperation: new theoretical insights into how and why? Research Studies Press Ltd, Baldock

Rogers EM (1995) Diffusion of Innovations, 4th edn. The Free Press, New York

Schiemann A (2008) Enterprises by size class: overview of SMEs in the EU. Eurostat: statistics in focus — 31. http://epp.eurostat.ec.europa.eu/cache/ITY_OFFPUB/KS-SF-08-031/EN/KS-SF-08-031-EN.PDF. Accessed Mar 2011

Shove E, Walker G (2007) Caution! transitions ahead: politics, practice, and sustainable transition management. Environ Plann A 39:763–770

Smith A (2007) Translating sustainability between green niches and socio-technical regimes. Technol Anal Strateg Manag 19(4):427–450

Van Bueren E, De Jong J (2007) Establishing sustainability: policy successes and failures. Build Res Info 35(5):543–556

Van Hal JDM (2000) Beyond the demonstration project; the diffusion of environmental innovation in housing. Aeneas, Boxtel

Van Hal JDM (2008) Challenging and valuable. Inaugural speech. Delft University of Technology, Delft

Van Hal JDM (2009) The merger of interests, on sustainability and benefits in the construction sector. Nyenrode Business University, Breukelen

Van Hal JDM et al (2008) Draaien aan knoppen. Nyenrode Business University, Breukelen

Van Hal JDM et al (2009) Financiën en energie besparen, kansen en mogelijkheden voor woning-corporaties. Nyenrode/Agpo-Ferroli, Breukelen

Van Marrewijk M (2003) European corporate sustainability framework. Int J Bus Perform Meas 5(2/3):213–222

WBCSD (World Business Council for Sustainable Development) (2007) Efficiency in buildings: facts and trends. Summary report. http://www.wbcsd.org/DocRoot/1QaHhV1bw56la9U0Bgrt/EEB-Facts-and-trends.pdf. Accessed Mar 2011

Williamson OE (2000) The new institutional economics: taking stock, looking ahead. J Econ Lit 38(3):595–613

Winch GM (2002) Managing construction projects. Blackwell, Oxford

Wortmann EJSA (2005) De Zonneterp – een grootschalig zonproject. InnovatieNetwerk Groene Ruimte en Agrocluster, Utrecht

Chapter 15
Conclusions and Solutions

Thorsten Schuetze, Hein van Bohemen, and Ellen van Bueren

Abstract In this chapter, conclusions are drawn from the content discussed in this book. Approaching urban areas as ecosystems made it possible to address a variety of topics that influence the well-being of our built environment and its users and occupants without losing sight of the interconnectedness between these topics. Especially, the urban metabolism metaphor is useful for understanding, identifying and measuring inefficiencies and quality loss within urban areas and for tracing opportunities to improve the metabolism. This includes proposals for the introduction of closed-loop recycling economies, of which some examples are presented and discussed in this chapter. These examples show that integrated ecosystem approaches, which are based on the specific basic conditions of a city's location, show great promise for the sustainable (re-)construction of urban areas.

15.1 Introduction

This chapter pulls together the main content of this book. By drawing conclusions from the chapters of this book and discussing recent research results and case studies, it is illustrated how (eco)system thinking and planning can facilitate sustainable development in general and of urban areas and their hinterlands in particular.

Regarding urban areas as ecosystems facilitates the identification of opportunities for the adaptation of urban areas towards more sustainability. The different aspects described in the chapters of this book, and how they will contribute to the development of sustainable urban areas, are discussed from two perspectives: 'urban metabolism' and 'importance of place and region'. Sustainable urban metabolism is calling for the abandonment of resource exploitation and linear resource flows

T. Schuetze (✉) • H. van Bohemen • E. van Bueren
Delft University of Technology, Delft, The Netherlands
e-mail: T.Schuetze@tudelft.nl

E. van Bueren et al. (eds.), *Sustainable Urban Environments: An Ecosystem Approach*, 399
DOI 10.1007/978-94-007-1294-2_15, © Springer Science+Business Media B.V. 2012

through the introduction of eco-efficiency and effectiveness as well as closed-loop recycling production processes and the use of renewable resources. Specific places and regions are the starting basis for the development of ecosystems because they represent the eco-topes, with their environmental and natural basic conditions, occupied by specific anthropogenic urban systems. We will also discuss the question of why ecosystem thinking has already become part of policy processes and why not. Furthermore, it will be elaborated how the paradigm of ecosystem thinking can be further stimulated as a practical tool for sustainable urban development.

15.2 Improving the Metabolism of Urban Areas

The chapters in this book confirm that the urban metabolism approach is a strong metaphor. It emphasises the importance of analysing and modelling multiple material and resource flows going in and out of urban environments as well as occurring within. This also includes the processes in which these flows are involved.

A wide variety of methods and tools have been developed to analyse different flows, helping to identify inefficiencies and opportunities for improvement. In each of the different flows discussed in this book, water, energy, materials, ecology and transport/mobility, significant progress has been made with regards to the development and use of this approach.

Within the field of water, integrated resource management has already become a key guiding principle. In many initiatives, guidelines and directives around the world, important steps mark some progress in this direction. In the Netherlands, for example, the National Water Policy is based on these principles, which have also been included in the European Water Framework directive. The programs of UNEP, UNESCO and UN-Habitat demonstrate progress towards integrated management at the level of the United Nations. This change of attitude and general strategy followed a number of pioneer projects and also stimulated many new initiatives, from Emscherpark (Germany) to Portland, Oregon (USA) and from Tokyo (Japan) to Curitiba (Brazil), just to name a few of many more.

The energy field, with its limited availability of fossil energy carriers (uranium, coal, gas and mineral oil) as well as the related "side effects", such as emissions causing pollution and climate change, and also political and economic dependency, have already introduced a shift in thinking. The establishment of the International Renewable Energy Agency (IRENA) in 2009 represents the global trend that a shift from non-renewable to renewable energy production is indispensible. By March 2011, 148 states and the European Union had signed the Statute of the Agency. IRENA will promote the widespread and increased adoption and sustainable use of all forms of renewable energy. Access to all relevant renewable energy information, including technical, economic and renewable resource potential data, will be provided. Furthermore, experiences on best practices and lessons learned regarding policy frameworks, capacity-building projects, available finance mechanisms and renewable energy-related energy efficiency measures will be shared (IRENA 2011).

The booming and growing world markets for wind, solar and biomass-based energy, with rising tendencies, are clear indicators that the future will, and has to be, renewable. Recent studies and research results show that a shift to total renewable energy supply until the middle of the twenty-first century is on the one hand necessary to facilitate a similar and/or better life for the world's population. On the other hand, such a change is technically and economically feasible. In Europe, for instance, it could be realised by 2050, even if all conventional power plants, which are currently planned or are under construction, would be realised. However, the extended use of expensive and risky nuclear energy plants could be a significant barrier for that shift. Wind, sun and biomass alone can provide sufficient energy and food for the growing world population. Non-renewable resource consumption, required for renewable energy production, for instance for the construction of wind-power generators, batteries for electric energy storage and mobility, as well as photovoltaic and solar thermal generators, is not a limiting factor in theory. The required resources are available in sufficient quantities to realise a complete shift. However, the recycling of all utilised materials, particularly of strategic resources and rare elements after the end of a product's lifetime, is indispensible for sustainable production (Mocker and Faulstich 2011). Furthermore, there are some challenges related to the organisation of the recycling and geopolitics that may reduce the practical availability of these materials, notably so-called "strategical resources", such as noble earths, which push up prices and slow down processes of diffusion and adaptation of these technologies.

Regarding the environmental effects of building and construction products, material flow analysis created awareness amongst producers and designers. The lifecycle approach emphasised that many buildings are not built for eternity, and that aspects of maintenance and the specific lifetime of building materials and components should be taken into account for production and use. Improvements of tools that use this information enable more informed and smart choices for design and maintenance. Reuse and recycling of materials have become more common. Metal, such as steel, is generally recycled and even up-cycled. The mining of ore can be avoided and huge amounts of energy saved compared with the production of new material. However, the recycling process still requires a considerable amount of energy, which is much higher compared with the effort for the reuse of building components. For other materials, such as concrete, recycling remains a big challenge and up-cycling illusionary, because the production of new cement is also required for concrete, which is produced from recycled aggregate. The development of effective recycling methods for all non-renewable materials therefore remains a big challenge. The industrial production of goods as we know them today requires huge amounts of fossil fuels but also after the end of the oil and gas age, industrialised production can be continued. Many synthetic materials can for instance also be produced by use and transformation of carbon dioxide and hydrogen, produced for example with solar–thermal power plants (Mocker and Faulstich 2011).

In the field of urban transport, many countries have focused especially on the enhancement of safety and on reduction of emissions. The number of human road fatalities has strongly declined in most western countries by (well) over 50% since

the mid-1970s. Specific road vehicle emissions, such as fine dust and lead, have decreased significantly, despite the significant growth in vehicle use. The average kilometres driven per car and year, for example, grew in the USA by more than 250% and in Germany by approximately 400%. However, a great deal still has to be done to improve air quality in cities. Air pollution is regarded as one of the main threats to the health of the urban population, causing earlier deaths. In general, urban air quality and road safety have improved but there are significant local differences in air quality, depending on the amount of traffic on certain roads. Greenhouse gases and NO_x emissions are generally still on rise. Therefore, in urban areas, particularly in inner city districts, policies aiming for emission reduction by individual motorised transport have been introduced. As a result, the role of motorised traffic in central urban areas has already decreased.

Examples for such policies are the introduction of pedestrian areas, not allowing motorised vehicles on certain roads at all, or only if they meet specific emission standards (restrictions in so-called environment zones), parking restrictions, and the availability of public transport, bicycle lanes and pedestrian zones. Interest is growing in a more integrated approach towards the planning of different transport modes for humans and goods within and between urban areas and their surroundings and hinterland. The increased use of electric-driven mass transport (trains and buses) and individual ones (cars and scooters) as well as walkable neighbourhoods are paving the way towards transport infrastructures which are not air polluting and contribute to increased health and liveability. They also facilitate the increased production and use of renewable energy, because they facilitate better energy management through increased storage capacities and smart grids, which allow for optimising supply and demand of centralised and decentralised sources.

Policy makers increasingly recognise the fragmentation of green areas and bottlenecks between transport and ecological infrastructure networks. To reduce habitat fragmentation and animal road kills, mitigation measures, such as eco-tunnels and eco-ducts crossing roads, as well as the defragmentation and the combination of green with transport infrastructures, are much promising approaches which contribute to the enhancement of the ecological and social quality of the urban environment.

The development of methods, tools and strategies for analysis and management of the different flows discussed in this book has played an important role in the enhancement of resource efficiency. Some of the tools, such as the environmental assessment systems tools for building design, have integrated knowledge on various flows in one tool and, ready to be used by practitioners. Other systems, such as the ones for water management, are used by authorities at different administrative levels for planning, and are thus being used on a more strategic level.

In many cases, governments support the use of tools and methods for the assessment of sustainability, but sometimes also the private sector initiates and stimulates their use, which can be of a voluntary or of a binding character. Laws and formal regulatory control are often used to safeguard a minimum quality, for example of air, drinking water and sewage through quality standards. Emission standards are used to directly control emissions from identifiable sources and production processes, such as combustion engines of vehicles and finishing products (e.g. paints).

However, regulations can also be used to enforce minimum performance requirements, for instance through the labelling of products (such as energy efficiency classes for electric appliances) or restrictions such as limitations for the maximum energy used for the heating and/or cooling of buildings (which may be included in the building codes). There are also many private sector initiatives for regulatory control, especially in the field of labelling and certification. Even though these initiatives are not obligatory, they are influential and emphasise the business opportunities of sustainability through advertisement and branding.

15.3 Making Areas and Places More Sustainable

Areas and places are important in ecosystem thinking in many respects. They should desirably be occupied by flora and fauna and contribute to the identity of human beings. The location of urban areas has strong influences on the urban metabolism and the opportunities for its sustainable management. Geophysical and climate conditions, for example, could stimulate the use of specific local materials and climate-responsive urban design and architecture. In various chapters, it has been discussed how places can be made more sustainable, ranging from buildings and their indoor climate to urban areas and their (ecological) structure.

It is widely accepted and acknowledged that urban form, program and structure matters, for example with regards to transport and mobility needs and patterns as well as ecology. However, this knowledge has been quite limited in its use for the (re-)development of urban areas. Policy documents often do not explicitly speak of urban form, as in many countries, policy, let alone instruments, related to urban form are not (yet) developed or only in a rather vague way. It is easier to mention urban form than to actually create concrete instruments that aim to guide urban developments. That being said, if policy documents do contain leads in the direction of urban form they usually mention the compact city. References to urban form, however, in general can more often be found in an implicit way as the measures mentioned in policy documents are focused on keeping the city compact. In general, this is achieved either through restrictions, cities for example are not allowed to expand further into the surrounding greenfield, but first have to redevelop their brownfields, or through positive stimulation by creating new metro lines or giving subsidies rewarding behaviour. It is a process of carrots and sticks, but urban form is always present somewhere in the background. The question is whether it is still a valid goal to be aiming for, or whether an update is required in order to evaluate what has been achieved so far and to be able to incorporate possible new insights in terms of the sustainability of the different urban forms.

Urban expansions do not necessarily affect opportunities for the development of ecology negatively if for example existing ecological zones are integrated in the city development and new habitat for ecological development is created. A low population density of urban extensions and the peri-urban and rural hinterland generally results in the need for commuting of residents to areas with higher densities, for work

and shopping. This results mostly in an increase of individual motorised mobility and trip lengths. Accordingly, the resource consumption per inhabitant is much higher than in areas with higher densities and less commuting needs. More land is occupied by buildings and roads and other infrastructures, e.g. for electricity, water and sewage, which require resources for construction, service and maintenance. This includes amongst others green surfaces, lengths of cables and pipes, and comparable high infrastructure costs per inhabitant. In addition, the resource consumption per capita is by nature lower in areas with higher population and building densities and mixed programs, simply because the required infrastructure to fulfil the daily needs can be shared with more people. Furthermore, the need for commuting and the related time effort can be minimised and the saved time can be spent on other activities. However, resources which are required to fulfil the basic needs, such as food, water and energy, are generally not produced in cities and have to be transported from the hinterland.

With an increasing amount of time and energy spent in buildings, the human presence in urban public space per m^2 decreased, leaving the majority of space for most of the time unused by people. Urban green is represented in a great diversity of relatively quiet areas. As a result, the amount of different plant and animal species in many cities, as observed and listed by local nature associations, is often comparable to that in nature reserves and can therefore be much higher than in areas which are only used for intensive agriculture. Another explanation is that pesticides are not widely used in cities. Even beekeepers have discovered cities as new territory for their honeybees to escape from chemicals which can harm them. The majority of species in cities represents the species composition of the surrounding rural regions of the city. However, the number of different species does not tell us essentially much about the ecological quality of the specific green areas.

Disturbances in the water cycle through elimination of green and building constructions as well as the waste heat from urban processes, such as motorised transport, as well as heating and cooling, results in urban heat islands. In colder seasons or climates this effect can attract animals and plants stemming from warmer climates as precursors of climate change.

Urban developments and building activities, which are based on the destruction and total restruction of former built-up areas, as well as public and green areas, can decrease the identity, history and diversity of districts with their buildings and urban public and green spaces. That raises the question of local identity: what is the difference of one urban area compared with other urban areas, what remains recognisable from local history, and what makes a living environment attractive? Factors such as these determine how local inhabitants are connected to their neighbourhood and also feel responsible for its operation, development or conservation.

In the recent past, it has been recognised that generally more attention is given to the fact that citizens and companies prefer a green environment as such, and that areas for recreation, education, water retention, air quality and biodiversity as well as from the perspective of human health should be present. In many urban areas, green infrastructure has become part of the planning and design processes.

In urban design, there is a basic awareness in addressing needs like health and safety, but on a detailed level there will always be work to do, like the tension

between child-friendly design and accessibility by car. Also, air quality and social safety are on the agenda. Other aspects of sustainable liveability are being more and more addressed in the last 5 years. There is more research on the enriching combination of qualities of green in the built environment. We see a shift in sustainable urbanism from emphasising the compact city towards literally greening the city. Next to the health aspect (like fighting obesity) is feeding the city an incentive. In the design of housing areas, there is more attention to the quality of the street (more than a traffic machine) and more specific to the zoning between private and public space. Even in a high-density neighbourhood like IJburg in Amsterdam, the vast majority of houses have a semi-private zone between the front door and the street. A future challenge is to create such usable zoning in multi-storeyed apartment buildings between the front door of the building and the front doors of the apartments. The existing design facilitates anonymity and no control over social interaction. Another aspect of control also needs to be on the agenda; the control by citizens over the process of design and management of their built environment. The market may move more towards community architecture.

15.4 Promising Solutions

From this book, multiple possible solutions can be drawn to make the urban metabolism as well as urban areas more sustainable. Ecosystem thinking and the use of ecosystems' services should be the starting basis for sustainable urban (re-) development; the proper analysis of the specific natural local basic conditions, its renewable resources and flows over time is a first step to understanding the potential of a specific place and area. The second step is the development and analysis of the program and the required minimum resources for its construction, operation, service and maintenance. This includes all aspects and so-called flows which have been discussed in the framework of this book. However, it is not enough to think only about the optimisation and enhancement of efficiency of systems we already know and which are already in place, but to think about more effective solutions which create synergies between the different sectors and flows, not only regarding environmental and social criteria but also and particularly regarding economic criteria. The right technologies, infrastructure systems and urban typologies have to be identified and combined to fit to the specific (re-)development.

 For the measurement of sustainability levels of buildings, neighbourhoods, districts and cities, a well-balanced set of criteria should be used, which can be assigned to economic, ecological and social aspects, as well as to the quality of the location and involved processes (planning, construction, operation, maintenance, deconstruction). The use of Life Cycle Assessment and green building, respectively neighbourhood certification tools, such as LEED, BREEAM and DGNB, are a first step in this direction and can help to assess and compare the degree of sustainability of specific solutions. However, these tools are also far from being complete, even though their focus has broadened from ecological criteria to social and economic criteria.

The use as well as the weighting of the different criteria is critically discussed amongst users. Depending on which system is considered, they lack more or less proper indicators for the measurement of specific sustainability criteria. Furthermore, assessment tools are not planning tools and can therefore not assist in the design and planning process itself. First, design proposals have to be developed before they can be assessed. An integrated planning and design process in which experienced experts of different fields of practice are developing design proposals and plans, which are continuously evaluated and optimised, is therefore indispensible for the making of plans for sustainable urban developments.

A very promising approach is the design of healthy, liveable and attractive urban environments, which integrate closed-loop recycling systems, for water, waste, energy, soil and horticulture, and the economic valuation of ecosystem services on the basis of integrated system thinking, which is inspired by nature. Such an approach is looking for fruitful combinations of processes and is directly or indirectly mimicking integrated systems in nature, which do not produce waste but only resources for other processes. For a better understanding, this approach is discussed using examples for specific very promising combinations and case studies.

15.4.1 Significantly Reducing Resource Flows

As already discussed in the chapters of this book, the starting basis for the development of sustainable urban areas is the reduction of resource flows in urban developments. In developed areas with comparable high household water consumption levels, the drinking water consumption can, for instance, be easily reduced (in the Netherlands, for example, by approximately 30%) – and without limiting the comfort or requiring a change in user behaviour – only by applying water-efficient appliances and user interfaces such as taps, showerheads and toilets. By recycling and reusing wastewater, for instance grey water from shower and bath, as water with secondary water quality for non-drinking purposes, such as laundry, cleaning and toilet flush, the water consumption can be further reduced (in the Netherlands by approximately 20%). In this way, the pressure on the environment for freshwater extraction and the related processes (such as drinking water production and wastewater purification) can be significantly reduced, for example in the case of the Netherlands by 50% (Schuetze et al. 2008). The same principle of demand reduction can also be applied to buildings. For instance, in comparison with the energy demand for heating and/or cooling of the existing building stock in the Netherlands, a reduction of up to 90% is achievable by appropriate climate-responsive design, insulation and building services engineering.

Even though these numbers look quite impressive, the related measures are not based on the integration and creation of synergies between different sectors. However, they are the first required step towards a higher level of sustainability. Only by significant reduction of the demand does it become feasible to supply the required

resource within a small area, e.g. a city, and with a minimised environmental impact. For instance, the thermal and electrical energy demand of cities can be generated with solar thermal collectors and photovoltaic generators, but the available space for these installations in cities is limited. A maximum surface for energy generation, by minimising the investment costs, can be provided by the replacement of conventional building components through solar thermal collectors and PV modules (Schuetze and Hullmann 2011). In this way, the energy dependency of urban areas can be reduced and, in the best case, energy independency realised. This requires the combination with other means of energy production, such as from biomass and/or energy storage. For both needs, space has to be provided, desirably as close as possible to the consumer.

15.4.2 Looking for Synergies

Considering the ecosystem approach and the goal to 'green' cities, not only at ground level but also by applications of greened roofs and façades to buildings, to create a better urban microclimate, at first glance the available space for energy production and storage as well as for integrated water management seems to be even more limited. However, by the development of promising combinations and smart systems, this 'limitation' can be turned into a 'profit'. Therefore, it has to be considered that living plants turn approximately 80% of solar radiation into latent heat through evapotranspiration, while on sealed surfaces like roads, roofs and façades, the radiation is turned into potential heat and contributes to the 'urban heat island effect', or is reflected back to the atmosphere. Hence, plants contribute significantly to active cooling of the environment (Kravčík et al. 2007; Schmidt 2010)[1] and can be used as natural air conditioning and cooling systems for urban areas and buildings. This cooling effect can, on the one hand, mitigate urban heat island effects. On the other hand, it can enhance the solar energy production of PV cells during warm outside temperatures and high radiation, because the efficiency of PV cells generally declines with rising temperatures. Therefore, the combination of greened surfaces for passive cooling with PV modules is a synergy.

[1]Depending on the species, plants can evaporate much more water than open water surfaces, if they are sufficiently supplied with water. In the Netherlands for instance, the potential evaporation rate is approximately 500 mm/year, but evaporation through plants, with realistic values for evapotranspiration per square meter in the conditions of the temperate climate zone, reaches values of 3 l/day, which represents a latent heat of 2.1 kWh/day. Some plants, so long as they have sufficient water available, are able to evaporate in the course of a sunny day more than 20 l of water per square meter, which is similar to 14 kWh latent heat. The maximum solar radiation which arrives per square meter per year in the Netherlands is approximately 1,100 kWh/m^2. However, it can reach a maximum of 3,000 kWh/m^2 in other zones.

15.4.3 Integrated and Decentralised Water Resource Management

To enhance the evapotranspiration and cooling performance of plants, they have to be sufficiently irrigated, particularly in seasons when there is not enough precipitation. If water efficiency in the framework of a supply-driven perspective is considered, this may be regarded as a conflict particularly in periods of drought and water scarcity. From an integrated and decentralised water resource management perspective, this is not necessarily the case. The decentralised processing of domestic wastewater generates a source for urban water supply, which is available during the whole year in quite similar quantities, and also during periods of water scarcity and can therefore be used for irrigation. There is no need for a secondary complex water distribution system, because the wastewater occurs almost everywhere in a city where water is consumed. If there is no need for irrigation, for instance during periods with sufficient rainfall or non-vegetation periods in temperate and cold climates, the surplus water can be used for the augmentation of ground or surface water bodies which can be combined with different qualities of 'urban green' and contribute to the spatial and ecological quality and liveability of urban areas, as well as the food and energy production with biomass and, last but not least, for the production of drinking water. It is obvious that the separated and decentralised management of rainwater by retention, infiltration and storage is the starting basis for this integrated ecosystem approach. Also, in virgin natural greened areas, most of the rainwater is absorbed by the soil and brought back to the atmosphere by evapotranspiration. The rest is contributing to the recharge of ground water and, but only in a small portion and only in cases of heavy precipitation events, running off the surface. Regarding recent research findings (Kravčík et al. 2007; Schmidt 2010), it is very likely that the reconstruction of this natural water balance can, if applied extensively, not only contribute significantly to the mitigation of the urban heat island effect but also to the effects of climate change by reconstruction of small water cycles. Furthermore, plants absorb dust and contribute to a better air quality and to the well-being and health of the residents.

15.4.4 Creating Further Synergies with Energy and Agriculture

The decentralised management of urban wastewater and organic waste streams can be used for the creation of further synergies with the areas of 'energy', 'resource efficiency' and 'urban green'. Portions of the urine in urban areas can be very easily collected, for instance with waterless urinals for men. In the case of the application of so-called 'separation toilets', theoretically even a big part of the total urine, also from women could be collected. The partly separation can contribute to the renewable resource production of nitrogen and phosphorous fertiliser, and to the optimisation of centralised (current state of the art) and decentralised wastewater

treatment processes. Furthermore, using the example of the Dutch situation, the existing sewage treatment plants could be turned from energy consumers to energy producers. Taking all required measures, costs and potential earnings into account, the introduction of such a system would be economical profitable (Wilsenach and Loosdrecht 2006). The energy would be produced by combined heat and power generation with biogas, produced by the anaerobic digestion of sewage sludge in centralised sewage treatment plants. Afterwards, the sludge is generally dewatered, dried and finally burned, again for energy production. The reuse of dried sewage sludge as a fertiliser in agriculture is only practiced if pollution from industry or traffic areas can be controlled. Therefore, the current trend in developed countries, which can afford the costly centralised collection and treatment of wastewater, is not, or only to a limited degree, to apply the processed sludge in agriculture.

The production of biogas from concentrated black water from toilets and organic waste materials (from households, food production, restaurants, horticulture/ agriculture) is also feasible and already practised on a decentralised level. After the anaerobic digestion process, the leftover can be processed in different ways, which again can be profitable for other processes. Thus, the sludge can be used directly as fertiliser in agriculture. However, this is generally difficult in urban areas without urban agricultural areas due to a lack of appropriate space or to the required transport over long distances. Alternatively, the sludge can be separated in liquids, which can be processed together with other urban wastewater streams, while the solids can be treated together with other organic waste, for instance from households, restaurants, and urban horticulture. The current state of the art practice for treatment and the recycling of organic waste are composting processes. The final product, compost, can be used for urban horticulture, or transported to farms and used for fertilisation and enhancement of soil quality (Luethi et al. 2011).

15.4.5 Reinventing Terra Preta

This is already a first step towards sustainable organic waste management, but according to recent research findings and developments, there are even much more promising technologies available, which can be used for the (re-)construction of ecosystems. Particularly the production so-called 'Terra Preta' (Portuguese for 'black soil') offers manifold possibilities for integrated urban resource management. Terra Preta was originally produced and used by Indian cultures in the Amazon basin, to facilitate permanent settlements, which existed over several hundreds to thousands of years. Excavations show that huge areas in the Amazon are covered with layers of anthropogenic Terra Preta, which allowed the dwellers to practice permanent agriculture in the tropical climate on naturally poor soils.

The secret of this particular soil is a lactic acid fermentation process, which incorporates manure, human faeces, and organic material as well as charcoal. The nutrients (nitrogen and phosphorous) contained in the waste of humans and animals is kept in this soil and bound to the charcoal particles. The nutrients stay in

the soil until they are made available to the roots of plants by microorganisms. Due to this property, sufficient amounts of Terra Preta facilitate permanent rich plant growth without the need to use artificial fertilisers, and can contribute to the purification of rainwater runoff, also in the case of heavy precipitation events, even though it is rich in nutrients. The good water storage facilities help to cope with floods and periods of drought and can therefore be used for adaptation to the effects of climate change. Furthermore, this soil contributes to CO_2 sequestration from the atmosphere (as opposed to soils which are used for conventional agriculture) and therefore contributes to climate change mitigation (Factura et al. 2010).

Scientists have developed different recipes for the contemporary production of Terra Preta, and for the use of its wonderful properties for multiple purposes, such as the restoration of destroyed top soils, organic horticulture and reforestation, as well as the management of urban organic waste. Black soil can be produced centrally, collectively and also on an individual level and is therefore applicable in almost all environments. The lactic acid fermentation is driven by effective microorganisms (EM), which can be collected from healthy soils in the area of application (Park and DuPonte 2008). The bio-charcoal for its production can be produced by pyrolysis of dry organic matter, such as waste material from agriculture or wood. This process facilitates both the production of charcoal (bio-char) and the production of heat through the burning of the occurring pyrolysis gas.

Simple self-made pyrolysis cookers are for instance already used in poor areas to optimise the current resource (usually wood) used for cooking and avoid polluting exhaust gases from conventional burning processes. In industrialised countries, the pyrolysis process is executed in reactors and the resulting gas is used to run combined heat and power generators. The resulting charcoal is a kind of 'by-product' of the renewable energy production process. Alternatively, bio-char can be produced out of wet biomass (e.g. sewage sludge or organic waste) by an exothermal process, which is called 'hydrothermal carbonisation'. The process is supposed to be more energy effective than biogas production and the produced coal is, like biogas, an energy carrier, which can be stored and burned for combined heat and electrical power generation.

15.4.6 Urban Ecosystem Approaches: Successes and Challenges

The technologies described and the integrated system approaches for integrating urban resource management are currently being applied and tested to achieve sustainable urban environments. The basic principles are the decentralised collection of liquid and solid waste products. Liquid waste is processed and reused on more decentralised basis (including rainwater, grey water and black water). The treatment and reuse of urine and solid waste (including organic waste from filtered wastewater, food production and horticulture) may be more feasible on a collective or central basis (dependent on the specific basic conditions, such as density and culture).

The transport required is desirably electrically driven and based on the storage of photovoltaic energy produced decentrally. Urine and organic waste is processed to Terra Preta and fertiliser and used for the quantitative and qualitative enhancement of horticultural areas in and around urban areas. This facilitates the organic production of food (including urban agriculture) and biomass (such as fast-growing timber) in and around urban areas. The biomass can be used for the production of bio-char and renewable energy, as well as additional Terra Preta, the same as the food, which finally ends up again in organic waste, which can be again recycled (Schuetze and Thomas 2011).

The approach described here is a good example for an ecosystem thinking approach for the (re-)construction of sustainable urban areas. Through integrated resource management it is possible to provide a stable basis for the development of green and liveable cities and areas, which are less, or in the best case, not dependent any longer on imports of resources, such as water, food, energy and fertilisers, to fulfil their basic needs.

We can design, develop and implement sustainable solutions for urban infra-structure systems. We can picture the ideal situation and by backward and forward mapping we can develop a roadmap that will get us where we want to be. However, in reality, such roadmaps turn out to be difficult to make because every situation is unique and the right choices have to be made according to the complex specific local basic conditions. For instance, the situation in developed and developing areas is significant different. Even among places, areas and regions with same gross domestic product, differences in natural basic conditions, existing infrastructures, institutional and legal frameworks and cultures require the development of individually adapted ecosystem approaches.

The complexity and uniqueness of urban ecosystems make it challenging to transfer successful projects to other places. Knowledge transfer amongst city administrations usually takes place by communicating best practices. However, many of these best practices are context-bound, and realising the value of the lessons learned in one place for other places is not straightforward. In addition, the sustainable building and neighbourhood projects, which have been realised so far, particularly in developed areas, were relatively small in scale, limited to small areas or to small numbers of citizens. The individuals involved were often highly dedicated to the project concerned and were willing (to try) to change their behaviour when needed. However, recently, the ecosystem approach has been successfully implemented by developers and on comparably big scales. A successful example is the 'Dockside Green' project in the City of Victoria, British Columbia, Canada. The new district has been constructed on an old contaminated industrial site. It was designated by the City and aimed to achieve the LEED Platinum levels for the buildings as well as for the neighbourhood development. A valuation study resulted in the award of the development rights to a mixed residential – retail district to a private developer and an investor (respectively 'Windmill Developments' and 'VanCity Credit Union'). The development concept is based on Integrated Resource Management (IRM), with a decentralised wastewater collection, treatment and disposal system.

The core design concept for the on-site treatment processes is based on the principles of closed-loop recycling, the minimisation of operating costs and resource recovery. The application of the concept of IRM source separation and treatment of different sewage streams is facilitated by the application of decentralised infrastructures for rainwater and domestic wastewater management and recycling. The water is reused for service purposes in the buildings, irrigation of landscapes and green roofs, and the supply of the artificially constructed urban water body for enhancement of the ecological quality. However, the on-site wastewater management is connected via an emergency bypass to the city's sewer system. The drinking water is supplied conventionally via the central infrastructure. The system is managed and operated by a service provider and was planned and constructed based on conventional top-down planning approaches (O'Riordan et al. 2008).

The described development can be regarded as a good practice example for a centrally planned, constructed and operated large-scale urban ecosystem, driven by economic criteria. It indicates that there are many different ways to develop sustainable urban areas, based on ecosystem approaches. Compared with traditional bottom-up planning approaches of sustainable urban (re)development, top-down planning approaches do not necessarily also exclude participatory processes and bottom-up feedback, and can successfully lead to the creation of sustainable, attractive and liveable neighbourhoods.

Questions

1. How can we describe the metabolism of urban areas in the form of flows?
2. What are the possibilities to measure the specific degree of sustainability of cities?
3. Formulate three different approaches for making urban areas more sustainable?
4. How can a 'green' approach facilitate the development of a more sustainable urban environment which will have a high level of comfort and will also have a high level of ecological values?
5. Can you give examples of how we can in future make use of the different levels of scales in relation to urban form and environmental problem solving?

References

Factura H, Bettendorf T, Buzie C, Pieplow H, Reckin J, Otterpohl R (2010) Terra preta sanitation: re-discovered from an ancient Amazonian civilisation – integrating sanitation, bio-waste management and agriculture. Water Sci Technol, WST 61.10–2010, London, pp 2673–2679
IRENA – International Renewable Energy Agency (2011) About IRENA. Preparatory commission for International Renewable Energy Agency IRENA. http://www.irena.org/. Accessed 6 Mar 2011

Kravčík M, Pokorný J, Kohutiar J, Kováč M, Tóth E (2007) Water for the recovery of the climate – a new water paradigm. Publisher Municipalia. http://www.waterparadigm.org/

Luethi C, Panesar A, Schuetze T, Norström A, McConville J, Parkinson J, Saywell D, Ingle R (2011) Sustainable sanitation in cities: a framework for action. Sustainable sanitation alliance & International forum on urbanism. Papiroz Publishing House, Rijswijk

Mocker M, Faulstich M (2011) Strategische Rohstoffe für den Ausbau Erneuerbarer Energien. Festvortrag & Tagungsband 26. Symposium Photovoltaische Solarenergie, ISBN 978-3-941785-51-9, Ostbayerisches Technologie-Transfer-Institut e. V. (OTTI), Regensburg, Germany, pp 554–559

O'Riordan J, Lucey P, Baraclough CL, Corps CG (2008) Resources from waste – an integrated approach to managing municipal water and waste systems. Ind Biotechnol 4(3):238–245

Park H, DuPonte M (2008) How to cultivate indigenous microorganisms. Biotechnology, BIO-9. College of Tropical Agriculture and Human Resources (CTAHR), University of Hawai'I, Manoa

Schmidt M (2010) Main cause of climate change: decline in the small water cycle. Water infrastructure for sustainable communities: China and the world. IWA Publishing, London, pp 119–126

Schuetze T, Hullmann H (2011) Wirtschaftliche Aspekte beim Einsatz multifunktionaler photovoltaischer Bauteile. Tagungsband 26. Symposium Photovoltaische Solarenergie, ISBN 978-3-941785-51-9, Ostbayerisches Technologie-Transfer-Institut e. V. (OTTI), Regensburg, Germany, pp 546–551

Schuetze T, Thomas P (2011) Towards zero emission cities through integrated urban resource management. In: Proceedings 5th conference of the International Forum on Urbanism (IFoU), Global visions –risks and opportunities, School of Design and Environment, National University of Singapore (NUS), Singapore

Schuetze T, Tjallingii SP, Correljé A, Ryu M (2008) Every drop counts. UNEP DTIE IETC, Osaka/Shiga

Wilsenach JA, van Loosdrecht MCM (2006) Integration of processes to treat wastewater and source-separated urine. J Environ Eng ASCE 132(3):331–341

Contributing Authors

Ellen van Bueren is intrigued by multi-actor decision-making. In her research and teaching, she focuses especially on the design, organization and management of such processes in the field of environmental and urban planning and building and construction. She is assistant professor at the Faculty of Technology, Policy and Management of the Delft University of Technology and editor of *Bestuurskunde*, the Dutch journal of public administration.

Hein van Bohemen has been head of the environmental research department at the (former) Road and Hydraulic Engineering Institute of the Ministry of Transport, Public Works and Water Management in the Netherlands. He worked at the Delft Interfaculty Research Centre, entitled 'The Ecological City', and until (pre-)pension, he was a lecturer in ecological engineering at the Civil Engineering Faculty of the Delft University of Technology. He is (a founding) member of the executive board of the International Ecological Engineering Society (IEES) and has a consulting firm (BohemenEcoEngineeringConsultancy) involved in ecological engineering.

Machiel van Dorst holds an MSc in environmental technology (Eindhoven University of Technology) and a PhD on Urbanism from the Delft University of Technology. He is working as an associate professor at the Faculty of Architecture, at the Delft University of Technology. Specializations are environmental psychology, sustainable urbanism and design methodology. Van Dorst is member of architectural juries, quality teams and diverse associations for quality of public space.

Michiel Haas is professor of Materials and Sustainability at the Faculty of Civil Engineering and GeoSciences at the Delft University of Technology. He is founder and owner of NIBE, the Netherlands Institute for Building Biology and Ecology. At NIBE, he developed the TWIN model, an LCA-based model to determine the environmental impact of building materials and building designs, which is part of GreenCalc. NIBE is housed in a former water tower, which has won an award for the 2011 most sustainable office building in the Netherlands.

Anke van Hal is professor of Sustainable Housing Transformation at Delft University of Technology and professor of Sustainable Building and Development at the Center for Sustainability of Nyenrode Business University. She holds a PhD in Architecture, and has worked as a private consultant and journalist in the field of sustainable building. In her publications and consultancy, she aims to bridge the gap between producers and consumers.

Loriane Icibaci specializes in applying new sustainable technologies to construction with a special focus on affordable construction in developing countries. She studied at the University of Sao Paolo in Brazil and Kagoshima University in Japan. She has experience in architecture firms and design companies and is conducting PhD research at the Faculty of Industrial Design of the Delft University of Technology.

Laure Itard After studying physics and thermodynamics, Laure Itard took her doctoral degree on modeling heat pumps and worked as a consultant for energy and technical equipment in buildings. She is associate professor at the Delft University of Technology and at the Hague University of Applied Sciences where her research focuses on thermal simulation models, environmental analysis of buildings and the effects of regulations and occupant behavior on energy use.

Taeke M. De Jong is full professor of Technical Ecology and Methodology at the Faculty of Architecture at the Delft University of Technology and shares the Chair of Metropolitan and Regional Design. The Chair's education is aimed at the broad range of environmental aspects and how they can serve as a precondition within the various design disciplines. The methodological, philosophical and practical consequences of this are also examined. Areas covered include sun, wind, water, soil and ecology, as well as amenities and their distribution. De Jong edited the methodological handbook entitled, '*Ways to study and research urban, architectural and technical design*', published in 2002. He is currently a member of the Delft University of Technology Board for Doctorates.

Arjen Meijer is a researcher at the OTB Research Institute of the Delft University of Technology. His research is focused on health effects as a result of emissions of construction materials to the indoor environment in life cycle assessment of houses. Arjen holds a PhD in Environmental Sciences from the University of Amsterdam.

Frits Meijer is senior researcher in Housing Quality and Process Innovation at the OTB Research Institute of the Delft University of Technology. He specializes in building regulations and quality assurance and has done comparative international research into systems of building regulations and supervision.

Jody Milder During the time of writing, Jody Milder was a researcher at the OTB Research Institute of the Delft University of Technology. He specialises in policy related to urban and regional development on the strategic level with the focus on sustainability and the European context.

Lorraine Murphy holds an MSc in Environmental Sciences from Trinity College Dublin. She is currently a researcher at the OTB Research Institute for the Built Environment in the Netherlands. Her research focus is the role of policy instruments in improving the energy performance of buildings. Lorraine has previously advised on environmental issues for the built environment in the UK and the Netherlands for both the private and public sector.

Arjan van Timmeren is Associate Professor of Green Building Innovation & Product Development at the Department of Building Technology, Faculty of Architecture, Delft University of Technology. Upon his graduation in Architecture, he worked in several well-known international architectural offices like 'Renzo Piano Building Workshop', Genova, Italy; 'Arribas Arquitectura', Spain; 'Gunnar Daan Architectuur', the Netherlands; and 'Karelse & Van der Meer Architecten', the Netherlands. He is also partner in 'Atelier 2T' (Haarlem, the Netherlands), an architecture and engineering office dedicated to Climate Integrated Design and Research, with emphasis on bio-climatic design, sustainability and self-sufficiency. He has received several (inter)national awards for his work and has seats on many International Scientific Advisory Committees and Expert Panels.

Sybrand Tjallingii is an urban and regional planner with a background in landscape ecology. His PhD Thesis, Ecological Conditions (Delft University of Technology 1996), analyzes the role of ecology in urban planning. He worked in teaching, research and consultancy at Delft and Wageningen and retired as an associate professor in 2006. He is still a guest lecturer and researcher at the Delft University of Technology.

Henk Visscher holds a chair of Housing Quality and Process Innovation at the Faculty of Architecture at Delft University of Technology. He is coordinator of the Department of Sustainable Housing Quality at the OTB Research Institute of the Built Environment. The research deals with technical, management, policy and process issues of a sustainable housing stock. He leads the international CIB task group TG 79: Building Regulations and Control in the Face of Climate Change.

Bert van Wee (1958) is professor of Transport Policy at the Delft University of Technology, in the Faculty of Technology Policy and Management. In addition, he is head of the section Transport and Logistics. His research areas include land-use and transport interaction, accessibility, the environment/sustainability, evaluations and policy analysis, and large infrastructure projects.

Index

A

Abiotic depletion, 295–296
Acidification
 energy production, 119
 environmental impact category, 297
 geothermal plant operation, 161
 transport, 249
Adaptive Methodology for Ecosystem
 Sustainability and Health
 (AMESH), 51
Agenda 21 declaration, 344
Air change per hour (ACH), 130
Air quality and human health
 biological pollutants
 construction phase, 217
 design phase, 216–217
 house dust mites, 210
 legionella bacteria, 211
 moulds, 210
 people, 211
 plant and pet allergens, 210–211
 use phase, 217–218
 chemical pollutants
 building materials, 209
 combustion gases, 209–210
 construction phase, 217
 consumer products, 209
 design phase, 216–217
 use phase, 217–218
 exposure
 emission rate, 211–212
 ventilation rate, 212
 health effects, 215
 lighting
 categories, 214
 colour temperature, 214–215
 construction phase, 219

 design phase, 218–219
 use phase, 219
 noise
 causes, 214
 construction phase, 219
 design phase, 218–219
 use phase, 219
 outdoor air pollutants
 agricultural activities, 207–208
 industrial activities, 207
 NO_x concentrations, 208
 traffic, 207
 thermal comfort
 construction phase, 219
 design phase, 218–219
 parameters, 212
 sensation, 213
 use phase, 219
 velocity and turbulence, 213
Apparent liveability, 225–226

B

Bio-ecosystems, 42
Biogas Support Programme, 354
Biovaerk project, 321–322
Building
 air tightness, 212
 building-related energy demand, 123
 certification standards, 314
 climate
 environmental conditions, 124
 heat island effect, 125
 components, 294
 construction phase, 219
 design phase, 218–219
 electrical energy demand, 145–147

E. van Bueren et al. (eds.), *Sustainable Urban Environments: An Ecosystem Approach*,
DOI 10.1007/978-94-007-1294-2, © Springer Science+Business Media B.V. 2012

Printed by Publishers' Graphics LLC
MO20120507